News Evolution
or
Revolution?

Mass
Communication
and
Journalism

Lee B. Becker

GENERAL EDITOR

Vol. 13

The Mass Communication and Journalism series
is part of the Peter Lang Media and Communication list.
Every volume is peer reviewed and meets
the highest quality standards for content and production.

PETER LANG
New York • Bern • Frankfurt • Berlin
Brussels • Vienna • Oxford • Warsaw

News Evolution
or
Revolution?

The Future of Print Journalism in the Digital Age

Edited by
Andrea Miller & Amy Reynolds

PETER LANG
New York • Bern • Frankfurt • Berlin
Brussels • Vienna • Oxford • Warsaw

Library of Congress Cataloging-in-Publication Data

News evolution or revolution?: the future of print journalism in the digital age /
edited by Andrea Miller, Amy Reynolds.
pages cm. — (Mass communication and journalism; vol. 13)
Includes bibliographical references and index.
1. Journalism—History—21st century. 2. Journalism—Technological innovations.
3. Journalism—Economic aspects. 4. Online journalism. 5. Times-picayune.
I. Miller, Andrea, editor of compilation. II. Reynolds, Amy, editor of compilation.
PN4815.2.N49 070.4—dc23 2014005960
ISBN 978-1-4331-2316-0 (hardcover)
ISBN 978-1-4331-2315-3 (paperback)
ISBN 978-1-4539-1338-3 (e-book)
ISSN 2153-2761

Bibliographic information published by **Die Deutsche Nationalbibliothek**.
Die Deutsche Nationalbibliothek lists this publication in the "Deutsche
Nationalbibliografie"; detailed bibliographic data are available
on the Internet at http://dnb.d-nb.de/.

Cover design concept by Minjie Li

The paper in this book meets the guidelines for permanence and durability
of the Committee on Production Guidelines for Book Longevity
of the Council of Library Resources.

© 2014 Peter Lang Publishing, Inc., New York
29 Broadway, 18th floor, New York, NY 10006
www.peterlang.com

Printed in the United States of America

For Doug, Gracie, and Zach
—Andrea Miller

For Tad, Chase, Mom and Dad
—Amy Reynolds

Table of Contents

Acknowledgments

Not long after *The Times-Picayune* announced in May 2012 that it would decrease its print publication to three days a week, we sat around a conference table and talked about the significance of that decision. The former professional journalists inside us had an emotional response to the news. After we digested the potential implications of *The Times-Picayune's* announcement, the scholars inside us saw an unusual opportunity. What if we could study this transition in real time? Within weeks, we decided we had enough research ideas to fill a book. Our colleagues who produced this volume with us liked the ideas we pitched to them. They pitched ideas back. Before *The Times-Picayune* print reduction occurred in October, we had a team of researchers on board and data collection well underway. Our data collection continued well into 2013 to ensure that we could keep up with the story we wanted to tell—how *The Times-Picayune* represents a microcosm of the news business, and can tell us something important about the future of print journalism. Without our team of scholars this book would not exist. We want to thank Louisiana State University Manship School of Mass Communication colleagues Jinx Coleman Broussard, Jerry Ceppos, Nicole Dahmen, and Lance Porter, and University of Alabama colleague Chris Roberts for their willingness to take on a challenging project with tight deadlines.

We are also indebted to several Manship School graduate students who made strong contributions to multiple chapters—doctoral students Lindsay McCluskey and Young Kim; master's student Paromita Saha; and, former doctoral student Ben LaPoe who is now an assistant professor at Western Kentucky University.

We knew from the beginning of this project that we did not want to explore the topic from a distance, but rather from within and around as many newsrooms as we could enter. It was critical for us to gain access to journalists, editors, publishers and photojournalists so our research would have professional validation and relevance. We were overwhelmed with the positive response we received—very few people refused our requests for interviews or site visits. We are grateful to all of the people we interviewed for the book. In the end, our team conducted 95 interviews that took us from the West Coast to the East and in-between.

We owe a special note of gratitude to the leadership at *The Times-Picayune*. Immediately following the announcement of the print reduction at the paper, media coverage of the decision was decidedly unkind. Amid some harsh and public criticism, Ricky Mathews and Jim Amoss were still willing to spend half a day with us and talk on the record about difficult topics. They didn't censor us, nor did they try to limit our access to information. It was clear to us that no matter how well this new strategy works, Mathews and Amoss are committed journalists who care deeply about *The Times-Picayune* and its future.

We are also particularly thankful to the staffs at *The Newtown Bee*, the *Asbury Park Press* and *The Press of Atlantic City*. They welcomed us into their newsrooms and talked with us about their highly emotional experiences at a time when the Sandy Hook shooting and Superstorm Sandy were still fresh and painful memories.

Peter Kovacs and John Georges at *The Advocate*, Bob Mong, Jim Moroney and David Duitch at *The Dallas Morning News*, and Evan Smith at the *Texas Tribune* were also generous with their time. We appreciate their thoughtful interviews, their interest in helping us understand the complexities of the newspaper business today, and their willingness to give us access to their news organizations.

Several people also aided us in this effort by way of transcription, copyediting, reference checking, and more. Our thanks to Farren Davis, Ellada Gamreklidze, Kristen Higdon, Shelby Holloway, Tim Klein, Rachel Reynolds, Kate Royals, and Elle Schmidt. Thanks also to Minjie Li who designed the book's cover. Additionally, we'd like to thank Mary Savigar at Peter Lang Publishing, and Lee Becker at the University of Georgia for their helpful edits and guidance throughout the writing and publication process.

Finally, we'd like to thank our families for always offering their support and encouragement.

Introduction

ANDREA MILLER & AMY REYNOLDS

Former *Times-Picayune* reporter and current WWL-TV investigative reporter David Hammer smiled as we asked him to talk about what makes New Orleans different. "I'm glad you asked me that 'cause it is one of my favorite topics," he said (personal communication, February 5, 2013). Hammer didn't believe he would settle in New Orleans as a working journalist after college, but Hurricane Katrina solidified his love of and dedication to the city. As a seventh generation New Orleanian, he felt a great responsibility to be a conduit of information on the recovery. Unique in the U.S., Hammer said the city has a sense of self that goes beyond a platitude. He calls it a "real identity experience," an intellectual look at your own identity and the identity of the city itself (personal communication, February 5, 2013). The city perceives itself as socially, culturally, and politically engaged and that, he suggests, has in large part been driven by the city's historic and award-winning newspaper, *The Times-Picayune*. "We're lucky in this way in New Orleans that we have a newspaper that was held in such high regard" (personal communication, February 5, 2013). And when the reduction in print publication of the newspaper happened, "It was like you're ripping our heart out to do that to us," he said (personal communication, February 5, 2013).

In May 2012, Advance Publications, Inc., owned by the Newhouse family with a long history in New Orleans, announced the decrease in print publication of *The Times-Picayune* to three days a week. After a decade of journalism convergence and cutbacks across the U.S., *The Times-Picayune* became the largest market daily to be targeted by such reductions. Some 84 employees would be laid off.

A city with an unusual attachment to its daily, printed newspaper felt blind-sided. Although the newspaper hired back many newsroom workers and added some younger faces to its staff—and in 2013 resumed printing daily through the addition of its publication *TP Street*, designed to fill in the publication gaps left by *The Times-Picayune*—the damage to the newspaper's brand and credibility remains more than a year and a half later.

This book tells the story of modern-day newspapers by exploring the digital transition of *The Times-Picayune* as a microcosm of the industry. We explore the economic, political, and social context of the move of the largest market daily newspaper (to date) from print to the Web. While the circumstances in New Orleans anchor the book, through the process of our research we expanded the book's reach to include exploration of other for-profit and nonprofit business models for newspapers; differences in how communities handle news during a crisis; how Advance's decision impacted other newspapers it owns; and, how different communities believe a decline in print journalism impacts politics and the functioning of local government.

The Times-Picayune is particularly important to study because it isn't just any newspaper in any community. The residents of New Orleans feel a personal attachment to *The Times-Picayune* because of its stability through a long, unstable past—almost the way many would view a loyal friend.

We saw more evidence of this when more than a dozen prominent New Orleanians wrote a letter to 22 members of the Newhouse family, asking them to reconsider their decision or sell the newspaper. After lauding the many good contributions the family and the newspaper made to the community, these leaders wrote, "It is painful to report that right now it is nearly impossible to find a kind word in these parts about your family or your plan to take away our daily newspaper. Our community leaders believe that your decision is undermining the important work we continue to face in rebuilding New Orleans. … If you have ever valued the friendship you have shared with our city and your loyal readers, we ask that you sell *The Times-Picayune*. Our city wants a daily printed newspaper, needs a daily printed paper and deserves a daily printed paper" (as quoted in Allman, 2012). Authors of the letter included journalist Cokie Roberts, political strategists James Carville and Mary Matalin, musician Wynton Marsalis, retired football player Archie Manning and the presidents of Tulane and Xavier Universities, among others.

The community also reaffirmed the value of a daily printed newspaper in an August 2012 survey of 1,043 New Orleans area residents that we conducted for this book (Margin of error was +/- 3 percent).[1] Results showed that 41 percent of respondents think the loss of a daily, printed newspaper will have a major impact on their ability to keep up with local news (PPRL, 2012). Almost a quarter of the respondents said that the loss of the daily printed edition would lead to more government corruption in the city. And, almost half of the respondents

confirmed that they trust *The Times-Picayune* and other local news outlets more than the national news on important stories—49 percent said that the local news coverage of the 2010 BP oil spill was better and more accurate than the national news (PPRL, 2012).

Because *The Times-Picayune* is a standard bearer, a newspaper known internationally by its "publish at all costs mindset" during Hurricane Katrina, for which it won numerous national awards including a Pulitzer Prize, particular attention must be paid to its digital transition. Especially in light of the digital divide apparent in the market. According to the non-profit New Orleans publication *The Lens*—based on Federal Communications Commission (FCC) and U.S. Census data:

> Orleans Parish has 40 percent to 60 percent broadband subscription rates, which compares poorly with most metropolitan counties nationwide, which average in the 60 percent to 80 percent range. Louisiana is ranked 44 out of 50 states in terms of broadband subscription, with just 51 percent of residents subscribing, according to data compiled by the Investigative Reporting Workshop at American University. The average state has 60 percent broadband subscription (Davis, 2012).

In addition to New Orleans' status as a less wired city, *The Times-Picayune's* digital transition is also hindered by a lack of awareness of the paper's online site. According to our survey, only one in 10 residents reported reading *NOLA.com* every day and less than half of the respondents (47 percent) were even aware that *NOLA.com* is the digital Web version of *The Times-Picayune* (PPRL, 2012).

The New Orleans media market is unusual in many respects and deserves attention. It is a market that is a mecca for culture, music, and food—but one that is also part of the Louisiana tradition of colorful and corrupt politics. New Orleans is also noteworthy because it has been the unfortunate recipient of multiple, crippling disasters. Hurricane Katrina (2005) and the Deepwater Horizon/BP oil disaster (2010) cemented the city's need for a robust local press. A true melting pot of diverse people, the community's dedication to the city and its institutions is another reason we decided to study the reduction at the newspaper as our focal point. The reaction was unprecedented. What other U.S. city is described with such passion and verve? What other city reacted to its newspaper's downsizing with grassroots and intelligentsia protest movements and a jazz funeral? What can we learn about the impact of the decline of newspapers, particularly in a distinct city like New Orleans, that translates to the rest of the world?

This book will document the changing mode of information delivery and its effects as New Orleans once again becomes an exemplar for something larger—the success or failure of the floundering worldwide print newspaper industry. This book will explore the shift from a daily printed newspaper to a three-day-a-week publication with an emphasis on Web delivery of news. Published in

1978, sociologist Michael Schudson's classic book *Discovering the News* explored the relationship between "the institutionalism of modern journalism and general currents in economic, political, social and cultural life" (pp. 10–11). It's time to take another look at the institution of journalism through a twenty-first century lens. More than 40 years later, communication scholars can learn much more about how modern technology, business models, communities, and culture can impact journalism. And, the New Orleans *Times-Picayune* offers the opportunity to study this impact in real time. Therefore, this book is organized around three broad themes—social/cultural, economic, and political. Contributors utilized a variety of methods and several forms of scientific inquiry including historical research; content analysis; newspaper and technology company site visits; qualitative meta-analysis; a New Orleans survey that included more than 1,000 respondents; and, 95 in-depth interviews with newspaper professionals, scholars, media critics, and community leaders. We take an edited volume approach—to draw on the expertise of scholars and professionals across a range of areas to paint a complete picture.

By researching in real-time the metamorphosis of the New Orleans *Times-Picayune*, we will show what news organizations, journalists, news consumers, and professionals can learn about the future of the global newspaper industry. Is the newspaper industry in the midst of evolution or are its decisions sparking a revolution?

NEWS EVOLUTION OR REVOLUTION?

Evolution involves the change in inherited characteristics over generations. Revolution is the forceful overthrow of a government or social order in favor of a new system. Which is happening to newspapers? It depends on whom you ask. The longer digital disruption persists, the more media scholars and professional journalists talk about revolution.

"This is not an evolution. This is a revolution," said Rosental Alves, Knight Chair in international journalism and professor at the University of Texas School of Journalism. Before moving to Texas, Alves spent 27 years as a professional journalist in Brazil. "It is not just technological advancement or evolution as usual. It's a huge transformation" (personal communication, July 29, 2013).

Alves created the International Symposium on Online Journalism (ISOJ) in 1999 to bring journalists and academics together to study and discuss what was then the evolution of a new genre of journalism. Today, Alves said he takes the "radical view" that what we're witnessing in the digital revolution in its entirety is "the extension of our muscles, our force, we could move faster, we could communicate faster … what we are seeing now is the extension of our minds, our brains" (personal communication, July 29, 2013). Alves said that he travels

to newsrooms around the world "to preach this almost as an evangelizer, trying to call attention to this fact. I never said that newspapers are going to die. I have always said that newspapers who are not understanding this (digital revolution), the impact of this change will die, like the careers of all journalists who do not understand this will die," he said. "But I see a role for professional journalism in this new environment, perhaps even stronger than before" (Alves, personal conversation, July 29, 2013).

Former *Washington Post* Executive Editor Len Downie, Jr. and sociologist Michael Schudson have written that "American journalism is at a transformational moment, in which the era of dominant newspapers and influential network news divisions is rapidly giving way to one in which the gathering and distribution of news is more widely dispersed" (2009, para. 1). They also predict that television and newspapers will not vanish in the "foreseeable future," but that their roles will be diminished in the new world of digital journalism.

Writer Clay Shirky (2008) noted that "Because social effects lag behind technological ones by decades, real revolutions don't involve an orderly transition from point A to point B. Rather, they go from A through a long period of chaos and only then reach B. In that chaotic period, the old systems get broken long before new ones become stable" (p. 67–68). Shirky suggested that in revolutionary times professional self-defense is common but misplaced. "We do not want to see a relaxing of standards for becoming a surgeon or a pilot. But in some cases the change that threatens the profession benefits society, as did the spread of the printing press" (p. 69).

As chapter one notes, one impact of the changing media environment is audience fragmentation. We use the term fragmentation to describe the transition from a few, large audiences for news to numerous, smaller ones that are often less diverse (Tewksbury, n.d.). Fragmentation can lead to new forms of alternative journalism. Take, for example, Mídia NINJA. In June 2013, people across Brazil gathered to protest increases in transportation ticket prices, but expanded (reportedly to more than one million people) to protest other issues including police brutality against the protestors. Within the protestors, reporting live from the streets and using cell phones and other 4G devices to broadcast their unscripted account of events, emerged Mídia NINJA. NINJA stands for "Independent Narratives, Journalism and Action" in Portuguese. The group's livecasts have reached more than 100,000 viewers. The "ninjas share their content through social media and receive responses from their audiences that well surpass the number of interactions Brazilian larger media outlets receive through their pages" (Mazotte, 2013, para. 3). Activist journalism is not new, nor is livecasting from an event. But, when a fragmented audience moves to collective action through the ability to connect with each other using new communication tools—then organizes further to report their actions live using mobile technology that

reaches more than 100,000 people—it creates a new form of social media-based activist journalism with potentially unlimited boundaries.

OVERVIEW OF CHAPTERS

As noted earlier, this book is organized according to three broad themes that continued to surface during our research—social/cultural, economic, and polit-ical. This book offers different perspectives from different stakeholders within different frames. The first three chapters focus on social/cultural impacts; the next four chapters examine economic conditions that shape the current media environment. The next set of chapters looks at news content and advertising and cuts across all three of the themes. The last chapter focuses on politics and news. A medium-sized state with more than 4.5 million people, Louisiana boasts three distinct regions and attitudes. Louisianans refer to residents based on what part of the state they live in: North Louisiana, South Louisiana, and New Orleans. Local media are at the center of these communities and help define culture and identity as well as what is important to residents.

Chapter one explores the importance of the newspaper to public life, society, and democracy. Based on history and on the scholarly literature from mass com-munication, sociology, law and political science, this chapter shows how changes in journalism and technology have impacted society, democracy, and public life, as well as how changes in society, democracy, technology, and public life have impacted journalism. Amy Reynolds argues that while media and technology have evolved over time, democracy, society, and public life have changed, too. Each affects the other. Yet, core beliefs about the purpose and function of the press and the related societal and democratic needs are still there, even if they show up in different forms as technology transforms the media landscape. Without a vibrant source of news to contribute to public life, communities cannot thrive.

In chapter two, Jinx Coleman Broussard and Benjamin Rex LaPoe explore *The Times-Picayune*'s 175-year history. Until the reduction in print in 2012, the newspaper had printed every day for 175 years. The only exceptions were the three days during Hurricane Katrina in 2005, when the staff was forced to evac-uate the flooded city via delivery truck. Even then, the paper published online from LSU's Manship School of Mass Communication, about 80 miles down the road in Baton Rouge. The newspaper was established in 1837 and is a year older than the first New Orleans Mardi Gras parade. The newspaper was there for a deadly yellow fever epidemic; when the term "jazz" was used for the first time; when Bonnie and Clyde and Huey P. Long were gunned down; when a Klansman became a candidate for governor; and, when Hurricane Katrina and the BP oil disaster delivered a one-two punch that devastated much of the Louisiana coast.

The newspaper's history is intertwined with politics and corruption, race and long-standing southern perceptions, as well as a distinct culture and sense of community. This chapter explores the newspaper's rich history that is parallel to the city's, its ownership changes, and the development of the New Orleans media market into the twenty-first century.

Chapter one established the importance of press in a community. Chapter three establishes the life-saving importance of the media in crisis situations. New Orleans is synonymous with jazz, the Saints, and Mardi Gras. However, New Orleans is also synonymous with one of the greatest disasters to hit the U.S., Hurricane Katrina. Local journalists not only covered the storm, they lived it. Their personal and professional stories were intertwined—their personal needs often sacrificed for the community's needs. This is a story that is repeated in other towns, by other journalists, in other disasters. This chapter is based on interviews with more than three dozen journalists across four disasters that had both local and national impact—Hurricane Katrina (2005), the Deepwater Horizon/ BP oil disaster (2010), Superstorm Sandy (2012) in New Jersey and the Sandy Hook elementary school shooting (2012) in Connecticut. Andrea Miller explores common themes of disaster coverage articulated by the journalists including how digital is changing the transmission of information at critical times, the differences between local and national coverage of crisis, and how their local ties changed how and what they reported.

The next four chapters explore economic concerns. After decades of clinging to an old business model, the newspaper industry as a whole is trying to figure out ways to generate robust profits and in some cases how to avoid ceasing to exist. When the reduction occurred in New Orleans, the print edition of *The Times-Picayune* was making money. The newspaper reached 60 percent of adults and had one of the highest penetration levels in the country. Was management finally getting ahead of the industry and making changes before it was too late? Chapter four addresses how the newspaper industry got into its present state. Manship School Dean Jerry Ceppos, a former vice president for news at Knight Ridder, interviewed top media executives and industry economists to offer a glimpse into the decision-making process that is controlling the current changes in print and online. Additionally, this chapter takes a look at a new addition into the New Orleans media market—Baton Rouge's *Advocate*. New Orleans businessman John Georges recently purchased *The Advocate,* and he has promised to move into the New Orleans market and compete, while not short-changing the capital city.

In chapter five, Reynolds explores the history of news as a commodity and how different economic models and business strategies are emerging to face the challenge of digital disruption. The chapter also explains Harvard Business Professor Clayton Christensen's notion of disruptive technology and the business strategies he suggests can aid in adaption. Through qualitative meta-analysis of

ISOJ transcripts, the Pew Research Center's Project for Excellence in Journalism State of the News Media and other annual reports and Ken Doctor's Newsonomics blog on the Nieman Journalism Lab website (all between 2010 and 2013), Reynolds identifies patterns, strategies, and trends currently employed by the news industry. In-depth interviews and visits to three news organizations with different business models (*The Times-Picayune, The Dallas Morning News* and the nonprofit *Texas Tribune*) give currency to emerging strategy patterns and trends that could offset the continuing decline in print advertising revenue and offer avenues for new profits.

Chapter six explores the shift in the New Orleans media landscape toward more competition in order to fill a perceived news gap. While many local business people like Saints owner Tom Benson expressed outrage at the changes with *The Times-Picayune*, others in the business and media community saw opportunity. A month before *The Times-Picayune's* move to three-day-a-week printed publications, *The Lens*, a non-profit publication, announced it would hire former *Times-Pic* and *Miami Herald* investigative reporter Tyler Bridges to beef up its local coverage.

As noted earlier, the Baton Rouge *Advocate*, located about 80 miles to the west of New Orleans, announced it would begin printing a daily New Orleans addition. New sources of information sprung up at the same time. Many of these new sources were created by people and organizations not affiliated with the mainstream press. The Web was simultaneously destroying traditional models for profit and creating new avenues for information. The "Wild West" news environment of the Web soon became a cliché, and alternative media settled into a different news ecosystem comprised of unexpected partnerships. Simply put, competition exploded and cooperation thrived between news organizations and/ or individual journalists. In chapter six, Paromita Saha also explores the growing influence of community news blogs and the role of citizen journalism in the new media ecosystem of New Orleans.

Advance Publications, Inc. is a private company that owns multiple magazines including *Parade* and *Golf Digest*, has interests in cable television, and owns newspapers in more than 25 American cities, including three in Alabama. In chapter seven, Chris Roberts explores the same frequency downsizing at the *The Birmingham News, The Mobile Press-Register* and *The Huntsville Times*. The combined circulation of these three papers is double that of *The Times-Picayune*. Some 600 employees were laid off. This chapter is a personal look at the reductions by a former employee of one of the papers, who is now a communication scholar at the University of Alabama. The downsizing in these cities was met with community responses very different from New Orleans, but as the author argues, these reductions are no less important.

The next series of chapters looks at how social and economic changes influence content. Chapter eight explores the inevitable comparisons between digital content

and traditional content. In this chapter, Miller and Young Kim ask, "Does the shift to digital affect the core principles of journalism? And does it have to?" First, our PPRL survey asks residents to weigh in on how they feel the lay-offs will affect the credibility and accuracy of *The Times-Picayune*. Next, a content analysis of newspaper articles and online content before and after the layoffs found differences in content between print and online. Is the industry engaging in shovelware, where the print content is just being "shoveled" online? Story topics were also analyzed and compared. Was there a decrease in public affairs reporting that is so important in a democracy? And if so, what replaced it? The landscape shifted dramatically as "digital first" emerged as the mantra for journalists. Digital is a new way to engage audiences and tell stories utilizing social media and other new tools readily available to any who wished to experiment with digital storytelling. But is digital content better? To give insight into that question, we interviewed dozens of journalists to find out what they believe is the promise of digital—presentation, interaction, aggregation (news items taken from different sources and placed on one site), immediacy, abundance, and immortalization.

In chapter nine, Lance Porter explores what it means when distribution of information, which includes advertising, shifts to mostly digital—to customers and the industry. The 2012 PPRL survey of New Orleans area residents affirmed a digital divide, or the difference between those in the community that do and do not have access to the Internet brought about by socioeconomic inequalities. This change in distribution can change who gets what information and when, but it also affects who is likely to contribute to the online conversations causing not only a knowledge gap, but what Schradie (2011) calls a "digital production gap" (p. 166). In order to be a part of a community, members must have access to information and the ability to exchange ideas. This chapter also describes the rise of Web advertising and the importance of digital branding.

Although photos and visuals are central to good storytelling, photojournalists have not escaped the seemingly continuous rounds of industry lay-offs. For example, in June 2013, the *Chicago Sun-Times* laid off its entire photography staff. Broadband journalists, as they are often called in the digital age, have greater responsibilities and pressures than ever before operating in this new realm. In chapter ten, Nicole Smith Dahmen explores the changing role of the photojournalist as well as the considerations related to static photos in a dynamic digital space. The chapter features interviews with photo managers/editors from seven news organizations, in addition to *The Times-Picayune*: *Detroit Free Press, Chicago Tribune, The Dallas Morning News, San Francisco Chronicle, Tampa Bay Times, The Denver Post*, and *San Jose Mercury News*. Photojournalists, with a combination of emotion and skill, capture the iconic moments of life and history. This chapter explores the new way visuals are being imagined and perpetuated in the digital world.

As newspapers reimagine images online, many say they also have to re-think their approach to investigative, watchdog journalism. One consequence of downsizing is having fewer resources devoted to watchdog journalism. But, does the downsizing of the local newspaper affect the political process? Will politicians behave differently if they feel an absence of the physical presence of the local newspaper? Chapter eleven explores these questions, and goes be-yond the watchdog function of the press to explore how the digital disruption of newspapers affects journalism's ability to continue to serve as an important force in government. Using Timothy Cook's (1998) framework that defines media as a political institution, Reynolds and Lindsay M. McCluskey examine whether that function is diminished as newspapers increasingly produce different kinds of digital content for Web audiences. In-depth interviews were conducted with current and former public officials in Syracuse, New York and in the state of Louisiana (two of the first locations at which Advance Publications rolled out its print and delivery reduction strategies). The public officials share concerns about the digital migration of news and suggest that shrinking newsrooms and less online content about civic and public affairs issues may be harming the re-lationship between the government and the public by diminishing the watchdog role of the press; by embracing news values and routines that favor speed and maximizing story "clicks;" by giving advantage to politicians who no longer need the press to directly reach the public en masse; and, by increasing media bias and diminishing journalistic credibility.

SIGNIFICANCE

In 2013, a group of LSU Manship School of Mass Communication faculty visit-ed technology companies (Google, YouTube and Twitter) in California as part of our commitment to maintain a current digital curriculum. We asked, "What are you looking for in new graduates?" At YouTube, they called our current students digital natives—people who don't know what it is like to not have 24-hour access to information in the palm of their hands. They dubbed our students Generation C, which represents four "Cs"—collaborate, create, curate, and community (per-sonal communication, January 29, 2013). Generation C sees legacy media as "old media"—even television limits them. They are what many call the three-screen watchers: those who watch TV with a tablet in their laps and their smartphone beside them. They do not read printed newspapers. Instead, they are masters of content curation—the process of sorting through, organizing, and presenting online content, often but not always, around a specific theme or interest. They want what they want, when they want it. The news is becoming an interactive reflection pool and the news gatekeepers can easily be bypassed. This is the future

news audience. Figuring out ways to get the information to them is of the utmost importance, and changes daily with new apps and innovations.

When one views the changes at *The Times-Picayune* in the above context, the reduction doesn't seem so drastic. Or does it? We recognize that some of the issues surrounding the industry's uncertain future are generational. Older audiences tend to view the news as more real and credible when it is in print. Other issues surround access to digital and the traditional role of the gatekeeper (discussed in chapter one). This book synthesizes all of the issues facing the modern newspaper industry. The importance of information in a democratic society, and the belief that journalism is a noble profession are also contextually important for this book. Today, media make up a complex, diverse ecosystem that is multiplatform and multiaudience. One size does not and will not fit all. While each market is different, news and information are staples that will continue in both new and traditional forms. And while many believe print is dying and digital is dancing on its grave, news management with print in their repertoire would argue perhaps not for a revolution or evolution, but reincarnation and diversification.

NOTE

1. The Public Policy Research Lab (PPRL), a part of the Reilly Center for Media and Public Affairs at LSU's Manship School of Mass Communication, conducted the survey on behalf of a team of Manship School researchers studying the New Orleans media landscape soon after the announcement of the print reduction. The survey team included Andrea Miller, Lance Porter, Amy Reynolds, Meghan Sanders, Michael Climek, Lina Brou and Kirby Goidel. The PPRL released the survey results to the public at the time the survey was complete. That report is titled "The State of Newspapers in New Orleans: Citizens' Reactions to the Loss of the Daily *Times-Picayune*." Chapters eight and nine provide greater detail about the survey results.

REFERENCES

Allman, K. (2012, July 9). *Times-Picayune* citizen's group formally asks Newhouse family to sell the paper. *Gambit*. Retrieved from http://www.bestofneworleans.com/blogofneworleans/archives/2012/07/09/times-picayune-citizens-group-formally-asks-newhouse-family-to-sell-the-paper

Davis, M. (2012, March 23). Poorer communities continue to suffer lack of broadband access—and related opportunity. *The Lens*. Retrieved from http://thelensnola.org/2012/05/24/broadband-acces/

Downie, L. & Schudson, M. (2009, October 19). The reconstruction of American journalism. *Columbia Journalism Review*. Retrieved from http://www.cjr.org/reconstruction/the_reconstruction_of_american.php?page=all

LSU Manship School of Mass Communication Public Policy Research Lab. (2012). The state of newspapers in New Orleans survey: Citizens' reactions to the loss of the daily *Times-Picayune*.

Retrieved from http://sites01.lsu.edu/wp/pprl/files/2012/07/LSUTimesPicayuneSurveyReport_Final2.pdf

Mazotte, Natalia (2013). Mídia Ninja: An alternative journalism phenomenon that emerged from the protests in Brazil. *Journalism in the Americas blog*. Retrieved from https://knightcenter.utexas.edu/blog/00-14204-midia-ninja-alternative-journalism-phenomenon-emerged-protests-brazil

Schudson, M. (1978). *Discovering the news: A social history of American newspapers*. New York: Basic Books.

Schradie, J. (2011). The digital production gap: The digital divide and Web 2.0 collide. *Poetics*, 39 (2) 145–168.

Shirky, C. (2008). *Here comes everybody: The power of organizing without organizations*. New York: Penguin Books.

Tewksbury, D. (n.d.) Audience fragmentation. *Oxford bibliographies*. Retrieved from http://www.oxfordbibliographies.com/view/document/obo-9780199756841/obo-9780199756841-0009.xml

Newspapers & Society

A Symbiotic Relationship

How Changes in Journalism, Technology, and Public Life Impact Each Other

AMY REYNOLDS

Fifty years ago (1964), in one of the most important U.S. Supreme Court cases in First Amendment history, Justice William J. Brennan, Jr. underscored the significance of information to democracy and to society, noting that the U.S. has "a profound national commitment to the principle that debate on public issues should be uninhibited, robust, and wide-open" (*New York Times v. Sullivan*, 1964, p. 270).

Fast-forward to 2009, at a Senate Hearing on the "Future of Journalism." Then-Senator John Kerry, who chaired the Communications, Technology and the Internet Committee, opened the hearing by noting "how the American people get their information … is of enormous interest to all of us because it is the foundation of our democracy … If we take seriously this notion that the press is the fourth estate or the fourth branch of government, then we need to examine the future of journalism in the digital information age, what it means to our republic and to our democracy" (Senate Hearing 111–428, 2009, p. 1)

When we talk about the future of journalism, we often talk about the ability of sustaining news media in a challenging and changing economic environment. And while news is a commodity (more on that in chapter five), it is not the same as other goods and services traded in the market. Rather, its production through adherence to professional norms and under the protection of the First Amendment is central to political and social life in the U.S., as both Kerry and Brennan observed. "Journalists themselves have insisted that their work is essential to the public good," writes sociologist Michael Schudson (2008, p. 11). "Their self-promotion, along with what came to be the self-evident importance of freedom

of expression in any society claiming to be a liberal democracy, made journalism's role seem obvious" (p. 11).

This chapter will explore how changes in journalism and technology have impacted society, democracy, and public life, as well as how changes in society, democracy, technology, and public life have impacted journalism. As this chapter will show, while media and technology have evolved over time, democracy, society, and public life have changed, too. Each affects the other. Yet, core beliefs about the purpose and function of the press and the related societal and democratic needs are still there, even if they show up in different forms as technology transforms the media landscape.

HISTORICAL CONTEXT

What is journalism? Public life? How do we think about them differently today than we did in the past? At a basic level, the broad function of journalism is communication. Communication is "the social coordination of individuals and groups through shared symbols and meanings" (Schudson, 2008, p. 11). Schudson (2008) defines journalism as

> ... the business of practicing and producing and disseminating information about contemporary affairs of general public interest and importance. It is the business of a set of institutions that publicizes ... information and commentary on contemporary affairs, normally presented as true and sincere, to a dispersed and anonymous audience so as to publicly include the audience in a discourse taken to be publicly important (p. 11).

The way we define journalism is tied to its history. At different points in time, we would not have called journalism an institution or a business. Yet, we have always thought of journalism as a reflection of our society, politics, and culture, and as a written form of chronicling events. Media scholar John Hartley (2008) says journalism makes sense of modern life, and he considers most journalism born from newspapers. But, journalism is also a written form of history that dates back to 440 BC. For example, Windschuttle (1999) notes that Thucydides differentiated his writing about the relationship between Greek states before the Peloponnesian war (431–404 BC) from myth and storytelling traditions by trying to identify the causes of the war. His work, *The History of the Peloponnesian War*, is "a commentary on the course of the war as it unfolded" (Windschuttle, 1999, para 4), and is a form of journalism.

Until the 1760s, printers in colonial America were businessmen first (Schudson, 2003). They avoided politics and local controversies and published mostly foreign news (Schudson, 2003; Franklin, 1996, originally published in 1793). But, in 1765 politics entered the picture through the practice of pamphleteering. After Thomas

Paine's *Common Sense* became widely read and reprinted in newspapers, a mass audience began to develop. Paine reached beyond political elites by writing in plain language. While pamphlets grew in popularity, newspapers started to emerge as mouthpieces for the political parties. The "party papers" were popular among political and business elites through the first half of the nineteenth century (Schudson, 1978).

Conversely, the commercial newspapers that surged in popularity in the 1830s and into the twentieth century, "Created more of a common language and common view of the world than did the small-circulation elite (party) press it challenged" (Schudson, 2003, p. 29). At the same time, the press of the nineteenth century represented the pluralism of American society. In 1827, *Freedom's Journal* emerged as the first African American newspaper; in 1828 the *Cherokee Phoenix* began publication as the first American Indian newspaper. William Lloyd Garrison's *Liberator*, the most famous abolitionist newspaper, illustrated how newspapers could be used to help organize social movements (Reynolds, 2006; Reynolds, 2001). In the period leading up to the Civil War in 1861, the German language press flourished. At the time, Germans represented 25 percent of the nation's growing immigrant popula tion. The "country weeklies" or other non-daily newspapers with a local focus and local circulation were the most widely read. This was also the time when newspapers began interviewing, newsgathering, and reporting as common practice (Schudson, 1978; Reynolds, 2005).

Interviewing, "fit effortlessly into a journalism already fact-centered and news-centered, rather than devoted primarily to political commentary or preoccupied with literary aspirations," Schudson notes (2003, p. 81). "Interviewing was one of the growing number of practices that identified journalism as a distinct occupation with its own patterns of behavior. The growing corporate coherence of journalists generated social cohesion and occupational pride, on the one hand, and internal social control, on the other" (p. 81–82).

In the early twentieth century, journalism had a strong desire to separate itself from the emerging profession of public relations and from governmental propaganda (Reynolds & Hicks, 2012; Schudson, 1978; 2003). The concept of objectivity took hold, and most of the professional norms of journalism as it is practiced today solidified.

While journalism evolved, so did public life and community. In 1830, French philosopher and political thinker Alexis de Tocqueville visited the U.S. and identified what many historians have called the "empirical center" of the history of democracy and public life in the country (Ryan, 1997). Tocqueville had visited the U.S. in search of a new political system and he reported that he not only discovered democracy but also a social and active public (Tocqueville, 1830). Historians have noted that the strong, socially-based public sphere that Tocqueville encountered was at the core of his conception of democracy. For example, Tocqueville (1830) observed,

The people of one quarter of a town met to decide the building of a church; there, the election of a representative is going on; a little further, the delegates of a district are posting to the town in order to consult some local improvements; the laborers of the village quit their ploughs to deliberate upon the project of a road or a public school (p. 108).

Tocqueville's visit "intersected with the moment when the term democracy became the best designation of the new nation's political ideology and institutions" (Ryan, 1997, p. 9). Schudson (1978) argues that the changes in journalism in the 1830s were closely connected to the broad social, economic, and political change that he calls the rise of a "democratic market society" (p. 30). He defines the democratic market society as the "expansion of a market economy and political democracy ... the democratization of business and politics sponsored by an urban middle class which trumpeted 'equality' in social life" (Schudson, p. 30).

Business and politics were not the only aspects of society that helped public life foster democracy at this time. By exploring public records and newspaper accounts, historian Mary Ryan reconstructed public life in New York, San Francisco and New Orleans between 1820 and 1835. She found that public engagement, not only among the elite voting class, was strong during this period because "antebellum cities in general boasted relatively ample centralizing spaces, especially public squares, prominent public buildings such as city hall, and local landmarks such as grand hotels, which provided a place for public assembly and symbolic civic attachment" (Ryan, 1997, p. 43).

Although the evidence suggests a strong and active public sphere in the 1830s, it was far from perfect. The functioning public and democracy was highly exclusive—only white, male property owners could vote, for example. Still, the idea that a vibrant public life, connected to democracy and to the health of communities, took root. While this was the period during which journalism became a commercial activity, it also became clear throughout the nineteenth and early twentieth century that journalism was vital to the "opening of a public sphere where private persons could freely discuss and debate public issues of the day" (Schudson, 2003, p. 212; Habermas, 1989). In addition to serving democracy in this way, news also served communities by giving mass attention to a common set of stories that "built a sense of locale, region and nationhood. This sense came not from journalism's focus on politics but from its stories which sustained communities' imagination that could not be experienced face-to-face" (Schudson, 2003, p. 212; Anderson, 1983).

So, in the nineteenth century we saw the commercialization of news; the rise of professional routines to gather, write and report news; and, a mass consumption of news that was not only reserved for elites. Societally, we saw an interest in making politics, the economy and public life more equal, and the newspaper played a role. The twentieth century solidified much of this, and saw even greater efforts to promote equality—post-Civil War slavery disappeared, free blacks and eventually

women could vote, and the health of society often fluctuated based on the health of the government and the economy. The twentieth century also saw technology change media and strengthen the impact it could have on the public, in both good and bad ways.

Prior to the introduction of radio and television as new mass media in the twentieth century, journalism had previously adjusted to an important new technology when the telegraph emerged in the nineteenth century. During the Civil War, the telegraph was a primary way reporters sent information and many newspapers hired "telegraphic correspondents," people they trusted to deliver news from distant locations. Both the benefit and the challenge of the telegraph was speed. Because the mid- to late-nineteenth century was a time when newspapers slowly evolved from partisan reporting to objectivity (which really didn't take permanent hold until about the 1920s), "the mix of partisan reporting and telegraph speed to deliver information led to a significant amount of 'bad' news ... And often the speed with which reporters were sending the news resulted in the publication of errors, rumors, military propaganda and political propaganda. Often it was hard for a reader to discern the truth of information that came quickly from the Civil War battlefield" (Reynolds, 2005, p. 13).

When radio emerged in the early twentieth century, its popularity led to the formation of the basic regulatory structure we have for electronic communications today. Congress passed The Radio Act of 1912 to give the federal government the power to license wireless communication and subsequent legislation (The Radio Act of 1927 and the Communications Act of 1934) highlighted the growing importance that radio, and then television, had on public life, business, politics, and journalism (Trager, Russomanno, Ross & Reynolds, 2014).

Television, like the telegraph and radio, showed that "familiar patterns repeated themselves—the creation of a larger, and more democratic community, political and social reorganization, and renewed tension," write Bill Kovach and Tom Rosenstiel (2010, p. 19). "With newspapers, readers could pick and choose what articles they wanted to read ... Radio made the news more intimate and national. But television unified it" (p. 19).

By the 1960s, more than 25 percent of all Americans (70 percent of all U.S. televisions in use) watched one of the three network news programs (CBS, NBC, and ABC) during the dinner hour. Before remote controls and recording devices, viewers had to watch the newscasts as they were designed or turn the TV off. "The effect was a growth in what social scientists call 'incidental news acquisition'—when people learn about things they might not be interested in" (Kovach & Rosenstiel, 2010, p. 19).

As television usage grew in the 1960s and 1970s, so did cynicism. News about government became more critical (many attribute this to coverage of the Vietnam

War and Watergate), and news organizations began to produce more soft news or "infotainment" (Schudson, 2008). With television came the nationalization of politics and a sense that the increased interest in television would encourage more people to pay attention to issues of public importance. People who follow the news are more likely to vote, and people who are informed are more likely to participate in public life (Norris, 1996). "Television coverage of dramatic events, and the sense that the news was now less mediated, also gave ordinary citizens dramatic new power to effect political change," write Kovach and Rosenstiel (2010, p. 20). "Televangelists, anti-war protesters, and members of the women's rights movement all were politically empowered by the new form of communication and began to change the nature of the political debate in the United States" (p. 20).

But, television's success came at a price for some newspapers. Afternoon newspapers could not compete with television for the same audience and many ceased publication. This left the morning and Sunday newspapers in a great position to capitalize on advertising. Most of the surviving newspapers' reaction to television was to offer "a new deeply analytical format that combined hard factual reporting with analytical detail drawn from the reporter's own experience, observations, and conclusions" (Kovach & Rosenstiel, 2010, p. 21). *The New York Times* is perhaps the best example of this. The opposite approach—one taken to emulate television's shorter style with strong visuals and lots of color—is seen in *USA Today*.

> The push for elite demographics ... gave more influence to advertisers. Morning papers that had begun to enjoy monopoly status in their markets had more advertising than they ever expected. The business was frankly easy and lucrative. As a result, most newspapers were slow to react with creative thinking about their content until they were at risk of being relegated to a niche position by television, as radio had been. When newspapers did react, their confusion over the nature of the challenge was reflected in the fact that the two major innovations followed diametrically different paths (Kovach & Rosenstiel, p. 20–21).

The next big technological innovations were 24-hour cable television news followed by satellite and digital technology. Within a relatively short period of time people had access to news and information virtually any place, at any time. And when it came to news online, "The Web didn't introduce a new competitor into the old ecosystem ... The Web created a new ecosystem" (Shirky, 2008, p. 60). Journalism changed, but so did public life and how we organize and think about communication and social relationships. Shirky (2008) argues that what is happening in journalism today "isn't a shift from one kind of news institution to another, but rather in the definition of news: from news as an institutional prerogative to news as part of a communication ecosystem, occupied by a mix of formal organizations, informal collectives, and individuals" (p. 65–66).

THE NEWS & INFORMATION ECOSYSTEM

At its most basic level, community is defined as "a group of people living in the same place or having a particular characteristic in common" (Merriam-Webster, 2013). How individuals within a community engage in political processes, public life and the consumption and production of information changed dramatically as more and more people gained access to the Internet and could more easily define community beyond geographic considerations. In *Bowling Alone*, sociologist Robert D. Putnam draws from a variety of data to show that community is weakening in the United States. Putnam (2001) suggests that social capital—the networks of relationships among people who live and work in a particular society, enabling the society to effectively function—is in decline, partly because the kinds of in-person, group activities that create and sustain social capital are increasingly going away.

Others suggest that new communities have emerged and can be organized differently now because of the declining cost in creating avenues for group activity or community engagement online. The cost of "sharing, cooperation, and collective action—have fallen so far so fast that activities previously hidden ... are now coming to light," Shirky (2008) writes. "Prior to the current era, the alternative to institutional action was usually no action. Social tools provide ... (an) alternative: action by loosely structured groups, operating without managerial direction and outside profit" (p. 47).

One characteristic of the new information ecosystem is the proliferation of blogs and what Shirky (2008) calls the "mass amateurization" of media because everyone can publish. The Web "allows individuals—even children—to post, at minimal cost, messages and images that can be viewed instantly by global audiences," note Lupia and Sin (2003). "It is worth remembering that as recently as the early 1990s, such actions were impossible for all but a few world leaders, public figures, and entertainment companies—and even for them only at select moments. Now many people take such abilities for granted" (p. 316).

Most people have hoped that "the Internet would expand the public sphere, broadening both the range of ideas discussed and the number of citizens allowed to participate" (Hindman, 2009, p. 7). Millions of blogs exist on the Web, and yet very few attract an audience. According to the Pew Internet and American Life Project, tens of millions of Americans read political blogs occasionally and the most popular blogs are widely read sources of political commentary. "Yet the very success of the most popular bloggers undercuts blogging's central mythology. Of the perhaps one million citizens who write a political blog, only a few dozen have more readers than does a small town newspaper," Hindman (2009, p. 128) notes. "For every blogger who reaches a significant audience, ten thousand journal in obscurity ... the few dozen bloggers who get most of the blog readership" are

overwhelmingly well-educated white male professionals (from education, business, tech, or journalism) (Hindman, p. 128).

The Pew Internet and American Life Project (2006) reported that 52 percent of bloggers surveyed say that they blogged for themselves. The same percentage reported that their primary motivation for blogging was creative personal expression. The report showed that a majority of blogging is about narrow, niche subjects. "It's a granularity of media that we in the commercial media could not scale down to. Niche media is 'me' media, and the blogosphere is the ultimate manifestation of that" (Lee, July 20, 2006).

All of this supports the idea that the Web has established a news and information ecosystem of which blogging is only one part. An ecosystem is a "complex set of relationships among the living resources, habitats and residents of an area" (Merriam-Webster, 2013). The relationship between blogging and other forms of user-generated content has helped "create an incipient new function of journalism for democracy, one in which the divide between the journalist and the audience for journalism disappears. Some people talk about this as 'citizen journalism.' It has always existed to a degree" (Schudson, 2008, p. 25). Schudson notes that people have always called in tips to the newspaper or written letters to the editor. Now, people simply publish on their own. "This is a new self-organizing journalism, already making waves, already enacting something new and exciting" (Schudson, 2008, p. 55).

Media scholars have observed that as news has moved online it has become more event-driven and less institution-driven. Events then serve as "jumping-off points for thematic exploration of social issues" (Schudson, 2008, p. 56). Content analysis of newspapers over the past century shows that journalists increasingly pay attention to context and to reporting events in greater detail as a way to invite discussion and exploration of political and social issues (Lawrence, 2000).

But where does that discussion now occur? The answer is everywhere. In online chat rooms, via social media in all its forms, in the comments underneath news stories, within online journalism and on blogs. In the twenty-first century, everyone can be a media outlet. "Our social tools remove older obstacles to public expression, and thus remove the bottlenecks that characterized mass media," Shirky observes. "The result is the mass amateurization of efforts previously reserved for media professionals ... Most professions exist because there is a scarce resource that requires ongoing management ... In these cases professionals become gatekeepers, simultaneously providing and controlling access to information, entertainment, communication, or other ephemeral goods" (Shirky, 2008, p. 57). One important characteristic of traditional news organizations that the openness and availability of the Web has weakened is the practice of gatekeeping.

GATEKEEPING

Media scholars who study gatekeeping often cite the original gatekeeping study from 1950 when David Manning White reported the personal and subjective judgment of editor "Mr. Gates" as he decided what wire stories and pictures to publish in the newspaper (White, 1950). Since then, a robust theory of gatekeeping has emerged. Shoemaker and Vos (2009) suggest that gatekeeping is one of the media's central roles in public life. They define gatekeeping as the process of determining what events get published and what the content and nature of news will be. Gatekeeping explains how and why certain information is published by the media (Shoemaker and Vos, 2009). In addition to subjective judgment, gatekeeping studies have shown that journalists' shared news values and professional judgment offer stable views about what is likely of public interest and relevance (McQuail, 1994; Shoemaker & Reese, 1995).

"This gatekeeper notion governed newsrooms for most of the twentieth century and instilled the sense of civic responsibility in the journalist. After all, who else could stand sentinel at the gate of public knowledge? The newsroom was the sole intermediary between the citizen and newsmaker," write Kovach and Rosenstiel (2010, p. 171). "Now, however, the metaphor of the solitary gatekeeper mediating facts on behalf of the public is increasingly problematic—or even obsolete. There are many conduits between newsmakers and the public. The press is merely one of them" (p. 171).

The weakening of the media's gatekeeping function has transformed the media environment "because personal communication and publishing, previously separate functions, now shade into one another. One result is to break the older pattern of professional filtering of the good from the mediocre before publication; now such filtering is increasingly social, and happens after the fact" (Shirky, 2008, p. 81).

As the gatekeeping function diminishes, society sees an increase in the amount of information available from a wide variety of sources. Many scholars suggest, though, that the weakening of gatekeeping has led to an extraordinary audience fragmentation, where some people only seek out content from like-minded sources who share the same political and social beliefs. Content is readily available and easy to find, share, or produce. Although numerous media critics have decried the concentration of media ownership over the past several decades, one of the benefits of that concentration is that it "had the merit of contributing toward common political communication and perceptions, at least in comparison to the most extreme possibilities of decentralization and fragmentation (that are) now visible" (Bimber, 2003, p. 247).

As fragmented audiences have more and more information sources to personally aggregate (from traditional news to blogs to social media), people can live in "information cocoons, spending much of their time immersed in their particular

Daily Me. But many other people are taking advantage of new methods for uncovering the widely dispersed knowledge that people actually have" (Sunstein, 2006, p. 19). When audiences fragment along shared values, beliefs, or interests, the result is not always bad. "When people shift from indifference to intense concern with local problems, such as poverty and crime, group polarization is an achievement, not a problem," Sunstein (2009, p. 249) writes. "The American Revolution, the civil rights movement, and the fall of both communism and apartheid had everything to do with mechanisms of (this) sort ..." (p. 249).

As people sort themselves into communities of like-minded others, often we see the phenomenon of information cascades. During information cascades people "abandon their own information in favor of inferences based on other people's actions" (Easley, 2010, p. 483). Sunstein (2009) holds that in communities defined by common political beliefs, "cascades are almost inevitable, and they might well be based on poor thinking and confusion" (p. 98).

And yet, as noted earlier, not all cascades are based on poor thinking and confusion. The point is that the source of the information comes from a place of shared belief as opposed to coming from a traditional news source applying established professional norms that pre-filter inaccurate or biased information. "The most important reason for group polarization, and a key to extremism in all its forms, involves the exchange of new information," Sunstein (2009, p. 21) writes. "Group polarization often occurs because people are telling one another what they know, and what they know is skewed in a predictable direction. When they listen to each other, they move" (p. 21). Information cascades can be based on truthful or inaccurate information. Ultimately, information cascades create shared awareness, "which is the ability of many different people and groups to understand a situation, and to understand who else has the same understanding ... Shared awareness allows otherwise uncoordinated groups to begin to work together more quickly and effectively" (Shirky, 2008, p. 63; Lohmann, 1994).

Information cascades were at work during the Arab Spring and show how the new social tools available have made group organizing around shared beliefs much easier and ripe for social and political action. Shirky (2008) writes,

> In this view, the current changes are good because they increase the freedom of people to say and do as they like. This argument does not suffer from the problems of incommensurability, because an increase in various forms of freedom, and especially in freedom of speech, of the press and of association, are assumed to be desirable in and of themselves ... it assumes that the value of freedom outweighs the problems, not based on a calculation of net value, but because freedom is the right thing to want for society (p. 305–306).

Not all audience fragmentation leads to political or social action in a positive or negative way. The majority of fragmentation leads to no action at all. And in many cases, fragmented audiences focus on shared interests that have nothing to do with

political or social issues but rather entertainment. Further, some scholars have argued that because most Americans still get their news on the Web from the same mainstream, traditional news sources they consumed from the newspaper or on television, that "traditional patterns of political communication will simply reproduce themselves in the new information environment" (Bimber, 2003, p. 248; Davis, 1998; Margolis & Resnick, 2000). In such cases, gatekeeping is not effectively weakened, because despite the wide range of available information people are still going to their familiar news sources precisely because they are trusted gatekeepers.

"Journalists not only report reality, but create it," notes Schudson (2003, p. 2). "To say that journalists construct the world is not to say they conjure the world. Journalists normally work with materials that real people and real events provide. But by selecting, highlighting, framing, shading, and shaping in reportage, they create an impression that real people—readers and viewers—then take to be real and to which they respond in their lives" (p. 2). The news also serves as an important source of common knowledge within communities (for more on the value of common knowledge beyond that provided by the news, see Suk-Young Chwe, 2001). Even as technology allows us to blur the line between journalist and citizen, the value of professional journalism as a way to help people organize and attend to news and information is still critical to society.

THE WATCHDOG FUNCTION

Perhaps the best illustration of the value of journalism to public life and democracy is the watchdog function of the press. Downie & Schudson (2009) define watchdog reporting as "reporting that holds government officials accountable to the legal and moral standards of public service and keeps business and professional leaders accountable to society's expectations of integrity and fairness" (para. 20).

One of the reasons journalists receive a qualified legal "privilege" to challenge some subpoenas to testify before courts and/or reveal confidential sources is to protect their ability to perform the watchdog function. If journalists are compelled to reveal their sources, then sources may not offer the kind of information that can only be obtained through promises of confidentiality. But, on the flip side, if every individual citizen had a limited legal right to avoid testifying in a civil or criminal trial, the judicial system could not work. "If anyone can be a publisher, then anyone can be a journalist. And if anyone can be a journalist, then journalistic privilege suddenly becomes a loophole too large to be borne by society" (Shirky, 2008, p. 71).

Schudson (2008) writes that "Democracies still need the press and particularly require an unlovable press. They need journalists who get in the face of power—and are enabled to do so because both their doggedness and their irreverence

is protected by law, by a conducive political culture, and by a historical record of having served self-government well when they hunt down elusive or hidden facts" (p. 10).

Blogs and other public forums can strengthen the watchdog function and enhance the ability of citizens to engage in direct political speech. Yet, "while it is true that citizens face few formal barriers to posting their views online, this is openness in the most trivial sense. From the perspective of mass politics, we care most not about who posts but about who gets read—and there are plenty of formal and informal barriers that hinder ordinary citizens' ability to reach an audience. Most online content receives no links, attracts no eyeballs, and has minimal political relevance" (Hindman, 2008, p. 18).

So, despite increased capacity to publish and share information, citizens still need journalism. In the twenty-first century, Schudson (2008) argues that journalism has six functions it serves, and one function it "should" serve, which is publicizing the value of representative democracy. The six functions include: providing information; investigation (the watchdog function); offering analysis; offering social empathy by telling people about others in the world with different lives and viewpoints; serving as a public forum; and offering an avenue for mobilization around political programs and perspectives (Schudson, 2008).

If the new media landscape requires news consumers to serve as their own editors and gatekeepers, then "what is the role of the new citizen—a realistic role, not a utopian one? What responsibilities does it convey? What are the skills we need to be our own editors? What is required of us in the way of knowing?" (Kovach & Rosenstiel, 2010, p. 8).

One way to help citizens navigate the vast array of news and information on the Web is to consider what people need from the journalism of the twenty-first century. According to Kovach and Rosenstiel (2010), the "next journalism" has eight essential functions that have always been present, just obscured from the public behind the gatekeepers. Those functions include authenticating what information is true; making sense of information and putting it into context; continuing to serve as a watchdog through providing independent, investigative reporting; bearing witness to events and maintaining the monitoring function of journalism; empowering people to be citizens and not just audience members; aggregating news and information to "harness the power of the Web;" organizing public forums for discourse and debate; and, modeling good journalistic practices and behaviors for citizen journalists (p. 176–180). They note that none of these function, is new, they just need to become more "dynamic" as technology continues to expand our capacity to communicate.

> In this new competition, it is critical that we use the promise offered by emerging communications technologies to create a journalism that joins journalists and citizens in a journey of mutual discovery. The next journalism ... recognizes that to assure the principles of

traditional journalism do not disappear, journalists must adjust to those things that are irrevocably changed by technology in the distribution and organization of news ... But one thing has not changed. Democracy stakes everything on a continuing dialogue of informed citizens. And that dialogue rises or falls on whether the discussion is based on propaganda and deceit or on facts and verification pursued with a mind willing to learn (Kovach & Rosenstiel, 2010, p. 196–97).

Survival of the watchdog function of the press rests largely on the willingness of traditional news media to continue to devote resources to investigative reporting, and on citizen journalists and others who engage in public speech online to hold government and business officials accountable. Concerns about a diminishing watchdog function emerge as newspapers cut costs by shrinking their newsrooms. Can citizens or other forms of media pick up the slack if established news organizations quit watching?

CONCLUSION—NEW ORLEANS

Despite all of the ways that public life, journalism, technology and society have changed over the past two centuries, for people who care about maintaining a journalism that contributes positively to public life, technology should be a facilitator and not an inhibitor. This book explores the ways that digital technology is changing journalism, and a few stories from New Orleans are indicative as they relate to community and public life in the city.

As noted in the introduction, New Orleans residents feel a personal attachment to *The Times-Picayune*, the city's daily newspaper. In May 2012, the paper's parent company, Advance Publications, Inc., announced the decrease in print publication of *The Times- Picayune* to three days a week. After a decade of journalism convergence and cutbacks across the U.S., *The Times-Picayune* became (at the time) the largest market daily to be targeted by such reductions.

The community responded with protests and Facebook groups devoted to saving the newspaper. Not long after the reduction was announced, several high-profile citizens wrote an open letter to members of the Newhouse family, which owns Advance Publications Inc., asking them to reconsider the decision or sell the paper. The community leaders believed the move would hurt the city's ongoing recovery. But more importantly, they asserted that the community "needs" and "deserves" a printed daily newspaper (Romenesko, 2012).

Why the backlash if the world is moving in a digital direction? Perhaps it ties to the ritual of news as identified by Berelson (1949) decades ago. In 1945, Berelson explored public attitudes toward the newspaper during a New York City newspaper strike. He found that people were more conscious of what the newspaper meant to them when it was not there, and that they felt they were less informed on matters of public concern in the absence of the paper (Berelson, 1949).

The New York Times media columnist David Carr puts it another way: "the people who newspapers normally kick the shit out of, the public officials, the chamber, the various dot-orgs, all freaked out and realized that something fundamental was being imperiled" (Carr, personal communication, July 20, 2013). He adds that New Orleans and its history of abuses by people in power further underscores the importance of maintaining a strong, objective news presence in the city. "When you live in a game preserve of corruption it can't be good that your primary source of accountability is being wiped out," Carr says (personal communication, July 20, 2013).

Jim Amoss, editor of *The Times-Picayune*, doesn't believe that the paper or the commitment to watchdog journalism in New Orleans is being wiped out. Amoss says that whether news comes in printed form or on the Web, the watchdog function is central to *The Times-Picayune* and *NOLA.com* newsroom. "I think it is a function that you have to very consciously pursue and emphasize," Amoss says. *The Times-Picayune* and *NOLA.com* "have made it a priority as part of our journalistic mission. It is embedded in the very job descriptions of our reporters, that they must fulfill—the enterprise role of what we do and the watchdog/First Amendment functions of what we do" (Amoss, personal communication, April 25, 2013).

Former *Times-Picayune* reporter and current WWL-TV investigative reporter David Hammer says the community was particularly upset about *The Times-Picayune's* decision because of a perception that the paper was financially stable.

> That was the shocking thing about *The Times-Picayune's* experience, was that they were surviving … And, they made this decision to go with essentially their healthiest entity—Advance's healthiest entity—to make the change first, as opposed to going to a weaker entity, and doing it there. And, that really shocked people. And I think if people had felt like, 'You know what, *The Times-Picayune* was dying, and they needed to do something to save it,' they would've been more forgiving. But when people heard that *The Times-Picayune* was making money, and that BP and the Saints winning the Super Bowl had created this huge windfall for them and then immediately on the heels of that they're, you know, taking it out from under them, that really upset people (Hammer, personal communication, February 5, 2013).

Alex Martin, the page one editor at *The Wall Street Journal*, is a New Orleans native who grew up in a multigenerational home with grandparents, aunts and uncles, his parents, siblings, and cousins. He says that both the afternoon *States-Item* and the morning *Times-Picayune* were a big deal in his house. "For example, when the *States-Item* quit publishing, my aunt and my mom, they saved a copy of the last edition of the *States-Item* and put it in the cedar chest" (Martin, personal communication, November 14, 2012). Soon after the *States-Item* stopped publishing it merged with *The Times-Picayune* for a short period. "People called it 'the tipsy,' (TPSI)" Martin recalls. "The paper was a deal, and people divided it up. My dad read the police reports, and my grandmother and aunt fought over the crosswords,

and people read the comics and they read the news," he says. "They consumed news like crazy and it was an important part of the house. It seemed like a thing that people did ... My mom worked in ... a state office. My aunt worked for the federal government, my dad worked in a restaurant, my uncle was baker—these are just ordinary folk, (and the newspaper) ... was really important to them" (Martin, personal communication, November 14, 2012).

He adds, "When you hear that somebody's going to stop printing a newspaper—whether it's an afternoon newspaper, after television is ascendant or whether it's a daily newspaper in an age of the Internet—it's difficult for people to hear" (Martin, personal communication, November 14, 2012). Hammer agrees. He says that Hurricane Katrina amplified the city's identity and its attachment to the newspaper. "We're lucky in New Orleans that we have a newspaper that was held in such high regard ... You know, everybody did these stories after Katrina, on a national media level about how amazing it is that people are so civically engaged after Katrina and, look, you go to a coffee shop and everybody's reading *The Times-Picayune* and how strange that is," he says. When Advance made cuts to *The Times-Picayune's* staff and publication schedule, "people had a hard time accepting that, and that's why they reacted the way that they did. So much of their own perception of themselves *and* the national perception of them was this engagement—social engagement, civic engagement—driven by, in a large extent, *The Times-Picayune*" (Hammer, personal communication, February 5, 2013).

In 2013, *The Times-Picayune* publicly admitted that it unintentionally alienated some readers with its decision to reduce print publication. In a blog on *NOLA.com* in June 2013, Amoss told readers the paper would add a new, printed publication called *TP Street* that would appear on newsstands during the days *The Times-Picayune* was not printed. Why? "Many of you told us that, even if you understood business realities, we were no ordinary business to you. You told us how *The Times-Picayune* is intertwined with your lives, your routines, the priorities we set for ourselves as a community," Amoss wrote. "Even many of you who live in the digital world and follow us every day on *NOLA.com* told us how much you missed holding the printed *Times-Picayune* in your hands every day over coffee" (Amoss, June 22, 2013, para. 5).

Ultimately, the story of the New Orleans *Times-Picayune* and of newspapers across the globe is still unfolding. But, what these comments suggest is that people in New Orleans value the role of the newspaper as a part of the social fabric and as a partner in maintaining public life. That matches history. The impact of digital technology on newspapers, journalism as a profession, public life, and society illustrates their interconnectedness. History tells us that journalism is important to democracy and to sustaining public life. Whether it comes in a printed form or digitally, scholars who study media, sociology, political science, and communication all agree—the health of public life and community depends on a vibrant public

sphere, and if newspapers are not central to crafting that public space then the risk to society is great. Evan Smith, editor of the nonprofit *Texas Tribune*, perhaps says it best: "You're trying ... to make people smarter, to make people into more thoughtful and productive and engaged citizens ... You want people out in their communities having conversations, making better choices," he says. "You want people inspired, motivated to pay attention and to shake their fists or to give a thumbs up to the people and to the policy makers and the policy implementers in their communities. Without that basic information, there is no community" (Smith, personal communication, July 29, 2013).

REFERENCES

Amoss, J. (2013, June 22). TP Street to land on newsstands Monday. *NOLA.com*. Retrieved from http://www.*NOLA.com*/opinions/index.ssf/2013/06/tp_street_to_land_on_newstands.html

Anderson, B. (1983). *Imagined communities: Reflections on the origin and spread of nationalism*. London: Verso.

Berelson, B. (1949). What missing the newspaper means. In P. Lazarsfeld & F. Stanton (Eds.), *Communications Research 1948–1949* (36–47). New York: Harper and Brothers.

Bimber, B. (2003). *Information and American democracy: Technology in the evolution of political power*. New York: Cambridge University Press.

Committee on Communications, Technology and the Internet (2009, May 6). The future of journalism. Senate Hearing 111–428. Retrieved from http://www.gpo.gov/fdsys/pkg/CHRG-111shrg52162/pdf/CHRG-111shrg52162.pdf

Davis, R. (1998). *The web of politics*. New York: Oxford University Press.

Downie, L. & Schudson, M. (2009, October 19). The reconstruction of American journalism. *Columbia Journalism Review*. Retrieved from http://www.cjr.org/reconstruction/the_reconstruction_of_american.php?page=all

Easley, D. (2010). *Networks, crowds and markets: Reasoning about a highly connected world*. New York: Cambridge University Press.

Franklin, B. (1996). *The autobiography of Benjamin Franklin*. New York: Dover Publications.

Habermas, J. (1989). *The structural transformation of the public square*. Cambridge, Mass.: MIT Press.

Hartley, J. (2009). *Popular reality: Journalism and popular culture*. New York: Bloomsbury.

Hindman, M. (2009). *The myth of digital democracy*. Princeton, N.J.: Princeton University Press.

Kovach, B & Rosenstiel, T. (2010) *Blur: How to know what's true in the age of information overload*. New York: Bloomsbury.

Lawrence, R. (2000). *The politics of force*. Berkeley: University of California Press.

Lee, F.R. (2006, July 20). Survey of the blogosphere finds 12 million voices. *New York Times*. Retrieved from http://www.pewinternet.org/Media-Mentions/2006/Survey-of-the-Blogosphere-Finds-12-Million-Voices.aspx

Lohman, S. (1994, October 1). The dynamics of information cascades: The Monday demonstrations in Leipzig, East Germany, 1989–91. *World Politics, 47*, 42–101.

Lupia, A. & Sin, G. (2003). Which public goods are endangered? How evolving technologies affect the logic of collective action. *Public Choice, 117*, 315–331.

McQuail, D. (1994). *Mass communication theory* (3rd ed.). New York: Sage.

Margolis, M. & Resnick, D. (2000). *Politics as usual: The cyberspace "revolution."* Thousand Oaks, Calif.: Sage Publications.

New York Times v. Sullivan, 376 U.S. 254 (1964).

Norris, P. (1996). Does television erode social capital? A reply to Putnam. *PS: Political science and politics, 29,* 474–80.

Putnam, R. (2001). *Bowling alone: The collapse and revival of American community.* New York: Simon & Schuster.

Reynolds, A. & Hicks, G. (2012). *Prophets of the fourth estate: Broadsides by press critics of the Progressive Era.* Los Angeles: Litwin Books.

Reynolds, Amy. (2006). Through the eyes of the Abolitionists: Free association and anti-slavery expression. *Communication Law & Policy, 11,* 449–476.

Reynolds, A. (2005). Northern newspapers in the Civil War. In A. Reynolds & D. Reddin Van Tuyll (Eds.), *Volume III: The Civil War—North and south* (1–288). Westport, Conn.: Greenwood Publishing Group.

Reynolds, A. (2001). William Lloyd Garrison, Benjamin Lundy and criminal libel: The abolitionists' plea for press freedom. *Communication Law & Policy, 6,* 577–607.

Romenesko, J. (2012, July 9). Our city wants a daily, printed paper. *Romenesko.com.* Retrieved from http://jimromenesko.com/2012/07/09/our-city-wants-a-daily-printed-paper/

Ryan, M.P. (1997). *Civic wars: Democracy and public life in the American city during the nineteenth century.* Berkeley: University of California Press.

Schudson, M. (2008). *Why democracies need an unlovable press.* Malden, Mass.: Polity Press.

Schudson, M. (2003). *The sociology of news.* New York: W.W. Norton & Company.

Schudson, M. (1978). *Discovering the news: A social history of American newspapers.* New York: Basic Books.

Shirky, C. (2008). *Here comes everybody: The power of organizing without organizations.* New York: Penguin Books.

Shoemaker, P.J. & Vos, T. (2009). *Gatekeeping theory.* New York: Routledge.

Shoemaker, P.J. & Reese, S.D. (1995). *Mediating the message: Theories of influence on mass media content* (2nd ed.). New York: Longman.

Suk-Young Chwe, M. (2001). *Rational ritual: Culture, coordination and common knowledge.* Princeton, NJ: Princeton University Press.

Sunstein, C. (2009). *Going to extremes: How like minds unite and divide.* New York: Oxford University Press.

Sunstein, C. (2006). *Infotopia: How many minds produce knowledge.* New York: Oxford University Press.

de Tocqueville, A. (1830) *Democracy in America.* New York: Penguin Classics (2003).

Trager, R. Russomanno, J., Ross, S.D. & Reynolds, A. (2014). *The law of journalism and mass communication.* New York: CQ Press.

White, D.M. (1950). The gatekeeper: A case-study in the selection of news. *Journalism Quarterly, 27,* 383–90.

Windschuttle, K. (1999, July 1). Journalism and the Western tradition. *Australian Journalism Review.* Retrieved from http://www.sydneyline.com/Journalism%20and%20Western%20Tradition.htm

A History OF THE New Orleans *Times-Picayune*

JINX COLEMAN BROUSSARD & BENJAMIN REX LAPOE

Eliza Jane Poitevent, newly married to Alva M. Holbrook, rested in her bedroom on Constance Street in New Orleans during the humid morning hours of June 17, 1872. Poitevent was unaware that Jennie Bronson, her husband's ex-wife, had traveled from New York to confront her. Bronson stormed into the bedroom, fired a revolver twice at the new wife, missing both times. As Poitevent frantically tried to escape, stumbling over her own feet and shouting frantic screams of terror, Bronson beat her over the head with a bottle of rum. Two servants rescued Poitevent and ushered her to safety. As Poitevent tried to stop the bleeding, Bronson found an axe and took out her rage on the furniture. Eventually, Bronson was arrested and the Holbrooks moved to another house on Magazine Street (Dabney, 1944).

Just months before the assault, Holbrook, one of the first investors in the *Picayune* newspaper, sold it to a group of businessmen. He had become the guiding force for the paper in 1851. Eliza Jane Poitevent, whom readers knew as the poet Pearl Rivers, continued submitting poems. Holbrook bought the newspaper again in 1873 after the new owners led it into debt. Holbrook died three years later, leaving the *Picayune* and its $80,000 debt to his wife. What was the poet, and now newspaper owner, to do? This Mississippi native calculated her next move for three and a half months. An exceptionally creative child, she preferred to live in fantasy, making friends with bees and naming acorns while spending as much time as possible in nature—the inspiration for her pen name (Dabney, 1944). Her imaginative spirit manifested itself in poems, which she initially published in the *New York Journal* and other publications.

She had met Holbrook earlier while visiting her grandfather in New Orleans. The astute newspaperman soon learned of her talent and offered her a position at *The Picayune*. Undaunted by concerns her family expressed about her working in what was essentially a man's world, as well as fears about the dangers of living alone in New Orleans, Poitevent eagerly accepted the offer. She challenged the gender norms of her time, and became the first woman in New Orleans to earn a living working for a newspaper (Karst and Shea, 2011; Louisiana State University, Timeline of Louisiana Women's History).

When her husband died, she again defied convention and chose to carry on as publisher of *The Picayune*. She convened a meeting of the newspaper's staff, and, as the story goes, she told them: "I am a woman. Some of you may not wish to work for a woman. If so, you are free to go, and no hard feelings. But you who stay—will you give me your undivided loyalty, and will you advise me truly and honestly?" (Dabney, 1944, p. 266). Loyalty is what she received from those who stayed; they defended her as ardently as knights. The paper's chief editorial writer, Jose Quintero, "polished up his pistols and passed out the word that if anybody craved satisfaction for what *The Picayune* said, come to him" (Dabney, 1944, p. 266).

Pearl Rivers' first poem in *The Picayune*, "A Little Bunch of Roses," had spoken of thorns amongst beauty and the steadfast commitment needed to hold a rose (Rivers, 1866). That was perhaps a signal of how she would run the newspaper— with a firm commitment to truth, the best interest of the community, and innovation that defined the publication under her and continued throughout the history of *The Times-Picayune*. Mrs. Holbrook took over the newspaper when it was in its 36th year. During her time, the community withstood yellow fever epidemics, levee breaks, plagues, the Civil War and Reconstruction (Leavitt, 1982). Regardless of obstacles the newspaper faced, it survived and became a journalistic pillar in the South and Southwest.

ORIGINS OF *THE PICAYUNE*

When *The Picayune* began publication, New Orleans was one of the most diverse cities in the country. One historian even called it "the Great Southwestern metropolis" (Osthaos, 1994, p. 49). Located on a sliver of crescent-shaped land "on the bank of the grand continental waterway, the Mississippi," this gateway was naturally situated "for establishing it as a portal of sea trade for all the Lower South, the Southwest and the valley of the great rivers to the northward for many hundred miles" (Osthaos, 1994, p. 11). American Indian tribes interacted with each other and used this essential trade route to share goods, beliefs, traditions, and knowledge (Eggler, 2013). European settlers from diverse backgrounds who converged on the

area were attracted by its capacity to be an entrance to the continent. France founded the city of Nouvelle-Orléans in 1718 and it quickly grew into a commercial mecca. The Spanish next ruled the city, followed by the French again (Leavitt, 1982). Countless cultures and people contributed to the vibrant and resilient community still admired today, and tried to take advantage of the region's bounty.

Access to diversity, both in terms of culture and information, tends to inspire ideas that, subsequently, cultivate innovation and progress; such was the case for New Orleans, pre-dating even European exploration. As the city became more and more cosmopolitan, this cultural interactivity engendered a space for infinite ideas. To help communicate and serve this electric marketplace, an unflappable press was needed.

In 1837, New Orleans was well on its way to becoming the Queen City of the South (Leavitt, 1982). It was third in the nation in population and second in commerce, and was poised to become number one in per capita wealth. Thus, began the story of what was to become a newspaper that served New Orleans and a large swath of the South as a daily for more than 175 years (Dabney, 1944) before switching to a thrice-weekly printed publication with a daily online presence. What is now called NOLA Media Group began as *The Picayune* when two men from the Northeast came to New Orleans in 1835. George Wilkins Kendall, reared in New Hampshire, and Francis Asbury Lumsden, born in North Carolina in 1800, invested $75 and a borrowed press (Osthaos, 1994) and founded a morning daily newspaper that would appeal to the "man on the street" with an entertaining style and with content salient to a broad audience (Dabney, 1944, p. 22). Both brought a wealth of printing experience with them. Lumsden had worked for the editor of the Raleigh *Observer* and the *National Intelligencer* in Washington. Kendall began his career at the age of 14, working first for the *Telegraph* in Washington, then for the *Register* in Mobile, and later with Horace "Go West" Greeley, a prominent journalist, abolitionist and penny press pioneer, in New York (Karst & Shea, 2011).

Kendall and Lumsden worked as compositors for a newspaper in New Orleans after having worked together for the *National Intelligencer* in Washington, D.C. (Osthaos, 1994). By all accounts, they instantly became friends and formed a partnership that would last a lifetime. "It was an ideal partnership. Both men were warm-natured, tactful, cheerful in disposition; so the danger of friction would be minimized, and there would always be courage in meeting the problems which assault every new business" (Dabney, 1944, p. 19). Kendall was known for enthusiastically seeking new ideas and new methods, technologies, and innovations; Lumsden was known as the organizer, the steady hand, the responsible voice to balance Kendall's exploring spirit.

The first issue of the paper rolled off the presses on January 25, 1837 (Dabney, 1944). It was only four pages, 14 x 11 inches, but it aimed to have an impact with gentle ridicule, wit, and sarcasm. It set the tone in its prospectus that outlined its

mission and provided an explanation for its odd choice of name taken from the Spanish coin.

> Editors are often tempted by the devil to do strange things, and our diabolus ad typo, puffed up with technicality and temerity, suggested the title of the small pica-yune as a demon-stration. But the devil was cast out; and what is most extraordinary, the office was too hot to hold him. After holding a levee by the picayune tier—[which picayune tier is held by the levee]—and struct with admiration as we beheld the graceful model, the tall and tapering spars, and the rakish rig of a beautiful privateer schooner that floated like a feather down a silver stream—we concluded to launch a literary craft of the same class. The Picayune will be built of the best materials: but instead of being copper-fastened she will be leaded (*The Picayune*, 1837, January 25, p. 2).

As the first penny newspaper in the South, *The Picayune* was a pioneer. It sold for six and one quarter cents, more than the New York penny papers that cost two cents, but less than a dime, the cost of other newspapers in New Orleans. Lumdsen and Kendall sought to not only provide information to a growing urban and cosmopolitan population, but to entertain. Like successful penny papers, such as Benjamin Day's *New York Sun* and James Gordon Bennett's *New York Herald, The Picayune* had conversational writing style that informed readers about the police, crime, the courts, and local and foreign news; made fun of the competition; and tried the right the wrongs of society by emphasizing reform and good government (Sloan, 2011; Schudson, 1978). Often a booster for the city, early on, *The Picayune* criticized the largely upper class practice of dueling, supported temperance, and advocated cleaning up the city's filthy streets and improving sanitation (Dabney, 1944). It even weighed in by supporting proposals to build a new $1,500 clock for the city, to be placed in the tower of St. Patrick's Cathedral in 1851(*The Daily-Picayune*, 1851, October 16, p. 1).

The newspaper prided itself on being unlike other New Orleans papers that were "long-winded, didactic, and self–important, and that advanced an exclusive literature for polite society in New Orleans" (Osthaos, 1994, p. 50). New Orleans was "unique" … "in its story and situation and social feature." *The Picayune* captured, chronicled, and embraced that distinctiveness while addressing major issues of the day. The sassy newcomer left little doubt that Lumsden and Kendall knew they needed to attract readers in a fashion that both entertained and informed, and, for that reason, the paper voiced its opinion in a colorful way on any manner of topics. One early piece included flippant accounts of church meetings that might have been of interest to housewives; a thank you to the man on the street who returned a "roll of bank bills" one of the newspaper employees lost; inquiries about how ladies endured a drought; and, why the "walking gentlemen" did not report on the casual conversations about weddings (*The Picayune*, 1837, July 4, p. 2).

In another article, *The Picayune* eviscerated a "fashionable monthly" magazine the staff accidentally came across during "an invalid spell" when some were "seeking composure from long irritation and uneasiness of mind and body" (*The Daily-Picayune*, 1842, October 13, p. 2). Although the magazine had been published nine months before, it was still new to *The Picayune*, whose staff poured over the contents for several hours and concluded:

> Never before did we fling aside a book with such thorough discontent about our waste of time. Do the publishers of these very handsome and, indeed, generally interesting journals pretend to tell their writers that there is no better taste alive than for namby-pamby nonsense and 'sucking romance?' If they do, they are woefully mistaken, and the writers weak enough to be so misled will trifle seriously and materially with their reputation … A writer cannot be always brilliant, but the effort to be so will make him at least lively (*The Daily-Picayune*, 1842, October 13, p. 2).

Within months of its founding, the newspaper had become well-respected and well-read, owing its success to its "broader interpretation of news values, to the brevity of its stories, to its humorous slant, and to the freedom of the publishers from political entanglements, as well as their fearlessness, and the good nature of their criticism" (Dabney, 1944, p. 24). By November 1837, the paper was so secure in its success, it added *Daily* to its masthead and renewed its pledge to report all manner of subjects, including "earthquakes, anecdotes, suicides, marriages, murder, sea serpents, conflagrations, cholera, sad accidents, mermaids, shipwrecks, melancholy, catastrophe, terrible afflictions, laughable occurrences, nick nacks, picnics, and even politics, millerian, Mesmeris, and Mormonism" (Osthaos, 1994, p. 48).

News about the business of shipping was featured prominently in early issues because that enterprise was so crucial to New Orleans. As the prospectus noted: "The growing importance of this metropolis of the West, and the daily extension of its commerce, almost ensure the success of any undertaking which would tend to facilitate our merchants in those dealings which are the foundation of the greatness of our city" (*The Picayune*, 1837, January 25, p. 1). Less than four years after it began publishing, *The Picayune* moved beyond a strong focus on light-hearted entertainment and became a "serious journal of news and celebrated as a civic-minded institution" (Osthaos, 1994, p. 67). It was the largest daily in New Orleans and was destined to become the largest in the South by 1860. So much of its notoriety developed prior to and during the Mexican-American War that began in 1846, thanks to Kendall and the other correspondents the newspaper sent to gather news directly from the battlefield. Always the adventurer, Kendall first headed west in 1841—just three years after starting *The Picayune*. As both a correspondent and observer, he left New Orleans and joined a Republic of Texas expedition to New Mexico. Suspecting that the true purpose of the mission was for Texas to take New Mexico, the Mexican Government captured and imprisoned Kendall and the rest

of his party. When he was released after about one year, Kendall chronicled his experiences from memory in a series of articles he published in his newspaper and in a two-volume book, which brought him considerable fame.

Within four years, the U.S. and Mexico were at war. Compared to its peers, the newspaper was very anti-Mexico and pro-war leading up to and during the conflict. For instance, on April 10, 1846, *The Daily-Picayune* criticized Mexico for expelling representatives and private citizens of the U.S. for far too long. Intelligence the newspaper received via the steamship *Mississippi*, convinced it that the U.S. should be sterner, even if that meant war (*The Daily-Picayune*, 1846, April 10, p. 2).

It came as no surprise that Kendall was eager to play a role, both as a correspondent and soldier, when the war began. He became known as one of the first two "celebrated professional foreign correspondents" (Hamilton, 2009, p. 47). His articles, which newspapers far from the conflict picked up, helped solidify *The Daily-Picayune*'s reputation as a quality newspaper. The paper helped shape public opinion and lead the U.S. to war, in large measure because of its editorials and the coverage its six correspondents (more than half of all of the correspondents covering the war) (Osthaos, 1994), especially Kendall. He provided information via a relay system utilizing men on horseback, ships and the telegraph to get news from the battlefield into print before the competition (Hamilton, 2009). The "Kendall Express" was known for quickness and accuracy, and reports often came out before official dispatches.

As "rumors of peace" circulated, *The Daily-Picayune* reported on February 2, 1848, that it remained skeptical about the government's ability to end the war. Charging that the U.S. would make "peace on any term," the newspaper opined that the current treaty prospect was the same as other failed agreements (*The Daily-Picayune*, 1848, February 2, p. 2). The Treaty of Guadeloupe Hidalgo was signed on that very day.

THE DAILY-PICAYUNE AND THE CIVIL WAR

During the 1850s, the newspaper continued to prosper, just as the city did. In what might have been a nod to the staples contributing to a solid economy, *The Daily-Picayune* rolled out a new title vignette that showed a pelican sitting on her nest "against a backdrop of sugar cane, cotton, and harbor activity" (Dabney, 1944, p. 104). Investment in new presses ensured that *The Daily-Picayune* would be able to publish even more and increase the number of pages to sixteen by the end of the decade (Dabney, 1944). But a confrontation that would involve the city, the state, the South and the nation for generations was brewing as the 1850s drew to a close.

That conflict revolved around states' rights, the status of blacks in America and the abolitionist movement. At the same time that *The Daily-Picayune* was reporting on the Mexican-American War, it also was running stories about abolition and the possibility of secession. New Orleans, on the eve of the war, was a cosmopolitan urban center, unlike other areas in the South. More than 10,000 of the city's population were free people of color who owned shops and were salesmen and skilled craftsmen working as brick-masons, cabinetmakers and carpenters. As historian John Hope Franklin notes, many operated in those capacities freely, "even when it was a violation of the law" (Franklin, 2010, p. 143). But slavery was the backbone of the neighboring agrarian economies, and *The Daily-Picayune* adamantly favored maintaining the status quo in race relations. "Confound abolition!" one article offered. "We hate the very sound of the word," the newspaper offered, adding: "If a man should say, 'abolition' in our hearing while drinking a sherry cobble, we should sputter and lose our liquor, and throw the empty tutabler at his head … We oppose abolition … Negroes must be slaves, or worse" (*The Daily-Picayune*, 1840, August 8, p. 2).

Numerous articles ran about the perceived threat if slaves were emancipated. Blacks might forget their place, as "The Negro Outrage at Washington" suggested (*The Daily-Picayune*, 1838, August 23, p. 2). Not only was a riot possible after a black servant at a foreign embassy was found "guilty of an assault upon sundry persons," but "a mulatto scoundrel," who undoubtedly disagreed with the verdict, "became very insolent to a shopkeeper, who ordered him out of his shop" (*The Daily-Picayune*, 1838, August 23, p. 2). That, of course, was the outrage. This was a source of concern, but more importantly, the continuation of slavery was paramount because it was a very profitable enterprise for the state and the South. The paper cited "industrious and prosperous" St. Mary Parish as an example. "It is exclusively agricultural; lying in the Teche region, and cultivated with slave labor, by a class of quiet, refined, and intelligent planters " (*The Daily-Picayune*, 1858, August 12, p. 2). That would all go away if abolitionists had their way.

Unlike most other southern newspapers, once the Civil War began, *The Daily-Picayune* was relatively objective—mostly reporting on the events of the war and rarely commenting on the cultural ideologies driving the bloodshed. The newspaper primarily excluded the racial component of the struggle, while most of its southern, and frequently, northern peers did not. Prior to the onset of the war, it defended the honor of the South and the tenuous situation the region might be in if Abraham Lincoln was elected president, asking: "On what issue is the determination made up to seek safety in a disruption of the government which has only shown an almost unlimited capacity for good?" After all, slavery was only one possible southern wrong in a history of monumental successes that included U.S. Presidents from the South and the spearheading of the Louisiana

Purchase by southern men, according to the newspaper (*The Daily-Picayune*, 1860, November 4, p. 1).

On November 4, 1860, *The Daily-Picayune* predicted that Lincoln's election would be a source of conflict for the South, would rupture the President's Cabinet that was composed of some who supported the South, and possibly lead to secession (*The Daily-Picayune*, 1860, November 4, p. 1). That prediction came true even before Lincoln was inaugurated in March. South Carolina was the first southern state to secede in January 1861, and was followed almost immediately by six more states, including Louisiana. Four additional states seceded in April 1861, and as tensions escalated, *The Daily-Picayune* argued that Lincoln's "conquering spirit" would result in much more bloodshed and the dismantling of the South. Lincoln's intent was to conquer the region as a dictator would, *The Daily-Picayune* opined, and he was using slavery as a means to that end (*The Daily-Picayune*, 1861, April 14, p. 1). According to the newspaper, abolitionists deserved blame because they were seeking monetary gain, not civil liberty (*The Daily-Picayune*, 1861, May 1, p. 1).

Although *The Daily-Picayune* consistently challenged President Lincoln and abolitionists, it devoted the majority of its Civil War coverage to battle stories. After New Orleans fell to the Union in October 1862, *The Daily-Picayune* had to navigate its role as a community advocate and conveyor of information about Confederate victories. It did not want to alienate either side (Dabney, 1944). While advertising grew during the run up to the war, it decreased during the conflict. The paper shrunk to just two pages as a result of censorship, a scarcity of newsprint, and an inability to obtain news because its news service was dependent on the telegraph and the mail, which shut down (Hamilton, 2009). This was a problem that plagued the entire confederacy (Sloan, 2011).

The Civil War and Reconstruction, the period following the Civil War when the country attempted to restore the seceded states, adversely affected New Orleans and *The Daily-Picayune*. The newspaper became a morale booster, city and region promoter, and a stout advocate against what it perceived as extreme northern designs against the South. Among the many decisions that had to be made, such as how to reestablish the war-decimated region's primarily agricultural economy, was how to help recently freed slaves integrate into American society. Southern states opposed any proposal giving African Americans democratic representation, such as voting and serving in office. The Fifteenth Amendment, ratified on February 3, 1870, protected blacks' right to vote and run for office.

The Daily-Picayune, like most of its southern peers, argued against the constitutional amendment. For instance, a *The Daily-Picayune* editorial reflected a fear that granting voting rights to African Americans would dampen white voting patterns. Characterizing the election bill as wicked and having "dangerous grants of power to the few men who are to carry it out," the editorial argued that the legislation

was "full of provisions carefully framed in derogation of the liberties of the citizen in the exercise of the right of voting," because it was a bill that suppressed popular elections, the most valuable right in American democracy (*The Daily-Picayune*, 1870, February 4, p. 4).

Major developments occurred in the city, state, and nation during the 1870s and 1880s that led to an influx of political coverage from *The Daily-Picayune* as it chronicled that history. Louisiana's population increased 28 percent to nearly 934,000, and the population of New Orleans increased by 13 percent. Louisiana adopted a new Constitution in 1879, the first to invoke guidance by God, and three years later New Orleans adopted a new charter. The Cotton Exchange was organized and a new paddle wheel machine was added to the city's drainage system. Shortly after Thomas Edison invented the light bulb, *The Daily-Picayune* illuminated its offices with 169, 16-candlepower bulbs. Electricity brought new hazards, and that was the impetus for the newspaper to wage the most vigorous campaign in history for safety measures (Dabney, 1944). When railroad mileage in 13 Southern states increased, the newspaper ran stories about how people might enjoy the transportation, as well as the need for a public belt railroad and for constructing a bridge over the Mississippi River. Stories also abounded about the petroleum industry. The newspaper took pride in being a booster for the city, and it did so during that period (Dabney, 1944).

It was during this time that Eliza Poitevent Holbrook took over the newspaper and initiated a period of inventiveness and profitability comparable to prior prosperity. Poitevent was the first woman publisher of an important daily in the United States. To appeal to women, she started a society column and she employed Elizabeth Meriwether Gilmer to write the Dorothy Dix advice column that was syndicated and had nearly 60 million readers around the globe. Another long-lasting creation was the Weather Frog whose attire and attitude told people what the weather would be for the day.

In 1892, New Orleans became ground zero for a firestorm that would have long-lasting implications for the city and nation. *The Daily-Picayune* chronicled Homer A. Plessy's efforts to test Jim Crow laws that mandated separate accommodations for blacks and whites. Plessy, a black man, and the Comité des Citoyens (Citizens' Committee of New Orleans) filed suit and lost after he was jailed and found guilty of sitting in the white-only railway car en route from New Orleans to Covington, Louisiana. He lost his appeals as both the Louisiana Supreme Court and the U.S. Supreme Court upheld the doctrine of separate but equal, legalized segregation and thereby put its stamp of approval on the South's discrimination against blacks (Franklin, 2010; *Plessy v. Ferguson*, 1896). *The Daily-Picayune* commended the decision, writing, "Equality of rights does not mean community of rights" (*The Daily-Picayune*, 1896, May 19, p. 4). If separate but not equal laws did not exist, according to the newspaper, there would be

"no such things as private property, private life, or social distinctions, but all would belong to everybody who might choose to use it," ending with "absolute socialism" (*The Daily-Picayune*, 1896, May 19, p. 4).

THE TWENTIETH CENTURY

At the dawn of a new century, *The Daily-Picayune* reminded readers of its mission as it celebrated its 75th anniversary. It would "furnish the world with an orderly, connected and comprehensive account of the advantages of New Orleans, to acquaint the world with the city's attractions as a place of resident and business, and to give particularly, certain details of its more recent advancement" (Englehardt, 1903, p. 3). *The Daily-Picayune* had remained a profitable enterprise for much of its history, except for the three years businessmen owned it before Poitevent and during the Civil War. It found itself in a precarious situation in 1914 as a result of the high cost of news presses and competition from two other dailies; thus, it merged with the *Times-Democrat*, its primary competitor, and immediately became the most powerful newspaper in the South. Readers woke up to the following announcement on April 5, 1914:

> This morning's edition of The Picayune is its last issue. Negotiations, which have been pending for some time for the consolidation of the Times-Democrat and The Picayune, were closed yesterday. Beginning tomorrow morning the two papers will be published as one...The name will be the Times-Picayune. The union of the two newspapers means for New Orleans and its trade territory a bigger and a better paper...The policy of the paper will be the up building of New Orleans and the surrounding territory. The same lines of clean journalism that have marked the conduct of both papers in the past will govern the bigger paper in the future (*The Daily-Picayune*, 1914, April 5, p. 13).

Following that merger, coverage of three major national events joined the continued emphasis on local news in the paper: World War I, the Roaring Twenties, and the Great Depression. Similar to its national colleagues, the paper supported the United States' neutral approach to World War I; however, once the nation joined the conflict, *The Times-Picayune* was supportive and highlighted the city's special ability to help support the navy, which it commended as the best the world had ever seen. When the war ended, and as the roaring twenties began, New Orleans became home to a series of strikes. Three thousand streetcar men demanded 65 cents an hour, a 55 percent raise. The paper cautioned that violence related to the strike could attract the attention of federal troops. The paper was right. A group of "strike-busters" comprised mostly of U.S. marshals ended the strike.

As the decade continued, like much of the nation, the city experienced a "boom" that symbolized the roaring twenties, a decade of prosperity (Dabney, 1944). During this decade, the New Orleans skyline rose and new highways and

bridges increased the speed of commerce. The city expanded, and so did the newspaper, increasing its circulation and moving to a larger home that gazed upon Lafayette Square. The new location came with new, modern equipment. The newspaper flourished, and founded a journalism department at Tulane University (Karst & Shea, 2011).

The Great Depression began on October 24, 1929. It marked the end of the prosperity that characterized the roaring 1920s as the stock market crashed. Again, comparable to other national newspapers, *The Times-Picayune* did not sensationalize the story—in part because it did not fully understand the severity of what was happening and, it did not want to make things worse by causing panic. At the start of the Great Depression, the state and the city did not begin to feel the brunt of economic collapse as quickly as the more industrialized states; in fact, for a short period, Louisiana saw a boom as sugar became more valuable (Dabney, 1944). Still, the economy struggled throughout the decade and unemployment peaked in 1933. Resources became scarce. To help stay afloat, *The Times-Picayune* purchased the New Orleans *States* newspaper on July 17, 1933—entering the "afternoon field," and increasing its supremacy in the region (Dabney, 1944, p. 461). Huey P. Long, elected governor of the state in 1928, emerged as a source of scandal coverage for the paper. For instance, only a few weeks after his election, he ignored state legislation, saying, "I hold the deck and I deal it to suit myself" (*Times-Picayune*, 1928, June 26, p. 10). The newspaper reacted by citing numerous officials, including New Orleans Mayor A.J. O'Keefe, who said that working with such an individual was hopeless.

The Times-Picayune exposed, in what became one of its hallmarks at the end of the decade, graft and corruption in Louisiana that led to the resignation of Governor Richard Leche in June 1939, and eventual imprisonment. Among the dozens of others affiliated with the Huey P. Long political machine who were caught up in what became known as the Louisiana Scandals were Louisiana State University President James Monroe Smith and Seymour Weiss, who headed the firm that built the state capital.

While local news was paramount to *The Times-Picayune*, it did not turn its attention from national and international affairs. The newspaper vigorously supported the U.S. after the Japanese attack on Pearl Harbor led to the country's involvement in World War II. In stinging language, one editorial offered: "Japan's military gangsters, crowing lustily over the alleged success of their foul blow, will squawk much more loudly over its ultimate consequences" (*Times-Picayune*, 1941, December 11, p. 10). After the U.S. dropped nuclear bombs on Japan on August 6, 1945, *The Times-Picayune* hailed the destructive "super bomb," and wrote: "The paralyzing effect of a missile with the explosive power of 20,000 tons of TNT should greatly simplify the Allies' invasion task

if the Jap militarists hang on until that final drive is launched" (*Times-Picayune*, 1945, August 7, p. 8).

CIVIL RIGHTS

The decades following World War II were characterized by social upheaval as minorities fought for and won equal rights. *Brown vs. the Board of Education* (1954), the historic Supreme Court case that overturned the "separate but equal" doctrine upheld by *Plessy v. Ferguson* (1896), helped jump start the civil rights movement. On May 18, 1954, Edgar Poe, the newspaper's Washington correspondent, wrote that the court's unanimous decision to outlaw "segregation in the public school system of this country" was "the most momentous and far reaching race relations decision since the War Between the States." Poe noted that most southerners probably would disobey the decision (Poe, 1954, May 18, p. 1).

Unlike its objections to abolition and support of "separate but equal," *The Times-Picayune* covered the decision, and the subsequent struggle for equality, with relative objectivity—marking a changing perspective and coverage of race relations. One of the paper's first worries was how the Supreme Court decision would affect New Orleans. The newspaper included a variety of sources to help answer that question for its readers. Among those sources were the governor, a U.S. senator, and a black college president. "Gov. Robert Kennon said, the "Louisiana Legislature and the local school boards have already done much to provide new school facilities" (*Times-Picayune*, 1954, May 18, p. 3). Louisiana Senator Allen J. Ellender predicted "violent repercussions," if "efforts were made to immediately enforce the decision, adding, "I don't want to criticize the Supreme Court," but the decision "is bound to have a very great effect until we readjust ourselves to it" (*Times-Picayune*, 1954, May 18, p. 3). Albert W. Dent, president of Dillard University in New Orleans, was more optimistic and enthusiastic, describing the decision as "further evidence that our American brand of democracy is the finest for living known to men and women who cherish freedom and believe in the rights of the individual" (*Times-Picayune*, 1954, May 18, p. 3).

The lead editorial on May 18, 1954 took a well-reasoned approach to the situation, pointing out that "imponderables" the decision raised threw "doubt on its long-term effects" (*Times-Picayune*, 1954, May 18, p. 8). It offered that in states where most blacks lived, and because of the probable "efforts to preserve some lines of separation," the decision would exacerbate chronic problems that public schools faced, and would cause turmoil and an unraveling of public support, as well as an "upsurge of interest in private schools" that might impose an increase in "the total financial burden of education on the people" (*Times-Picayune*, 1954, May 18, p. 8). After acknowledging "the disappointment and frustration" of southerners,

the rather long editorial pointed out that "neither caival [sic] nor just complaint" would help solve the South's problems. Southern states should "shoulder the burden the court has placed upon them and work soberly to redirect their educational efforts along that will be acceptable to all and at the same time will preserve its vitality" (*Times-Picayune*, 1954, May 18, p. 8).

Many, often bloody, confrontations arose as the country readjusted to the overturning of "separate but equal." In New Orleans and other places, chants of "Two, Four, Six, Eight: We Don't Want to Integrate" protested the decision (*Times-Picayune*, 1954, May 18, p. 7). One article in the paper argued that the decision financially threatened the area and that education would decline for white children while it rose for African American children (Krebs, 1954, May 18, p. 7).

The Times-Picayune continued to signal the importance it affixed to covering civil rights or racially charged issues as the years progressed. It dispatched a reporter to Jackson, Mississippi in 1955 to cover the trial of the white men accused of lynching Emmett Till, a 14-year-old from Chicago who had been accused of whistling at a white woman. When the acquittal decision was handed down, the reporter indicated a lack of surprise because that jury was all white (Minor, 1955, September 24, p. 1). A decade later, the 1964 Civil Rights Act was signed into law by President Lyndon B. Johnson, a monumental decision for minorities in the U.S. that became a constitutional staple for removing institutionalized barriers of oppression. *The Times-Picayune* reported that President Johnson considered passage "wonderful and hopeful," as he appealed for "wholehearted compliance" (Cornell, 1964, July 4, p. 1). It also noted that White House Press Secretary George Reedy said feedback was positive: 'They are coming from all sections of the country, including the deep south ... the President discussed with [Mississippi] governor both the law and the case of three civil rights workers who disappeared in Mississippi nearly two weeks ago" (Cornell, 1964, July 4, p. 1). Mississippi's Governor, however, expected "real trouble when Negroes seek admission to public accommodations, that he thinks hotel and restaurant owners should refuse to obey the law, and that the law should be tested in court" (Cornell, 1964, July 4, p. 1).

The civil rights movement manifested in the election of New Orleans' first black mayor, Judge Ernest N. "Dutch" Morial in 1978. He was a pioneer well before that election, having been the first black graduate of the Louisiana State University School of Law, the first black juvenile court and appellate court judge in New Orleans. He was re-elected to a second term. During the runoff elections, the newspaper reported that Morial won primarily because nonwhites voted for him; however, it downplayed Morial's symbolic representation, especially in the South (*Times-Picayune*, 1977, October 2, p. 1). While *The Times-Picayune* undoubtedly considered its coverage balanced, Morial believed that coverage of him was biased; he even commissioned a study in 1983 to document a "consistent pattern of unfair, inaccurate and unbalanced reporting" by *The Times-Picayune/States-Item* paper and

several other media organizations, but especially by two of the newspaper's political columnists (*Times-Picayune*, 1983, April 27, p. 19). The 300-page, three pound, one and one-half inch-thick report was subsequently published in book form. The paper's editor vouched for the professionalism of its reports, but pledged to "review the mayor's report carefully to ascertain which, if any, of the charges have merit."

The Times-Picayune merged with the other S. I. Newhouse paper in New Orleans, the afternoon *States-Item*, in 1980. Ashton Phelps Jr., the fifth generation in his family to lead the paper, became publisher, and Charles Ferguson became editor. Jim Amoss replaced Ferguson in 1990, and is still *The Times-Picayune* editor today. Bucking a trend of other metropolitan dailies that were negatively affected by local competition, *The Times-Picayune* expanded to the suburbs and thrived. Phelps opened five bureaus and created zoned editions in seven surrounding metropolitan parishes. With a laser focus on local news, *The Times-Picayune* became the dominant newspaper in the seven-parish area.

The newspaper used that perch to embark on an ambitious project in the mid-1990s to explore race, which its editors acknowledged was still a source of friction in New Orleans. On May 9, 1993, *The Times-Picayune* began a series titled, "Together Apart: The Myth of Race," that was promoted as a "special report on race relations" in six installments, ending November 18, 1993. Amoss and Phelps wrote on the first page of the first issue that the series was:

> The story of black and white people in New Orleans. Their tumultuous three-century-old relationship continues unresolved to this day. But it is also a story that stands for the unfinished business of race throughout America ... We believe that racial discord remains the gravest threat to the future of our community and nation, and that honest dialogue is a remedy to fear, mistrust and rage ... Our readers helped us, responding to our invitation to speak on race relations. Their 6,500 recorded telephone calls yielded more than 1,000 published comments that appeared in 58 full newspaper pages while the series ran ... The going is painful. But we offer the following pages for those who are willing to begin the journey (Amoss & Phelps, 1993, May 9, p. 2).

Compared to the first issue of *The Picayune* in 1837, which wrote that those "who oppose slavery, because they are themselves the slaves of ignorance and superstition," (*The Picayune*, 1837, January 25, p. 2) the series showed that the newspaper changed with the times as it explored the many layers and social fabrics undergirding racial conflict in New Orleans and America from the perspectives of its readers. The series included excerpts from readers trying to define race, historical accounts, and possible solutions. The series reflected the newspaper's position as a prominent public opinion shaper, a role it played again in 2005 following Hurricane Katrina.

In both instances, that groundbreaking work has received notoriety. For instance, 10 years after the race series, the Pew Research Center Project for Excellence in Journalism, noted the following:

In the early 1990s, the *New Orleans Times-Picayune* deviated from traditional journalism in a major way in the manner it tackled two controversial subjects. First, the paper abandoned the principle of objectivity and aggressively used news columns as well as editorials in a concerted campaign to defeat a former Ku Klux Klan leader who was running a strong race for governor. Later, the paper published a sensational, trail-blazing series of articles on race relations that, among other things, documented the *Times-Picayune*'s own racist past. No other newspaper had ever taken such a searing look at its own role in perpetuating segregation and white supremacy (Nelson, 2003).

For much of its first 100 years, *The Times-Picayune* maintained a steady course, providing news and information it deemed the public wanted and needed to know. It was unabashedly a booster for New Orleans. While it started out with the intention of appealing to the middle and working class, segments of the population were invisible in its pages. "Community leaders who were white and majority male ... were well covered, but others were excluded" (J. Amoss, personal communication, May 21, 2013). Where African Americans were once invisible or even maligned during much of the newspaper's first century and well into its second, *The Times-Picayune* played a role in race relations similar to the role it played prior to the Mexican-American War. Over the next 75 years, the paper evolved, and so did its coverage. "There is a big difference between the kind of chamber of commerce journalism *The Picayune* saw itself performing at the turn of the century and now," its current editor, Amoss, notes (Amoss, personal communication, May 21, 2013).

In the first issue of *The Picayune*, the prospectus compared the newspaper's goals metaphorically to a levee protecting New Orleans from known threats; on August 29, 2005, collapsed levees flooded the streets of New Orleans in the wake of Hurricane Katrina. While those levees failed, *The Times-Picayune* endured, galvanizing the newspaper's innovative, adaptive, steadfast legacy. It had printed almost every day for 175 years; for three days during the Hurricane the staff was forced to evacuate the flooded city via delivery truck. However, true to its prospectus, the newspaper used the latest technology available to serve the community—the Internet.

In what may now be interpreted as foreshadowing, *NOLA.com*, the newspaper's online presence, became *The Times-Picayune*'s primary information portal during Katrina, allowing the news staff to constantly publish content while they were unable to print hard copies. On May 24, 2012, 175 years after its first printed issue, *The Times-Picayune* announced a bold step in adopting a new digital approach by suspending daily print publication, only publishing hard copies three days a week, in favor of online content. The move was greeted with local protests with many remembering how *The Times-Picayune* robustly and steadfastly served the community and informed its readers during and after Katrina. While some media critics and other pundits accused *The Times-Picayune* of boosterism after the storm, Amoss makes no apologies for its Pulitzer Prize-winning coverage.

The storm created "upheaval" and was "a life-changing moment for everyone in this community and for the newspaper," according to Amoss. "It destroyed the civic fabric and made us question everything we had taken for granted ... It robbed the newspaper of its marketplace, the lifeblood of what we do" (Amoss, personal communication, May 21, 2013). It also showed the editors and publisher the future, where a scattered community desperate for news and information turned to *NOLA.com*, now the paper's digital platform for real-time information. Amoss believes the new model for its organization will ensure future success. The print copies provide in-depth, investigative, explanatory treatment of news as information, while the Web version provides almost instantaneous coverage of news and events that audiences now demand. In addition, the three-day-a-week home delivery paper is being supplemented with a tabloid paper for newsstand distribution the other days, thus, providing its readers a printed paper every day of the week.

Today, this news organization and website, as Amoss refers to what many still call "the paper," now have an expanded mission. As still the largest media organization in the region, its role is to report in its news columns and in real time and to advocate for what it sees as the best interest of the community via its editorials.

REFERENCES

A public clock. (1851, October 16). *The Daily-Picayune*, 1.

Abolition. (1840, August 8). *The Daily-Picayune* 2.

Amoss J. & Phelps, A. (1993, May 9). Together apart. *Times-Picayune*, 2.

Brown v. Board of Education, 347 U.S. 483 (1954).

Cornell, D. (1964, July 4). Wonderful, LBJ's word on reaction. *Times-Picayune*, 1.

Court rules on segregation. (1954, May 18). *Times-Picayune*, 3.

Dabney, T. (1944). *One hundred great years: The story of the Times-Picayune from its founding to 1940.* Baton Rouge: Louisiana State University Press.

Editorial. (1846, April 10). *The Daily-Picayune*, 2.

Editorial. (1945, August 7). *Times-Picayune*, 8.

Editorial. (1896, May 19). *The Daily-Picayune*, 4.

Editorial. (1941, December 11). *Times-Picayune*, 10.

Editorial. (1837, July 4). *The Picayune*, 2.

Eggler, B. (2013, February 20). FEMA archaeologists find American Indian pottery, other items by Bayou St. John. *Times-Picayune*. Retrieved from http://www.*NOLA.com*/politics/index. ssf/2013/02/fema_archeologists_find_indian.html.

Englehardt, G. (1903). New Orleans, the crescent city, the book of the *Picayune*, also of the public bodies and business interests of the place. New Orleans: The Picayune.

Franklin, J. (2010). *From slavery to freedom: A history of Negro American*. New York: McGraw-Hill Publishing Company.

Hamilton, J. (2009). Journalism's roving eye: A history of American foreign reporting. Baton Rouge, La.: Louisiana State University Press.

Karst, J. & Shea, D. (2011). *Our times: New Orleans through the pages of the Times-Picayune.* New Orleans: Times-Picayune.

Kennon is calm on school edict. (1954, May 18). *Times-Picayune,* 3.

Krebs, B. (1954, May 18). Edict threatens severe changes. *Times-Picayune.* 7.

Leavitt, M. (1982). *A short history of New Orleans.* San Francisco: Lexikos.

Long's ultimatum on natural gas rate is attacked. (1928, June 26). *Times-Picayune,* 10.

Magazine writing. (1842, October 13). *The Daily-Picayune,* 2.

Minor, W. (1955, September 24). Two not guilty of Till murder, jury declares. *Times-Picayune.* 1.

Morial, Kiefer reach runoff. (1977, October 2) *Times-Picayune,* 1.

Morial report criticizes TP/SI columnists. (1983, April 27). *Times-Picayune,*19.

Nelson, J. (2013, February 15). New Orleans Times-Picayune series on racism. *Pew Research Center's Project for Excellence in Journalism.* Retrieved from http://www.journalism.org/node/1784.

Osthaos, C. (1004). Partisans of the southern press: Editorial spokesman of the 19th century. Knoxville, Ky.: University Press of Kentucky.

Plessy v. Ferguson, 163 U.S. 537, (1896).

Poe, E. (1954, May 18). Segregation void in public schools. *Times Picayune.* 1.

Prospectus of the commercial news and reading room of the true American. (1837, January, 25). *The Picayune,* 1.

Prospectus of the Picayune. (1837, January 25). *The Picayune,* 2.

Rivers, P. (1866, October 17). A little bunch of roses. *The Daily-Picayune.* 1.

Schudson, M. (1978). *Discovering the news: A social history of American newspapers* (New York: Basic Books).

Segregation decision. (1954, May 18). *Times-Picayune,* 8.

Slave labor: A wealthy community. (1858, August 12). *The Daily-Picayune,* 2.

Sloan, W.D. (2011). *The media in America: A history* (Northport: Vision Press).

Special correspondence of the Picayune (1848, February 2). Washington correspondence, *The Daily Picayune,* 2.

Timeline of Louisiana women's history. Retrieved from http://www.lib.lsu.edu/soc/women/timeline.html.

The Negro outrage at Washington. (1838, August 23). *The Daily-Picayune,* 2.

The president and the secessionists. (1860, November 4). *The Daily-Picayune,* 1.

The design. (1861, April 14). *The Daily-Picayune,* 1.

The Civil War. (1861, May 1). *The Daily-Picayune,* 1.

The election laws. (1870, February 4). *The Daily-Picayune,*4.

Union of the morning papers means greater, better paper. (1914, April 5). *The Daily-Picayune,* 13.

What is the true issue? (1860, November 4). *The Daily-Picayune,* 1.

The Importance OF Local News IN Tragedy—The Gulf Coast's Dual Disasters AND Beyond

ANDREA MILLER

Times-Picayune Editor Jim Amoss describes the relationship between the newspaper and the New Orleans' community after Hurricane Katrina as an "espirit de corps" (personal communication, April 25, 2013). Publisher Ricky Mathews argues the frequency change "detractors" played on that emotional connection as they rallied the troops in protest of the newspaper's unprecedented move to reduce its print publication to three days a week (personal communication, April 25, 2013). However, as seen throughout *The Times-Picayune's* history, the connection between the paper and the people it serves is well-established and strong. Tragedies find a way to dislodge those feelings and bring them floating to the surface. The newspaper becomes more than an ink-filled tabloid or broadsheet in times of crisis. It becomes a lifeline, a guardian, an advocate, a family member, a memorial.

This chapter will explore the importance of the local media during times of disaster through in-depth interviews with more than three dozen journalists who covered Hurricane Katrina (2005) and the BP oil spill (2010) in Louisiana, Superstorm Sandy (2012) in New Jersey, and the Sandy Hook Elementary School shooting (2012) in Connecticut. Hurricane Katrina is now a part of New Orleans' historical signature, remembered with caution every June when hurricane season begins and commemorated with recovery stories every August. This chapter will address how Katrina and another disaster just five years later, the BP oil explosion and spill, helped transform the media market. While it appears New Orleans has become synonymous with disaster, it is not the first or the last community to experience excruciatingly tragic events.

While Katrina and BP are years out, a constant news cycle of tragedy continues to reaffirm the importance of local news. Also in this chapter, Superstorm Sandy journalists speak about their experiences covering the superstorm. Additionally, we visit *The Newtown Bee* journalists whose suffering is as deep as their journalistic duty to community. Common themes across all four tragedies explored in this chapter are how digital is changing the transmission of information at critical times, the differences between local and national coverage of crisis, and deep connections to community that affect the process and product of journalism.

HOW DIGITAL CHANGES THE TRANSMISSION OF CRISIS INFORMATION

Many say Hurricane Katrina was the beginning of a digital maturation for the city's media outlets. *Times-Picayune* Editor Amoss points to what he calls a "defining moment," the night spent waiting for Katrina, August 28, 2005 (personal communication, April 25, 2013).

There, by the light of generator-powered computers, the realization of where the industry was going hit him:

> I remember wandering through the newsroom in darkness—this was ... at 2 a.m. or so—and finding this little lighted bunker in the middle of our old newsroom over on Howard Avenue with these various editors, taking in dispatches from reporters in the field and just disseminating them on the Internet. I mean, pre-Twitter, and certainly pre-smart phone era... But, the revelation of that moment was that this is how we're going to reach our readers, that ... no press was going to crank up that night. No trucks powered by a fossil fuel were going to be delivering things to doorsteps because there weren't any people behind the doorsteps. And yet, there were thousands and eventually millions of people on the other end, receiving those, and finding out, really, the true nature of the storm, which they were not getting from the AP or CNN or NPR. They were getting (information) from us because our reporters knew where to go and knew how to capture the story. So that was, I think, the beginning of the revolution for us (personal communication, April 25, 2013).

Hurricane Katrina came ashore as a Category 4 storm on August 29, 2005, hitting a city where levees were only designed to protect against a Category 3 (Grunwald & Glasser, 2005). Two of the levees protecting New Orleans from Lake Pontchartrain broke. The death toll skyrocketed to more than 1,800 people, hundreds of thousands of homes were destroyed, and the damage estimates were in the tens if not hundreds of billions of dollars (eight years later, these numbers, including the death toll, remain in dispute).

The storm decimated the communication infrastructure in New Orleans. Residents could text, but made few successful phone calls. And even then there was no electricity to charge the phones. A majority of the city was flooded, including

newsrooms. News gathering was limited to pounding the pavement, with reporters traveling a few blocks from their newsroom, then returning to report what they had seen and learned firsthand. They shoveled all of the information they gathered to the Web. For the first time in 175 years, *The Times-Picayune* would not print a daily newspaper for three days. Instead, the information was published on its website *NOLA.com*. Citizens from across New Orleans could contribute to the site as well, giving detailed and specific information about neighborhood damage. Websites became community portals in an emergency, providing a valuable lifeline and outlet for those still in the city (Miller, Roberts & LaPoe, 2014)—and information to the more than one million people from southeastern Louisiana who had evacuated to neighboring states (Boyd, 2010).

Headquartered in the French Quarter, CBS affiliate WWL-TV, always had a plan of action for the perfect storm. Sandy Breland, news director at the time, and Chris Slaughter, assistant news director at the time, met in New Orleans with representatives from the Louisiana State University (LSU) Manship School of Mass Communication in October 2004 to discuss moving to the school's television studio in case their facilities were overcome by flooding. It was discussed casually over dinner at Ralph's on the Park, but as I look back as a participant, it was all business, serious business. After Katrina hit, staff from WWL and *The Times-Picayune* ended up at the Manship School facilities in Baton Rouge in order to fulfill their commitment to informing citizens about the unfolding catastrophe in their city.

While WWL was able to stay on the air, the Web became an important part of information transmission. WWL streamed its coverage online for 24 hours a day the week after the storm, but only after the website crashed on the first day and online staff took steps to address this unexpected occurrence. Once the server went down, CBS, its national network affiliate, lent the station bandwidth. But within a few hours, that partnership also crashed—too many users wanted immediate information from a local source. An impromptu alliance with Yahoo!, hammered out within minutes over the phone according to Slaughter (who was at the time WWL's assistant news director), allowed the website enough bandwidth to handle the millions of hits it received in the days and weeks after the storm (personal communication, February 26, 2013). The need for greater online capabilities during a crisis had been established. This partnership lasted throughout the month of September, providing the link that turned local news into international news.

Pre-Twitter, pre-smartphone, Facebook only in its infancy, the New Orleans media market had come of age during Katrina—reaching beyond the city, state, and region with their websites, becoming international news sources. While New Orleans began its digital maturation with Katrina, the storm prolonged it as well, at least for *The Times-Picayune*. The recovery and rebuilding became a focus, and it was profitable. Katrina forced the digital shift in information transmission—but it also held off cuts and changes. "What happened was, Katrina hit, the call

structure goes down because some employees leave and the size of the company shrunk some, just by virtue of some people not coming back," said Publisher Ricky Mathews. " ... there was a spur of economic development (that) occurred right after Katrina that actually helped. You know, insurance, advertising, other kinds of—stores reopening, so, I would say, maybe Katrina *delayed* some of the inevitable actions" (personal communication, April 25, 2013). Additionally, Amoss said that after Katrina, they went back to their "print-centric ways" (personal communication, April 25, 2013). That is, until now.

Superstorm Sandy came ashore early on October 29, 2012 near Brigantine, New Jersey, just northeast of Atlantic City. She was what the National Hurricane Center called a post-tropical cyclone with 80 mile an hour winds. Dubbed Superstorm Sandy and Frankenstorm by the media, the Jersey shore took a direct hit. Sandy also sent a storm surge (one wave in New York Harbor measured more than 32 feet) into New York City flooding subway tunnels and knocking out power to much of the city (Freedman, 2012). Sandy caused billions of dollars in damage to New York and New Jersey alone and caused about 150 deaths along the East Coast and in the Caribbean (Howell, 2013). The world watched Sandy come ashore in real time. The technology and social media have come a long way since Katrina in 2005. For the journalists who covered the New Jersey shore, this event promised to change their hometowns and the norms and routines of their craft forever—much like Katrina did seven years earlier in New Orleans.

The day I arrived at the *Asbury Park Press* in April, the six-month anniversary of Sandy was nearing and there was an editorial meeting scheduled to plan coverage. One sales staffer at the meeting had not yet moved back in to her destroyed home, but she was hopeful because progress was being made. At lunch at a restaurant on the Boardwalk, saws hummed and hammers pounded. Workers were hurrying to get the Boardwalk repaired before the traditional summer kick-off and the tourist season, Memorial Day.

Alexandra Smith, assistant breaking news editor whose house was also damaged, recalled working more than 80 hours that week after the storm, tethered to her computer. Just as in Katrina, cell service was virtually nonexistent, but people's phones were their only source of communication. "So we spent a lot more time making sure that mobile was optimized, to get the key information out there. Where you could find gas, what food stores were open," said Smith (personal communication, April 9, 2013). Smith spent much of her time aggregating information from Facebook, Twitter, and reporters in the field who called in after they found a "hotspot"—she compiled and published "any raw information that we could (find) out there" (personal communication, April 9, 2013). This new kind of digital journalist may never leave the newsroom during a crisis, but serves as an in-house clearinghouse of information for immediate dispersal. The more, the better. The quicker, the better.

The website also became a portal for community information, and *The Press'* management could not stress enough the impact of social media. Executive Editor Hollis Towns said they put a live Twitter feed on the website and it just exploded. "People loved it. It was real time … it was certainly the eyes and ears of the community" (personal communication, April 9, 2013). They also included a live chat box that allowed for two-way public conversations about what people were seeing and experiencing in the days after the storm.

After the storm, management realized a restructuring of how they covered breaking news was necessary. The breaking news and online shifts were moved, and they added overnight staffers to provide 24-hour coverage. They drilled down even further to hyperlocal, town-by-town information sections after the storm. Every day they would publish online information blurbs from approximately 80 towns. The blurbs might include what a mayor said or where locals could charge their phones. "It really endeared us to the community," Towns says (personal communication, April 9, 2013). "They were so pleased that the *Asbury Park Press* cared about their town and that we had someone paying attention and writing something every single day" (personal communication, April 9, 2013).

Management also recognized that all of this was not available to the journalists who covered Hurricanes Andrew (in South Florida in 1992), Katrina, or perhaps even Ike (along the Gulf Coast in 2008). "Our coverage of Sandy, in ways that were real as opposed to theoretical, deepened our commitment to living the digital life," says Managing Editor James Flachsenhaar (personal communication, April 9, 2013).

Some 80 miles away at *The Press of Atlantic City*, environmental reporter Sarah Watson had a story of interaction with users that only a local reporter, with knowledge of the area's topography could tell. Watson lives in Ventnor City, a barrier island, three blocks from the ocean and 75 yards from the bay. A self-described "weather nerd," by her own rule, she doesn't live on the first floor of a building near the water, but the third. During Sandy, the first floor was flooded with three feet of sea water and the storm knocked out the hot water heater and cooking gas. "You just learn to suck it up and deal with it knowing that there are people worse off than you are," said Watson (personal communication, April 10, 2013).

Watson evacuated to her father's house in Washington, D.C. From her dad's basement, she worked for the newspaper via social media helping individuals who followed her on Twitter:

> One of the most profound moments was at about 11 o'clock when the water finally started going down for the first tide. People started asking can we get out? Is it too late? And none of us could reach the Office of Emergency Management because they were out busy rescuing people. I had in my head the full topographical map of what floods where in Ventnor, in Atlantic City, in Ocean City, various places where I know their roads and the elevation of those roads because I have been around and I pay attention to the water

levels. So I had people, I was saying, okay, well how high is the clearance of your car? What kind of car do you have? Where exactly are you? And giving people directions via Twitter on how they can leave the island still. Then came the very hopeless moment—it's 2 o'clock, the water is starting to come back. You have got to stay home. You can't leave. That's something people in New Jersey have never really been told before. They are used to doing whatever the heck they want. So [I'm] watching the storm surge and I'm watching it online via the online gauges and putting out water levels (personal communication, April 10, 2013).

A profoundly helpful, perhaps even life-saving service was being offered via Twitter by a local reporter, who had the in-depth knowledge to serve her community on almost a street-by-street level from more than 200 miles away. Combine her knowledge with the immediacy and two-way function of social media and service to community becomes real-time help in the midst of a natural disaster. Digital evolved even further during Sandy with journalists offering these minute-by-minute, personal updates as well as serving as aggregators who collected as much information as possible. Digital shines in tragedy. The tenets of immediacy, abundance of information, as well as interactivity, which will be addressed in chapter eight, are important on a daily basis, but are especially crucial in crises situations.

On December 14, 2012, the staff of *The Newtown Bee* was jumping up and down to celebrate winning a Christmas office party radio contest. Then the police scanners went off, carrying news of something that sounded like a shooting at Sandy Hook elementary. A few hours later, *The Bee*'s website would crash, overwhelmed by the volume of visitors. It appears almost instinctive now—when crises happen, people go to the Web to get immediate information—and they want it from those closest to the news event—local news sources.

The Bee is a weekly paper that hits newsstands on Fridays. One *Bee* reporter admitted the pace of getting information on the Web that first day was hectic. The sad facts of the story were that a gunman killed his mother, then traveled to Sandy Hook elementary and opened fire on children and teachers before killing himself. In the end, 26 innocents died in the school, 20 of whom were children. On Saturday, the day after the shooting, Editor Curtiss Clark decided to put together a special print edition. It was the first time *The Bee* had done a special section in its 135-year history. Not even Pearl Harbor had warranted such a journalistic response. News outlets inherently recognize the importance of getting information to people quickly, even if it means losing money. *The Bee*'s special edition was free and the staff said they received very positive feedback from people in the community. There is something about a special edition in print, says reporter Andrew Gorosko, who has worked at *The Bee* for some 25 years. The special edition not only contained information, but it became a memorial of the event from the town's paper of record. "It becomes an historical object," says Gorosko. "It's an artifact" (personal communication, April 8, 2013).

The Bee prints in black and white only. On its website, however, users will find the December 17, 2012 special edition—digital and in full color. Digital breaks news and links people immediately, print provides depth and a memorial to the event. In crisis, all platforms are necessary at different stages of the disaster.

NATIONAL VERSUS LOCAL NEWS IN TRAGEDY

Newtown Bee reporter Eliza Hallabeck says she was more embarrassed than angered by the national press' actions while covering the Sandy Hook story (personal communication, April 8, 2013). She points to the fact that many of the national journalists didn't even find out how to say the name of the town before they went on the air. "That's one of the first things you learn in journalism school," she says (personal communication, April 8, 2013). During Hurricane Katrina national coverage, one CNN anchor repeatedly called Biloxi, Mississippi (pronounced "Buh-LUCK-see") "Bih-LOCKS-ee," still others said "Bye-LOCKS-ee."

Beyond the who, what, where, when, why, how, and correct pronunciations, local news has the ability to serve important roles in crisis. Communication scholars call these roles management, recovery, linkage, and social utility (Perez-Lugo, 2004). In the management and recovery roles, both national and local media outlets equally transmit basic public information. Where the divergence occurs is in two other roles that allow the local media to provide emotional support and facilitate cohesion in the community (Perez-Lugo, 2004). The linkage role of the media does what it suggests, links the community to information it needs (Red Cross phone numbers, where to find water or batteries), and the power of social utility comes after people are linked up when the collective action of doing something can take place (where to drop off donations, fundraisers) (Perez-Lugo, 2004). Point-in-time disasters will create the need for the national press to descend on the event, yet it is the local media that are in it for the long haul, creating community and providing emotional support that adds another dimension to the media-audience relationship.

National news serves a distinctly different audience than local. In order to appeal to a mass audience, national news must be all things to all people. And often, that means painting stories with a broad brush. Local news, as described above, has a very specific micro-audience, with specific issues to cover and a proximate audience to serve. In tragedy, the differences between the two are often highlighted as each entity concentrates on serving its publics and going about newsgathering in very different ways with different end goals. Tragedy affects the newsgathering process—especially when tragedy is in your backyard—or offshore.

On April 20, 2010 the Deepwater Horizon oil rig exploded off the coast of New Orleans killing 11 workers. The rig burned and sank and thousands of

gallons of oil began to gush out of the blown-out well on the bottom of the ocean floor. After 90 days and more than 200 million gallons of crude oil spilled, the well was capped. In less than five years, New Orleans journalists had to cover two historic, career-making events, yet each was distinct. The oil spill was a very different situation. By this time employee cuts at media outlets had begun. Couple that with the complexity of the disaster and coverage became difficult (Miller, Roberts & LaPoe, 2014).

Unlike Hurricane Katrina, the rig explosion occurred 40 miles off the coast. The blown-out well gushed almost a mile underwater. Access to the location was limited or nonexistent and just getting the facts was problematic (Miller, Roberts & LaPoe, 2014). When the oil started coming ashore, there were reports of BP and the Coast Guard blocking access to some of the affected marshes. "In some cases, the same guys who are public servants agree to these restrictions," says Slaughter, former WWL-TV news director (personal communication, February 26, 2013). "But BP and geography presented some real challenges. You know, the obvious efforts to suppress information. Then I think there was a little bit of lingering disaster fatigue in the area" (personal communication, February 26, 2013).

Additionally, the close relationship with authoritative sources experienced in Hurricane Katrina was absent for the oil disaster. Coast Guard Admiral Thad Allen, BP executives Tony Hayward and Doug Suttles preferred to talk to the national media with a larger audience, than to local media. During Katrina, reporters had direct access to then-Governor Kathleen Blanco, then-Mayor of New Orleans Ray Nagin, New Orleans Police Superintendent Eddie Compass, etc. This was not the case in the BP disaster. Not only did national media parachute in to cover the story, the sources also parachuted in (Miller, Roberts & LaPoe, 2014). This put local media on the back burner and took away much of their power to control the story and offer what the local constituents needed in terms of locally-relevant information.

"And that's how our town turned into not our town. It was not our town," said *Newtown Bee* reporter Kendra Bobowick, who experienced something similar after the school shooting (personal communication, April 8, 2013). Bobowick's nephew attended Sandy Hook elementary. He was at school that day and returned home safely. The presence of the aggressive national press made the Newtown community angry. Journalists' sources dried up and once friendly community leaders were abrupt and distant. "We're just another person with a camera. We weren't a neighbor, we weren't from here, we were just a part of the press and treated as such and shuffled around and controlled," said Bobowick (personal communication, April 8, 2013). "And to have people in the community who don't necessarily know me either looking at me with disgust a day or two later because there I was to tape or videotape and broadcast their hometown horror. I became a part of that crowd instead of their neighbor. And that's awful. I was embarrassed

to have a camera, and downtown Sandy Hook became a really ugly place to be" (personal communication, April 8, 2013).

As I drove in to Newtown on a Sunday afternoon in early April 2013, I took note of my first impressions of the town. A festival was taking place and the sun was shining. American flags flew and green and white ribbons (the colors of Sandy Hook elementary school) blew in the breeze. True or not, it was just as the national journalists had described it—the ideal, quaint, quintessential New England town. When you reach the enormous American flag and pole at the top of the hill in the middle of town, turn right and *The Newtown Bee* is just up the street on the left. Continue less than two more miles on that same road and you run into Sandy Hook elementary. In Louisiana, by this time of year, the trees and bushes are bursting with leaves and azalea flowers. Newtown appeared more like winter than spring. In the corner of a strip mall parking lot, there remained a pile of snow as tall as the windows of a car and about twelve feet wide—stacked and unmelted after a winter plowing. Most trees were bare and the grass was brown. However, I did see a few buds on the trees. Perhaps spring was finally on its way after a very long winter.

A green and white sign with "We are Sandy Hook. We Choose Love" was on the front door of *The Newtown Bee*'s office. The inside is decorated in a very eclectic manner—full of antiques and different pictures and statues of bees. It almost looked like a series of booths in a dusty attic. Three large dogs—two Golden Retrievers and one chocolate Labrador—roamed the office. Curtiss Clark, the editor, was out sick that day. We used his office and cluttered desk for some of the interviews. My first impression of the Newtown journalists was that they were guarded, perhaps just like the residents. They were very careful with their words. All but one teared up during my interviews—emotions were still very raw—and just below the surface. All were hesitant and not happy that they were thrust into this situation. My first interviewee disliked the "idyllic" portrayal of Newtown by the national press. She had an almost "how dare they" attitude because, as she said, no town is perfect. However, the second interviewee said Newtown was "the perfect town" and how dare this happen here! Their duty and ties to community were heavy on their hearts.

Newtown is approximately an hour and a half away from the center of the world's news, New York City. So the speed and ferocity of the arrival of the national press was no surprise. Hundreds of news outlets showed up within hours of the shooting. All of *The Newtown Bee* news workers said they had problems almost immediately with aggressive, national press getting in the faces of victims. John Voket, *Bee* associate editor, said it was routine to hear on the police scanner, "send a car here. Somebody is knocking on their door that looks like they are from the press" (personal communication, April 8, 2013). He said there were probably a dozen incidences of journalists walking right up to victims' doors. "One person

who called me and said they were at the home of a family and they were expecting a relative and the door knocked and they thought it was the relative and they opened the door and the lights went [on] and the microphone was in their face," said Voket. "So that was one that set me off" (personal communication, April 8, 2013).

Voket, also a member of the Board of Directors of the New England Newspaper and Press Association (NEN&PA), issued a stern message to colleagues across New England and the U.S. to leave victims alone. It worked. By Monday or Tuesday, according to Voket, the front door ambushes had ceased.

In Atlantic City, inaccurate national coverage led to a marketing campaign by the city to correct the misinformation that Superstorm Sandy destroyed the Boardwalk (Neill Borowski, personal communication, April 10, 2013). The week before my arrival at *The Press of Atlantic City*, the latest round of layoffs took place. Editor Neill Borowski said a couple of the employees were already thinking about retiring and one of those he laid off was his own wife, who worked in sales.

The Press lead local content producer Peter Brophy tells the story of the national media's mistake:

> Al Roker (NBC morning weather anchor)… showed a piece of boardwalk that had been washed away. Well, that piece of boardwalk actually was destined to be demolished. He interviewed the mayor and when all was said and done, the typical viewer came away with the idea that the Atlantic City Boardwalk had been washed away while we're sitting here looking at it. It's there; it's safe and sound. It's got virtually no damage at all, but the result is that the tourism industry is still suffering the effect of not just that interview but other reports too that went around the country that there was damage to the Boardwalk (personal communication, April 10, 2013).

While the national media report on the story and then leave, perhaps to cover the next tragedy, the local journalists remain to correct inaccuracies and help facilitate recovery. "Some days I wish I could just leave and forget about it," says *Bee* reporter Gorosko. "But you don't forget about it. There is no way to forget about it. It's here" (personal communication, April 8, 2013). But Gorosko also sees the local media as a necessary "public utility"—providing consistent, sound information for people to base important decisions before, during, and after a crisis (personal communication, April 8, 2013). While both local and national news fulfill distinct, important roles, it is imperative for the national press to get the information right from the very beginning and to tread lightly on other journalists' territory. The journalists wanted the national media to walk in their shoes—what if it was your hometown? Or your child's school? Local reporters argued that service to a national audience can still be accomplished with solid and sensitive reporting. *Bee* reporter Bobowick has this advice: "Just be gentle and realize someone is having the worst moment of their life while you are just getting a photograph" (personal communication, April 8, 2013).

COMMUNITY CHANGES JOURNALISTIC APPROACHES

Ties to community can change how journalists approach stories in the positive and in the negative. After Hurricane Katrina, there was a sense of camaraderie between the local press and the city's authorities. Both groups, after all, were on the receiving end of some very stressful times. Both had been burdened with huge responsibilities to cover an underwater city—while at the same time worrying about their family's safety and property. There was a sense that we were all in this together, and it was reflected in their reporting. Reporting, that in some cases, did not dig deep enough and did not ask basic questions (Miller, Roberts & LaPoe, 2014).

Six days after Katrina, on September 4, 2005, a group of people were crossing the Danziger Bridge (which spans Industrial Canal) when New Orleans police arrived to what was reported as an "officer down" situation. It turned out there was no officer down, and the group crossing the bridge was unarmed. When it was all over, two people were dead, including a mentally challenged man who was shot seven times by police, six times in the back. The Danziger Bridge incident sparked a police cover-up, criminal charges against seven officers, and three federal civil-rights lawsuits. At the time of the shooting the reporting by local media was favorable, mostly portraying stressed-out New Orleans police officers as tireless protectors of the city (Miller, Roberts & LaPoe, 2014). It wasn't until month's end that the story began to unravel and reporters from *The Times-Picayune* recognized their reporting errors. The connection to community had mediated their journalistic instincts and allowed questionable accounts to be put forth as fact.

USA Today's Gary Stoller, who lives and raised his family in Newtown, questioned his journalistic instincts as to whether he should call the victims' families after the shooting. Stoller covered the Columbine High School shooting in 1999 and just months prior to Sandy Hook, the Aurora movie theater shooting. But this time, it was different. "My investigative sense, being a trained investigative journalist, was to call… [But] the stories I was doing don't seem to necessarily get to the heart of how they were doing. I thought, what could they really tell me? Investigative stuff should be more on the Lanzas (the killer's family) and the motives. They sent their kids to school and they got killed. So how much do you have to dig up their grief?" (personal communication, April 8, 2013) Instead, Stoller acted more as a coordinator for *USA Today's* coverage, feeding phone numbers and contacts to his reporters because "no one knew what Newtown was or who to talk to" (personal communication, April 8, 2013).

The Newtown Bee made a conscious decision not to interview victims or their families. "That's what we decided and we have stood there since then," says reporter Nancy Crevier (personal communication, April 8, 2013). "If families have a story that they want to share… they all know us. They will when they are ready,

if they have a story to share. We are not going after them. We are not sensationalists. We are the friends and neighbors. This was a very personal disaster here in town. So, and again our job—I have always felt is to give people the news they *need*. They can get the news they *want* somewhere else" (personal communication, April 8, 2013). Crevier, who has lived in Newtown for 18 years, writes the paper's obituaries. Before the shooting, a "bad week" was two or three obits. The paper made the decision not to run pictures of the victims unless the families or funeral homes approved.

Bee reporter Eliza Hallabeck has lived all her life in Newtown. Her beat is education so she felt a personal connection to Sandy Hook's principal Dawn Hochsprung. She took the picture of Hochsprung that was widely distributed by state, national, and international press. She says that one photo changed her outlook on her work:

> The first time I saw that photo in news elsewhere, I was down in Stamford, shopping, and then look up and I see, I forgot whether it was *US Weekly* or *People*, but I look up and it was just the photo I took of this woman I've known for so, for a couple of years, and I had to go out to the car. And luckily, my boyfriend just paid for the groceries cause I couldn't. I didn't want to see that. It was just, you know, I just really hope she liked that photo (personal communication, April 8, 2013).

Immediately after the shooting, *Bee* Associate Editor Voket was the only local media member allowed in the firehouse, just up the hill from the elementary school. The firehouse was the staging ground for authorities as well as a gathering place for parents picking up and waiting for their children after the shooting. Born less than twenty miles away in Waterbury, Voket has covered the city for nine years. Early reports came in that there was one victim who had been shot in the foot. From his firehouse vantage point, it became clear that wasn't the case. "And then I saw two big burly state cops kind of hang on to each other crying," said Voket. "So at that point, I knew it was just bad" (personal communication, April 8, 2013). Voket's connection to community had allowed him unprecedented access to victims, families and authorities in the minutes and hours after the shooting. But Voket, who on the day I interviewed him knew almost exactly how many days it had been since the shooting (115), didn't see it as an exclusive, he saw it as a responsibility:

> That's when the reporter switch went off. I was like, I just have to try to observe to the best of my ability without being invasive, but I also have to be the representative of the newspaper here who's invested in the community. I have to take care. The information that I end up, having [to] relay is sensitive and accurate and not sensational. So the first selectmen confirmed how many were dead. I said I'm going to be here to help if I can, in terms of getting accurate communication out. If you need me to leave, I will leave. If you want me to stay, I'll stay. She said no, we want you to stay (personal communication, April 8, 2013).

Overall, journalists told us because they live and work in the community, it allows their journalism to be more in-depth, contextual, and during tragedy, careful and restrained. *Bee* reporter Gorosko says this event had made him more sensitive to what he puts in writing. As a police, court, and crime reporter, he was cognizant that his reporting needed to be less graphic going forward. The community connection, for the most part, makes for better journalism they said. "I think the crisis kind of validated the kind of journalist I always was, but never had the opportunity to ever prove I was because I never had a situation like this," says Voket (personal communication, April 8, 2013). He says that people trust you because you work next door, but with that trust comes the responsibility to be accurate, sensitive, and perhaps less competitive.

I witnessed a lack of the stereotypical competitive drive in many of *The Bee* reporters. They knew the story was important and many people were counting on them, but they saw their duty differently. There was no desire to call or knock on the doors of the victims' families. Their duty was to supply information about what happened, news that was useful, and what they felt people needed. Stoller says he believes because they didn't pursue victims, this in itself was service to community. These are their friends and neighbors, and will be for years to come, so they didn't want to trample on their community's pain. In a way, this was similar to the Katrina journalists giving the authorities a break after the storm. They were also part of the community and also in pain. They saw this as an "in this together" situation. *The Bee* served the community by what its reporters and editors call being respectful and human. It is different for a local journalist covering a tragedy with insatiable global-interest. "If you are the local journalist and you are invested in your community in your heart," continues Voket, "that doesn't matter who says they reported it first because you reported it best because you know best how to report it " (personal communication, April 8, 2013).

IMPORTANCE OF LOCAL PRESS TO COMMUNITY

Throughout this chapter, the underlying current is the importance of the local press to community in crisis. However, there are a few more examples of this connection that need highlighting. Paywalls at the *Asbury Park Press* and *The Press of Atlantic City* were taken down during Sandy, and the *Bee*'s special edition was free. The media recognize that, in times of crisis, it has a responsibility to serve the community and provide as much information as possible. But it often goes beyond information. In Asbury Park after Superstorm Sandy, the newspaper's building had power and hot showers. Employees' families were invited to stay. Breakfast, lunch, and dinner were served to everyone for two weeks. An insurance company across the street used the lobby to process claims, national press members slept in a

conference room, the Red Cross used the building as a temporary staging area, and gas from a tanker truck was offered to employees and anyone who needed to fill up. In this sense, the press was fulfilling the direct linkage and social utility roles, serving the community above and beyond journalism.

Reporters said the local media are a mirror, reflecting the people in the community, and that reflection feeds into every town's sense of self. *The Times-Picayune* has always had a strong, historic connection to the community. Katrina and the oil spill strengthened that bond. So when the reduction was announced, ABC News reporter and a multiple generation New Orleanian Cokie Roberts (2013), says it was like a "slap in the face." On a recent visit to LSU to deliver the May commencement address, Roberts had lunch with students and faculty at the Manship School of Mass Communication. Roberts (2013) says the Advance management "shockingly misread" the city's reaction. She says New Orleans is a newspaper town, always has been, and the reduction signaled to the community that they were "not good enough" to have a daily newspaper (Roberts, 2013). The proud community dug in and ferociously protested. Slaughter says the community took it personally and felt betrayed because the town saw the newspaper as "part of their family" (personal communication, February 26, 2013).

The situation in New Orleans aside, that relationship between the community and the local press needs to be recognized and nurtured. The community is important to the local media and the local media are important to the community. It is a symbiotic relationship. And that relationship, says *Bee* Associate Editor Voket, needs to be taken to another level during crisis. Voket says that he is an advocate for preferential treatment of the local press by local authorities during times of crisis. He advocates for the local media outlets to have frank, personal meetings with local authorities and community leaders before a tragedy strikes to build up rapport and an understanding about how the chain of information is going to be handled in crisis. "It can't be CBS News, it can't be CNN, it can't be Anderson Cooper... they don't know the community, they don't have the embeddedness," says Voket (personal communication, April 8, 2013). "There has to be a voice of real truth, and that really should be the paper that is the trusted communications source and organization that may form the most in-depth historical record of what could be the worst incident to ever hit a community" (personal communication, April 8, 2013).

Tragedies in your own backyard are personal. It is also important for the community to remember that journalists are not only covering the tragedy, but they too are living it. In Katrina, many journalists lost everything. Stoller said that the people of Newtown had "lost everything" as well, yet in an emotional sense (personal communication, April 8, 2013). Gorosko calls it a watershed moment in his life. He says for the rest of the world the event will become less vivid, but not for Newtown. "Some hellishly bad stuff has happened here ... and it's hard to

get past it" (personal communication, April 8, 2013). *Asbury Park Press* staff writer Jean Mikle teared up when asked about the importance of the media in tragedy. She says for years she had been working in a malaise. But covering Superstorm Sandy, she says, had reenergized her and she now feels the importance of what she does—all over again (personal communication, April 9, 2013).

All journalists will cover tragedy sometime in their careers, whether a deadly automobile accident, a drowning, or a murder. But when large-scale tragedy affects the *entire* community, the journalists' involvement and reporting goes to another level. National news serves a different master, actually, millions of masters across the nation. Local news serves the community in which its reporters live: 24/7, 365 days of the year. Both serve different purposes and are no less important. But different crises affect communities in different ways. For Katrina, everyone was in the same boat, but for the oil spill the journalists felt they were without a boat, relying on others. For Superstorm Sandy, one community was destroyed, and one had the perception of being destroyed (the Boardwalk). Therefore, the knowledge of the local community allowed the reporters to adapt to the different circumstances and situations. Once tragedy strikes, the community connection allows much more flexibility and the ability to adapt to the unfolding crises.

The audience recognizes its need for local media when tragedy strikes. In August 2012, a survey of the New Orleans area showed 82.6 percent of residents recognized the importance of local media in disaster saying they strongly agree that when disasters such as Hurricane Katrina threaten or strike the New Orleans area, they rely on local news for information (PPRL, 2012). Another 8.1 percent somewhat agreed. Therefore, more than 90 percent of those surveyed understood their reliance on local media in a disaster. In terms of which local outlet they choose in crisis, 61.5 percent go to local TV, 20.7 percent to local radio, 12.7 percent to local websites, and only 3.9 percent go to local newspapers. The fact that almost 21 percent recognized the need for radio in a disaster shows these respondents have been through a disaster before and know that when communication infrastructure is decimated, radio always works. About 89 percent of those surveyed lived in the New Orleans-area during Hurricane Katrina, the *average* number of years to live in the area, just over 41. The survey showed these are seasoned disaster veterans who see local news as a lifeline when their world is adrift.

The local media, in the disasters studied in this chapter, rose to the expectations of their audience. Hurricane Katrina solidified the need for immediate, digital transmission of information. The media continued to adapt to digital and used it in new and exciting ways during Superstorm Sandy. The local media also became protectors and advocates for their communities using their platforms to help victims, while still getting the information out. The reporters we talked to felt entrusted to cover their communities. They feel they have the integration and history in order to assimilate the information with a level of sensitivity and with a

scope and depth that national media will not have. *Bee* reporter Gorosko calls the local press the canvas on which the local community is painted (personal communication, April 8, 2013). And while the picture is often not pretty post-disaster, it still contains elements of home. It is the journalist's responsibility to help move the picture and the community forward.

REFERENCES

Boyd, E. (February, 2010). *The evacuation of New Orleans for Hurricane Katrina: A synthesis of the available data.* Unpublished paper presented at the National Evacuation Conference, New Orleans. Retrieved from http://www.nationalevacuationconference.org/files/presentations/day2/Boyd_Ezra.pdf

Freedman, A. (2012, November 14). *32-foot-plus waves from Superstorm Sandy topple record.* Climate Central. Retrieved from http://www.climatecentral.org/news/32-foot-wave-from-hurricane-sandy-topples-records-noaa-finds-15241

Grunwald, M. & Glasser, S.B. (2005, September 21). Experts say faulty levees caused much of flooding. *The Washington Post.* Retrieved from http://www.washingtonpost.com/wp-dyn/content/article/2005/09/20/AR2005092001894.html

Howel, E. (2013, July 15). Superstorm Sandy's track shows it was a 1-in-700 year storm. *The Huffington Post.* Retrieved from http://www.huffingtonpost.com/2013/07/16/superstorm-sandy-track_n_3606456.html

LSU Manship School of Mass Communication Public Policy Research Lab. (2012). The state of newspapers in New Orleans survey: Citizens' reactions to the loss of the daily *Times-Picayune.* Retrieved from http://sites01.lsu.edu/wp/pprl/files/2012/07/LSUTimesPicayuneSurveyReport_Final2.pdf

Miller, A., Roberts, S. & LaPoe, V. (2014). *Oil & water: Media lessons from Hurricane Katrina and the Deepwater Horizon disaster.* Jackson, MS: University Press of Mississippi.

Perez-Lugo, M. (2004). Media uses in disaster situations: A new focus on the impact phase, *Sociological Inquiry,* 74: 210–225.

Roberts, C. (2013, May 16). Informal lunch talk presented to Manship School of Mass Communication students and faculty.

The Economics OF News

How We Got Here AND What It Means FOR New Orleans News Consumers

JERRY CEPPOS

The first shot in the news revolution that led to the elimination of daily publication of the New Orleans *Times-Picayune*—and dramatic changes in the news ecosystem in other cities—was fired in 2004.

Or 1991.

Or 1993.

Or 1995.

One of the enduring mysteries for a future business school dissertation is why the newspaper industry seemed to ignore the revolution, almost like a coastal community shrugging off a Category 5 hurricane warning. The fact that different industry leaders noticed the revolution at different times helps explain in part why the industry was slow to react. In addition, regional economic differences and varying expectations of stockholders or family owners also help explain the lackadaisical reaction. Finally, indecision, or bad decisions, about whether print executives could run an entirely different business initially also plagued some companies, including Advance Publications, the owner of *The Times-Picayune*.

Nonetheless, the industry reaction was catatonic. Texas columnist and straight shooter Molly Ivins may have summed it up best: "I don't so much mind the newspapers are dying—it's watching them commit suicide that pisses me off" (Doctor, 2010). As analyst Ken Doctor wrote, "The digital transformation was just too hard for newspaper companies to think about, to weigh and to act on." Marc Andreesen, the founder of Netscape and a Silicon Valley venture capitalist, said, "It's not that you can't make money in print newspapers. It's not that there aren't people who love them." But successfully dealing with transformative technology requires going "on

100 percent offense" (McBride & Reuters 2001). (Andreesen, speaking at a conference sponsored by *The New York Times,* also said that the company should shut down the *Times* print edition "as soon as possible" to focus instead on digital products).

THE GOOGLE EFFECT

As if to confirm those criticisms, many publishers hesitated to do anything that would hasten the flight of print advertising to the Internet, especially low-cost, high-revenue classified ads, because print profits are so much greater. But advertisers quickly learned that targeted advertising, easily possible on the Internet, proved much more economical than expensive, scattershot print ads. Imagine being able to talk only to consumers who had shown an interest in buying a new Volvo rather than wasting money speaking to hundreds of thousands of newspaper readers who had just bought a new car, preferred Fords anyway or, worse, couldn't possibly afford a new Volvo. (Similarly, news consumers interested in a particular subject can search thousands of sources covering just that subject—at no cost.)

Just one Internet advertising medium, Google, already pulls in twice as much revenue as "the combined print and digital ad sales of all of the 1,382 daily newspapers in the land," according to analyst Alan Mutter, who writes the Newsosaur blog (personal communication, February 15, 2013).

Newspaper vs. Google ad sales

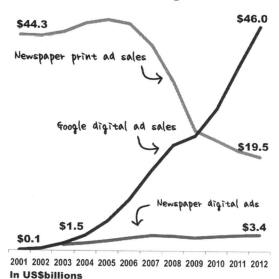

2001 2002 2003 2004 2005 2006 2007 2008 2009 2010 2011 2012
In US$billions

Source: Newspaper Association of America and Google
Fig 4.1. Mark J. Perry, Carpe Diem blog, used with permission.

Consider, too, that Google is about 15 years old; the newspaper industry is more than 180 years old. Despite that, U.S. newspaper print advertising revenue has fallen for six years (Pew Research Center, 2013) or seven years (Mutter, 2013), depending on who's counting. Print revenue fell $1.8 billion, or 8.5 percent, in 2012, even as the economy improved, the Pew Research Center's "State of the News Media" reported. Of even greater concern, digital advertising "has grown anemically the past two years" and "does not come close to covering print ad losses," the report said. Pew said that digital advertising now represents 15 percent of total newspaper ad revenue—a number that would be much smaller if print revenue hadn't been cut in half since 2005.

Pew estimated that 15 print ad dollars are lost for every digital ad dollar gained, thus the frequent comment that publishers are trading "dollars for dimes" (Reinan, 2012).

Others slice the numbers differently—with the same results. Mutter reported that ad revenue at newspapers in the first half of 2012 "fell 25 times faster than digital sales grew, demonstrating the feebleness of the industry's response to the shifting (shifted?) media landscape" (Mutter, 2013).

Mark J. Perry, a professor of economics and finance at the Flint campus of the University of Michigan, said that newspaper ad revenues fell to a 60-year low in 2011 (and yet lower in 2012): "The decline…is amazing by itself, but the sharp decline in recent years is pretty stunning. Last year's [2011] ad revenues … were less than half of the $46 billion spent just four years ago in 2007, and less than one-third of the $64 billion spent in 2000." He points out that "it took 50 years to go from about $20 billion in newspaper ad revenue in 1950 (adjusted for inflation) to $63.5 billion in 2000 and then only 11 years to go from $63.5 billion back to about $20 billion in 2011" (Perry, 2012).

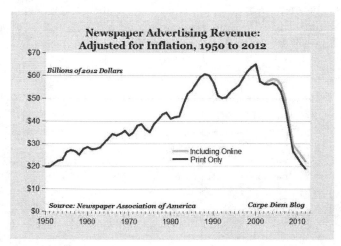

Source: Newspaper Association of America

Fig 4.2. Mark J. Perry, Carpe Diem blog, used with permission.

EVERYTHING DECLINES EXCEPT AGE OF NEWSPAPER READERS

Of course, targeted advertising isn't the only problem. Newspaper readership is dropping and the few readers who exist are getting older (Mutter, 2013). Mutter calculates that almost three-quarters of newspaper readers in 2013 were 45 years or older, up from half of the readers three years earlier. That means their prime earning years will end fairly soon and that they won't be around as long to read newspapers.

Naturally, declining advertising revenues and declining readership mean declining profits for newspaper publishers. Gross margins in 2011 were about 15 percent; net margins were only about 5 percent, half of what they were in 2000 (The State of the News Media, 2012). Stock prices of publicly held companies have risen slightly but still are a fraction of what they were. For example, the McClatchy Co., publisher of the *Sacramento Bee* and the *Miami Herald* among other titles, traded at $74.50 in 2005, before it bought Knight Ridder; it sells for about $3.10 today.

While this collapse of a 180-year-old tradition didn't happen overnight, it was well on its way before most newspaper people paid attention. Ironically, the company that first took the Internet seriously also was its first victim. As *Columbia Journalism Review* wrote in an article headlined, "The Newspaper That *Almost* Seized the Future," Knight Ridder's *San Jose Mercury News* "was among the first daily newspapers in the country with an online presence, the first daily to put its entire content on that site, the first to use the site to break news, and among the first to migrate that burgeoning online content to the web. In the early 1990s, the joke among the paper's small online staff was that, given the still modest returns on its digital investment, the paper could still make a few bucks charging admission to all the visitors from papers across the country (and around the world) who showed up to see how they were doing it" (*Columbia Journalism Review*, 2011).

Author Michael Shapiro, a professor at the Columbia Graduate School of Journalism, concluded that the *Mercury News* attempt to see the future was flawed. (Full disclosure: I spent almost all of my career at Knight Ridder, most of it at the *Mercury News*.) What he wrote could apply to the rest of the newspaper industry:

> Disruptive technology is only half the story of what happened to newspapers. There is also the response. The disruption opened the path to change, and not just for small companies unburdened by legacies of success. The change could also come for those older newspaper companies willing to accept that what was happening was not so much an existential crisis in journalism as it was a catastrophic assault on the most prosaic aspect of the newspaper business: the classifieds. Tough to do in any circumstances. Even tougher at a time when things feel as if they are going better than ever (Shapiro, 2011).

In fact, classified advertising was one of the first important revenue categories to suffer in print, largely because software engineer Craig Newmark decided to expand his website about events in the San Francisco Bay Area to help-wanted and other classified listings. (It started in 1995 as an e-mail distribution list and moved to the Web in 1996.) Until 2004, there was no charge for any listing.

Craigslist now charges $75 per job ad in the biggest cities and $10 per ad for broker-placed apartment listings in New York. Other listings are free. Craigslist is privately held—by Newmark and a few others, including eBay in an uncomfortable partnership. So revenues are not public. But they have been estimated to be as high as $126 million a year, with profits up to $103 million annually because of very low expenses (Zollman, 2012). "And it's the 20th U.S. website by traffic, making it larger than sites that have raised hundreds of millions of dollars and employ hundreds or thousands of people, like Twitter, ESPN.com, Yelp and even NBC Universal" (Tweney, 2012).

SO WHEN DID THE WORLD TURN UPSIDE DOWN?

In 2004 or 2005, all of those figures told P. Anthony Ridder, chairman and CEO of Knight Ridder, then the country's second-largest newspaper publisher, that the world had changed. "It was clear in 2004, 2005 that the print revenue had never rebounded. Our print revenue was actually declining ... Our total revenue was growing but the only way ... was that our Internet revenue was compensating for the loss in print revenue ...," Ridder, my former boss, told me. "The problem was that ... if you get $1 in print ad revenue ... you could maybe charge 10 to 15 cents for the Internet"—literally dimes for dollars.

After shareholders unhappy with Knight Ridder's stock price threatened to put the company in play, Knight Ridder sold itself to the McClatchy Co. in 2006 for $4.5 billion, just as the newspaper economy was collapsing. According to Moody's Investors Service Credit Rating Report (2013), the debt that McClatchy incurred has hobbled that company ever since (p. 3).

Ridder believes that newspapers should have "moved faster to build up revenue" by packaging print with the Internet in some sort of paywall arrangement. But "newspapers have cut, cut, cut, so the content isn't nearly as valuable, so now it's harder to charge for the content" (P. Anthony Ridder, personal communication, May 29, 2013).

Richard Manship, whose Manship Media sold the Baton Rouge *Advocate* in 2013, saw the world change earlier, maybe in 1993. "Newspapers were making tons of money," but newspaper people would "look at you like you're an idiot" when you suggested the threat of change. "There was no flexibility in the newspaper

business," Manship said. "The newspaper people didn't think they had competition." Manship, who directly ran WBRZ-TV in Baton Rouge and supervised *The Advocate*, said that after the shock of Sept. 11, 2001, "the TV people knew where the switch was to get it working again. The newspaper people spent two to three years looking for the switch" (Richard Manship, personal communication, June 4, 2013).

Robert D. Ingle, who founded Mercury Center and later Knight Ridder New Media, said he decided in about 1991 that the world had changed. "All during that period, revenues weren't doing that bad, but the problem is they were doing it totally on rates. We were jacking the hell out of rates. I said to myself, at least, this can't go on forever because there's too much competition … In the early going, a lot of people didn't see the Internet as a big threat to newspapers, but I thought it would be at some point." Ingle would have gone easier on rates for advertising and circulation: "You can't jack up rates ad infinitum and think that people are going to sit still for it" (Robert D. Ingle, personal communication, May 30, 2013).

"The model of CPM did not work in an online world," agreed Donald F. Cass Jr., a long-time Belo newspaper, television and cable executive who now works with pagers and customer-surveying tools as president and CEO of Long Range Systems of Addison, TX. The measure he cites, CPM, is a long-time newspaper and magazine evaluation of cost per thousand impressions. It is a measure that Google and other online advertising services would say is irrelevant because many print impressions go to those Ford drivers who aren't in the market or can't afford the Volvos being advertised.

Cass saw the change around 2004. "We saw CPMs level out. At the moment, you were in a dimes-for-dollars approach … It was undeniable" (Donald F. Cass Jr., personal communication, June 4, 2013).

Doctor, a former Knight Ridder editor and now a media analyst for his Newsonomics organization, said that he saw the revolution as "an ongoing epiphany." If pushed, he'll say that the 1995–1996 period was when he realized that the world had changed for print journalism. Knight Ridder was developing an entertainment product called "Just Go," which Doctor saw as "a metaphor for the flexibility of the digital world as opposed to the sixteenth century." Doctor said the ability to "sort, tailor, customize" entertainment information eliminated the restrictions of a weekly entertainment section (personal communication, July 5, 2013).

Of course, these were not the first ideas to overcome the limitations of newspapers printed hours before delivery. In the 1930s and 1940s, futurists envisioned the newspaper being printed at home over a radio frequency. In 1967, Walter Cronkite demonstrated a Philco-Ford newspaper printer with content sent by satellite. In 1988, the *Los Angeles Times* Magazine looked ahead to "the family's

personalized home newspaper, featuring articles on the subjects that interest them … being printed by laser-jet printer off the home computer—all while the family sleeps." In 1962, the *Jetsons'* third episode pictured George reading the paper on a "Televiewer," which wasn't very well defined. I liked another idea, that newspapers could be delivered by giant pneumatic tubes hooked to every home. (Newsroom veterans remember that hard copy used to be sent to the composing room that way. But, as far as I know, pneumatic tubes never extended to homes.) And in 1900 the editor of the *London Daily Mail* predicted the advent of national newspapers (Paleofuture, 2013).

With such revolutionary ideas developed over a century, with horrible financials for newspapers, and with declining readership nationwide, you wouldn't have expected a cataclysmic reaction when Advance Publications, privately held and controlled by the Newhouse family, confirmed huge changes at *The Times-Picayune*. Actually, it was David Carr of *The New York Times*—not *The Times-Picayune* itself—who reported on May 23, 2012, that the New Orleans newspaper was "about to enact large staff cuts and may cut back its daily print publishing schedule, according to two employees with knowledge of the plans" (Carr, 2012). For a short time—until Advance announced changes in other cities—it would become the largest American city without a seven-day-a-week newspaper, a source of civic embarrassment.

With that, *The Times-Picayune* lost control of the story and hadn't regained it more than a year later. Steve Newhouse, the chairman of Advance.net and the leader of Advance's newspapers, told me, "We handled our communication really badly. That was one contributing factor" why "the constituency reacted as vocally and angrily"(Steve Newhouse, personal communication, May 31, 2013). (I don't have particularly great sources but even I received an e-mail while sitting at a Manhattan restaurant two days before Carr's column appeared. It generally reported what was about to happen. If even I knew about the cataclysmic change in New Orleans publishing, a lot of other people also did, thus Carr's article.)

The Newhouse family had operated below the radar despite publishing large newspapers and some of the most famous magazines in the business (*The New Yorker, Vogue, Vanity Fair, W*). Partly because it is privately held and partly because the family avoids publicity, the Newhouses and Advance never had attracted the criticism of publicly held companies such as Gannett and Knight Ridder as the news revolution occurred. *The New York Times* once quoted biographer Richard Meeker as writing that Samuel I. Newhouse, who created the publishing empire, "kept his life shrouded in such secrecy that only a small fraction of the tens of millions of readers of his publications ever realized that the newspapers and magazines were his" (Friendly, 1983).

THE *TIMES-PICAYUNE* BECOMES LESS-THAN-DAILY

All of that changed with the decision to shift the focus to digital delivery of news and print *The Times-Picayune* only on Sunday, Wednesday and Friday, three days traditionally good for advertising and circulation, beginning in October 2012. Those papers are home-delivered and also sold on newsstands for 75 cents. Later, the company announced a free weekly tabloid, *BR*, available in Baton Rouge. Finally, *The Times-Picayune* decided to publish another tabloid, to be sold only on New Orleans-area newsstands for 75 cents on Mondays, Tuesdays and Thursdays. It began June 24, 2013. Called *TP Street*, it looks almost nothing like the full-sized edition. It clearly appears designed to blunt the New Orleans edition of *The Advocate* of Baton Rouge. In addition, early print editions of the Sunday *Times-Picayune* are available on some New Orleans-area newsstands on Saturday, a throwback to the days of early "bulldog" editions. (Those editions presumably were so named because New York City publishers of the 1890s "fought like bulldogs over circulation" (Poynter.org, 2002)).

Newhouse said he "didn't go in with the illusion that the elimination of four days of full-size, home-delivered newspapers would be greeted with joy." He accurately noted that "a certain group of readers … like things the way they are" and will react badly to even minor changes, such as a dropped comic strip (Newhouse, personal communication, May 31, 2013).

Sure enough.

Columbia Journalism Review attacked the company for ignoring the digital divide: "New Orleans is one of the poorest and least digitally advanced cities in America." Tom Benson, who owns the football New Orleans Saints and the basketball Pelicans, criticized the decision and offered to buy the paper; entrepreneur John Georges said that he did, too. The Newhouse family wasn't interested. Sen. David Vitter (R., La.) wrote Steve Newhouse, "From a pure business perspective, you're about to get smoked. *The Advocate* and others are moving in to fill the void you are creating. And *TP* subscribers, including me, will be eager to cheer them on by trading our subscriptions" (Vitter, 2012).

In short, "Advance misjudged the marketplace—the whole city and state went ballistic when the changes were announced—and failed to execute a modern digital strategy. Now it is in full retreat with new competition," Carr wrote a year after the experiment was announced. He noted that Republican Gov. Bobby Jindal and New Orleans Mayor Mitch Landrieu, a Democrat, both accompanied John Georges to the news conference on May 1 when Georges announced that he was buying the Baton Rouge *Advocate*. Interestingly, they showed up even though Georges had run for political office against both (and lost). Carr concluded, "It was an indication that the home team had chosen sides and the once-beloved *Times-Picayune* was on the wrong side of the field" (Carr, 2013).

I found the "beloved" part interesting. At a time when fewer and fewer people read newspapers and more and more question their credibility, the public outrage was reassuring in a strange way. Of course, *The Times-Picayune* staff had won a Pulitzer for public service for its coverage of Hurricane Katrina in 2005, and four reporters also won a Pulitzer. Much of the prize-winning coverage was online because the newspaper couldn't publish and distribute for three days.

Although *The Times-Picayune's* circulation has dropped by around half since Katrina—partly because of the population decline in New Orleans—its market penetration is quite good. ("Penetration" refers to the percentage of residents who read the paper.) At 65 percent, it had the fourth-best penetration in the country in 2011 (Myers, 2012). Sunday digital and print circulation figures of *The Times-Picayune* in March 2013 were up 13 percent over the same time a year earlier, to 175,097—but Sunday print only circulation is down 9 percent. The increase is due to digital "circulation," possibly proving that the cutback in print frequency will work. (Although, it is not clear what digital circulation means. It's impossible to compare daily circulation before the cutback because the printed newspaper no longer is a daily (Beaujon, 2013)). Interestingly, the circulation of the daily Baton Rouge *Advocate* went up in the same period: to 87,831 daily, up 12.8 percent over the prior year, and to 105,537 Sunday, up 3.1 percent (Peter Kovacs, personal communication, July 3, 2013.)

New Orleans readers weren't the only ones to complain. Journalists other than Carr roared with outrage, too: How could a daily newspaper not be published daily? However, at the risk of betraying the profession that fed me for 36 years, I thought that the reduction in frequency was an interesting experiment after almost everything else had failed for the newspaper industry. Those in the industry have known for years that the Monday and possibly Tuesday papers are loss leaders; if you fairly allocated costs and revenues, no paper in the country would report a profit for Monday and Tuesday. I said this when "Marketplace," the public radio show, interviewed me after the Baton Rouge *Advocate* announced a New Orleans edition. As I recall, my explanation ran as the top of the broadcast and led to other interviews—apparently because many people thought that newspapers were profitable seven days a week. No, they are not, any more than many retailers are profitable every month. In addition, I get most of my news online, too. I believed Steve Newhouse when he said, "left unsaid is that we would not be able to produce a seven-day-a-week newspaper" given revenue projections (Beaujon, 2012). Not many people, including Newhouse's peers, agree, though.

Ridder told me, "I do not understand Newhouse, which has no pressure from shareholders ... In my wildest dreams, I never would have thought of that ... If we were still in business, I would not be pushing to eliminate home delivery four

days a week. I'd be making people pay more for content" (Ridder, personal communication, May 29, 2013).

At the American Society of Newspaper Editors meeting in June 2013, current CEOs sang the same tune: "McClatchy's CEO Patrick Talamantes, *New York Times* Co. CEO Mark Thompson and *Washington Post* Publisher Katharine Weymouth all said they were sticking with daily publication. Gannett CEO and President Gracia Martore "was less certain … 'I can't predict what is going to exist in five years,' she said" (Beaujon, 2013).

Two industry analysts also had significant concerns about the Newhouse plan but focused on the digital part of the strategy. "What they have not done is they have not stepped back and done a deep dive and thought about what they really should be doing," said Mutter. "All they really did was they got rid of a lot of high-priced print guys … They found young people who would be willing to tweet on the way to the bathroom. But what they are still pursuing (is) … this monolithic, newspapercentric, one-size-fits-all publishing model. And if they think by getting out sooner that there is a mattress fire on such-and-such a street that they are now hip … that's not what people are looking for … In the modern world a consumer has a power of choice … especially with half of page views being consumed on mobile devices … It's just very easy to look at something else" (Mutter, personal communication, February 15, 2013).

Mutter said that editors and publishers "keep fussing with the front page of their website and they can't understand why so much of the traffic goes someplace else on their website instead. It's because people don't consume anything in a linear way … More than half the page views on a newspaper website come in through … Google … through Facebook or Twitter … What I'm seeing today (on *NOLA. com*) is a rendition of what I would call a 1958-style website. Nothing about it takes on board any of the ways consumers actually interact … That's why they call it interactive technology. Not 'I write, you listen' … They are putting up newspapery content in newspaper websites for newspaper readers" (Mutter, personal communication, February 15, 2013).

Doctor, of Newsonomics, made strikingly similar comments without having heard Mutter's. "There is some really good thinking" in the Newhouse formula, Doctor said. "It's very partial thinking is the problem … They don't have a very good digital strategy." Doctor credited Newhouse with throwing "a hand grenade" into the newspaper economic model but said there was a better way: "They could have spent months training, getting the best mobile apps," making aggregation deals and showing off the product to readers before they shut down print. "It's just ridiculous," he said. "They have made their chances of succeeding much less" by putting the strategy "into effect so poorly" (Doctor, personal communication, July 5, 2013).

THE *TIMES-PICAYUNE'S* SIDE

On the other hand, *Times-Picayune* Publisher Ricky Mathews and Editor Jim Amoss see their site, *NOLA.com*, as a leader. Mathews shows off new Silicon Valley-type offices on the top two floors of swanky Canal Place in downtown New Orleans. White boards seem to outnumber reporters' notebooks; Mathews and Amoss talk about the ability for journalists and advertising employees to collaborate while looking out at spectacular 31st-floor and 32nd-floor views at the crescent of the Mississippi River (Ricky Mathews & Jim Amoss, personal communication, April 25, 2013).

A few years ago, most editors and publishers would chat about their print product. In our interview, Amoss and Mathews talked almost entirely about digital publication—and that clearly is what they want talked about in their newsroom. Mathews elaborated: "The way that we've described our mission is to create a digitally focused news organization bringing the quality journalism of *The Times-Picayune* and up-to-the-minute information—*NOLA.com*—together, ensuring Greater New Orleans has 24/7 access to what's happening in our community and beyond ... People will say we've moved to three days of distribution; what we actually like to say is that we're now a 24-hour operation."

Like Newhouse, Mathews agreed that *The Times-Picayune* was profitable before the cutback in frequency—but "if we did not transform ourselves now, we would have to, we would have jeopardized our future." New Orleans roughly was following the model of Newhouse's 174-year-old *Ann Arbor News*, which in 2009 emphasized its website and moved to two-day-a-week print publication. At about the same time as New Orleans, the Newhouse papers in Mobile, Huntsville and Birmingham, Ala., shifted to the same printing schedule as *The Times-Picayune*. After New Orleans and the Alabama papers, Newhouse properties in Harrisburg, Syracuse, Cleveland and Portland either shifted to similar publication schedules or announced the switch. In each city, newsroom employees and others were cut; some reports said that *The Times-Picayune* laid off "nearly half" its newsroom employees, but Amoss and Mathews insisted that many, possibly with new skills, will be replaced. A few newspapers not owned by Newhouse have made similar moves. While most are in smaller cities, the *Detroit Free Press* home-delivers newspapers only Thursday, Friday and Sunday; its partner in a joint operating agreement, the *Detroit News*, delivers only Thursday and Friday. A small newsstand edition is available other days.

Amoss argued that his staff—much of it new—understands the transformation. "They're thinking about, 'What are the best photos I can possibly shoot for this event that I'm covering or for this story that's breaking?' They're thinking about, 'What is the best way to engage readers who are coming to the website.'... At the same time, this print team, which has considerable talent and

considerable news judgment brought to the process, is thinking about how this is going to be presented as a printed publication" (Amoss, personal communication, April 25, 2013).

THE BATTLE FOR LOUISIANA

Speaking of print publications, perhaps the biggest surprise in the news war in Louisiana is the Baton Rouge *Advocate*'s energetic push into New Orleans, launched the same week that *The Times-Picayune* cut back frequency. *The Advocate* said that it gained almost 20,000 circulation instantly. Richard Manship said the number was about 15,000 by the time the paper was sold; new owner Georges said *The Advocate* is gaining about 500 subscribers a week since his purchase.

Manship said his family decided to go into New Orleans, about 80 miles southeast of Baton Rouge, "to increase circulation ... to shore up what you had." Manship said the risk was fairly low: "$1 million would have been the most we would have lost" if the plan failed (Manship, personal communication, June 4, 2013). Manship kept costs relatively low by stationing a skeleton newsroom staff—about six—in New Orleans and redoing a limited number of pages for the New Orleans edition. Tearing Baton Rouge stories out of one edition and replacing them with New Orleans articles is a time-consuming, expensive operation. A Baton Rouge story may well need to find a less prominent home in the New Orleans edition; the emphasis that the New Orleans story deserves may not be exactly the same as the emphasis that the Baton Rouge story deserved; both are likely to need new headlines to fit in different spots and may need editing to fit the space in the second edition. For sure, Manship had to add a second press run for New Orleans. If the New Orleans edition ever draws significant advertising, those logistical challenges mount because ads in the two editions are likely to be of different sizes and will get different prominence, depending on the advertiser.

When the Manships sold *The Advocate* to entrepreneur Georges (who owns the fabled Galatoire's restaurant in New Orleans—and Baton Rouge) and his wife, those economies went out the window. He hired two former *Times-Picayune* managing editors, Peter Kovacs and Dan Shea, as editor and general manager, respectively. Consider that: Two top editors who were passed over at *The Times-Picayune*—and actually ignored in the restructuring process—are in charge of defeating *The Times-Picayune*.

They in turn have hired about 10 former *Times-Picayune* employees, ballyhooing each hire in *The Advocate*. So the payroll increased to 130 full-time-equivalent employees before a July announcement of buyouts for 19 employees in all departments; specific newsroom numbers weren't announced. Each paper almost never had hired from the other in decades, a situation unusual for newspapers in the

same state. (No one appears to have defected from *The Advocate* to *The Times-Picayune* since the news war began, though Kovacs and others caution that that is sure to happen.) Those costly remakes of pages happen regularly now, requiring big swaths of newsprint real estate to be redone. *The Advocate* also convinced a number of funeral homes in New Orleans to place paid obituaries in the paper; "obits" build readership in addition to generating revenue. The Baton Rouge and New Orleans editions look quite different.

Georges, Kovacs, and Shea clearly are on the way to producing two significantly different newspapers (and probably websites, though the emphasis at *The Advocate* seems to be on print). In fact, *The Advocate* announced in August that the name of the New Orleans edition will be changed to the New Orleans *Advocate* (*The Advocate*, p. 1, Aug. 18, 2013). "We will be two newspapers," Georges told the Baton Rouge Press Club. He told me in an earlier interview, "At the end of the day, we're on a collision course" with *The Times-Picayune* (John Georges, personal communication, June 11, 2013).

By the end of August, Georges was talking even bigger. In 2014, he said, the paper will increase its coverage of Acadiana (the region in South Louisiana with strong French heritage and primarily located east of Lake Charles and west of Baton Rouge). *The Advocate* reported that he promised a group in Lafayette "that one day newspaper readers in south Louisiana could have three distinct papers with *The Advocate's* banner in New Orleans, Baton Rouge and Lafayette" (Georges, 2013). *The Advocate* competes with the Gannett-owned *Daily Advertiser* in Lafayette. Georges says it has a circulation of about 20,000 and *The Advocate* has "fewer than 10,000" circulation in Acadiana.

Georges isn't worried about his increasing costs; he says with a smile that *The Times-Picayune* should thank him for hiring senior journalists away, thus saving the Newhouses money. "This thing has no financial burdens on it," he said of *The Advocate*. "This enterprise does not have to service any debt," one of the problems facing many newspaper companies. "I've got other businesses to fund this" (Georges, personal communication, June 11, 2013).

Georges also has no patience for those who point out that very few newspapers successfully have invaded neighboring cities, especially those that are 80 miles away and have very different cultures. "It's not Chicago invading Boston," he scoffed when I challenged the strategy. "It's not even Philly going to New York." Georges maintained that Baton Rouge and New Orleans "would be one metropolitan area if they were in the Northeast. This is one big area" (personal communication, June 11, 2013).

In fact, newspapers have had a tough time breaking out beyond county lines. The *Los Angeles Times* is everyone's prime example, with huge investments that failed in Orange County, San Diego County and elsewhere: "Instead of being welcomed, its high-quality presence in Orange County, San Diego, the San Fernando

Valley and beyond provoked an unanticipated reaction. Mediocre newspapers in outlying areas became markedly better just to keep up with the *Times*, yet managed to use their hometown advantage to keep the *Times Mirror* superpower at bay" (McDougal, 2002).

Kovacs points out that the *Orange County Register* hadn't reduced its publication days by more than half when the *Los Angeles Times* invaded its turf (personal communication, July 2, 2013). So, the analogy isn't perfect. But many industry experts disagree with Kovacs and Georges. (Georges wouldn't be surprised. He is tough on people who have been involved in the news industry. "Entrepreneurs like myself are well-suited to buy newspapers," he told the Press Club. "When you've been running a monopoly, it's hard to compete with an entrepreneur like me.")

Ridder, who has had multiple experiences trying to invade other cities, calls the New Orleans initiative "a waste of money. It's money that will come out of their ability to strengthen Baton Rouge. I think it's a crazy idea." Interestingly, Ridder's experience with expansion parallels Georges'. In 2000, Ridder's *San Jose Mercury News* tried to expand into San Francisco, where it long had had token circulation and virtually no advertising. Like Baton Rouge, San Jose enjoyed economic prosperity but San Francisco, like New Orleans, was the sexier, tourist-oriented city. The flavors of the two cities were very different, as were the flavors of the *Mercury News* and the *San Francisco Chronicle*. A year later, the *Mercury News* gave up on San Francisco in the midst of the Internet bust. Knight Ridder's *Miami Herald* certainly had problems for decades in neighboring Broward and Palm Beach counties, too. There are many other such stories from other newspaper companies.

Analyst Doctor wondered where the advertisers for the New Orleans edition will come from. "The ability to pull away *Times-Picayune* advertisers is just incredibly hard to do," he said. "You can be an insurgent. You can pick up more audience. (But) the power to get big advertisers is very, very hard to do." As a former journalist, Doctor said, "It's a great newspaper war … for readers. It's just not going to move that needle. *The Times-Picayune* is still *the* paper of New Orleans." Doctor also wondered about the New Orleans market: "They're fighting over an amount of money that is in constant reduction … It's not a smart business move" (personal communication, July 5, 2013).

In addition to fighting in print—and in off-the-record comments during interviews—the participants in the Louisiana news war obviously are fighting on the Web. However, for news organizations that claim to care so much about the Internet, neither set of electronic products seems sophisticated, at least to a reader such as me. Both sets of products are basic, with little day-to-day variety; unlike print front pages with big headline type or arm-waving TV reporters, these sites almost never demonstrate excitement about a big story (though *The Times-Picayune* site is organized better than its much-criticized earlier version, which was maintained by a separate Advance organization).

To be fair, both organizations spend lots of time on electronic products. Both maintain "traditional" websites, mobile versions that are fed by those websites and iPad and Android apps. Both publish an electronic edition, a clickable replica of the printed newspaper. Both maintain Baton Rouge and New Orleans "editions" of their electronic services.

But oddities stand out. For example:

- Until months after the paper was sold, *Advocate* stories contained no links even though they are the building block of the Internet. My guess is that print-newsroom editors dumped stories directly onto the Internet—and print stories obviously didn't contain links. But others, including *The Times-Picayune*, earlier found ways to insert links.
- Other than occasional collaborations, neither site has alliances with a big variety of bloggers and others who could help fill holes in their own coverage. In contrast, *The Seattle Times* began collaboration with four sites that would have been considered competitors in an earlier time; the number now is 60.
- Other organizations have found new ways to think big. For example, Jill Abramson, then-executive editor of *The New York Times*, announced in July 2013 plans for "an immersive digital magazine experience, a lean back read that will include new, multimedia narratives in the tradition of Snow Fall and last weekend's compelling account of the Arizona fire, as well as some of the best reads published during the previous week" (Dylan Byers, Politico, 2013). ("Snow Fall" was an interactive, multimedia long-form piece of journalism that won a Pulitzer Prize.) The sorts of words she used aren't mentioned in New Orleans or Baton Rouge.
- More important, neither organization's iPad app has much to offer a frequent user (such as I am). This is curious because mobile devices such as Apple's iPad are where the growth of news organizations will occur. The Donald W. Reynolds Journalism Institute reported that its survey in the first quarter of 2013 found that respondents said they had used at least one wired mobile device in the past seven days, a 13 percent increase over the prior year.

"The number of respondents who said they used mobile media to keep up with the news … grew significantly in all age groups. More than half (55 percent) overall in 2013 were mobile news consumers compared to 42 percent of respondents overall in 2012." The most stunning conclusion: "In every age group except for those 65 and older, the percentage … who used mobile media devices to keep up with the news exceeded the percentages of those who used desktop computers for news" (Reynolds, 2013). A 2012 study by Frank N. Magid for the Newspaper Association of America found that news consumers love reading newspapers on tablets.

Despite all of that, the iPad seems an afterthought at *The Advocate* and *Times-Picayune*. At both organizations, the prominence of stories on the iPad seems determined by some automated switching mechanism that tries to make the site less static rather than by news values. This results in strange situations when, say, an opinion column briefly gets the greatest display, but the headline reads as if it's an objective news story. (For no apparent reason, the Associated Press' daily list of celebrity birthdays often gets very strong play on *The Times-Picayune* iPad pages; a list of adoptable pets often gets big display on *The Advocate's* iPad pages.)

Peter Kovacs, editor of *The Advocate*, likely identified the problem when he guessed that technicians often focus on one product, such as the main website, to the detriment of other applications that are being fed from that site.

Reporters for both organizations do tweet prodigiously, which could lead to more interactivity for both groups. *The Times-Picayune* also produces a lot of video, and more may be in the future for both organizations. Both announced—on the same day in June 2013—TV alliances. *The Advocate* is aligning itself with WWL-TV in New Orleans and historically has been close to WBRZ-TV in Baton Rouge because of the Manship ownership of both. But *The Times-Picayune* clearly is ahead in the video market with the "Black and Gold Report" on the Saints and other video of sharply varying quality. Of course, the sports market isn't theirs alone. The New Orleans Saints and Pelicans don't really care what the papers are doing; they are creating an entire team devoted to digital to produce content for both teams. My guess is that their single-minded focus will result in a more compelling Web presence than either paper has.

Across the nation, scholars and others wonder about entirely new economic models for news, such as government-supported news operations (a worry to many of us) or nonprofit models largely supported by foundations and readers, such as *ProPublica*. Most of the small number of nonprofits focuses on investigative reporting, which is costly and seems to have disappeared from some newspapers. Most also stress collaborations with other news organizations. In Louisiana and the rest of the Gulf region, the New Orleans-based *The Lens*, a nonprofit, investigative, online news organization has alliances with both *The Advocate* and *The Times-Picayune* as well as other news organizations. But the Louisiana war largely appears to be fought on the underlying national and perhaps global question: What's best, print or online?

The Times-Picayune seems determined to replace declining newspaper circulation and advertising, printed on costly newsprint and delivered by costly trucks and drivers, with lower-cost Internet news and advertising that is more timely and appears to be much more appealing to today's readers and advertisers (Doctor, personal communication, July 5, 2013). Doctor estimates that *The Times-Picayune's* newsroom cost-cutting and reduction in frequency will save at least 25 percent. *Columbia Journalism Review* says Newhouse "mainly … has stuck by what was

conventional Web wisdom from before the recession—chasing clicks … In this system, a distracted click on a story that says, in its entirety, 'Hornets officially announce their nickname will be changing from Hornets to Pelicans,' is worth as much as one on, say, a prison exposé. More, actually, since the former comes with less time and effort" (Chittum, 2013). But *The Times-Picayune* also seems determined to counter every move that *The Advocate* makes in print, even if that wasn't part of the original Newhouse plan.

On the other hand, *The Advocate* seems focused far more on traditional newspapers, apparently thinking that expansion to New Orleans to the southeast and Lafayette to the southwest will counter the national trend of declining circulation and possibly declining advertising. Seemingly unworried about profits—an almost unprecedented situation—*The Advocate* is spending relatively freely on payroll and on the other huge costs of expanding to a new city—a strategy that has been very difficult to execute elsewhere. One critical question is whether readers in that very different city, New Orleans, will accept a paper with Baton Rouge genes. But the even more important question is this: What circulation is necessary to lure major advertisers (the few there are) from *The Times-Picayune?*

New Orleans and Baton Rouge residents don't know or care when the news revolution began. But they will decide who wins the battle in Louisiana, the latest skirmish in the revolution.

REFERENCES

Beaujon, A. (2012, Aug. 3). There's every reason to be upset and angry, but … *Poynter.org.* Retrieved from http://www.poynter.org/latest-news/mediawire/183922/newhouse-theres-every-reason-to-be-upset-and-angry-but/

Beaujon, A. (2013, April 30). New York Times passes USA Today in daily circulation. *Poynter.org.* Retrieved from http://www.poynter.org/latest-news/mediawire/211994/new-york-times-passes-usa-today-in-daily-circulation/

Beaujon, A. (2013, June 25). Media CEOs 'hopeful' about digital subscription growth. *Poynter.org.* Retrieved from http://www.poynter.org/latest-news/mediawire/216844/gannett-ceo-cant-predict-what-will-happen-with-print-editions/

Byers, D. (2013, July 12). NYT's Sam Sifton out as national editor, will head new digital projects. *Politico.com.* Retrieved from http://www.politico.com/blogs/media/2013/07/nyts-sam-sifton-to-head-new-digital-magazine-food-168173.html

Carr, D. (2012, May 23). New Orleans paper said to face deep cuts and may cut back publication. *The New York Times.* Retrieved from http://mediadecoder.blogs.nytimes.com/2012/05/23/new-orleans-paper-said-to-face-deep-cuts-and-may-cut-back-on-publication/?_r=0

Carr. D. (2013, May 12). Newspaper monopoly that lost its grip. *The New York Times.* Retrieved from http://www.nytimes.com/2013/05/13/business/media/in-new-orleans-times-picayunes-monopoly-crumbles.html?pagewanted=all

Chittum, R. (2013, March 1). The battle of New Orleans. *Columbia Journalism Review*. *Retrieved from* *http://www.cjr.org/feature/the_battle_of_new_orleans.php?page=all*

Credit Rating Report on The McClatchy Company. (2013, July 17). *Moody's Investors Service.*

Doctor, Ken (2010) *Twelve new trends that will shape the news you get.* New York: St. Martin's Press.

Fidler, R. (2013, April 25). *2013 Q1 Research Report 1: News consumption on mobile media surpassing desktop computers and newspapers.* Donald W. Reynolds Journalism Institute, School of Journalism, University of Missouri.

Friendly, J. (1983, Nov. 12). Newhouse's private empire. *The New York Times*. Retrieved from http://www.nytimes.com/1983/10/12/business/newhouse-s-private-empire.html

Gunn, B. (2013, Sept. 1) Georges: *The Advocate*'s expansion plans include Acadiana in 2014. *The Advocate.* Retrieved from http://theadvocate.com/home/6895539–125/georges-the-advocates-expansion-plans

Henderson, R. (1998). *Encyclopedia of Word and Phrase Origins.* Facts on File Inc.

McBride, S. (2012) Marc Andreesen denies internet bubble, advises *New York Times* to stop printing. *The Huffington Post.* Retrieved from http://www.huffingtonpost.com/2012/12/12/marc-andreessen-internet-bubble_n_2286840.html

Mcdougal, D. (2002). Privileged son: Otis Chandler and the rise and fall of the L.A. Times dynasty. Da Capo Press.

Mutter, A. (2013, April 8). Newspaper ad sales skid for seventh straight year. Retrieved from http://newsosaur.blogspot.com/2013/04/newspaper-sales-skid-for-seventh.html.

Myers, S. (2012, May 25). Will Orleanians follow *The Times-Picayune* online after it cuts back on print. *Poynter.org.* Retrieved from http://www.poynter.org/latest-news/top-stories/175122/will-new-orleanians-follow-the-times-picayune-online-after-it-cuts-back-on-print/

Newspaper Association of America. (2012). *2012 Newspaper multiplatform usage study.* Retrieved from http://www.naa.org/docs/NewspaperMedia/data/NAA-Multiplatform-Usage-Study.pdf

Paleofuture (2013, March 18). The newspaper of tomorrow: 11 predictions from yesteryear. Retrieved from http://blogs.smithsonianmag.com/paleofuture/2013/03/the-newspaper-of-tomorrow-11-predictions-from-yesteryear/

Perry, M. (2012, Feb. 26). Carpe diem. Retrieved from http://mjperry.blogspot.com/2012_02_26_archive.html

Reinan, J. (2012, March 26). Newspapers are swapping dollars for dimes. *MinnPost.* Retrieved from http://www.minnpost.com/business/2012/03/newspapers-are-swapping-dollars-dimes

Shapiro, M. (2011, Nov. 10) The newspaper that *almost* seized the future. *Columbia Journalism Review.* Retrieved from http://www.cjr.org/feature/the_newspaper_that_almost_seized_the_future.php?page=all

The State of the News Media 2012. Pew Research Center's Project for Excellence in Journalism. Retrieved from http://www.pewresearch.org/2012/03/19/state-of-the-news-media-2012/

The State of the News Media 2013. Pew Research Center's Project for Excellence in Journalism. Retrieved from http://stateofthemedia.org/

Tweney, D. (2012, Aug. 2). Stop complaining about Craigslist, you whiners. *Venturebeat.com.* Retrieved from http://venturebeat.com/2012/08/02/stop-complaining-about-craigslist-you-whiners/

Vitter, D. (2012. July 26). David Vitter letter to Steve Newhouse. Retrieved from www.vitter.senate.gov/newsroom

Zollman, P. (2012, Nov. 7). Craigslist 2012 revenues increase 9.7%; "Big Four" battle for global classified lead. *Aimgroup.com.* Retrieved from http://aimgroup.com/2012/11/07/craigslist-2012-revenues-increase-9–7-big-four-battle-for global-classified-lead/

Economic Models AND Business Strategies FOR THE Digital Media Environment

AMY REYNOLDS

What happens when printed newspapers die?

David Duitch is a veteran in the television news business. In 2012, he left KDAF in Dallas to become the editor of *Dallasnews.com*, the website for *The Dallas Morning News*. "I was never party to a conversation in the TV world where we discussed, well, what happens when there's no more TV? What happens if our industry dies? I've been in several conversations on the newspaper side," he says, "where—what happens if the newspaper goes away? What happens if our industry goes away?" (Duitch, personal communication, July 19, 2013).

If you Google the phrase "death of newspapers," the top result is Newspaper Death Watch, a blog that lists the U.S. metropolitan dailies that have closed since the site launched in 2007. The blog also posts opinions and articles about the news business and the future of journalism. The site says it is "chronicling the decline of newspapers and the rebirth of journalism." The site creator notes, "Sadly, the economic foundation of [the legacy] media scions is badly broken" (Gillin, 2013).

For the past decade, news organizations have taken a variety of approaches to replace the revenue they've lost from declining print advertising (discussed in detail in chapter four). This chapter will explore the emerging business strategies and economic models that newspaper owners are employing to avoid landing on the "Newspaper Death Watch" list. Using qualitative meta-analysis (Sandelowski, Docherty & Emden, 1997; Sandelowski, 2004) of Pew Research Center's Project for Excellence in Journalism reports, Ken Doctor's Newsonomics blog on the

Nieman Journalism Lab website, and International Symposium on Online Journalism (ISOJ) conference transcripts (all between 2010 and 2013) as well as in-depth interviews and visits to three news organizations with different business models (2013), this chapter will identify emerging strategy patterns and trends that could offset the continuing decline in print advertising revenue and offer avenues for new profits.

In 1897 Mark Twain responded to an erroneous report in the *New York Herald* that suggested he was "grievously ill." This chapter will show that Twain's famous response to that false information is apropos to the most dire predictions of the fate of the newspaper industry: "The reports of my death are greatly exaggerated" (Campbell, 2006; he notes that the actual Twain quote was "the report of my death was an exaggeration").

NEWS AS A COMMODITY

To understand the current state of the newspaper industry it is helpful to know how the news became a commodity in the United States. Through the 1830s, U.S. newspapers were primarily tied to political parties. The "party papers were dependent on political leaders, not only for their initial capital and their point of view, but for maintenance through the paid publication of legal notices when the party they backed held power" (Schudson, 1978, p. 15). Commercial papers existed at the time, too. They were expensive (six cents per issue when the average daily wage was 85 cents), and a person could not buy a paper without a subscription (generally eight to ten dollars per year). This was also the case with the party papers. Newspaper circulation was low for both because readership was "confined to the mercantile and political elites," and newspaper content "was limited to commerce and politics" (Schudson, 1978, p. 15).

In 1833, the penny press emerged. The penny papers got their name because they cost only a penny and a person did not have to subscribe. One could buy a paper from a newsboy on the street. The penny papers claimed political independence. Historians consider the penny press a commercial revolution in American journalism because they sought large circulation and advertising and they let go of a reliance on political party subsidies and subscription fees (Mott, 1966; Tebbel, 1969; Schudson, 1978; Reynolds, 2005).

The penny press also "invented the modern concept of news," (Schudson, 1978, p. 22) and for the first time American newspapers regularly reported more domestic than foreign news, more local politics than national, began to cover crime, write human-interest stories, and cover social issues. The penny papers conceptualized news as a marketable product that was important to a person's daily life (Mott, 1966).

Schudson suggests that the changes in journalism at that time were in sync with economic, political, and social changes, what he calls the emergence of the "democratic market society" (p. 30). The penny press extended the market in two ways—it made advertising available to more people and by doing so enlarged the market for manufactured goods; and, it transformed the newspaper from something borrowed or read at a library (for people who could not afford a subscription) to a product that a person bought for home consumption.

Advances in technology—notably the development of high-speed presses, telegraphic communications and the expansion of the railroads for delivery—all contributed to the growth of cheap, mass-circulated, independent newspapers. Economist James T. Hamilton (2004) writes that these technological advances led the news business even farther away from the partisan press model. "To reach more readers, and therefore spread the high fixed costs (of printing) across many consumers, newspapers stopped talking about politics in an explicitly partisan manner," Hamilton notes. "[A]dvertising became an important way for companies with nationally and locally distributed brands to raise awareness of their products. Papers with larger audiences attracted more attention from advertisers, another incentive to increase readership" (Hamilton, p. 3).

Schudson (1978) writes that the technological advances of the mid- to late-nineteenth century were mechanical changes that came about because of business and society's demands for invention, and because of the merger of business interests and journalism. He also suggests that if newspapers did not produce distinctive content, no one would have bought them, limiting their ability to attract large audiences.

Between 1890 and 1920, newspaper "publishers came to regard subscribers less as readers than as consumers to be delivered to merchandisers" (Kielbowicz, 1990, p. 458). According to historian Thomas Leonard, some journalists even saw their stories as "written bait," to encourage the public to read the newspaper and "take in ads" (Leonard, 1995, p. 164; see also, Pope, 1983). Though most publishers sought to take on more and more advertising, some resisted. E.W. Scripps, for example, would not accept national advertising campaigns in his newspapers in the early twentieth century and he told his editors not to solicit ads (Reynolds & Hicks, 2012; Leonard, 1995).

In 1912, the Newspaper Publicity Act allowed newspapers and magazines to maintain their second-class postage rate (which saved them substantial amounts of money), but only if they disclosed three pieces of financial information to the public. First, newspapers must publish, at least twice a year, the names of owners and stockholders. Second, daily newspapers must provide sworn statements that asserted accurate circulation figures. Third, newspapers must label all advertising as such to avoid confusion between news and advertisements (Reynolds & Hicks, 2012). The last two provisions show the concern that people had about the

growing influence of advertising within the press. Many historians have documented that newspapers used vastly inflated circulation numbers to attract advertisers, and that newspapers during this time engaged in "the widespread practice of disguising advertising as news stories and editorials" (Kielbowicz, 1990, p. 482).

In addition to solidifying advertising as a significant source of revenue for newspapers (advertising revenue tripled between 1915 and 1929, from $275 to $800 million), the early twentieth century also saw two other trends emerge that would impact the business of news—mergers and the growth of chain newspapers. Mergers came about because of increased operating costs; newspaper chains emerged as a way for papers to share information and for the wealthy individuals who owned them to expand their fortunes, give them political power, and publish news and information about specific social justice causes. For example, by 1920 E.W. Scripps and William Randolph Hearst each had created important newspaper chains. Scripps invested in newspapers to take on "big business," while Hearst used his papers to promote his political causes and try to influence public opinion (Reynolds & Hicks, 2012; Whyte, 2009; Demers, 1996).

THE ECONOMICS OF NEWS

From a business perspective, today's newspapers still share many characteristics of the penny press and the papers of the turn of the twentieth century. For example, advertising (and by extension circulation) remains critically important to a news organization's profitability. From a journalistic perspective, though, much has changed. Over the past 70 years, as journalism emerged as a profession and journalism schools began to train people how to write and report in responsible and "objective" ways, the editorial side of journalism did not think much about the business side. Yet, Hamilton (2004) suggests that the information that ultimately becomes news today is still dependent on a specific set of five "Ws" important to the news market: "Who cares about a particular piece of information? What are they willing to pay to find it, or what are others willing to pay to reach them? Where can media outlets or advertisers reach these people? When is it profitable to provide the information? Why is this profitable?" (p. 7).

Hamilton (2004) writes that the kind of content produced by newspapers today depends on these five market-based "Ws" and on five economic qualities of newspapers—as public goods and experience goods, with high fixed costs and low variable costs and based on product differentiation. Newspapers are more of a public good than a private good. People can consume public goods without paying for them, and one person's consumption does not limit the ability of another person to consume the good. Private goods, on the other hand, cost money and one person's consumption prevents another's. A person cannot consume a private good

without paying. While newspapers share both qualities, Hamilton argues they are closer to a public good than a private one. Newspapers are also experience goods. In order to judge the quality of news content you need to consume it (or experience it). News content is highly differentiated and can vary among dimensions, for example, length, accuracy, focus, and style of presentation (Hamilton, 2004).

Newspapers have high fixed costs, or costs that do not vary with the number of units produced after you produce the first unit. They also have variable costs, which are dependent on the number of units produced and include the cost of items such as paper, ink and delivery trucks. Hamilton argues that the kind of information that gets published in a newspaper or on a news website depends on these five qualities and "often define news as what is new." He adds, "The uncertainty surrounding the content of a story prior to its consumption, however, leads news outlets to create expectations about the way they will organize and present information" (p. 9–10). In essence, the way that different news organizations present and organize news is brand creation or product differentiation in the market. A reader knows the difference between the *New York Times* and *USA Today*, for example, based on the different ways they select, organize, and present news.

From the audience side, Downs (1957) notes that information has four functions: consumption, production, entertainment, and voting. Hamilton (2004) explains:

> An individual will search out and consume information depending on the marginal cost and benefits. The cost of acquiring information can include subscription to a newspaper, payment for cable television, or the time spent watching a television broadcast or surfing the Internet. Even information that appears free because its acquisition does not involve a monetary exchange will involve an opportunity cost; reading or viewing the information means one is forgoing the chance to pursue another activity. Since a person's attention is a scarce good, an individual must make a trade-off between making a given decision based on current knowledge or searching for more information (p. 10).

Brand differentiation becomes important because audience attention is a scarce good. This leads back to Hamilton's five "Ws" that drive decisions about what information audiences want to read or to share. Chapter eight explores how digital and print content varies, and part of that variation is driven by who determines news content if the desires of audiences, journalists, and owners differ.

One must also take into account the motive of the owner(s) of a newspaper or media company. Hamilton suggests that, "Owners vary in the degree that they seek profits, public goods, or partisan ends" (p. 24). Because most print and online news outlets are publicly traded stock companies, it is fair to assume the prime motive is profit maximization. But, when "ownership is concentrated in an individual or family, then these people may take pleasure in sacrificing some profits for the sake of the public good (as they perceive it)" (Hamilton, p. 24).

As this chapter considers emerging business strategies and new economic models for news, it is useful to consider as context Hamilton's five market-driven "Ws," the five economic qualities of newspapers, Down's four functions of information for an audience, and the motivation of owners.

DISRUPTIVE TECHNOLOGY

One final area for context is technological change. Harvard Business School professor Clayton Christensen is an expert on how changes in technology can impact business performance and strategies. In his well-known book *The Innovator's Dilemma* (2011) he describes two types of technologies that work differently. Sustaining technologies improve the performance of a company's products "along the dimensions of performance that mainstream customers in major markets have historically valued" (p. xviii). Disruptive technologies, though,

> … bring to a market a very different value proposition than had been available previously. Generally, disruptive technologies underperform established products in mainstream markets. But they have other features that a few fringe (and generally new) customers value. Products based on disruptive technologies are typically cheaper, simpler, smaller and frequently, more convenient to use (p. xviii).

The current revolution in the news industry has largely occurred because of the disruption caused by digital technology. When dealing with disruptive technology, Christensen (2011) offers several suggestions for businesses that hope to adapt. He also poses some questions that companies need to ask themselves moving forward: "Where is the market? How are today's companies marketing the product? What should our product, technology and distribution strategies be? What organizations best serve disruptive innovations?" (p. 240)

Christensen's general suggestions, which are not specific to newspapers or media companies, include the following:

- The pace of progress of technology often differs from the pace of progress that the market demands. "This means that products that do not appear to be useful to our customers today (that is, disruptive technologies) may squarely address their needs tomorrow," Christensen notes. "Recognizing this possibility, we cannot expect our customers to lead us toward innovations that they do not now need" (p. 258).
- Companies must make innovation a high priority and allocate resources (both money and people) to give new ideas a chance to succeed.
- Match the technology to the correct market. Christensen notes that if a company tries to force a disruptive technology to fit current customers it will likely fail. "Historically, the more successful approach has been to find a

new market that values the current characteristics of the disruptive technology. Disruptive technology should be framed as a marketing challenge, not a technological one" (p. 259).

- Tolerate some failure, because when dealing with disruptive technologies good information often does not exist and "the risk is very high that any particular idea about the product attributes or market applications of a disruptive technology may not prove to be viable." Christensen suggests, "Managers who (leave) room to try, fail, learn quickly and try again, can succeed at developing the understanding of customers, markets and technology needed to commercialize disruptive innovations" (p. 260).
- Don't adopt a blanket technology strategy to always be a leader or a follower.
- Finally, Christensen writes that often the barriers to entry are powerful and different than historically defined: "Perhaps the most powerful protection that small entrant firms enjoy as they build the emerging markets for disruptive technologies is that they are doing something that it simply does not make sense for the established leaders to do. Despite their endowments in technology, brand names, manufacturing prowess, management experience, distribution muscle, and just plain cash, successful companies populated by good managers have a genuinely hard time doing what does not fit their model for how to make money" (p. 260–61).

Today, many media companies are following Christensen's advice. He concludes his book by noting that

> The dilemmas posed to innovators by the conflicting demands of sustaining and disruptive technologies can be resolved. Managers must first understand what these intrinsic conflicts are. They then need to create a context in which each organization's market position, economic structure, developmental capabilities, and values are sufficiently aligned with the power of their customers that they assist, rather than impede, the very different work of sustaining and disruptive innovators (p. 261).

What follows are the emerging strategies that newspaper companies are employing to guide them into the future as they address the challenges posed by digital disruption.

META-ANALYSIS & INTERVIEWS

The patterns, strategies, and trends identified below come first from a meta-analysis of the Pew Research Center's Project for Excellence in Journalism State of the News Media and other annual reports, Ken Doctor's Newsonomics blog on the Nieman Journalism Lab website, and the annual International Symposium on Online Journalism (ISOJ) conference transcripts (all between 2010 and 2013).

Qualitative meta-analysis involves the systematic and comprehensive analysis of completed, qualitative studies in a specific area to establish patterns of results (Sandelowski, 2004). This method is typically applied to research published in academic journals, but given the nature and scope of this chapter it seemed more appropriate to explore reports produced primarily by knowledgeable and credible leaders within the journalism profession. Once business trends, strategies, and patterns were identified, they were then extrapolated through in-depth interviews with publishers and editors at three news organizations with different structures and approaches to the digital disruption.

The first news organization is the New Orleans *Times-Picayune*, a newspaper held by Advance Publication, a large, private media company that owns newspapers, magazines, television stations, websites, business journals, and cable outlets. As noted throughout the book, in 2012 *The Times-Picayune* executed a controversial move to three-day-a-week publication, which at the time, left New Orleans as the largest U.S. city without a daily print newspaper (until it added a supplemental, printed tabloid publication in 2013 to complement publication of *The Times-Picayune* on days it does not appear in print). Advance is employing this strategy at various newspapers throughout the country, although in 2013 it backed off its limited publication approach just a bit, focusing more on limiting home delivery.

The second news organization is *The Dallas Morning News*, owned by the A.H. Belo Corporation. The A.H. Belo Corporation owns four newspapers and recently began investing in several related online businesses as one strategy to offset print ad revenue losses. *The Dallas Morning News* is the largest of the four papers the corporation owns.

The third news organization is the *Texas Tribune*, a nonprofit venture that focuses on covering state politics, government and public policy issues in Texas. In 2013, the Knight Foundation awarded the *Texas Tribune* a $1.5 million grant, a third of which will go to fund two "Tribune Fellows" who will join the management team and serve as consultants and researchers. According to Evan Smith, CEO and editor of the *Texas Tribune*, the fellows will identify, chronicle and disseminate "best practices in both nonprofit and for-profit news. Kind of how the industry is evolving, everything from content to sustainability on the economics side" (Smith, personal communication, July 29, 2013).

Each news organization represents a different type of ownership model—a large, private media corporation; a smaller, publicly traded newspaper, publishing and news/information corporation; and, a nonprofit. And, as you will see below, each has overlapping and varying strategies for tackling the economic challenges created by the digital disruption.

THE NONPROFIT MODEL

The nonprofit model typically refers to the financial structure and tax status of an organization. Since 1987, the Pew Research Center has identified 172 digital nonprofit news outlets in the U.S. Some of the outlets are national, others are hyperlocal, and "their editorial focus includes everything from investigative reporting to coverage of health and the environment," a 2013 report published by the Pew Research Center's Project for Excellence in Journalism notes (Mitchell, Jurkowitz, Holcomb, Enda & Anderson, 2013). Two nonprofit news organizations have won Pulitzer Prizes. Most are independent, but some are partisan. As noted earlier, most large media corporations' primary goal is profit maximization. While many corporate, for-profit newspapers are still committed to high quality, watchdog journalism, the need to turn a profit is always in the background.

"I love my brothers and sisters in the for-profit media, and I respect them and I admire them. They have been bearing up extremely well under the circumstances," says Evan Smith, publisher of the nonprofit *Texas Tribune*. "But their mission is not our mission. Our mission is essentially, if not expressly, to build community, to raise the level of engagement and to civilize the conversation" (Smith, personal communication, July 29, 2013).

Profit and quality journalism are not mutually exclusive, and those on the for-profit side will often point to the challenges of sustaining a nonprofit business model. If the model is not sustainable, then that quality journalism and civic engagement disappears. In 2013, the nonprofit sector grew and showed "some signs of economic health," but there are meaningful long-term challenges to the financial well-being of nonprofits (Mitchell, Jurkowitz, Holcomb, Enda & Anderson, 2013). A 2013 Pew report notes that most nonprofits get started from one-time seed money from foundations, but that they often are unable to find other resources or ways to broaden their funding base. This threatens long-term survival.

In addition, most nonprofits are small, and many will argue that lessens their potential impact (Mitchell, Jurkowitz, Holcomb, Enda & Anderson, 2013). The Pew study notes that 78 percent of the nonprofits it surveyed (93 organizations) had five or fewer full-time, paid staffers, and 26 percent of those had no full-time staff. Roughly half of the surveyed outlets produced 10 or fewer pieces of original content in the two-week period that Pew studied (Mitchell, et al., 2013). "They can hire good people if they've got the resources," says Jim Moroney, CEO and publisher of *The Dallas Morning News*. "So, the nonprofit that's into doing good journalism can do just as good a job as the for-profit, they just can't do it at scale" (Moroney, personal communication, July 19, 2013).

The *Texas Tribune* is one example of a successful nonprofit that has developed a sustainable business model. The *Tribune* emerged in 2009 with 17 full-time employees and 11 reporters. In 2013, the *Tribune* had 43 full-time employees with 21

in the newsroom. Venture capitalist John Thornton; Smith, who was then editor of the highly successful *Texas Monthly* magazine; and, Ross Ramsey, then editor of the *Texas Weekly* newsletter on government and politics, founded the *Texas Tribune* after Thornton's company decided not to invest in distressed media properties because it determined it would not turn enough profit.

"John came away thinking, even if the economic model of the for-profit media business is not up to the task of quote saving serious journalism, making certain that it continues to exist in the world—economic conditions notwithstanding, even if the for-profit media economy is not up to it—there needs to be an alternative that will sustain it," Smith says. "And so he gravitated quickly away from for-profit into nonprofit, not as an opportunity from a business perspective, but just as a kind of community stewardship exercise" (Smith, personal communication, July 29, 2013).

Smith says the success of the *Texas Tribune* comes from having a clear mission that involves specific, core expertise (which is discussed in more detail below) and from a diversified funding structure. "I think we've figured out what we are and what we're not," Smith says. "At no point in these four years have we ever strayed from the mission we articulated on the very first day—before the first day. There's been no mission creep. And we've remained as we contended and promised, completely non-partisan. I think that's been crucial to our success" (Smith, personal communication, July 29, 2013).

The *Texas Tribune's* mission is to cover public policy, government and politics in Texas, with a focus on public and higher education, immigration, health care and energy, among other significant issues. The *Tribune* works to promote civic engagement and public discourse, and "Our vision is to serve the journalism community as a source of innovation and to build the next great public media brand in the United States" (TexasTribune.org, 2013).

According to Smith, the *Tribune* has seven sources of funding—major individual gifts; foundations and grants; memberships; corporate underwriting; events; the *Texas Weekly* newsletter; and, work-for-hire. Major individual gifts are $5,000 or more from individuals or family foundations; foundation and grant money is typically "quasi-restricted if not outright restricted to specific project work that we've pitched these foundations to support," Smith says (personal communication, July 29, 2013).

Memberships come from across the country, although most are individual contributions from within the state of Texas. In the week following Wendy Davis's filibuster against a controversial abortion bill (the *Tribune* carried a live stream of the filibuster they shared with other news outlets), the *Tribune* received 800 membership signups, 95 percent of which were new, from 37 different states. Smith notes that at the end of July 2013 the *Tribune* had raised $505,000 in membership compared to just shy of $400,000 at the same time the year before (Smith, personal communication, July 29, 2013).

Corporate underwriting is a significant piece of the *Tribune's* funding model. It includes support of the site through basic sponsorship of the whole site or sponsorship of content in specific areas of the site. It also includes event sponsorship (discussed later). "We're approaching this more as a for-profit mentality behind the nonprofit model," Smith says. "I don't think people fully appreciate the degree to which the corporate support of this organization made it possible for us to do the work that we do" (Smith, personal communication, July 29, 2013).

Smith says many nonprofits shy away from corporate money because they believe taking corporate money somehow tarnishes the lofty ideals that often accompany nonprofit motivations for publishing. Smith suggests this is faulty thinking. "I will never compromise the integrity of the *Tribune*, and I will never give any donor or any other supporter access to us or to our people that is out of sync with the journalistic ideals of this organization. But I'm not going to be shy about monetizing work that we're doing" (Smith, personal communication, July 29, 2013).

Because events are a strategy used by both for-profit and nonprofit and is an area in which news organizations have growing interest, it is detailed below in a separate section. Smith projects that the *Tribune* will make more than a million dollars from events in 2013, with most of that money coming from corporate underwriting/sponsorship.

The *Texas Weekly* newsletter is subscription based. Ramsey edited the *Texas Weekly* before co-founding the *Texas Tribune* with Thornton and Smith. Smith says the *Tribune* acquired the *Texas Weekly* for one-time earnings and made the money back in the first year. It produces about $150,000 per year in revenue and "all of the expenses associated with producing it are baked into the *Tribune*, so it's like an ATM machine," Smith says. Finally, "work-for-hire" refers to agreements that the *Texas Tribune* has with *The New York Times* and with KLRN public television in San Antonio. Both organizations pay the *Tribune* for content, although *The New York Times* agreement generates the majority of the revenue.

Smith projects the *Tribune* will bring in about $5 million in revenue in 2013, with about $4.4 million going to expenses. "I'm optimistic going forward about the ability of the *Tribune* to continue to do the work that we do and pay for it, and continue to pay people generously and to not operate in austerity conditions, which so many other media have had to do," Smith says. He notes that the *Tribune* is growing and that the paper can pay its workers well. He adds that the anxiety that goes with working in the for-profit news business today is not present at the *Tribune*.

"It's sort of the same mentality of people who walk into an Italian restaurant and sit with their back to the wall, worried that some guy is going to shoot them. Most people (in the news industry) are convinced that today is going to be the day," Smith says. "What is not part of that mix (at the *Tribune*) is the anxiety that people in other places feel about layoffs or big corporate entities coming in and bigfooting them" (Smith, personal communication, July 29, 2013).

Although some of the *Tribune's* strategies mirror for-profit approaches that are struggling (for example, membership as an equivalent to subscription fees or corporate sponsorship as an equivalent to advertising), they are working for the *Tribune*. And competing for-profit media are glad to see the success. "At the end of the day, more journalism, more good journalism, is better than less," says Moroney. "If I had to net it all out I'd say I'm much happier that there is a *Texas Tribune* and any other nonprofit ... that are helping to cover, particularly government, in all of its forms. I think that's good for society; I think it's good for our country. It's good for democracy" (Moroney, personal communication, July 19, 2013).

BUILD AROUND THE CORE

At the 2013 ISOJ Conference, Clark Gilbert, president and CEO of Deseret News Publishing Company, noted that one difference between print and online news is that "The Web favors things that are nearly comprehensive, that is everything about something. Newspapers, by contrast, are variety shows, something about everything. What are you going to be great at? That is what the Web has forced us to answer. And newspapers have never had to do that before because they were oligopolies with low competition and high cost structures and high profit margins," he says. "Because in the world Web, if you aren't the best at what you do, switching costs are all but a click. The price of switching is literally the cost of lifting your finger" (Gilbert, ISOJ, 2013).

The *Texas Tribune*, which is digital only, took the approach that Gilbert articulates when it decided to focus on public policy, government, and politics in Texas. "At some point," Smith says about his discussions with Thornton and how they would focus the *Tribune* before its launch, "the conversation turned away from a broad and shallow and toward a narrow and deep execution of this content" (Smith, personal communication, July 29, 2013).

"I think if you put good, robust non-partisan content that is fact as opposed to opinion-based in front of people, they will gravitate toward it. We have very robust traffic. We have very robust clicks. We have very robust comments. We are the place to go, after three and a half years, if you care about these issues," Smith says. "If you care about one issue in a deep way, if you care about the panoply of issues in a very shallow way, we have built a community" (Smith, personal communication, July 29, 2013).

Jim Amoss, editor of the New Orleans *Times-Picayune* and *NOLA.com*, still sees his news organization's brand tied directly to what makes New Orleans a distinct city. So, even though the digital product has global reach, the focus on core issues is still important. "If you're a reporter in charge of covering music in New Orleans, or you're a reporter in charge of covering city hall in New Orleans,

you have to have absolute mastery of that area and everything that's occurring in it at every moment of the day," he says, "giving context on it in a way that no other news organization can, because we have the resources to do that, and to provide enterprise versions of the stories that occur in your area of mastery" (Amoss, personal communication, April 25, 2013).

Building around your core can be specific to content, but it can also be about recognizing your platform strengths. The State of the News Media report from 2011 noted that some national cable outlets began to realize that once they moved to the Web they often lost what made them readily identifiable. As a result, CNN and MSNBC produced major redesigns of their websites that emphasized video (Edmonds, Guskin & Rosenstiel, 2011).

Moroney says some news organizations are innovating around their core printed products, and that this is an important strategy as long as a market for print remains. "I think all of us naturally have been trying to innovate in the digital space. And some, I think, have let their print product decline," he says. That has not been the approach in Dallas. "We've actually added two full pages to the metro section this year. But, to some degree it's been a bit of a triage thing. You've only got so many resources, so we're just going to let this one stay here and stabilize and we're going to try to innovate over here" (Moroney, personal communication, July 19, 2013).

NEW PRINT PRODUCTS/DIGITAL ADD-ONS

As examples of innovations around the print core, Moroney points to efforts made by *The Toronto Star* and the *San Diego Union Tribune*. In Toronto, the paper has created an expanded weekly international news section that print subscribers can add for a dollar a week. They're also selling a separate, expanded puzzles section and their own robust, printed version of a local TV Guide. According to Moroney, 4 percent of current subscribers are buying these print add-ons. "If you think about that on a weekly basis, that's a lot of money and a good margin if you're just taking wire copy and reassembling it and putting it out," he says (Moroney, personal communication, July 19, 2013).

Moroney adds that the *San Diego Union Tribune* created a weekly, printed in-depth section that they have developed separate from the newspaper and it has attracted corporate sponsorships. "It was the old advertorial, but they're actually even integrating it more, but still creating some transparency that this copy is not provided by us but by the advertiser," Moroney says. "My point is that there's been this idea that newspapers are dead and maybe we should just leave them for dead, or at best keep them on life support. When in fact there are other papers, more aggressively than us by a long shot, they're saying, wait a minute. I still have these

people who love this product and I can add more things to it" (Moroney, personal communication, July 19, 2013).

The Dallas Morning News has created a new, printed publication called *Briefing*, designed for busy working parents and other adults who don't have time each day to read the full printed newspaper. *Morning News* Editor Bob Mong says they deliver the free paper every Wednesday through Saturday and circulation is about 200,000. More than 90 percent of the *Briefing* subscribers continue to take the publication after three years. In addition, they've added a printed Spanish-language newspaper and a printed magazine called *Luxe* that focuses on interior and home design, architecture and renovation. It is receiving national attention for the quality of the publication (Mong, personal communication, July 19, 2013).

"I just think we quit thinking as much about innovating around the core, so we need to innovate around the core, develop some new products, then do some business development," Moroney says. "And I think that's a model any newspapers can do" (Moroney, personal communication, July 19, 2013).

And while *The Times-Picayune* highlights its digital strategy moving forward, in June 2013 it launched a new, daily printed publication called *TP Street*. Available for sale at grocery stores, coffee shops, and newsstands in the seven Parish New Orleans area, "Together with the home-delivered Wednesday, Friday and Sunday newspapers and the Early Sunday Edition available for sale on Saturday mornings, it marks the return of *The Times-Picayune* to daily print publication," writes Amoss about the publication (Amoss, June 22, 2013).

In addition to efforts to maximize print revenue while it is still a viable product, many newspapers are experimenting with digital add-ons as well. *The Dallas Morning News* and others are publishing "one-off" e-books, although Moroney says those products don't generate a lot of revenue. *The Toronto Star* is publishing a digital-only, weekly in-depth, 10–12,000 word story that subscribers can receive for a dollar a week (subscriptions are sold on a yearly basis). "It's not going to take the place of print decline, but it could be a profitable business," Moroney says. "It helps to encourage some long-form journalism, and there's nothing wrong with that" (Moroney, personal communication, July 19, 2013).

NATIVE ADVERTISING

New York Times media columnist David Carr calls native advertising "journalism's new peril," but many news organizations are incorporating it into their digital strategies (Carr, September 15, 2013). Native advertising looks like journalism and mirrors the storytelling qualities of the host site. In January 2013 *The Atlantic* allowed the Church of Scientology to create a sponsored post that was in line with other editorial content on its site. Even though the Scientology ad was labeled as

sponsored content, the magazine received harsh criticism for it, especially after it admitted that the reader comments on the page had been moderated by *The Atlantic's* marketing team and that they deleted comments critical of Scientology. *The Atlantic* issued an apology and said it would review its future policies on sponsored content (Stelter & Haughney, January 15, 2013).

Despite the widespread negative attention *The Atlantic* received, Carr calls native advertising "the new rage." He says, "if the content is appealing, marketers can gain attention and engagement beyond what they might get for say, oh, a banner ad" (Carr, September 15, 2013). Many news organizations believe native advertising is appealing and they are incorporating it into mobile strategies, too.

"We deliberately designed for mobile to specifically have branded content in the (news) stream, so it really is an experience you can't miss," David Skok, director of digital at Global News in Canada, told the 2013 ISOJ conference. "But, I think picking up and learning from some of *The Atlantic's* troubles over the last few months around the Church of Scientology we were very transparent about what we're doing" (Skok, ISOJ 2013).

"We created another company to actually do the work, but now we're going to take that branded content, native advertising, call it what you will, on our sites and we had the news department and the sales department sit down and talk about how to create the rules for the road," Moroney says. "The editorial news department will always have the right of veto if they say this is just something we should not take, even if it's completely transparent … We are not going to put at risk the essence of our brand, which is the integrity of our journalism. On the other hand, there's a lot of money going here and if we can take it the right way, sure, let's do it" (Moroney, ISOJ 2013).

PAYWALLS & RISING PRICES

The 2013 State of the News Media report suggests that digital pay plans are showing promise and are typically built around three elements—paywalls that require heavy users to pay for digital content; allowing free access to content for more casual users who often get to a website via links on social media or searching; and, most commonly offering digital access for a significantly reduced price to print subscribers (Edmonds, Guskin, Mitchell & Jurkowitz, 2013). The report suggests that U.S. newspapers are still a ways away from the international norm of a 50–50 circulation/advertising split, with the exception of *The New York Times*, which achieved this in 2012.

Doctor notes in a Newsonomics column that audiences are increasingly crossing into digital reading (especially on tablets), and "We're not there yet, but publishers are starting to sense that the time when their business models become

more about digital and less about print gets closer every day" (Doctor, 2012). Part of *The Times-Picayune* digital strategy is to continue free access in order to build digital ad revenues by maximizing traffic. Publisher Ricky Mathews says, "We're very focused on growing the audience, but that's a dynamic area. You've got meter paywalls, you've got hard paywalls, and you've got premium content becoming part of the conversation." He adds, "There's a lot of learning going on in the industry, and if there were an evolution of a model that wasn't contrary to growing audience, that helped us in terms of creating a sustainable business model, I'm sure that our company would be open to that" (Mathews, personal communication, April 25, 2013).

Moroney says that *The Dallas Morning News* was one of the first metropolitan dailies to go behind a paywall (Moroney, personal communication, July 19, 2013). It is also one of the major metro dailies that decided to aggressively raise the price of its printed newspaper as well. "We lost about 12 to 14 percent of our subscribers when we raised the price by 40 percent on one day," Moroney says. "But, the study we did … it turned out the way that we planned it. And, if total revenue is the rate times the volume, and you raise the rate by 40 percent and you only lose 12 percent of your volume, total revenue goes way up. So we raised a lot of money in circulation."

Duitch, now the editor of *Dallasnews.com*, worked at a competing Dallas television station when the newspaper decided to put up a paywall on its website. "We got very excited," he says, "because our website is just going to go through the roof now. People are going to come to us, we are going to own it, these newspapers are nutty." But, he said that in Dallas and in other markets that was not the case. "You know, the question then becomes, for the website, why are people coming? Is it the content or the experience?" (Duitch, personal communication, July 19, 2013).

Figuring that out is one of the key questions, and it could vary by user and preferred platform. "We haven't talked much about the advertising experience," says Jennifer Carroll, Gannett's vice president for digital outreach, at the 2013 ISOJ conference. "We're paying a lot of attention to that, at the same time we're watching the content experience—to make it part of the experience of the swiping and engagement with the tablet."

Recently, Moroney said he considered lowering the *Dallasnews.com* digital only subscription price ($16.95 per month) because they weren't bringing on as many new subscribers as expected. Digital only included all digital forms—the Nook, the Kindle, the iPad, the iPhone, Android phone and tablets, and desktops. But, he says, they worried that if they lowered the digital only price too much they would have print subscribers who pay $36.95 a month switching to digital only. "And that's not a very good trade for us because a print subscriber is worth more to us on an advertising basis," Moroney says (personal communication, July 19, 2013).

So, they surveyed print subscribers to find out how low they could drop the digital price without losing them. "We find out whether there's going to be a cannibalization, if you will," he says. At $2 per month for digital only ($24 per year versus $420 per year for a print subscription), less than one percent of those they surveyed said they would switch. How can that be? "These aren't substitutes. You don't substitute tea for bread," Moroney says. "These people are telling you that the digital is not a substitute for the print ... Some of them will pay you a little bit extra to get the digital because they think it's a good add-on, but they simply aren't going to trade down" (personal communication, July 19, 2013).

Gilbert points out that as news organizations develop their digital products they will look different than their printed products. So, to Moroney's point, the print product and the Web product *should* be as different as tea and bread. "There is a whole new category of content that's growing out from my Web teams that would never be done by my newsroom ... I have to have the discipline to set up a separate group to do the Web only content because it actually makes the core journalism more relevant," Gilbert says. "Because people come in and engage in my site and I have much higher incidents than I would if all I did was put these heavy stories up all day, every day. And we've created a Web only mechanism so that pulls them in, and if you love traditional journalism, the rigor and discipline on both sides of this, choosing what you'll be good at and innovating in the digital space, allow it to actually have a greater impact than it would have if we just locked it down and pretended that the (newspaper) space is not being affected" (Gilbert, ISOJ 2013).

DIGITAL ADVERTISING

Chapter nine discusses digital advertising trends and strategies in greater detail, but it is still worth a brief mention here. In 2010, all forms of online advertising revenue surpassed spending on print newspaper advertising for the first time (Edmonds, Guskin & Rosenstiel, 2011). "The problem for journalism is that the growth that has occurred online has not occurred as much in advertising associated with news" (Edmonds, Guskin & Rosenstiel, 2011). The 2013 State of the Media report notes that digital advertising slumped in late 2011 and that the news industry's digital ad revenues grew by only 3.7 percent. Doctor (2013) reports that in 2012 digital ad revenue equaled 11 percent of total revenue according to figures from the Newspaper Association of America. He estimates that based on both public and private reports "newspapers top out at around 25 percent of their news-related-operations revenue coming from digital" (Doctor, 2013).

"We decided to make an assumption that print ad revenues are going to continue to decline," says Moroney of *The Dallas Morning News'* strategy. "So if you're going to have a declining revenue that you don't see ending, you better have something that is growing revenue sufficiently to offset it or your business is going to continue to decline, right? We also didn't believe that we could get sufficient growth in revenue from selling just digital advertising. It's a growth business, but it's not big enough at its base today, even growing at double digits, to offset the print decline" (personal communication, July 19, 2013).

Mathews and *The Times-Picayune* see it a little bit differently: "We know we have to continue to exponentially grow our digital revenue. We know that for a fact. And that we have to do everything in our power to slow down the print decline, in terms of the print advertising revenue," he says. "But we're not foolish in thinking we can stop it. You know? This effort's not about stopping it" (Mathews personal communication, April 25, 2013).

Mathews was asked about an example of how *The Times-Picayune's* digital ad strategy works in line with its print strategy when the printed publication was only three days a week: If I'm the Mercedes dealer, am I spending on three days in print what I used to spend on seven days in print? Mathews says it doesn't work that way. "If you're a Mercedes dealer, and you used to put—Saturday's a very strong day for car dealers—so let's say you put a lot of money in Saturday's paper. We don't have a Saturday paper anymore. So you might've put a little bit more in Friday's paper, but you may've actually converted some of that budget over to digital, so that you're taking advantage of the full breadth of the products that we have in the automotive spaces, not just print" (Mathews, personal communication, April 25, 2013). He adds, "We expected declines in ad revenue ... some automotive revenue on Saturday mornings, as related to print, we knew we would take a hit and that was part of our assumptions. We've been pleasantly surprised with how much of that we've made up, actually, on the digital side. I'm not sure we expected to see the digital side of the equation grow as rapidly as it did, in things like automotive" (Mathews, personal communication, April 25, 2013).

Moroney does not think it is wise to rely heavily on digital advertising as a primary business strategy. As one example, he points to Google's first quarter earnings (2013) showing a drop. He says, "Google's CPMs (cost per thousand of impressions, or $1 for 1,000 ad views) have gone down six consecutive quarters in a row ... When the CPMs are going down you can't ramp your page views up that much unless you want to start doing roller skating squirrels, and that's just not our brand." He adds that newspapers are "not going to make the money on digital advertising alone to offset the print. And I think a lot of the newspapers in the country, that's been their idea ... It's going to be digital saves the day with digital advertising. It doesn't work" (Moroney, personal communication, July 19, 2013).

NEW INVESTMENTS

So, what does work in Moroney's opinion? *The Dallas Morning News'* innovation around its core print products is one avenue it sees as fruitful in the short term. It has also raised prices, cut costs, established a paywall, experimented with native advertising, digital advertising and other ways to manage the crossover to digital, it is taking advantage of commercial printing opportunities and it is reaching into events and digital marketing by investing in buying, building or partnering with new businesses. In the long term, investment in related businesses may be the most significant strategy the *Morning News* is pursuing.

"We want to start, buy or build businesses that we can bring a competitive advantage in the marketplace. So, most of what we're doing is marketing services companies," Moroney says. In 2012 *The Dallas Morning News* invested in five different companies, and expects revenue from those companies to offset declining print ad revenue. "Through the first half of the year we have offset the decline in print more than dollar for dollar with these new businesses ... We are going to continue to expand into related businesses, probably the media marketing and media services area" (Moroney, personal communication, July 19, 2013).

As more news organizations explore investments in marketing and social media services, Moroney says people often ask if journalism is still profitable.

> My answer is, without the journalism, which is the key to our brand ... all these things won't work. A lot of these businesses are being successful because ... the customer is getting called on by Purple Zebra, the new social media company that's been around for six months, has three people and they're undercapitalized and about to go out of business. Then, we come in and say ... we're *The Dallas Morning News*, and we call it 508 Digital, but we're owned by *The Dallas Morning News* and that brand, that credibility, gets us in the door and helps us grow the businesses. So if we discontinue doing the journalism we've traditionally done in the way we've done it, which we think is quality and quantity, then I think our brand starts to diminish and that's the core of our ability to grow our company in this area (personal communication, July 19, 2013).

According to the 2013 State of the Media report, many news organizations are "offering digital marketing services to local businesses that want a presence in social media but don't know how to go about it," and this is creating new revenue streams. The report also says that event marketing and other sponsorships are "a relatively easy sell in the current market" (Edmonds, Guskin, Mitchell & Jurkowitz, 2013).

EVENTS

The incorporation of event marketing into a business strategy has proven successful for both for-profit and nonprofit news organizations. Moroney says one of the new

businesses *The Dallas Morning News* has focuses on event marketing and the One Day University, a concept that began in New York. "They go find the best professors on a campus, the ones who are both informational and entertaining," he says. Then, on a Saturday, those professors give a series of lectures on interesting topics.

Other models for events exist, too. The *Texas Tribune* holds a big, three-day event each year, the *Texas Tribune* Festival. In 2013, the *Texas Tribune* Festival offered 150 speakers and 45 interactive events. The 2012 *Texas Tribune* Festival generated $400,000 in revenue. Smith expects all of his events in 2013 to generate $1.1 million, with 10 percent coming from ticket sales to the *Texas Tribune* Festival in September. The "big" festival is the only festival for which a ticket is required; all other *Texas Tribune* events are free (Smith, personal communication, July 19, 2013). In addition to the annual festival, the *Texas Tribune* holds about 60–70 events a year, all of them in line with its focus on government, public policy and politics. One example is the *Tribune's* conversation series, which it holds in different places once a month.

"We bring elected officials back home to their districts, where often they don't have to appear at events they don't control, and they don't have to answer questions they don't have in advance because they've got no competition back home—they don't have to go home to be reelected. They get re-elected summarily," Smith says. "No, no. We're going to drag you home; we're going to hold you accountable. We always partner with college campuses, which turns out to be a great thing because they are the last remaining public squares in many of these smaller communities ... We'll draw 300–400 people in a community of 60,000, we pay for lunch and we have them over the lunch hour" (Smith, personal communication, July 19, 2013). Smith says corporate sponsorship of the events covers the costs and generates revenue.

"I'm proud to say that I had a serious gut feeling about events being an important part of what we did," Smith says. "I never imagined it would be as important or successful" (personal communication, July 29, 2013).

COMMERCIAL PRINTING & PARTNERSHIPS

Earlier in this chapter, Moroney observed that *The Dallas Morning News'* price increase lost about 12 percent of its print subscribers. But, that loss in subscriptions netted an increase in press capacity, which led the company to begin to print *The New York Times*, *The Wall Street Journal* and the *Investor's Business Daily* in addition to *USA Today*, which it was already printing. "Then we started distributing those papers, so we have a commercial printing and distribution business," Moroney says. He notes that organizations are either outsourcing their printing or they're collecting it—"We're more in that collection part than outsourcing" (personal communication, July 19, 2013).

CONCLUSION

This chapter has explored some of the emerging business strategies and economic models that newspaper owners are employing as they transition more fully into the digital world. "The shift to replace losses in print ad revenue with new digital revenue is taking longer and proving more difficult than executives want," according to the Pew Research Center's Project for Excellence in Journalism. "At the current rate, most newspapers continue to contract with alarming speed" (Rosenstiel, Jurkowitz & Ji, 2012).

"The industry is inhibited by several obstacles that executives themselves candidly acknowledge. One involves the difficulty of changing the behavior of people trained in the ways of a mature and monopolistic industry," the Pew report says. "Still another is the unavoidable fact that the part of the newspaper industry that is growing, digital, continues to provide only a small part of the revenue, while the part that is shrinking, print, provides most of the money—a paradox that is difficult to navigate and hard to resist. One pervasive feeling is that 15 years into the digital transition, executives still feel they are in the early stages of figuring out how to proceed" (Rosenstiel, Jurkowitz & Ji, 2012).

"The cultural things are just as deeply tied to the economics as they are to the ways we think (as journalists)," Gilbert says. "If I have a journalist on my team who fights that, I don't really know if they can stay in our organization. I love our journalists. They are amazing, award-winning journalists who I can spend the whole day talking about. But if they aren't aware that the world's changing, that they need to be part of that transformation, then we're never going to make it" (Gilbert, ISOJ 2013).

Mathews says it is the culture within the city of New Orleans that needs to recognize the shift. "A lot of people don't seem to understand—in the world that we're in, we don't say "digital-first," we say "digitally-focused," because there's a difference. We're not saying that the printed newspaper's not important; in fact, we're saying it's extraordinarily important to us. It has to be, it has to be major-league quality. It has to serve readers like never before. And we're very, very aware of that. But our reporters and editors live in a digital world" (Mathews, personal communication, April 25, 2013).

Moroney agrees that the printed newspaper and its associated products are still critically important: "I think if you think print is going to go out of business you need to run the mortality table on all these people (who subscribe) and find out at what point is it that it doesn't make sense to print the paper anymore in terms of number of copies," he says. "I think that's (at least) a decade away" (Moroney, personal communication, July 19, 2013).

Despite continuing declines in print ad revenue and struggles within the industry to find feasible digital revenue strategies, billionaires are investing in newspapers. The most notable are Warren Buffet's Berkshire Hathaway company

which bought 28 newspapers in 2012; investor John Henry, who bought his home-town *Boston Globe* in 2013; and, Amazon CEO Jeff Bezos who personally bought *The Washington Post* in 2013. Doctor (September 12, 2013) writes that these buyers are getting into an important industry cheaply, and "They've bought strong brands with tens or hundreds of thousands of reader/customer relationships and thousands of advertising relationships. Those are the kinds of assets that a master marketer like Bezos knows he can build on."

Buffet has said he will explore hyperlocal approaches with his investment because, "Newspapers continue to reign supreme in the delivery of local news. ... Wherever there is a pervasive sense of community, a paper that serves the special informational needs of that community will remain indispensable to a significant portion of its residents" (Dan, August 11, 2013).

The nonprofit *Texas Tribune* is also an end product of a wealthy individual (Thornton) seeing opportunity, even if in this case the motive was not profit. "Cheap and easy access to technology made this possible. And I think, in a weird way, the toxicity of the politics that we see every day, here and in Washington, people want to be for something, not just against," Smith says. "The toxicity of politics has driven people in two different directions. One is completely away from the light and one is completely toward it. And we're in the "toward it" camp. The solution to problems is not to run away but to run toward" (Smith, personal communication, July 29, 2013).

As news organizations run toward digital, the hope is that sustainable economic models and strategies will follow close behind.

REFERENCES

Amoss, J. (2013, June 22). TP Street to land on newsstands Monday. *NOLA.com.* Retrieved from http://www.*NOLA.com*/opinions/index.ssf/2013/06/tp_street_to_land_on_newstand.html

Campbell, W.J. (2006). *The year that defined American journalism: 1897 and the clash of paradigms.* New York: Routledge.

Carr, D. (2015, September 15). Storytelling ads may be journalism's new peril. *NYTimes.com.* Retrieved from http://www.nytimes.com/2013/09/16/business/media/storytelling-ads-may-be-journalisms-new-peril.html?pagewanted=all&_r=0

Christensen, C.M. (2011). *The innovator's dilemma.* New York: First Harper Business.

Dan, A. (2013, August 11). When it comes to billionaires buying newspapers, marketers should pay attention to Warren Buffet, not Jeff Bezos. *Forbes.com.* Retrieved from http://www.forbes.com/sites/avidan/2013/08/11/when-it-comes-to-billionaires-buying-newspapers-marketers-should-pay-attention-to-warren-buffett-not-jeff-bezos/

Demers, D.P. (1996). *The menace of the corporate newspaper: Fact or fiction?* Ames, Iowa: Iowa State University Press.

Doctor, K. (2013, September 12). The newsonomics of Jeff Bezos' (and Warren Buffet's) runway. *Nieman Journalism Lab.* Retrieved from http://www.niemanlab.org/2013/09/the-newsononics-of-jeff-bezos-and-warren-buffetts-runway/

Doctor, K. (2012, March 1). The newsonomics of crossover. *Nieman Journalism Lab*. Retrieved from http://www.niemanlab.org/2012/03/the-newsonomics-of-crossover/

Downs, A. (1957). *An economic theory of democracy*. New York: Harper Books.

Edmonds, R., Guskin, E. & Rosenstiel, T. (2011). Newspapers: Missed the 2010 media rally. *The State of the News Media 2011*. Retrieved from http://stateofthemedia.org/2011/newspapers-essay/#digital-audience-growing-but-metrics-are-a-mess

Edmonds, R., Guskin, E., Mitchell, A. & Jurkowitz, M. (2013, July 18). Newspapers: Stabilizing, but still threatened. *The State of the News Media 2013*. Retrieved from http://stateofthemedia.org/2013/newspapers-stabilizing-but-still-threatened/

Gillin, P. (2013). *Newspaper Death Watch*. Retrieved from http://newspaperdeathwatch.com/about-2/

Hamilton, J.T. (2004). *All the news that's fit to sell: How the market transforms information into news*. Princeton, N.J.: Princeton University Press.

Kielbowicz, R.B. (1990). Postal subsidies for the press and the business of mass culture, 1880–1920. *Business History Review, 64*, 451–488.

Leonard, T. (1995). *News for All*. New York: Oxford University Press.

Mitchell, A., Jurkowitz, M., Holcomb, J., Enda, J. & Anderson, M. (2013, June 10). Nonprofit journalism—A growing but fragile part of the U.S. news system. *Journalism.org*. Retrieved from http://www.journalism.org/analysis_report/nonprofit_journalism

Mott, F.L. (1966). *American journalism: A history 1690–1960*. New York: The Macmillan Co.

Pope, D. (1983). *The making of modern advertising*. New York: Basic Books.

Reynolds, A. & Hicks, G. (2012). *Prophets of the fourth estate: Broadsides by press critics of the Progressive Era*. Los Angeles: Litwin Books.

Reynolds, A. (2005). Northern newspapers in the Civil War. In A. Reynolds & D. Reddin Van Tuyll (Eds.), *Volume III: The Civil War—North and south* (1–288). Westport, Conn.: Greenwood Publishing Group.

Rosenstiel, T., Jurkowitz, M. & Ji, H. (2012, March 5). The search for a new business model. Project for Excellence in Journalism. Retrieved from http://www.journalism.org/analysis_report/search_new_business_model?src=prc-headline

Sandelowski, M. (2004). Qualitative meta-analysis. In *The SAGE Encyclopedia of Social Science Research Methods* online. Retrieved from http://srmo.sagepub.com/view/the-sage-encyclopedia-of-social-science-research-methods/n782.xml

Sandelowski, M., Docherty, S. & Emden, C. (1997). Qualitative metasynthesis: Issues and techniques. *Research in Nursing Health, 20*, 365–371.

Schudson, M. (1978). *Discovering the news: A social history of American newspapers*. New York: Basic Books.

Shapiro, C. & Varian, H.R. (1999). *Information rules: A strategic guide to the network economy*. Boston: Harvard Business School Press.

Stelter, B. & Haughney, C. (2013, January 15). The Atlantic apologizes for Scientology ad. *NYTimes.com*. Retrieved from http://mediadecoder.blogs.nytimes.com/2013/01/15/the-atlantic-apologizes-for-scientology-ad/

Tebbel, J. (1969). *The compact history of the American newspaper*. New York: Hawthorn Books.

Thorne, S., Jensen, L., Kearney, M.H., Noblit, G. & Sandelowski, M. (March 2004). Qualitative metasynthesis: Reflections on methodological orientation and ideological agenda. *Qualitative Health Research, 13* (X), 1–24.

Whyte, K. (2009). *The uncrowned king*. Berkeley, Calif.: Counterpoint.

An Ecological Perspective ON THE Evolution OF New Orleans' News Media

PAROMITA SAHA

The announcement in New Orleans of a reduced version of the city's historic daily newspaper triggered a series of chain reactions within the local news media. The media and the public responded passionately to what many considered an important civic issue. While the outcry continued throughout the summer of 2012, the New Orleans news media soon became filled with announcements of new partnerships between the city's key news outlets.

The shifting New Orleans news market provided opportunities for newcomers such as the Baton Rouge daily newspaper, *The Advocate* to enter the market with the intent of becoming a leading New Orleans news provider. This chapter examines how these dramatic shifts affected the New Orleans news market and the way news is delivered in a city with a notable digital divide and strong civic needs. This is examined against the backdrop of Downie and Schudson's (2009) contention that because of the digital disruption the "character of news is being reconstructed and reporting is being distributed across a greater number and variety of organizations, new and old" (p. 1).

The New Orleans news media acts as an ecosystem (Anderson, 2010) with a complex mix of news models ranging from old to new that practice difference types of journalism against the backdrop of an evolving civic landscape. Consequently, these entities interact with one another through competition and symbiosis, a term used by Downie and Schudson (2009) to describe the collaborations that form between different types of media—in particular, legacy media

and the blogosphere. These formations are indicative of how these entities become interdependent on one another for the purpose of strengthening their position in the rapidly evolving digital oriented news media ecosystem. They take over the dichotomies that existed between traditional media in the twentieth century local news ecosystem (Miel & Faris, 2008, p. 1).

This chapter also takes an ecological perspective on the evolution of New Orleans news media since Hurricane Katrina in 2005. Anderson (2010) states the news ecosystem can be analogized as the trade and circulation of goods, i.e. news goods. Shirky (2008) notes that the "the definition of news has moved from institutional prerogative to news as part of a communications ecosystem occupied by a mix of formal organizations, informal collectives and individuals" (p. 66). For this chapter, my definition of a news ecosystem matches Shirky (2008). Subsequently, I focus on how different types of news media exists and interact together in one locality.

A city's civic nature determines the type of information that locals want (David Kurpius, personal communication, March 2013). As a result, the changing civic needs of the city since Hurricane Katrina combined with the impact of digital technology on traditional news practices are the major driving forces behind this ongoing news evolution in New Orleans. Furthermore, the size of the local audience changed as a result of the city's population decline in the aftermath of Katrina. According to the Greater New Orleans community Data Center, the city has lost 140,845 residents since 2000, largely as a result of the economic and residential destruction from Hurricane Katrina (Plyer, 2011). These aforementioned forces decentralize the news environment and contribute to the emergence of new civic-orientated and hyperlocal news entities (Papacharissi, 2010).

The New Orleans news evolution has taken shape over four significant phases. The first phase begins with Katrina in 2005, in which the city's news media relied heavily on the Internet for producing and disseminating information. This phase also experienced the birth of the city's blogosphere. The second phase, which starts in late 2005, can be referred to as the start of the post-Katrina era, and marks a rapid rise in citizen journalism in New Orleans. This burgeoning movement and *The Times-Picayune* acted as the city's watchdogs to unearth the city's corruption. The third begins with the first round of cuts at *The Times-Picayune* newsroom in 2009 followed by the rapid emergence of hyperlocal media and legacy media using social media as means of breaking news around the clock. The fourth phase begins in May 2012, with the announcement of the reduction of the daily *Times-Picayune* to three days a week. This announcement acted as a catalyst, speeding up and intensifying a news evolution already occurring since Katrina. The forces of symbiosis and competition intensify as old and new

media attempt to fulfill the civic and social functions of a daily newspaper (Siles & Boczkowski, 2012, p. 1380).

NEW ORLEANS' NEWS ECOSYSTEM

Currently, the local news ecosystem of New Orleans is made of layers of traditional and newer forms of news media. In general, there are 13 local television stations including affiliates for CBS, NBC, ABC, FOX, and PBS (Station Index, 2013). Six radios stations of 26 are considered talk or sports radio. WWNO is the National Public Radio (NPR) station for New Orleans and WWL (AM) is one of the city's leading commercial talk radio stations (Radio-locator.com). The city's major newspapers are *The Times-Picayune* and *The Advocate*. There is the long running, established alternative weekly paper *Gambit*. The city's leading monthly music publication is *OffBeat* magazine and *Where Y'at* is a monthly entertainment publication. The *Louisiana Weekly*, *Louisiana Data News Weekly*, and the monthly New Orleans *Tribune* primarily serve the city's predominant African American population, which stands at 60 percent, as well as radio stations WBOK and The Sunday Hour presented by Hal Clark on WYLD—FM. Other specialty publications include New Orleans *City Business*, which provides news on all aspects of business. The *Clarion Ledger* is the city's Catholic publication. Renaissance Media LLC is the publishing house for six local magazines including *New Orleans Life*, *St. Charles Ave* and *Acadiana Profile*. The newer media entities include several hyperlocal websites, which include profit and nonprofit news models (for example, *The Lens*). Meanwhile, the city's blogosphere is made up of some 300 bloggers from New Orleans or Louisiana, which either feature content about the city or Hurricane Katrina. Some of these do not exist anymore or still operate as civic activists that engage in journalistic practices such as opinion writing and muckraking.

For this chapter, I approached a cross selection of 19 media entities from legacy media, new media and alternative media (blogosphere), with the aim of representing the different types of journalism that currently exist in the city. Some came forward to be interviewed whereas others declined or did not respond. Nineteen in-depth interviews were conducted between fall 2012 and spring 2013, with either news editors, or managing editors of these various media operations. The interviews took place in either their offices or at local coffee houses close to the contributors' homes or place of work. I asked a series of questions including how the changes at *The Times-Picayune* affected their operations; their thoughts on the perceived news gap; how they felt the New Orleans media landscape was changing; and, whom they saw as their competitors and collaborators. Some interviews were tailored specifically towards the media entity in question.

HURRICANE KATRINA—BIRTH OF THE NEW ORLEANS BLOGOSPHERE

McChesney and Nichols (2010) write that the "most striking development" of the digital revolution maybe the rise of the blogosphere (p. 77). Scholars and media practitioners remain divided on whether blogs are a legitimate and credible part of the news ecosystem. For example, Benedetti and Compton (2011) state that blogs "produce if little, any original reporting" (p. 46). Whereas, Barlow (2008) argues that the "non professional can match the professional journalist almost every step of the way" (p. 93). McChesney and Nichols (2010) suggest that these "off the cuff-opinions" are inaccurate (p. 77), given the multifarious nature of the blogosphere.

The sample of bloggers interviewed for this chapter fit the archetype of a citizen journalist. First, blogging serves as a tool to execute their civic activism in the interests of the community. For example, Kalen Wright who goes by the name of lunanola, describes herself as the "catalyst that starts the fire" (K. Wright, personal communication, March 21, 2013). Second, some bloggers do not adhere to the tenets of traditional journalism such as objectivity. This is especially evident in their writing, which normally consists of cryptic comments, personal opinions and the occasional use of expletives. Third, they do not necessarily adhere to journalistic routines and norms, such as breaking news daily or producing a daily news agenda. However, these bloggers conduct journalistic activity, which Nip (2006) defines as "some original interviewing, reporting, or analysis of events or issues to which people other than the authors have access" (p. 68).

Curran (2010) states that journalistic activity in the evolving news landscape is "based on open-ended, reciprocal, horizontal, collaborative, self- generating, extensive, and inclusive reporting and comment of a kind never experienced before" (p. 46). Blogger Leigh Checkman who writes as Liprap says that adhering to journalistic principles is essential to the survival of blogging as a craft. "Bloggers have learnt to be newsworthy. You have to be trustworthy and transparent about your sources. You do want to be read, so you want to retain some kind of ethics," Checkman says (personal communication, January 24, 2013).

In New Orleans, the blogosphere developed as a result of the information needs of the city during Hurricane Katrina. According to Checkman, "blogging turned out to be a release for survivors of Katrina." Before the storm, the city's news ecosystem was primarily comprised of traditional news entities existing within the mainstream and alternative. Older publications such as *The Times-Picayune*, *Gambit*, and *OffBeat* started their websites in the last decade of the twentieth century and began breaking news on this new platform. According to Jim Amoss, editor of *The Times-Picayune*, the mid nineties "was when everybody realized that

the lifeblood of the website is news and breaking news" (personal communication, April 25, 2013) At the time, only a handful of blogs existed in the city. Mark Moseley, one of the city's core bloggers since 2004 (pre-Katrina), describes the scene as essentially "A group of likeminded people talking about current events. Trying to be perceptive and funny" (personal communication, November 27, 2012).

Hurricane Katrina became a catalyst in the history of New Orleans news reporting, and one that transformed the dissemination of news in the city. During the storm, blogging became a primary source of news as a result of the breakdown of the print press. *Times-Picayune* staff broke stories on the publication's website *NOLA. com*, which became a lifeline for many displaced residents. Evacuees blogged about their plight as means of reaching their loved ones and the outside world, while the mainstream news focused on narratives of public officials working around the clock to return the city back to normal (Robinson, 2009). According to Moseley, the authors of the city's established blogs experienced high readership on posts they wrote during the storm. Robinson (2009) states while mainstream journalists assumed the roles of "hero, authoritative witness and diligent watchdog," citizen journalists focused on narratives that were not only first-hand accounts but also focused on the marginalized voices of the city (p. 801). Blogger Troy Gilbert, who had electricity, stayed behind during the storm and live blogged on his site *GulfSails*, which attracted a national following. Moseley states that Gilbert "was giving real time impressions of what was going, which was a new and powerful technique, during a mega disaster that was about to unfold" (Gilbert, personal communication, November 27, 2012).

George E. Williams IV (known as Loki) is a freelance multi-media consultant who set up the collective blog site *Humid City* just before Katrina, with the goal of covering alternative arts in the city. He made a series of audio casts and posts about evacuating the city, which the British Broadcasting Corporation (BBC) picked up. However, his frustration at the inaccuracies of national media reports changed the focus of *Humid City* to more civic-oriented issues in the aftermath of Katrina. "This had shifted from arts culture to everything is fucked and the mainstream media is going to get this wrong in an attempt to post their own narrative," he said. "We need real voices in the middle of this talk. We have just seen the levees blow. We are about to start talking to people. These are our voices—not the medium" (Williams, personal communication, March 23, 2013). Robinson (2009) asserts that during this time bloggers established themselves as an authority to the press (p. 805).

POST-KATRINA: THE RISE OF CIVIC-ORIENTED MEDIA

After the storm, public anger grew toward the allegedly corrupt city system that many felt obstructed the development of an efficient infrastructure, which

subsequently caused the failure of the levee system. These frustrations culminated into a heightened civic consciousness and the need for robust public discourse and independent reporting. In the aftermath of Katrina, some of the city's established media adopted participatory journalistic practices, such as incorporating blogs into their websites. One example is *Gambit's* "The Blog of New Orleans." Moseley states this new consciousness contributed to a rise in the number of blogs focusing "on the need to communicate issues that were important and not being reported" (Moseley, personal communication, November 27, 2012). The number of blogs in the city rapidly increased over an 18-month period from immediately after the storm into early 2007.

Consequently, an active citizen journalist movement formed a public sphere that sought to reconstruct a devastated city through the means of deliberation on the Internet. The New Orleans blogosphere took on the role of the ancient Greek agora, a public sphere in which citizens deliberated key political decisions, essential for good governance and a healthy democracy. Most blogs during this phase existed in the form of daily, robust opinion pieces focusing on the political machinations of New Orleans' then-Mayor Ray Nagin's administration, and critiques of the Federal Emergency Management Agency (FEMA). Others enacted "social responsibility style reporting" (Atton 2004 p. 41), from the frontline of their communities. Pat Armstrong, who writes the blog Hurricane Radio, states that the emergence of the New Orleans blogosphere "set the stage for the fact that people wanted in depth information more than just the big local news organizations" (personal communication, March 25, 2013). These blogs would draw up to 50 comments a day, and the comments triggered public debates.

In blogs that she wrote for various national and local publications such as *Gambit*, Big Red Cotton focused on capturing the voices of the second line community as well as the Lower Ninth Ward, one of the city's poorest neighborhoods made infamous by Katrina. New Orleans has boasted a long running tradition of funeral jazz processions since the mid-nineteenth century. The "second line" is when friends, acquaintances and community pick up participants as they dance behind the first line, which consists of family members and a brass band. In twenty-first century New Orleans, the second lines are a regular feature of the city's culture, particularly within the African American community and occur on occasions including birthdays and weddings. They also happen on most Sunday afternoons from late August to late June (G. Wyckoff, personal communication, August 4, 2013). Cotton believes that the second line culture deserves equal importance as New Orleans high society. She says, "The mainstream media consider the St. Charles crowd and debutante, the only ones worthy of coverage. I take the same approach, I give the spotlight to working class people that I find interesting" (Cotton, personal communication, December 13, 2012).

Blogger Moseley, also a political pundit who calls himself a 'Vitterologist,' has focused on the movements of Senator David Vitter as well as other local political figures such as Nagin and then-Lieutenant Governor Mitch Landrieu (now the New Orleans mayor). He also analyzed elections and provided a local perspective on national politics on his blog *Right Hand Thief*. Checkman caught the attention of local school boards from posting pictures of the city's crumbling schools on her blog and on *Humid City*. Armstrong, at Hurricane Radio, wrote his blog as a personal journey. Wright, who writes as lunanola and started blogging later, focused on civic issues in the French Quarter. The late Ashley Morris was particularly renowned for his witty and expletive ridden rants on culture and political life in New Orleans. His larger than life presence and writing provided the basis for the lead character of Creighton Bernette on the HBO hit series Treme, which depicted the lives of various characters in the aftermath of Katrina. Karen Gadbois, who started the blog Squandered Heritage and later founded the nonprofit website, *The Lens*, was also featured in the series.

MUCKRAKING AND THE DOWNFALL OF MAYOR NAGIN

The vibrant civic consciousness of New Orleans during the post-Katrina era produced a distinct "critical culture" (Schudson, 1978), reminiscent of post-Watergate America, which called for a renewed muckraking news culture. Schudson (1978) states that muckraking is a form of reporting that typically focuses on exposing the corruptions of government. It was popular in the early twentieth century. The advent of digital technology means that this style of reporting could be disseminated widely and inexpensively today.

The city's bourgeoning blogging movement produced a type of citizen journalist that engaged in muckraking, including Jason Berry of *American Zombie*, Doug at *Slabbed*, and Gadbois of *Squandered Heritage*. These citizen journalists took it upon themselves to expose corruption in New Orleans and neighboring Jefferson Parish. Investigations editor Gordon Russell and reporter David Hammer at *The Times-Picayune* (neither of whom is still at *The Times-Picayune*) led the investigative efforts and broke stories in the mainstream press. The combination of these journalistic forces contributed to the eventual indictment of Nagin on 21 federal corruption charges in 2013, including allegedly taking payoffs worth at least \$235,000 from certain city vendors (Hammer, 2013). The exposé of Nagin highlights the dichotomies and symbiosis that can exist between old and new forms of journalism in the modern news ecosystem.

Gadbois, an artist, began blogging after her neighborhood fell in disrepair after the storm. She says, "There were a lot of predatory things that were happening that concerned environment and land use" (Gadbois, personal communication,

January 25, 2013). Gadbois noticed that the administration began using federal money to demolish numerous properties across the city, including historic buildings. She took pictures of properties earmarked for demolition and posted them on her blog, *Squandered Heritage*. She also attended hearings in which properties were approved for demolition even though they could easily be repaired. Often, the owners of these properties did not know that their building was earmarked for demolition. Gadbois' work grabbed the attention of *The Wall Street Journal*, which focused on her in its second anniversary of Katrina coverage.

Eventually, Gadbois caught wind of New Orleans Affordable Housing (NOAH) using federal money to repair the damaged homes of poor and elderly residents—part of Nagin's hurricane cleanup efforts. According to her research, many of these repaired homes did not exist or stood in considerable disrepair. Gadbois, frustrated with *The Times-Picayune* and other mainstream news outlets that ignored her findings, found an ally in WWL-TV's sports journalist Lee Zurik. She says, "Lee was someone who understood in an intuitive way. He trusted what I was saying." Zurik's report broke the story on WWL-TV and featured Gadbois as a civic activist and Internet blogger unraveling the scandal behind NOAH. The piece would draw the attention of Nagin who called a press conference the following day. According to Gadbois, "he went on the defensive," and criticized Zurik as "reckless" (Nossiter, 2008). Zurik and Gadbois, along with journalist Marcy Planer, would form a working relationship, which resulted in many news pieces being broadcast on the NOAH scandal on WWL-TV. The reporting subsequently won them awards.

In 2008, Gadbois' investigative efforts drew the attention of the FBI, which conducted a three-year federal investigation and eventually indicted some NOAH contractors. The experience left Gadbois, who already received death threats, feeling vulnerable and unsupported. She says, "That's when I thought, I need some institutional coverage, and build something that is more than just a blog" (Gadbois, personal communication, January 25, 2013). As a result, Gadbois and New York journalist Ariella Cohen set up *The Lens*, the city's first nonprofit news website devoted to investigative journalism.

Zurik and Gadbois' relationship is example of a "pro-am" partnership in which professional and amateur journalists come together in a form of "networked journalism" (Curran 2010, p. 467). While theirs succeeded, the relationship between traditional and citizen journalists can be complex. Muckraker Berry started his *American Zombie* blog immediately after Katrina and focused on exposing white-collar crime in the city. Berry thrives on sitting on the periphery of the mainstream, describing himself as "a monkey in a tree throwing turds at people on the street" (Berry, personal communication, October 16, 2012). He also sees his role in the same vein as Seymour Hersh, "the last true journalist who sits in the office and hates everybody." Berry's muckraking has cost him threats of libel and death.

Between 2006 and 2007, Berry turned his attention to exposing cronyism at the technology office run by Nagin's Chief Technology Officer Greg Meffert after receiving a series of anonymous tips, including from within Meffert's office. In September 2006, Berry posted an "imagined" conversation between Nagin and Meffert, on a paid vacation together in Hawaii in December 2004. *Times-Picayune* investigative reporter Hammer would confront Nagin about the Hawaii trip in March 2009, and Nagin subsequently denied the claims. Meanwhile, *Times-Picayune* investigations editor Russell also exposed other examples of cronyism, such as city vendor Marco St. Pierre providing freebies to Nagin and Meffert. Over five years, Berry and *The Times-Picayune* investigations team, led by Hammer and Russell, worked separately on different aspects of the story, which led to the eventual indictment of Nagin and members of his team, including Meffert and St. Pierre.

Local journalists and bloggers still debate who broke the story. But, this tension highlights a conflict over the definition of "breaking news" and "newsgathering" in a changing news ecosystem in which the traditional journalism is challenged and redefined by the arrival of new media entities such as blogs (Downie & Schudson 2009, Shirky, 2008, Curran, 2008 & Nip, 2006).

The examples of the relationships between these bloggers and legacy media reflect Downie and Schudson's analysis that "the blogosphere and older media have become increasingly symbiotic" (2009, p. 53). In some cases, the two entities "feed off each other's information and commentary, and they fact check each other." Shirky (2008) states that the news media can end up covering the story because something has broken into public consciousness via other means (p. 64).

These examples from the New Orleans blogosphere also suggest that the impact of citizen journalists depends on the mainstream news media taking cues from their work (Nip, 2006, p. 218) and crediting them accordingly. However, many of the bloggers interviewed in this chapter mentioned many occasions when some of New Orleans' established media outlets used their sources yet did not acknowledge or credit them accordingly.

Nonetheless, blogging is transient and the most short-lived medium in the news ecosystem. For example, the number of bloggers in New Orleans has dropped in recent years, partially as a result of the rise of social media.

However, despite the fall in numbers, citizen journalism still occupies an important place in the New Orleans news ecosystem and continues to infiltrate the mainstream. In exceptional cases, bloggers like Gadbois act as a catalyst, bringing the old and new worlds of journalism together to produce a "protean synergy" (Curran, 2010, p. 457), impacting another phase in the evolution.

THE RISE OF HYPERLOCAL AND SOCIAL MEDIA

The first round of cuts at *The Times-Picayune* in 2009 was another catalyst that caused shifts in the New Orleans news ecosystem. Advertising revenue at *The Times-Picayune* fell 23 percent, partly due to the decline in the city's population since Katrina (Hagey, 2012). The paper's editorial staff shrank to fewer than 170 from 265 prior to Hurricane Katrina (McCollam, 2012). At the same time, neighborhoods across the city expressed a need for more localized and neighborhood-oriented news. The combination of these factors gave rise to the hyperlocal news model that took root in the New Orleans news ecosystem between 2009 and 2011. The term "hyperlocal" refers to "news reporting that closely reflects the everyday life of residents in the community" (Kaye & Quinn, 2010, p. 44). Kurpius, Metzgar and Rowley (2011) define hyperlocal media as "geographically based, community oriented, original news-reporting organizations indigenous to the web, intended to fill perceived gaps in coverage of an issue or region to promote civic engagement" (p. 774). These news websites emerged nationally in the latter part of the twentieth century in response to the gradual decline of local newspapers. Kurpius et al. (2011) also state a city's civic needs and funding status dictate the size and type of hyperlocal websites that emerge (p. 774). In New Orleans, the hyperlocals exist or serve areas where there is a high concentration of Internet ownership (Davis, 2012).

Two of the city's main hyperlocal sites, *Nola Defender* and *Uptown Messenger*, assume the traits of the daily local newspaper. They emphasize breaking news and beat reporting. Both were founded and run by journalists from outside of New Orleans who were drawn to the city. Ben Mintz, a journalist and writer from Brooklyn, New York, launched the alternative online newspaper, *Nola Defender* in Spring 2010 in response to the cutbacks at *The Times-Picayune* in 2009. The headquarters of this hyperlocal is located amongst the colorful shotgun houses of the historic Faubourg Marigny, which sits on the periphery of the French Quarter. He states, "We basically looked at the holes that appeared in coverage as a result of these cuts and wrote about those topics" (B. Mitz, personal communication, October 15, 2012). *Nola Defender* initially covered arts and culture. However, the breaking news of the Deepwater Horizon oil spill in the Gulf of Mexico in 2010 called for further reporting on pertinent local issues such as the environment and politics. Mintz wants to build a news model based on the demand for certain types of news in the city covered by respected journalists and build the reputation of his writers, similar to those of the journalists at *The Times-Picayune*. Furthermore, *Nola Defender*'s motto "Blood, Alcohol and Content" indicates its mission to provide news content that reflects key nuances of New Orleans culture, which involves using terminology that touches upon dialect and local slang.

Robert Morris, a young but seasoned newspaper reporter from Mississippi, identified the need for a daily news entity in the Uptown neighborhood of New Orleans, while vacationing in the city with his wife. They both established the *Uptown Messenger* in August 2010, with the purpose of covering every bit of neighborhood news from charter school meetings to local restaurant openings. The website is essentially an online recreation of the small daily newspapers Morris worked for as a reporter. He states, "We were producing news every day for that community. We were covering every school and every crime. Why should a community like that have better coverage of itself than a city like New Orleans?" (Morris, personal communication, October 19, 2012). *Uptown Messenger* started as a one-man show with Morris taking on the role of editor and reporter, extensively covering every single beat in the Uptown neighborhood, while using innovative forms of reporting such as live tweeting from charter school meetings and during his coverage of Hurricane Isaac.

My Spilt Milk is the city's main music hyperlocal website. Alex Rawls, an established music journalist who previously wrote at *OffBeat*, started the website in May 2012, with the goal of producing regular entertainment news for the city. The website is a profit-based hyperlocal and depends on advertising revenue. Rawls takes a civic-oriented approach to his editorial content, especially in a city that is regarded as one of the music epicenters of America. He believes that music is an important source of news and states that "treating it trivially, is really actually trivializing people in a city like New Orleans" (A. Rawls, personal communication, October 15, 2012).

Meanwhile, the city's nonprofit media entities, *The Lens* and *NolaVie*, evolved during this phase as a result of the need for more investigative reporting and civic-oriented cultural news. Despite fundamental differences in content and approach, they share the mutual goal of providing robust civic coverage in their chosen areas. They do not devote their resources to breaking news on a daily basis. They also adopt participatory journalistic measures. For example, *The Lens* facilitates public debates on pertinent civic issues either on its website, via social media or in public meetings. In the twenty-first century news ecosystem, the investigative news site *The Lens* falls under Curran's category of a "pluralistic networked journalism model" (Curran, 2010, p. 457). The current make up of their newsroom consists of citizen journalists such as Moseley and award-winning traditional journalists like Tyler Bridges. *The Lens* started as an idea of a nonprofit website covering land use driven by blogger Gadbois and New York journalist Cohen. After seeking input from some of the city's established journalists, including Jed Horne, Steve Beatty and former WWL-TV reporter Zurik, *The Lens* became a project that brought together "public-interested journalists" with the mission of providing ongoing watchdog coverage of a broken city government struggling to recover from Hurricane Katrina, that

empowered citizens to deliberate and actively "influence the decisions made in the city" (Cohen & Gadbois, 2011).

With the cutbacks at *The Times-Picayune* in 2009, the arrival of *The Lens* seemed pertinent as ever, as the nonprofit website's editor Beatty highlights, "When they [*Times-Picayune*] lost their special projects editors, there wasn't as much investigative work that could be done. In New Orleans, trying to do investigative work is like trying to drink from a fire hose. There's more than enough for everyone" (personal communication, March 7, 2013). *The Lens* secured a partnership with one of the city's television news stations, Fox 8 WVUE. This new relationship with the station provided office space and the opportunity to reach a mainstream audience. The website established itself as a Louisiana nonprofit in February 2010 with a focus on the Gulf Coast and New Orleans. Since its inception, *The Lens* has produced in-depth stories on civic issues including charter schools, criminal justice and the environment.

The city's second nonprofit website, *NolaVie*, launched in February 2011, with a goal of providing cultural news. According to site founder Renee Peck, "the cultural life is what we think sets New Orleans apart from the rest of the world. These stories are not going to be covered unless somebody steps up to it" (personal communication, March 7, 2013). *NolaVie* is the brainchild of Peck, former features editor at *The Times-Picayune* for 32 years, and Sharon Litwin, originally from England, and a former director at the Louisiana Philharmonic Orchestra and New Orleans Museum of Art. *NolaVie* originally published on *NOLA.com*, until creative items such as poetry and creative writing did not fit with the website's editorial. *NolaVie* was born after securing seed funding from the McCormick Foundation. Like most cultural media entities, such as *OffBeat* and WWOZ radio, *NolaVie* attracts an international audience while providing coverage that meets the cultural needs of the city. In the last two years, 40 percent of the *NolaVie* audience is local, while 60 percent is global. *NolaVie* is an example of a hyperlocal model that depends on voluntary submissions from contributors who also cover "cultural beats" such as cycling and the film industry. The website publishes stories daily during the week and also sends out newsletters on a weekly basis to subscribers.

The emergence of these alternative forms of media also redefined traditional journalistic categories of news such as the concept of "alternative." Kevin Allman, editor of *Gambit*, highlights "maybe 'alternative' is now the *Uptown Messenger* or *The Lens* that go to unsexy meetings. Maybe that is the alternative to the mainstream. Before it used to be subjects that people never paid attention to, and now they've become bedrock" (personal communication, February 21, 2013).

2012 ONWARD—COMPETITION

By 2012, the city's leading news media entities adjusted to the new dynamics of competition in the digital sphere, while the hyperlocals worked on establishing their audiences and sustaining themselves financially. The announcement in May 2012 of a reduced *Times-Picayune* publication triggered public concerns about the demise of a valued watchdog and whether less independent reporting would impact an informed citizenry and the future health of democracy in New Orleans. Furthermore, Advance's new strategy, which involved cutting resources at the newspaper and investing new resources in the digital company *NOLA.com* drew criticism from all circles within and outside the media industry.

Former *Times-Picayune* reporter John McQuaid (2012) wrote in *The Atlantic*, that the new model is not about journalism but about clicks: "This can mean a hamster wheel ethic with staffers churning out blog posts, tweets, and video snippets 24/7, with little time to go deeper." The local news media reacted through increased intense collaboration and competition, as they tried filling the perceived news gaps and emulating well-loved traits of *The Times-Picayune* such as long form pieces of investigative journalism. According to Mintz, the new phase in this news evolution offers further opportunities for media entities to engage in both competition and collaboration. He states, "I like how we try to scoop each other. We help and cannibalize each other online" (Mintz, personal communication, October 15, 2012).

Fierce competition manifested itself in many forms and levels. At the top, the owners of *The Times-Picayune* saw that digital technology created "opportunities for competitors to come out of nowhere." In a multifarious digital news environment, *Times-Picayune* editor Amoss observes the news providers "intensely compete for reader's time and attention." He continues, "the competition is so manifold right now. TV station websites are very much in the breaking news game. If something happens in New Orleans, you can count on WWL, WVUE, WDSU, and *NOLA.com* to be on top of it right away" (Amoss, personal communication, April 25, 2013). The *NOLA.com* model is based on the idea that in the twenty-first century digital news ecosystem, a leading news provider breaks news the fastest and the most frequently. For example, the general assignment reporter at WWL-TV places stories onto the Web before airing on television. News director, Bill Siegel, emphasizes the importance of breaking news on social media before broadcast as a means of "keeping rolling, 24/7" (personal communication, February 15, 2013). Similarly, WWL (AM) takes the same approach in breaking news on social media, especially if a story is not ready for broadcast on radio.

In response to *NOLA.com*'s strategy, WWL-TV developed a competitive news model, which involved snapping up award-winning investigations reporter

Hammer and crime reporter Brendan McCarthy from *The Times-Picayune*, once the changes to the paper were announced. The idea was that these highly accomplished newspaper journalists would bring their loyal followings with them and inject more in-depth, independent journalism into their news products. Consequently, the WWL-TV website features more long-form news pieces with embedded video news inserts from the main news program. Tom Planchet, WWL-TV's online news and operations manager, states this direction reflected a change in people's online news reading habits. "One thing that I have noticed is that the average read time is 6.5 minutes, which is a lot. People were reading the entire things" (Planchet, personal communication, March 15, 2013).

The alternative media entities also took advantage of the changing labor market to replicate certain traits of a daily newspaper that strengthened their position in the market. Consequently, media outlets such as *The Lens* and *Gambit* hired established former *Times-Picayune* award winning reporters such as Bridges and Pulitzer Prize winning-environmental correspondent Bob Marshall, who came in early 2013. According to *The Lens* Editor Beatty, "Bob Marshall is a rock star. He's one of the few reporters that people know. It brings a lot of his cachet and he brings a lot of his brand" (personal communication, March 7, 2013). Meanwhile, *Gambit* took on former *Times-Picayune* columnist Stephanie Grace as a freelance contributor.

The digital news environment evolved into an even playing field for any form of media to actively compete with regard to breaking news stories and beat reporting. Hyperlocal news websites and some bloggers found themselves competing with some of the larger entities such as *NOLA.com*, who encroached on their beats or started covering aspects of their territory. *Nola Defender* editor Mintz states this is the nature of the beast in any news ecosystem as "all journalists are competitive. I get angry when I read things on our beat and they are published in places before us." However, he retains a pragmatic approach with regard to how he co-exists with leading news providers such as *The Times-Picayune* and *NOLA.com*. "I am not going to take down *The Times-Picayune*. As an 'alt' daily and a tabloid, I need *The Times-Picayune* in order to survive. You cannot be the 'alt' without the mainstream" (Mintz, personal communication, October 15, 2012).

A majority of the media entities interviewed for this chapter believe that the New Orleans news landscape still needs a standard news bearer in this rapidly changing news environment. Other news media entities such as the weeklies acknowledge that attempting to replace *The Times-Picayune* is a redundant exercise. *Gambit* Editor Allman states, "We shouldn't try to be a daily paper. I would rather we do our own stuff and not what someone else does" (personal communication, February 21, 2013). However, the intense dynamics of the changing news environment requires a different kind of stance from news organizations, especially for the sake of increasing sustainability.

SYMBIOSIS

Merrit (1998) defines symbiosis as two dissimilar organisms living in a mutually beneficial relationship (p. 48). The coming together of these forces also depends on compatible differences and shared goals. Previously, smaller news organizations such as the African American newspaper *Louisiana Weekly* formed symbiotic relationships with media entities including *The Lens*, and WWNO radio for the purpose of content sharing and ensuring that its stories on New Orleans' under-represented communities reached the mainstream. Other examples include collaborations between television and newspapers such as *Gambit* and WWL-TV. This relationship promoted the publication's brand to a wider audience, and the broadcast station benefited from fresh news content.

After the announcement of *The Times-Picayune* reduction, half of the entities interviewed for this chapter embarked on collaboration in an attempt to navigate through the sudden upheaval and uncertainty. In July 2012, the city's principal hyperlocal news websites formed the New Orleans Digital News Alliance. Beatty wrote on *The Lens* website that the alliance "strives to ensure that the city's digital press provides deep, current and breaking coverage of the community in a way that is true to its unique culture." The websites will regularly link to each other's stories as well as share resources in the live streaming of civic events such as charter school reporting and city hall meetings.

The various partnerships that formed in 2012 enabled each nonprofit entity to produce stories for the Web, broadcast and digital at a low cost and with minimum resources that benefit the entire community. For example, *The Lens'* partnership with WWNO allows Web stories to be produced on a radio platform that reach a wider audience. Because nonprofits are often dependent on limited funding sources, the survival of public and nonprofit media institutions could depend on forming symbiotic relationships with various partners, both for-profit and nonprofit. A 2012 survey by the LSU Manship School of Mass Communication's Public Policy Research Lab (PPRL) on the news consumption habits of more than 1,000 residents living in the New Orleans area, revealed that 9 out of 10 respondents had not visited *The Lens* website in the past week.

Since the announcement of the changes at *The Times-Picayune*, *The Lens* has adopted the role of a news agency in providing copies of its stories for free to nonprofit and for-profit partners including *The Advocate*, *Louisiana Weekly*, *NOLA.com* and Fox 8 WVUE. It also sees its role as a news aggregator within the local news ecosystem, compiling and disseminating the week's top stories from other outlets to its audiences and partners as a means of ensuring that the New Orleans population is fully aware of what is happening in the city.

The editors of *NolaVie* also believe in publishing content from other providers, and say that news aggregation is an effective model because it produces a domino

effect across the news ecosystem, which subsequently leads to a better-informed community. Peck, editor of *NolaVie*, says, "if you send people to new places and people send you to other places, it's to everyone's benefit. If you are counting clicks that's not going to work for you" (personal communication, March 7, 2013).

The partnerships can work well because these media partners share the same values and civic goals. But, the dynamics are not as straightforward when a non-profit and for-profit entity come together, but do not share the same medium. *The Lens* formed a partnership with Fox 8 WVUE, which provided the opportunity to collaborate on stories with the station's journalists. *The Lens* co-founder and reporter Gadbois says that relationship is effective when sharing resources. "Sometimes they can get interviews that we can't get and vice versa. We are able to share tape but still maintain integrity in terms of the story" (Gadbois, personal communication, January 25, 2013). But, Gadbois emphasizes, "we are trying to maintain the separateness and they are as well. We are not there to serve their needs. That's a good thing."

In 2013, New Orleans NPR station WWNO hired its first news director Eve Troeh, with a view of producing local news and more in-depth investigative features. WWNO is essentially a membership driven organization. It cannot directly compete with for-profit entities such as *The Times-Picayune/NOLA.com*, nor does it intend to try. As a result, WWNO's strategy involves seeking out partnerships while upholding values of public radio in "providing a space for trusted discussions and discourse" (Maassen, personal communication, April 11, 2013).

Previously, traditional news entities such as *The Times-Picayune* operated in a competitive news ecosystem in which news was determined "top down." It probably did not need partnerships for sharing content or resources, but may have occasionally engaged in collaboration. Hence, *NOLA.com* enters unknown waters in the twenty-first century news ecosystem, as it forms partnerships with competitors such as Fox 8 WVUE. Ricky Mathews, publisher of *The Times-Picayune* states, "the alignment of our brands together creates marketing opportunities," yet, he emphasizes that the relationship still retains a competitive edge (personal communication, April 25 2013). Meanwhile, Chris Claus, Vice President and General Manager of WWL (AM) who has a long running relationship with WWL-TV, remains skeptical about whether a partnership between television and newspaper presents equal benefits to both entities. "I don't know the value that gives to the television station. I think the value is more significant to *The Times-Picayune* because there is a big megaphone called Channel 8 that is talking to people that the paper might not as well reach" (Claus, personal communication, April 12, 2013).

Smaller for-profit entities such as *Gambit* and *OffBeat*, which operate on smaller economies of scale, are more laterally minded towards partnerships and collaborations. Jan Ramsey, editor at *OffBeat* explains, "You have to sell advertising to support the news organization. There is only so much money to go around,

when you partner with other entities, than it makes it little easier to provide content" (personal communication, April 18, 2013). Similarly, Hal Clark host of the African American news program Sunday Journal on WYLD-FM, says the current news environment presents "golden opportunities for black media such as the *New Orleans Tribune* and the *Louisiana Weekly* to develop partnerships with other media to increase their presence" (personal communication, April 4, 2013).

WHAT'S NEXT?

Most of the contributors interviewed, especially within legacy and hyperlocal news environments, report a marginal increase in Web traffic figures during 2012 and on social media. Some gave percentage and figures, while others were either reluctant or did not give an indication of figures. The measurements of Web traffic across outlets are not clean or consistent. However, these marginal increases in percentages, visitors per week or page views do reflect the overall trend in the U.S. toward increased use of the Internet for information. However, in New Orleans, the PPRL survey (2012) revealed that local television remains the main source of news and information for the local community. Couple this with the lower access rates to the Internet, and the uptake of alternative news sources appears slow compared to the residents in other U.S. cities who rely on a wider combination of platforms such as social media, blogs and local television websites (Miller, Rainie, Purcell, Mitchell & Rosenstiel, 2012). These increases also cannot be directly attributed to the changes at *The Times–Picayune* in 2012. Some of the entities, such as *NolaVie*, state that increasing exposure through partnerships with bigger and different news entities does have a positive impact on traffic figures.[1]

In 2013, more changes in the media ecosystem occurred that add to the dynamic environment. The signs of a newspaper war emerged as Baton Rouge's *Advocate* re-launched in the crescent city under the ownership of New Orleans businessman John Georges. His recruitment of former *Times–Picayune* talent and pro-active consultations with the city's civic leaders suggests that he intends on picking up from where the daily *Times–Pic* left off. Additionally, the NOLA Media Group announced the launch of a new printed, tabloid publication called *TP Street*, on the days originally without a *Times–Picayune*.

The question remains as to whether a daily newspaper can reclaim the laurels as a leading news provider in a twenty-first century digitally oriented and pluralistic news ecosystem. The post-Katrina news environment now comprises many watchdogs as opposed to one medium keeping a watchful eye on the city's civic well-being. A majority of the editors/producers interviewed for this chapter acknowledge that the news ecosystem needs leading news providers. Most state the role belongs to a multimedia operation such as *NOLA.com* or WWL-TV, who have

the resources and the ability to reach all audiences across all platforms. Currently, the local news ecosystem of New Orleans may appear in a state of fragmentation and uncertainty as news entities aggressively resort to symbiosis and competition as means of reaching every New Orleans citizen.

In an analogy apt to New Orleans, McChesney and Nichols (2011) describe the twenty-first century news ecosystem as a "great jazz performance." The citizen journalists and hyperlocals act as "improvisers that push the music to the edge." The professional journalists, whether they are in the alternative or mainstream news, "play the melody and the rhythm section." They continue, "The improvisers just make noise without the rhythm and music section. Eventually, both players feed off each other and produce genius" (2011 p. 91). However, this synchronicity also depends on mutual acknowledgement of each other's existence and the appreciation of the value each entity brings to New Orleans. Healthy competition and symbiosis between various entities ensures that people in New Orleans get a diversity of choice for news, which is essential to the overall civic well-being of the city.

NOTE

1. Figures from the city's alt weekly *Gambit* show a 37 percent increase in readership in 2012. Meanwhile, the profit based hyperlocals report marginal increase in their traffic figures. *Nola Defender* reported a 35percent increase in traffic between 2012 and 2013. In October 2012, Robert Morris at *Uptown Messenger* states that his figures have been rising steadily since July of that year. He also set up *Mid City Messenger* in early 2013, which covers the Mid-City neighborhood in New Orleans. Rawls, who runs the entertainment hyperlocal *My Spilt Milk*, states that his figures doubled during the annual music festivals, yet growth has been slow due to competition from the arts and entertainment desk at *The Times-Picayune* and *NOLA.com*. Non-profits *NolaVie* and *The Lens* report increases in their social media, Web traffic and membership subscriptions. *The Lens* reported 147,334 visits to its website in 2012. *NolaVie* doubled its figures from 2011, receiving up to 5,000 visitors per week in April 2012. It's hard to gauge a real picture of how blogs are performing in the city because of their transient nature. Berry at *American Zombie* states that when he is writing, he attracts between 20,000 and 30,000 readers a month. Some of the blogging entities including sites such as *NOLAFemmes* and *Humid City* also report a slight increase in traffic. However, these increases do not compare to the figures of leading news providers. In 2012, WWL-TV reported 121 million page views, 1.054 million unique visitors and 91 million mobile page views.

REFERENCES

Anderson, C. W. (2010). Journalistic networks and the diffusion of local news: The brief, happy news life of the "Francisville Four." *Political Communication, 27,* 289–309.

Atton, C. (2004). *An alternative internet.* London: Edinburgh University Press.

Barlow, A. (2008). *Blogging America: The new public sphere.* Greenwood, Conn.: Greenwood Publishing Group.

Beatty, S. (2012 July 23). Four online newsrooms form cooperative to strengthen and promote journalism. *The Lens.* Retrieved from http://thelensnola.org/2012/07/23/new-orleans-dna-announcement/.

Beatty, S. (2012 August 13) WWNO-FM, *The Lens* shift collaborative strategy to play to strengths. *The Lens.* Retrieved from http://thelensnola.org/2012/09/13/wwno-lens-revised-nonprofit-newsroom/.

Compton, J. R. & Benedetti, P. (2010). Labour, new media and the institutional restructuring of journalism. *Journalism Studies, 11,* 487–499.

Curran, J. (2010). The future of journalism. *Journalism Studies, 11,* 464–476.

Davis, M. (2012 May 24). Poorer communities continue to suffer from broadband access—and related opportunity. *The Lens.* Retrieved from http://thelensnola.org/2012/05/24/broadband-acces/.

Downie, L. & Schudson, M. (2009). The reconstruction of American journalism. *Columbia Journalism Review.* Retrieved from http://www.cjr.org/reconstruction/the_reconstruction_of_american.php?page=all

Gadbois, K. & Cohen, A. (2011). Letter from the founders, *The Lens* annual report 2011. *The Lens.* Retrieved from http://thelensnola.org/about-us/.

Gutierrez, A., Ramani, M, V. & Marshall, K. (2012). New Orleans blogroll. *RisingtideNOLA.com.* Retrieved from http://risingtide*NOLA.com*/blogroll.php

Hagey, K. (2012, September 6). Times-Picayune is singing the blues to angry readers. *Wall Street Journal.com.* Retrieved from http://online.wsj.com/article/SB10000872396390443589304577638023262616192.html

Hammer, D. (2013, January 18). Former N.O. Mayor Ray Nagin indicted on federal corruption charges. WWLTV.com. Retrieved from http://www.wwltv.com/news/eyewitness/davidhammer/Nagin-story-guts-182242111.html.

HBO's 'Treme' spotlights *Lens* founder Karen Gadbois. *The Lens.* Retrieved from http://thelensnola.org/hbos-treme-spotlights-lens-founder-karen-gadbois/

Kaye & Quinn (2010 as quoted in Siles and Boczkowski 2012). Siles, I. & Boczkowski, P. J. (2012). Making sense of the newspaper crisis: A critical assessment of existing research and an agenda for future work. *New Media & Society, 14,* 1375–1394.

Kurpius, D. D., Metzgar, E. T. & Rowley, K. M. (2011). Defining hyperlocal media: Proposing a framework for discussion. *New Media & Society, 13,* 772–787.

Kurpius, D. D., Metzgar, E. T. & Rowley, K. M. (2010). Sustaining hyperlocal media: In search of funding models. *Journalism Studies, 11,* 359–376.

LSU Manship School of Mass Communication Public Policy Research Lab. (2012). The state of newspapers in New Orleans survey: Citizens' reactions to the loss of the daily *Times-Picayune.* Retrieved from http://sites01.lsu.edu/wp/pprl/files/2012/07/LSUTimesPicayuneSurveyReport_Final2.pdf

McChesney, R. W. & Nichols, J. (2011). The death and life of American journalism: The media revolution that will begin the world again. New York: Nation Books.

McCollam, D (2010, July 1). Up and down on the bayou. *Columbia JournalismReview.* Retrieved from http://www.cjr.org/behind_the_news/timespicayune_five_years_later.php?page=all and http://www.bestofneworleans.com/blogofneworleans/archives/2011/08/26/a-new-round-of-buyouts-at-the-times-picayune

McQuaid, J. (2012, June 20) Why a weak website can't replace a daily newspaper in New Orleans. *The Atlantic.com*. Retrieved from http://www.theatlantic.com/national/archive/2012/06/a-weak-website-cant-save-new-orleans-news/258393/.

Merritt, D. (1998). *Public journalism and public life: Why telling the news is not enough*. New York: Routledge.

Miel, P. & Faris, R. (2008). News and information as digital media come of age. Cambridge, Mass.: Berkman Center for Internet & Society.

Mitchell A., Purcell K., Rainie L. & Rosenstiel T. (2011). How people learn about their local community. Pew Research Center's Project for Excellence in Journalism and Internet & American Life Project. Retrieved from http://www.pewinternet.org/Reports/2011/Local-news.aspx

Miller C., Purcell K., Rainie L., Mitchell A. & Rosenstiel T. (2012). How people get local news and information in different communities. The Pew Research Center's Project for Excellence in Journalism and Internet & American Life Project. Retrieved from http://www.pewinternet.org/Reports/2012/Communities-and-Local-News.aspx

Nip, J. Y. (2006). Exploring the second phase of public journalism. *Journalism Studies, 7*, 212–236.

Nossiter, A. (2008, August 12). Amid ruined New Orleans neighborhoods, a gadfly buzzes. *NYTimes.com*. Retrieved from http://www.nytimes.com/2008/08/13/us/nationalspecial/13activist.html?_r=0&pagewanted=all

Papacharissi, Z. (2010). *A private sphere: Democracy in a digital age*. New York: Polity.

Plyer, A. (2011). What census 2010 reveals about population and housing in New Orleans metro area. *Greater New Orleans Community Data Center*. Retrieved from http://www.gnocdc.org/

Robinson, S. (2009). 'If you had been with us': mainstream press and citizen journalists jockey for authority over the collective memory of Hurricane Katrina. *New Media & Society, 11*, 795–814.

Sasseen J, Olmstead K & Mitchell A. (2013) The State of the News Media 2013: Digital—As mobile grows rapidly, the pressures on news intensify. Pew Research Center's Project for Excellence in Journalism. Retrieved from http://stateofthemedia.org/2013/digital-as-mobile-grows-rapidly-the-pressures-on-news-intensify/.

Schudson, M. (1978). *Discovering the news: A social history of American newspapers*. New York: Basic Books.

Shirky, C. (2008). *Here comes everybody: The power of organizing without organizations*. New York: Penguin Books.

Meanwhile, IN Alabama

Cuts and Hiring, Consolidation and Expansion

CHRIS ROBERTS

When *The New York Times* broke the news online on May 24, 2012, that the New Orleans *Times-Picayune* would cut print publication and slash staff in October, the story made no mention that Advance Publications' three Alabama newspapers and a Mississippi offshoot would do the same (Carr, 2012).

When the next day's *New York Times* was printed, its front-page story about Advance's plans trumpeted "New Orleans" in the headline and mentioned the paper in six of the first nine paragraphs. Only in the tenth paragraph did readers first learn about changes at *The Birmingham News*, *The Mobile Press-Register*, and *The Huntsville Times* (Carr & Haughney, 2012).

While New Orleans' community leaders lashed out at Advance's owners and tried to buy the paper, Alabama community leaders kept their mouths and checkbooks closed. While Crescent City citizens held rallies and spiked their yards with "Save *The Picayune*" signs, Magic City citizens stayed silent (Whitmire, 2012).

And three months into the change to three-days-a-week publication, *60 Minutes'* story about upheaval in the newspaper industry focused almost exclusively on New Orleans. Correspondent Morley Safer never said the word "Alabama," and Alabama-related images appeared for 10 seconds in the 12-minute story—less time than the obligatory shots of diners in fancy New Orleans restaurants and revelers dancing in Crescent City streets (CBS, 2013).

But as this chapter will argue, changes to the three Alabama newspapers are at least as monumental as the changes in New Orleans. Those changes have shifted how they operate and produce news, which by extension limits the amount and

quality of local news and information they provide to their communities. Changed forever are Alabama Media Group properties—the umbrella organization for Advance's three Alabama papers, the *Al.com* website, the *Mississippi Press* edition of the *Press-Register,* and its accompanying *Gulflive.com* site for the Pascagoula area. Those papers combined had nearly twice the circulation of *The Times-Picayune,* with Birmingham alone printing more than the post-Katrina *Times-Picayune,* according to March 2013 data from the Alliance for Audited Media (2013). Those papers cover a much larger geographic area, stretching more than 330 miles along Alabama's spine of Interstate 65. *Al.com* regularly draws more traffic than *NOLA.com.* And two-thirds of the 600 jobs cut came in Alabama, although precise numbers are squishy because some staffers were rehired.

As Alabama Media Group bifurcated into a digitally-focused information provider with legacy print products, it is still learning how to serve both markets in real time and with few trailheads. It has cut deeply even as it expands. It has consolidated newsgathering and production operations that once stood fiercely independent. It is redefining news, whether intentionally or not, with implications not yet understood. As the newspaper industry tries various and starkly different ways to reclaim psychic territory and income amid declining print fortunes and rising online readership, the Alabama model will be closely scrutinized as a model of what works and what does not.

This chapter, written by a former *Birmingham News* staffer from 1989–98, is based upon decades of following the paper and conversations with more than a dozen current and past employees, most of whom asked that they not be identified. Alabama Media Group's top officials would not agree to interviews with this author, but some are quoted from public meetings with constituent groups.

INSIDE FOCUS WITH AN OUTSIDE OWNER

The roots of Alabama Media Group's three newspapers run two centuries deep, and they maintained their traditions of independence well after Newhouse began buying the papers in the 1950s. *The Birmingham News,* long the state's largest daily, was founded 17 years after the city's 1871 start as a railroad, mining, and steel town (*The Birmingham News,* 1988). *The Huntsville Times,* founded in 1910, chronicled a sleepy cotton-growing community that boomed when the federal government moved rocket development there after World War II. Newhouse bought both papers in 1955 for $18.7 million (Marshall, 2010), nearly $160 million when adjusted for inflation. The 200-year-old *Mobile Register* joined Advance in 1966 (*Mobile Press Register,* 2002), the same year it bought *The Mississippi Press* (Ruddiman, 2012). Until a few years ago, the three papers kept their editorial

distance for more than four decades under the same owner, not sharing news stories, coverage plans, or even lists of job openings.

The out-of-state owners rarely interfered with the news decisions made at individual papers, allowing each to build its own personality independent of the others (Fibich, 1994). *The Times* gained a reputation as stolid, not unlike the engineers who flocked to Rocket City. "*The Times* was tied into the spirit of the community," said Bill Keller, executive director of the Alabama Press Association for 16 years and retired from the University of Alabama journalism faculty. "That town was used to bringing in people from all over the world and turning out leaders in a very short time" (personal communication, July 15, 2013).

The Register was quirky, befitting the home of the nation's first Mardi Gras and a deep part of a town where important families go back many generations. "They were covering news before Alabama was a state," Keller said. "When you picked up the *Mobile Register*, you knew you were in Mobile" (personal communication, July 15, 2013).

The Birmingham News, one of the nation's largest afternoon papers until switching to morning publication in 1996, operated as it if were still owned by the Hanson family, who managed the paper for four decades after selling to Newhouse in 1955 (Tomberlin, 2009). The century of Hanson leadership made the paper circumspect and button-down—one publisher forbade the word "butt" from *News* pages, all but challenging reporters to sneak it into stories. *The News'* conservatism put it on the wrong side of the civil rights movement during the 1950s and 1960s, downplaying coverage and even spying on citizens for police (McWhorter, 2013).

In May 1963, while Birmingham police made the front page of *The New York Times* and other papers for assaulting civil rights protesters with police dogs and fire hoses, Birmingham papers buried the stories inside. As Alabama native Hank Klibanoff, co-author of the Pulitzer-winning book *The Race Beat* about reporting the civil rights beat, told National Public Radio: "The only newspapers that I knew of that did not see this as a front-page story were the *Birmingham News* and the *Birmingham Post Herald*" (Cornish, 2013). *The News* did not publish most of its civil-rights-era photos until decades later, after a college intern found negatives in boxes as the paper moved to new offices across the street in 2006.

At its zenith, *The News* had reporters spread across Alabama, and correspondents in Mississippi and Washington, D.C. It kept competitors at bay by introducing "zoned" editions in the 1970s that covered the area's many municipalities, although coverage was cut drastically in the 2000s. *The News'* two Pulitzer Prizes, for commentary in 1991 about Alabama's regressive tax system and investigative reporting in 2007 for uncovering corruption in the state's community college system, were the only won by Advance's Alabama papers.

The papers' higher-than-average salaries and relative freedom turned them into lifetime destinations for many who could have become stars in larger markets.

Until a mid-1990s hire broke a decades-long streak, Birmingham did not import a top-level editor from another paper; some editors never worked anywhere else. At an annual ceremony, workers reaching 25 years' service received a grandfather clock or similarly high-priced gift, and their names joined the full-page house ad each year congratulating the dozens of long-serving employees. Advance's non-union employees received a written promise that "you will not be laid off and you will not lose your job as a result of new equipment, technological advances or lack of work so long as the newspaper continues to publish" (*The Birmingham News*, 1989).

They didn't see what was coming.

CHANGES COME SLOWLY, THEN FAST

The first changes to Advance's arrangements at its Alabama properties came in 1997, when its Alabama Live.com division opened in Huntsville as the central Internet destination for all three papers. The division operated independently from the papers but relied upon them for its shovelware content. Papers' management seemed to dislike the arrangement, according to published court testimony and sources interviewed for this chapter. They saw it as a distraction from print, a muddying of the distinction among papers, and a financial drain that took content that readers would otherwise buy without returning revenue. But like readers everywhere, Alabama readers responded to online news—even in a state that ranks 47th nationally in broadband access (U.S. Economics and Statistics Administration, 2011).

America's great newspaper revenue slide—down more than half since 2006 to an estimated $22.5 billion in 2012—caught Newhouse, too (Edmonds, Guskin, Mitchell & Jurkowitz, 2013). The company does not release financial information, but the papers still turned profits during the freefall. Moreover, two Alabama properties had major capital outlays just before the decline. Mobile spent $65 million in 2002 for new buildings and a $20 million press. Birmingham paid nearly $41 million in 2005 to end its joint-operating agreement and close Scripps' *Birmingham Post-Herald* (The E.W. Scripps Company, 2006), a year before *The News* crossed Fourth Avenue North from its 1917 building to its new 110,000 square-foot building, valued at $21 million (Carlton, 2006).

As the revenue slide began, Newhouse responded by assuming more control of its newspaper operations and bringing in new managers, often McClatchy Co. executives. The first round of buyoffs, furloughs and pay cuts began in 2008. The company's pension contributions ended. A year later, Advance revoked its job security pledge. Advance Publications owner Donald Newhouse later testified that the pledge—printed in employment handbooks and reiterated in

annual Christmas letters to employees—was a promise, not a binding legal contract (Sayre, 2011a). Mobile publisher Howard Bronson was replaced in August 2009 by former McClatchy publisher Ricky Mathews, the first time Advance put a single in-state executive in command of all of its Alabama newspapers. Bronson sued over his dismissal, claiming the Advance pledge should have protected his job. Before reaching an out-of-court settlement, Advance attorneys argued during trial that Bronson, then 74, opposed the company's Internet strategy (Sayre, 2011b).

Other publishers went more quietly. In Birmingham, Victor Hanson III announced his retirement in September 2009, at age 53; his replacement was Pam Siddall, a McClatchy veteran who was publisher of the *Wichita Eagle*. Bob Ludwig was 63 when he retired as Huntsville publisher two years later; he was not replaced.

The late 2000s also brought the first sustained cooperation among Alabama papers, a cost-cutting move as papers began sharing their content and the coverage of Alabama and Auburn athletics, which is far and away the most popular content on the papers' website. An early champion of pooling resources was Kevin Wendt, a former editor at McClatchy's *San Jose Mercury News* who became Huntsville's editor in 2008, and was Alabama Media Group's original vice president of content. "The Auburn reporter had gone just before I got there," he said during a talk to University of Alabama students in March 2013. "Everybody on staff said, 'You need to go hire an Auburn reporter.' I said, 'Birmingham has at least one. Mobile has at least one. Why couldn't we work together and share content across the papers? How many Auburn reporters do we need?'" Similar consolidation was planned for political coverage in Montgomery and Washington, D.C., with a smaller stable of writers under an editor who served all three masters.

Al.com continued expanding in its first 15 years, generally staying separate from newsroom operations even after moving key operations to Birmingham (but not in *The News'* building). Only a few newspaper reporters and editors could post directly to the site, and each paper devoted on-site liaisons in newsrooms to feed *Al.com* and to wrangle copy from the majority of reporters still focused on the print edition.

Then came May 2012. Advance left signs of impending changes as early as 2009, such as job cuts and reshuffling at its small-by-comparison Michigan properties (Beaujon, 2012), but Advance gave no indication that Alabama and Louisiana would be next and more severe. Several people contacted for this chapter, including people who once worked for or still work for Alabama Media Group, criticized Advance for not better leading newsrooms into the digital age. They said Advance's hands-off policies allowed insular newsroom cultures where risks were not rewarded, and employees were not encouraged to be part of national conversations about the changing news industry. Besides columnists, few print journalists were "branded" as personalities by contemporary definitions and instead kept anonymous to the public but for their bylines, a far cry from today's

online operation where nearly every reporter's picture is posted with every story. This was particularly true in Birmingham, where management wanted no one staffer to be "bigger" than the paper and went decades without a metro columnist. Trend data about the industry or the health of the papers were rarely shared, and newsrooms were later than some in the industry to integrate their online and print operations.

A PRE-GAME FUMBLE

Chuck Clark is among the few who will speak freely now. The former *Birmingham News* managing editor resigned to become the University of Western Kentucky's head of student media a few days before the breaking *New York Times* story told Advance workers what Advance had not—400 Alabama jobs would be gone. *The Times'* scoop came weeks before Advance planned to make its announcement, catching management flatfooted and seemingly amazed that news leaks. Nearly three weeks after the story broke, 38 of 52 newsroom jobs in Huntsville were cut; in Mobile, it was 50 of 70 (Myers, 2012). Clark was in *The News'* building on June 12, 2012, when the company dismissed 65 of 112 newsroom workers. *News* staffers went one at a time into meetings just off the newsroom floor, where they learned their employment fate from managers and then walked back into the public space.

"It was terrible," Clark said (personal communication, February 27, 2013). "It was like everybody's mom passed away. There were people who left the newsroom that day because they couldn't cry anymore."

The severings were not immediate. Most of the soon-to-be-dismissed workers were told in June that they had to stay until September 30 to receive a package of 1.5 weeks' pay for every year at the paper, plus insurance and outplacement services. It was a mixed message of "we don't want you, but you can't leave yet," similar to Alabama textile workers who left the country to teach Mexican and Chinese workers how to operate the looms that once ran in American mills. Some past and current newsroom employees tell of "walking dead" jokes, survivor's guilt, the occasional bit of sabotage, and a thoroughly unproductive summer.

The changes were not fully or frankly explained to Alabama readers. After *The New York Times'* scoop on Wednesday and Thursday, *The Times-Picayune* led its Friday, May 25, paper with the all-caps, bold "NEWSPAPER TO MOVE FOCUS TO DIGITAL" headline and a staff-written story focusing on the city's reaction to the news (Pope, 2012). Over the objections of many newsrooms, including one then-employee who called it "demoralizing and shameful," the Alabama newspapers' journalists did not cover their own story on the first day. Instead, each paper's front page printed the same "from staff reports" press release masquerading as a news story that mentioned print cuts at the end of the second paragraph and

offered no specifics on job cuts (*The Birmingham News*, 2012). *Mobile's* headline, "Exciting changes for our readers ..." was mocked by nationally syndicated columnist Paul Greenberg (2012) as a credibility-killing spin that "amounts to a cruel joke on long loyal readers and those who write for them honestly and directly."

By holding themselves to a lower standard of accountability than they hold others on news pages, by defaulting to the posture of a privately held company in this most public of acts in this most public of forums, it is not surprising that Alabama community reaction was blasé. An editor at alternative-weekly *Weld for Birmingham* (later hired by *The News*) in June 2012 offered reasons ranging from the paper's bad history on civil rights to its bland contemporary report, along with the usual suspects of confirmation bias, and *Al.com's* virtual giveaway of the print product (Whitmire, 2012). *The News'* John Archibald, then a metro columnist and now a community engagement specialist, summed it up by writing that "New Orleans has identity and pride. Birmingham has division and hostility" (Archibald, 2012).

Indeed, while New Orleans rallies around its peculiarities, LSU and Saints football, its sufferings, and its post-Katrina *Times-Picayune*, Birmingham's metro area is marked by its preternatural ability to divide and be conquered. Jefferson County's nearly 700,000 residents live in 38 municipalities. Their children are educated in 12 separate school districts. They are 53 percent white and 42 percent black, meaning some readers perceive the paper to be simultaneously fawning yet racist. The metro area's politics veer from deeply conservative to wildly populist, meaning an editorial page that published both the right's Cal Thomas and the left's Cynthia Tucker is simultaneously too much, yet not enough for readers. Residents wear Alabama's crimson or Auburn's orange, meaning their newspaper obviously hates their team and loves the team they hate. Their parents and grandparents, and now a few of them, worked for U.S. Steel and similar out-of-state companies that shipped profits north and perpetrated massive layoffs when technology and external market forces changed. So in the case of the out-of-state-owned *Birmingham News*, what's one more? Besides, when they want news, they can get it for free online.

Former Alabama Press Association head Keller, who said he remains encouraged by strong reporters who were retained and some "top-flight young reporters joining the staff," criticized Newhouse's surprise announcement. "The worst thing is how they did it," he said. "They had no consultation with the community, or their advertisers as far as I know, if only to say, 'This is going to happen.' They didn't meet with the chambers of commerce.

"They didn't care. They really didn't care. It showed an arrogance. I use the old chip-on-my-shoulder Southern term 'carpetbagger,'" he said, describing Newhouse as a company that sent hundreds of millions of dollars of profit from Alabama to support its highbrow magazines. "I don't want them to fail, but they

didn't consult anyone here, and that's what rankles me" (personal communication, July 15, 2013).

MANAGEMENT'S PLAN: MORE DIGITAL, LESS INK, FEWER PEOPLE

Nostalgia gave way to the math of paper sales and Web traffic when Alabama Media Group began the nuts-and-bolts task of implementing Advance's directives. "The audiences and advertisers were already telling us where they wanted us to go anyway," said then-content vice president Wendt, noting that 75 percent of the company's revenue came from Sunday, Wednesday, and Friday papers. "We didn't just step back and say, 'OK, let's make up something new.'" The papers publish on those three days, while *The News* also sells a Saturday "bulldog" newsstand-only edition containing much of Sunday's content.

The process of newsgathering and distribution was new, as were the corporate entities created to do it. Advance built Alabama Media Group to gather news under Cindy Martin, an Alabama native who led *Al.com* since its inception. Former *Birmingham News* publisher Siddall led Advance Central Services Alabama, which handles the distribution and business side. Wendt was in charge of content. But all three moved to different Advance corporate jobs within 10 months of the big change. Martin became Advance Digital's senior vice president of business development in New Jersey. Wendt moved north to become Advance Digital's director of special projects. Siddall became Advance Publication's vice president of local digital strategy, but was briefly president of Alabama Media Group until July 2013, when Matt Sharp was promoted from vice president of sales and marketing at Advance's Michigan operations (*The Birmingham News*, 2013b).

Alabama Media Group divided further, into the big statewide staff that collects news and keeps the digital focus, and into the smaller publishing hub in Birmingham that builds 12 print newspapers each week for audiences in Huntsville, Mobile, and Birmingham. Along the way, the company redefined nearly every job and changed nearly every process. Wendt said the task was to flip mindsets from the focus on each night's 10:30 p.m. print deadline to a continuing "deadline-is-now" mindset. Speed matters in the search engine placement that delivers a third of the site's traffic, and frequent updates bring more frequent readers. It meant hiring new staffers, and further training the ones who were retained, to maintain traditional journalistic skills while working across formats.

The transition also gave Advance other ways to cut costs of personnel and fixed assets. Along with production-side cuts, many of the sliced jobs belonged to mid-level editors and higher-paid reporters, photographers, copy editors, and

artists with at least a decade at their papers. Instead of a single reporter for a major community in a coverage area, newer, younger reporters cover multiple towns. Redundancies at the papers were reduced to fewer people or a single staffer. Many print pages are duplicated across papers.

The company shuttered its Huntsville press, instead printing 100 miles away in Birmingham. It also put its buildings on the market, with its still-new buildings in Birmingham and Mobile at more than $21 million each (Kent, 2013) and Huntsville's 57-year-old site for $6 million. Huntsville employees first moved to its much smaller "hub" near downtown, and Birmingham and Mobile workers have moved to smaller "hubs," too.

Further long-term savings came when Advance trimmed future pension obligations by offering former employees not yet of retirement age, including this writer, the opportunity to take cash payouts or smaller pensions immediately and leave the pension program.

At the heart of the newsroom cuts were line editors, who directly supervise reporters and often are the first readers of reporters' stories. Costs were part of the issue, but in the new era reporters are more autonomous and post content, often without editing, and make editors seemingly redundant. Each reporter has a laptop for writing and uploading into the Movable Type blogging platform, and a smartphone for photos. Few have newsroom desks, and fewer have assigned desks, because they have been told to work from the field.

"At the end of the day, we're building an organization where the reporters are more autonomous than they have been in the past … What we want to get to is a place where [a reporter] knows that X is important, alerts the editor, begins work on how it's going to come together, and writes in a more iterative form," Wendt told University of Alabama students in March 2013. "We don't package and bundle everything up in one giant thing to share with readers … It's a much more live environment. We want to be a place where people can come and know that new information is being reported on a regular basis."

Once content goes online, "curators" who once were editors at their respective print papers come along behind, shaping online posts into stories fit for conventional print because most reporters generally do not write with print in mind. Designers still do their work, often scrounging through stock photos to replace art once delivered by traditional still photographers, most of whom were dismissed. (The new philosophy is to let photographers do what they do best, use staff writers' photos when possible, and let print designers decide how best to package the work, Wendt said.) The four remaining copy editors originally did little actual copy editing and instead inspected page proofs, but major print errors led to changes in early 2013 that required copy editors to read more stories. Among the most noticed editing error came in March 2013, when American Copy Editors Society blogger Charles Apple pointed out four errors in the headline, deck head, and first

paragraph of a *Huntsville Times* front-page centerpiece. He wrote: "[I]t's difficult for me to see rookie mistakes like this—after the cuts and trims this company has made to its print products—and remain convinced Advance is dedicated to putting out quality papers" (Apple, 2013).

A few days before Apple highlighted that error, Wendt noted that the company does not "edit a story layer upon layer" before print publication. "We need a group that knows the story is there, gives it the edits it's supposed to have, asks questions about it, improves it, and then packages it for a print edition that now in a three-day atmosphere is not going to be the breaking news vehicle that, frankly, it hasn't been for many, many years," he said.

NO DIRECT THREATS, BUT THREATENING OTHERS

Despite the cuts, and unlike the Baton Rouge *Advocate* march into New Orleans, Advance's Alabama properties have seen little movement by traditional competitors. The lone exception so far is *The Tuscaloosa News*, which began seven-day home delivery and news rack service in parts of Birmingham shortly after October 2012, and may expand there to answer what AMG's Wendt acknowlededes is the chief complaint of readers: "If you go deep enough with people, you'll get to, 'I just wish it was seven days.'" *The Tuscaloosa News* has not publicly discussed its plans, if any, for further expansion.

As Alabama Media Group cut, it also began expanding into what it calls "emerging markets" where it traditionally sells few papers. Its growth included new bureaus in Montgomery, and in east and west Alabama, with plans for more growth to the site, a larger statewide impact, and more appeal to statewide advertisers. "We're trying to look forward to see where the audience is," said Scott Walker, the company's news director for emerging markets. The daily newspapers in those emerging markets generally have paywalls on their websites. Advance has no paywalls and no plans to introduce them, instead relying on driving traffic through frequent updates and anonymous, nearly unlimited reader comments. As of March 2013, *Al.com* ranked third in traffic among Advance sites but tops in user comments, usually thanks to football, Wendt said.

Writers and editors are encouraged to take part in comment forums, answer questions, and update mistakes or check out leads suggested by readers. But Clark, and others, say the free-for-all has hurt the news product. Research suggests that reader comments harm story, and by extension, storyteller credibility (Anderson, Brossard, Scheufele, Xenos & Ladwig, 2013). Heuristics does, too: "You can have great journalism, but if you allow people to go unchecked with commenting, it undermines everything you're doing," Clark said. "It is changing the very fabric of society. People with the most extremist, isolationist views have the same volume

power as someone who tries to make reasoned arguments. Part of what journalism is, is filtering through that" (personal communication, February 27, 2013).

One change to journalism has been the traditional task of story selection—deciding what deserves front-page attention, what goes inside, and what is spiked. Journalists still use traditional news values when placing stories atop *Al.com*'s homepage, but much of the site's content lands on pages based on when they were posted, not how important they are. Wendt said reader habits have made a focus on the home page almost an afterthought, because just 30 percent of a typical month's 65 million page views start at the front door. The rest come in through the "side door," sent by social media or a search engine (LaFrance, 2012). "The focus that we have around 'teeing content up'—the editor's duty of 'we choose what's important, and readers come to us because we give them some of our guidance'—is fundamentally being changed by readers who go to a search engine, type in a topic, and are we the first one that shows up there," Wendt said.

REDEFINING NEWS, AND JOURNALISM

The definition of news changes when the goal is to feed the unquenchable beast of the Web, where clicks are counted and reported back to content providers, and where generating buzz and comments is key. Immediacy tops impact; quantity tops quality; information can trump knowledge. The reporting staff has had highlights, such as coverage of Alabama's utility rate structure and a legal battle over access to government records after a sign fell inside the Birmingham airport, killing a 10-year-old and injuring his mother and two siblings (*The Birmingham News*, 2013a). But the site also shows a greater reliance on rewritten press releases and aggregated content. Instead of focusing exclusively on local content, some *Al.com* staffers are doing their own writing (or rewriting) of stories likely to draw hits and comments. An example is the George Zimmerman trial of Summer 2013, when *Al.com* posted hundreds of updates—nearly all from *Al.com* staffers who rewrote wire stories or watched the Florida trial on television. Meanwhile, Alabama Media Group has no reporter in Washington, D.C., after several reporters left in the last part of the 2000s and the lone remaining reporter was not retained.

Clark said he hopes Alabama Media Group's model can work, but "it won't work in the long term if you abandon public-service journalism. I think a model with fewer days in print and a richer mixture of immediate stuff on the Web could be a good thing, and it could be a recipe for success in the news business, depending upon how it's approached. But how it's being approached in Alabama, it may prove that that mixture they're using is not that recipe for success" (personal communication, February 27, 2013).

In an industry once known for fretting about dropping "Hagar the Horrible" or changing a font size, Alabama Media Group if nothing else deserves credit for moving to a brave new Internet world. It has broken out of its boxed-in mindset and economic model, betting big on the Internet. Circulation reports are mixed between March 2012 and 2013, comparing an equal of months before the change to after: Sunday circulation in Birmingham fell 3.3 percent, to 167,528. Mobile rose 3.3 percent, to 106,756. Huntsville dropped 7.2 percent, to 63,175 (Poe, 2013).

In the business that famous Kansas editor William Allen White said no one can do to everyone's satisfaction (along with making love and stoking a fire), the newspapers' move to a digital focus came with collateral damage. Some former employees remain bitter. Some current employees have lost trust in a company that did not keep its promises. Reader reviews are mixed. Said Keller: "I've heard many people tell me that they're dropping their subscriptions because they pick up the paper and there's nothing new in there. They have already read it online" (personal communication, July 15, 2013).

But Alabama Media Group, even as it acknowledges its early stumbles, defends the change as the best way to provide any sustainable journalism in its markets, and reminds readers that it still has more journalists than all other newsgathering bodies combined. "Nobody is predicting that this will magically turn around the entire industry," Wendt told University of Alabama students six months after the change. "But at least it puts us in the position where we are building audience and a business around the digital landscape in a way we weren't previously."

REFERENCES

Alliance for Audited Media. (2013). Newspaper total circulation. Retrieved from http://abcas3.auditedmedia.com/ecirc/newsform.asp

Anderson, A. A., Brossard, D., Scheufele, D. A., Xenos, M. A. & Ladwig, P. (2013). Crude comments and concern: Online incivility's effect on risk perceptions of emerging technologies. *Journal of Computer-Mediated Communication*. Advance online publication. doi: 10.1111/jcc4.12009

Apple, C. (2013, March 15). One page-one centerpiece. One headline and deck. Four errors. Retrieved from http://apple.copydesk.org/2013/03/15/one-page-one-centerpiece-one-headline-and-deck-four-errors

Archibald, J. (2012, June 5). Why no protest in Birmingham? Retrieved from http://blog.al.com/archiblog/2012/06/why_no_protest_in_birmingham.html

Beaujon, A. (2012, August 9). What happened to Advance's papers in Michigan? Retrieved from http://www.poynter.org/latest-news/mediawire/183986/what-happened-to-advances-papers-in-michigan/

Carlton, B. (2006, August 11). *News* opens building for new century, *The Birmingham News*, p. A1.

Carr, D. (2012, May 23). New Orleans newspaper said to face deep cuts. Retrieved from http://mediadecoder.blogs.nytimes.com/2012/05/23/new-orleans-paper-said-to-face-deep-cuts-and-may-cut-back-on-publication/

Carr, D. & Haughney, C. (2012, May 24). New Orleans newspaper scales back in sign of print upheaval, *The New York Times*. Retrieved from http://www.nytimes.com/2012/05/25/business/media/in-latest-sign-of-print-upheaval-new-orleans-paper-scaling-back.htm

CBS. (2013, January 6). Outcry after NOLA's daily paper cuts back. Retrieved from http://www.cbsnews.com/8301-18560_162-57562200/outcry-after-nolas-daily-paper-cuts-back/

Cornish, A. (2013, June 18). How the civil rights movement was covered in Birmingham. Retrieved from http://www.npr.org/blogs/codeswitch/2013/06/18/193128475/how-the-civil-rights-movement-was-covered-in-birmingham

Edmonds, R., Guskin, E., Mitchell, A. & Jurkowitz, M. (2013, July 18). Newspapers: Stabilizing, but still threatened. Retrieved from http://stateofthemedia.org/2013/newspapers-stabilizing-but-still-threatened

Fibich, L. (1994). A new era at Newhouse. *American Journalism Review, 16*, 21–27.

Greenberg, P. (2012, May 31). Exciting changes, or: How not to report the news. Retrieved from http://articles.chicagotribune.com/2012-05-31/news/sns-201205311830—tms—pgreenbgtp—u-a20120531-20120531_1_newspaper-bad-news-front-page

Kent, D. (2013, January 25). Prices for *Birmingham News* and *Mobile Press-Register* buildings top $21 million. Retrieved from http://blog.al.com/wire/2013/01/birmingham_news_building_price.html

LaFrance, A. (2012, August 22). Coming in the side door: The value of homepages is shifting from traffic-driver to brand. Retrieved from http://www.niemanlab.org/2012/08/coming-in-the-side-door-the-value-of-homepages-is-shifting-from-traffic-driver-to-brand/

Marshall, M. (2010, March 21). New Times home fulfilled dream, *The Huntsville Times*, p. H3. Retrieved from http://www.scribd.com/doc/36140648/The-Huntsville-Times-100th-Anniversary-Commemorative-Edition

McWhorter, D. (2013, January 21). Good and evil in Birmingham, *The New York Times*, p. A21. Retrieved from http://www.nytimes.com/2013/01/21/opinion/good-and-evil-in-birmingham.html

Mobile Press Register. (2002, June 30). A history of *The Mobile Register*. Retrieved from http://www.al.com/specialreport/mobileregister/index.ssf?press1.html

Myers, S. (2012, June 12). What the future of news looks like in Alabama after Advance cuts staff by 400. Retrieved from http://www.poynter.org/latest-news/top-stories/177191/what-the-future-of-news-looks-like-in-alabama-after-advance-cuts-staff-there-by-400/

Poe, R. (2013, April 30). *Birmingham News* reports higher circulation since switch from daily. Retrieved from http://www.bizjournals.com/birmingham/blog/2013/04/alabama-newspapers-report-readership.html

Pope, J. (2012, May 25). Loss of daily newspaper stirs passions in the city, *The New Orleans Times-Picayune*, p. A1.

Ruddiman, S. (2012, September 29). *Mississippi Press* prepared to turn another page in its rich history of providing community news. Retrieved from http://blog.gulflive.com/mississippi-press-news/2012/09/mississippi_press_prepared_to.html

Sayre, K. (2011a, April 7). Donald Newhouse: A promise is not a contract. Retrieved from http://blog.al.com/live/2011/04/former_birmingham_news_publish.html

Sayre, K. (2011b, April 9). Former *Press-Register* Publisher Howard Bronson's civil trial ends in settlement. Retrieved from http://blog.al.com/live/2011/04/former_press-register_publishe_1.html

The Birmingham News. (1988). *The Birmingham News: Our first 100 years*. Birmingham, AL: Birmingham News Co.

The Birmingham News. (1989). *The Birmingham News Company employees benefit handbook*. Birmingham, AL: The Birmingham News.

The Birmingham News. (2012, May 25). Changes coming to The News: 24/7, 3-day delivery in fall, *The Birmingham News*, p. A1.

The Birmingham News. (2013a). Fatal airport sign collapse. Retrieved from http://topics.al.com/tag/fatal%20airport%20sign%20collapse/index.html

The Birmingham News. (2013b, July 25). Matt Sharp named Alabama Media Group president, *The Birmingham News*. Retrieved from http://www.al.com/business/index.ssf/2013/07/matt_sharp_named_alabama_media.html

The E.W. Scripps Company. (2006). Form 10-K. Retrieved from http://library.corporate-ir.net/library/98/986/98686/items/189728/200510K.pdf

Tomberlin, M. (2009, December 1). Victor Hanson III retires as publisher of *Birmingham News*. Retrieved from http://blog.al.com/businessnews/2009/12/hanson_retires_as_publisher_of.html

U.S. Economics and Statistics Administration. (2011). Exploring the digital nation: Computer and Internet use at home, November 2011. Retrieved from www.esa.doc.gov/Reports/exploring-digital-nation-computer-and-internet-use-home

Whitmire, K. (2012, June 5). New Orleans rallies around *Times-Picayune*, but where's the outrage in Birmingham? Retrieved from http://weldbham.com/secondfront/2012/06/05/new-orleans-rallies-around-times-picayune-but-wheres-the-outrage-in-birmingham/

Digital Content & the Fourth Estate

Is Digital Content Better?

ANDREA MILLER & YOUNG KIM

The newspaper industry is the fastest shrinking industry in America (Zara, 2012). Alan Mutter, a veteran news executive who now consults and writes a blog titled Newsosaur, likened the plunge in revenue to a person who loses half of his blood; the situation, according to industry experts and scholars, is critical (personal communication, February 15, 2013). As advertising dollars flee print for the cheaper, targeted, mass penetration of online, newspapers similar to *The Times-Picayune*, are making the move to online in dramatic fashion. In 2009, Advance Publications Inc. began its downsizing at papers in Michigan. It started a ripple effect across four other states and six papers—Alabama, Pennsylvania, Louisiana, and New York (Yu, 2012). Internal conversations, according to *Times-Picayune* publisher Ricky Mathews, led to the slow realization that the industry had tough choices to make. "We can suffer death by a thousand cuts or we can do something profound," said Mathews. "And our company chose to do something profound" (personal communication, April 25, 2013).

That profound move was to stop seven-day-a-week publication and focus on 24/7 digital delivery of news. Mathews makes it clear that the move was not "digital-first," but "digitally-focused." "Because there's a difference," said Mathews (personal communication, April 25, 2013). "We're not saying that the printed newspaper's not important. In fact, we're saying it's extraordinarily important to us. It has to serve readers, like never before. But our reporters and editors live in a digital world. They don't work on deadlines. It's extremely important for us to be able to tell people what we know when we know it, as opposed to holding stories for a printed publication" (personal communication, April 25, 2013).

The business side of the industry argues the lay-offs and decrease in print publication days are signs of the digital maturation of the industry—an inevitable fork in the news evolution road. The old "print vs. broadcast" war seems trivial compared to what the industry now faces. Chapters four and five explored how changes affect business models. Now, the questions shift to the presentation of information. Is digital better? How does the switch to a digital focus affect the core principles of journalism? And does it have to?

Throughout this chapter, we will explore the promise of digital and all it has to offer storytelling—presentation, interaction, aggregation, immediacy, abundance, and immortalization. But we will also look at the concerns of many who feel the switch will hurt the fundamentals of journalism. First, we asked New Orleans residents via a survey to weigh in on how they feel the lay-offs will affect the credibility and accuracy of *The Times-Picayune*. Will the newspaper still be the "go-to" outlet? Next, this chapter will include a content analysis of stories in *The Times-Picayune* and *NOLA.com* before and after the switch to majority online. Was there a decrease in in-depth, issues, or public affairs reporting? And if so, what replaced it? News is the transmission of information that will help audiences make good decisions about their lives, careers, families, institutions, and governments. Journalism is a business, but it is a business that enjoys First Amendment protection and has a social responsibility to inform the democratic electorate, whether in print, on TV, or online. Will *The Times-Picayune's* online vision have profound effects on the journalistic content? Third, we interviewed eight current content creators—reporters, bloggers, and managers in newspaper, television, and online to discover what they think when asked "is digital better?" They are all immersed in the digital space, and while the norms and routines of digital journalism are still evolving, all agree there are pros and cons to the content. Finally, we will explore the implications of the findings of the survey, content analysis, and interviews to better understand the promise of digital.

CONSUMER MEDIA USE & CONCERNS

In May 2012, when word leaked that the New Orleans *Times-Picayune*, the newspaper that had served the community for 175 years, would downsize to print only three days a week instead of seven (White, 2012), the community was outraged. Citizens held grassroots rallies and a jazz funeral for the paper. The business and political establishments weighed in with letters asking the paper's owner, Advance Publications, Inc., to reconsider. One letter included the signatures of Saints Owner Tom Benson, U.S. Senator David Vitter, and political pundit James Carville. Months later the paper was lampooned the "less than daily" or "SomeTimes Picayune" with floats during Mardi Gras. As noted in chapter

one, the community and newspaper have a special and important connection. In the wake of the outrage, the downsizing offered researchers the opportunity to study the New Orleans media use patterns and how those patterns may affect the use and distribution of digital content.

From July 31 through August 26, 2012, Manship School researchers in conjunction with the School's Public Policy Research Lab (PPRL) conducted a survey of 1,043 respondents in seven parishes that make up the greater New Orleans area. The respondents were almost evenly split between landline and cell phone users. The results were weighted to reflect the current population demographics of race, age, gender, education, and parish, according to the most recent census data. Margin of error was +/- 3 percent.

Before we continue with a discussion of the findings, we want to provide some context on this survey. Multiple researchers were asked to contribute questions with the intention of the survey informing many studies. Not only does this survey add to the discussion of whether digital is better in this chapter, but it is also the crux of the following chapter. In this chapter, the questions focus on media use and perceptions of digital effects on the tenets of solid journalism. The results given here are purely descriptive. In chapter nine, analysis of questions goes beyond the descriptive, and the data are used to answer questions of not only digital penetration, but how audiences use or don't use online products.

In answering our questions, what we found was a bit contradictory in terms of the outward outrage for the "frequency" change, as Mathews calls it (personal communication, April 25, 2013). Television news remained the main source for local news at 45 percent, with only 23 percent of residents saying newspapers were their main source of news. Only one person in four reads a local paper every day. And one person in three *does not* read a local paper *ever*. The Internet numbers could be viewed as even more discouraging. Only 19 percent of residents reported the Internet as their main source of news. And only 1 in 10 (11 percent) read *NOLA.com* every day (PPRL, 2012).

Residents agree that the role of the newspaper is to inform—88.3 percent believe the paper should inform them of local public events. While 86.1 percent believe it's the newspaper's role to inform them of local threats such as weather or crime, 83.9 percent also want to be informed about national and international events. More than 2 in 5 residents (42 percent) report that the loss of the daily *Times-Picayune* will have a major impact on their ability to keep up with news and information about their local community (PPRL, 2012).

When asked about some of the tenets of good journalism, only 26.9 percent of respondents trust the newspaper—it came in second behind television. However, online was the lowest. Only 7.6 percent of residents trust online news (PPRL, 2012). They are suspect of news they encounter online. Perhaps a known brand or longevity does matter in the news business? That is beyond the purview of this

survey and chapter, but something is at work here in terms of trust and distribution platform. The concern continues when credibility is queried. More than half of respondents—55.6 percent—believe the downsizing will have a major impact on the credibility of *The Times-Picayune*. And, 60.5 percent of those surveyed say they believe the downsizing will have a major impact on accuracy (PPRL, 2012).

"Digital is different," said Alex Rawls, editor of *mySpiltmilk.com* (personal communication, November 1, 2012). "It potentially offers a richer experience, but by virtue of living in the Web with porn, LOLcats, eBay and *The Drudge Report*, the context invites readers to see everything as a distraction instead of information. Because the Web delivers information constantly, there's less of a sense that it has passed through any sort of editorial filter, adding to the sense that everything on it is trivial at some level. Because newspapers come out once a day, there's a low-grade event quality to it that Web publishing lacks" (personal communication, November 1, 2012).

New Orleanians are acutely aware of the watchdog function of the newspaper: 77 percent believe it is the newspaper's duty to protect the public from government corruption, and 76.1 percent believe the role also applies to corporate corruption (PPRL, 2012). Lastly, 2 out of 5 (41.4 percent) said that the loss of the daily *Times-Picayune* would have a major impact on the ability of local news to serve as a watchdog over local government. So much so, that some New Orleans-area residents believe that the loss of the daily *Times-Picayune* will cause increases in institutional corruption. While the majority of respondents believe that the loss of the daily *Times-Picayune* will have no effect on corruption, roughly 1 in 5 respondents think the loss will cause a major increase in both business (20.5 percent) and government (21.8 percent) corruption (PPRL, 2012). The readers appear to prescribe to the social responsibility aspect of media—the importance of providing content that informs as well as protects.

TESTING CONSUMERS' CONCERNS

The survey numbers give context to residents' reliance on and expectations of local news in the New Orleans-area. While these numbers are interesting, they do raise additional questions about content that may or may not come to fruition as publication frequency declines. Media scholars have already begun to formulate a picture of online content by studying its accuracy and credibility (Deuze & Yeshua, 2001; Maier, 2005), inclusion of hard (public affairs) versus soft (entertainment) news (Eveland, Marton & Sea, 2004; Patterson, 2000), and the overall differences between online and print content (Hoffman, 2006; Maier, 2010b; Maier & Tucker, 2012).

The content analysis that follows seeks to make similar and additional comparisons to get a better picture of what the content looks like when print production

decreases and online production increases (Kim & Miller, 2013). The changes occurring within and between the two sister outlets (*The Times-Picayune* and *NOLA.com*) offered a real-time opportunity to study what was available to news consumers before and after print publication was reduced. Such a study allows us to better understand the differences in offerings within the context of journalistic values and the importance of information to society and community.

We decided to test some of the residents' concerns by conducting a content analysis of *The Times-Picayune* and *NOLA.com* (the online version of *The Times-Picayune*) before and after the frequency change (Kim & Miller, 2013). The sample consisted of the three weeks before the downsizing (21 days from September 10 to 30) and the three weeks after the downsizing (includes only 9 days of publication over 3 weeks—Sunday, Wednesday, and Friday from October 1 to 21) for a total of 30 days. The unit of analysis was every news article and photo published on the front pages of both *The Times-Picayune* and *NOLA.com* during the sample time periods. The total number of online samples was 2,476. In order to obtain an online sample that would be comparable to the print sample after the reduction, the authors selected a 544 subsample from the 1,270 online samples published on the same three days (Sunday, Wednesday, and Friday) as the print version (Kim & Miller, 2013).

The coding categories consisted of news origin, news source, photo inclusion, and type of news, which contained two subcategories. Public affairs included business/economy, crime, education/school, environmental issues, and policy/government issues/politics. Entertainment included entertainment (movies, books, food), human interest/personal stories, living/health, sports, and local events (Adams, 1978; Gaziano, 1984; Eveland et al., 2004; Patterson, 2004).

PRINT VS. ONLINE

The results of the content analysis before and after the print reduction found *few* differences. However, the results demonstrate the few differences that were found between the print and online offerings were *distinct* (Kim & Miller, 2013). The findings showed that "shovelware" cannot be applied in this case, and also contrasted with other studies on the homogeneity of news across outlets (Kim & Miller, 2013; Maier & Tucker, 2012. p. 58).

The front page of the newspaper and the homepage of the website is what readers and users will see first. The front page of *The Times-Picayune* in our sample time period contained approximately four news articles, most with medium-sized photos with captions. These four news articles covered local stories as well as regional crime and government news and were primarily written by the outlet's own reporters. On average, one article on the front page of the print version may

address a national or international issue. In contrast with the typical print front page, the homepage of the website consisted of approximately 20 articles (updated regularly), a majority covering sports and local crimes with small, thumbnail photos without captions. Typically, during the sample time period, no national or international news was featured on the "front page" of the Web version. Thus, print and online "front pages" provided different kinds of news and amounts of news and visuals (Kim & Miller, 2013). The content indicates that media homogeneity through "shovelware," or the repositioning of print news into an online product, may not be happening (Maier & Tucker, 2012), at least not in the case of *The Times-Picayune*'s local experiment (Kim & Miller, 2013).

The distinctive differences between "sister" versions of the same news entity can be better understood in terms of local media's ongoing efforts to maintain readership (Bunton, 1998; Heider et al., 2005; Maier & Tucker, 2012; Singer, 2001). As indicated by the survey results and prior research, some users get news from both traditional and online sources (Maier, 2010a; Maier & Tucker, 2012), while others selectively seek specific types of news online (entertainment news) or from newspapers (more depth-information, public affairs) (Hamilton, 2006; Maier, 2010b). The downsized newspaper industry has attempted to maintain current readers while attracting new readers by focusing on "local content choice" (Hansen & Hansen, 2011; Singer, 2001, p.77) that includes integration of individuals and families (Bunton, 1998; Heider et al., 2005; Singer, 2001). *The Times-Picayune* and *NOLA.com* are no different in regard to this effort (Kim & Miller, 2013). *NOLA.com* relied on "localized content regardless of the downsizing (before: 67.33 percent, after: 67.24 percent), while the regional and national news were instead provided by *The Times-Picayune*" (Kim & Miller, 2013, p. 20). The results showed that "through print, *The Times-Picayune* featured state/regional news or national news that connected readers to the broader public affairs world. *NOLA.com*, in turn, was used to integrate individuals and families into the local community" (Kim & Miller, 2013, p. 20). In line with earlier research, more public affairs news was offered by the print version, and more entertainment news was posted online (Kim & Miller, 2013). One of the fears identified by readers in the survey was that there would be less watchdog journalism focused on government and businesses with the downsizing. This fear was partially confirmed by the content analysis. There has been less public affairs reporting online since the frequency change (Kim & Miller, 2013). However, the amount offered in the print version has increased, yet remains limited due to the three-day-a-week frequency.

A symbiotic relationship appears to exist between *The Times-Picayune* and *NOLA.com* (Kim & Miller, 2013). Both venues were used to not only retain current readers, but to also attract new users via specific kinds of stories dependent on the platform. Simply put, for those seeking specific types of stories, public affairs could be found more in print and entertainment was more online (Kim & Miller,

2013). By providing different types of news (public affairs and entertainment) through different types of media, *The Times-Picayune* may have tried to meet the public's expectations of "good neighbor" (i.e., social responsibility) by trying to satisfy *everyone's* information needs (Hansen & Hansen, 2011; Heider et al., 2005). In its attempt to retain and grow readers and users, reading *both* versions is now required for a full complement of information about the local, regional, national and international world (Kim & Miller, 2013).

Maier and Tucker's 2012 study implied that the downsized news industry is creating less in-depth reporting online and producing more crime news, as well as more quick-hit and breaking news stories. Our content analysis showed similar results (Kim & Miller, 2013). Before the downsizing, in-depth public affairs topics such as environmental issues (Hurricane Isaac & coastal erosion) frequently appeared in print (21.34 percent). In that same time period, *NOLA.com* covered sports (26.62 percent), crime (18.66 percent), and entertainment news (food, movies, books—15.01 percent) more than environmental issues (9.29 percent). In turn, after the print reduction, *NOLA.com* increased its proportion of sports (30.51 percent) and crime (22.40 percent) stories (Kim & Miller, 2013). This study extends previous research that showed online news is both soft and episodic.

The lack of homogeneity between outlets that share a name, a staff, and a geographic location was surprising. Perhaps the difference lies in news philosophy, which is now hopelessly intertwined with *where* the stories are published. It appears a new stream of research beyond homogeneity and consensus must be developed that studies the differences in what is being offered online and in print (Kim & Miller, 2013).

The social responsibility of the NOLA Media Group to provide important news to the community is met when both outlets are used in a complementary fashion. This shows an almost national news-like sense of duty—an intentional effort to please a wide variety of audiences, both current and potential. Readers and users are now required to go to both outlets if they want to satisfy their news diet of public affairs, local, and global (Kim & Miller, 2013). However, former WWL-TV news director and lifelong New Orleanian Chris Slaughter, believes the reduction is a "half step toward extinction."

"People are getting out of the habit of reading the newspaper every day," Slaughter says. "There is no urgency to read the newspaper" (personal communication, February 26, 2013). If that time comes and the presses stop for good, as Slaughter suggests, the complementary relationship between outlets discovered in this study will also stop, potentially causing an unbalanced exposure to one kind of news—soft and entertaining.

The day after our interviews with Mathews and Jim Amoss, *Times-Picayune* editor, the group announced publication of the *TP Street* on the days

the traditional broadsheet does not publish. Even with this addition, they only support part of the mission of journalism to inform in lighter fare. This part of the news diet, which is growing, mirrors America's fast food addiction—inexpensive calories that may not add to a healthy overall diet. It is acceptable if it is balanced with lean protein and fruits and veggies, but a diet of all fast food is not healthy. Important information is like our fruits and veggies, if prepared well, we all like them. If not, they get scraped off the plate and into the trash. It is incumbent upon the journalists to make public affairs and important information taste good.

THE PROMISE OF DIGITAL

Mathews, *The Times-Picayune* publisher, found the reaction of the New Orlean community to the frequency change difficult to swallow.

> Probably the hardest part of this journey is that people had as part of their talking points that we were not committed to journalism. And I think it was particularly offensive to the team for that purpose that, our goal is actually to make a contribution to saving American journalism. So that notion that we were going to move away from that, it was just unbelievable (personal communication, April 25, 2013).

In late April, during an unusually cool Louisiana spring, we visited the NOLA Media Group's new modern headquarters on Canal Street on the 31st floor overlooking the Mississippi River. The location is particularly significant because through the floor to ceiling windows, you see the crescent turn of the mighty river—the crescent that gives the city its nickname and the NOLA Media Group its logo. "We can't underplay the point about actually making this very significant investment in the heart of the city," said Mathews (personal communication, April 25, 2013). "[It] really made a statement that we were very serious about what we were doing and this was not just a cost-cutting exercise … We've created a more collaborative work environment. We've empowered our team—teams that promote more of a digital focus" (personal communication, April 25, 2013).

Newspapers across the U.S. are selling buildings. In 2013, *The Birmingham News, The Huntsville Times,* and *The Mobile Press-Register* (all three Advance properties, as noted in chapter seven) had buildings up for sale. The *Asbury Park Press* has one up for sale. *The Press of Atlantic City* is selling one of its buildings and consolidating into one facility. Different digs, which seem to be short for digital, offer a way to start anew. Digital contains aspects that are not found consistently across other platforms that promises new dimensions to news coverage—it includes immediacy, abundance, and interactivity.

Immediacy

Immediacy is a tenet of good journalism, yet it is continuously blamed for bad journalism. Haste makes inaccurate waste. In the digital age, a single informational tweet breaking a story can be read around the world in a matter of seconds. For the subset of respondents who get at least some of their news online (which is roughly 40 percent of New Orleans area residents) the main reasons for doing so included a desire for immediacy (55.1 percent) (PPRL, 2012). The quicker people are informed about such matters as a local gas leak or a tornado warning, the better. Yet, often in the rush to get stories online or on the air first, the facts of the story may not have been properly vetted. "There's got to be a little bit more control over that, generally speaking, in journalism, I think, going into this new realm," said David Hammer, former *Times-Picayune* investigative reporter and current WWL-TV reporter (personal communication, February 5, 2013). This is not a new problem. But it is especially troubling, he says, for those citizen "journalists" whose accuracy thresholds are not as high "The content of a story has a certain level of responsibility to establish fact and verify, and the bloggers (for example) don't have that" (Hammer, personal communication, February 5, 2013).

Times-Picayune Editor Jim Amoss said his newsroom's basic mission is news and that at any given moment readers want to know what is going on in their "editorial brains" (personal communication, April 25, 2013). "Social media is the primary vehicle of making that happen," said Amoss (personal communication, April 25, 2013). However, if a tweet makes it around the world, the original source is often lost. For example, Hammer broke the story that former New Orleans Mayor Ray Nagin had passed up a plea deal in his felony corruption case. "Soledad O'Brien tweeted it. But she tweeted WWL Radio's story, citing my story," said Hammer (personal communication, February 5, 2013). "Twitter—even somebody like Soledad O'Brien, you would think, who's a journalist, and a serious one, and has that reputation, you know, she's not thinking, 'Oh I'd better tweet the actual story.' She just wants to get the information out there and who actually produced the original story gets lost. More people are getting the information in the long run, so it's like a win—there's some positives and some negatives" (personal communication, February 5, 2013).

But Hammer also says, in terms of immediacy, the playing field has been leveled. No longer can broadcast get the jump on breaking news. "It doesn't matter anymore what's in the physical paper; it matters who captures that audience online," said Hammer (personal communication, February 5, 2013). "And we have just as much right to capture that audience and ability to prove to the audience that we're the go-to source, as *NOLA.com* does" (personal communication, February 5, 2013).

Abundance

"The digital revolution is about abundance," said Mutter, Newsosaur blogger and former Silicone Valley executive (personal communication, February 15, 2013). "If you look at those digital technologies, it enables more stuff to be moved more quickly to more people at a better price. It's about abundance of entertainment, information, and content" (personal communication, February 15, 2013). An endless number of platforms and outlets are creating content, which is often difficult for the consumer to sort through. Many news websites now aggregate information. Hurricane Katrina, which began the digital maturation of New Orleans while at the same time delayed it, opened up an entire new world of diverse media outlets providing local content. Mathews agrees that there are numerous competitors in the digital space.

> A printing press created a barrier to entry in competing with us and the cost of doing business in the print space. But the digital space, it's a whole new ballgame. And new technology is creating opportunities for competitors to come out of nowhere, whether they're taking great ideas that somebody else had and just putting steam behind them, or whether new ideas are emerging (personal communication, April 25, 2013).

Probably the most important aspect of abundance is diversity of voices and viewpoints. Nearly 1 in 2 (46.6 percent) residents believe the loss of the daily *Times-Picayune* will have a major, negative impact on the diversity of views represented in discussing community issues (PPRL, 2012). However, with the explosion of outlets and interactivity (as noted in chapter six), minority voices can find a place to offer their stances. It is up to the consumer to sort through all of the different offerings for a relevant story on which to comment. Digital "allows marginalized voices to participate in the marketplace of ideas with minimal financial investment," said Rawls (personal communication, November 1, 2012). "But the wide spectrum of voices also makes it harder to find digital media sites and to decide on who is credible. As is the case with music today—more good music is available than ever; the challenge is how to find it" (personal communication, November 1, 2012).

Interactivity

"Interactivity means that I get to choose," said Mutter. "I can respond and info comes to me" (personal communication, February 15, 2013). It is no longer a one-way street. Viewers are now able to express their thoughts about a story or provide news tips. When WWL-TV New Orleans anchor Melanie Hebert announced she was leaving in June 2013, Facebook and Twitter buzzed with hundreds of

comments and questions in a matter of hours. When users click on a story, it constitutes interactivity and helps determine what stories stay up and what "kind" of story will be posted and updated in the future. Users are choosing what they want to read more about. And the news outlets are watching. Mathews said they now have a digital operations team with community engagement experts who are constantly monitoring whether or not a story "has legs" (personal communication, April 25, 2013). *The Lens'* Tyler Bridges is excited about engaging users in different ways. While comments tend to quickly move away from the article itself, Bridges said "you can provide links to articles, which is something that is big for us at *The Lens* to do. So if people want a deeper dive … more information … they can click on other articles … go to rich primary sources of information, and (the process is) more transparent as a result" (personal communication, February 20, 2013).

But the interactivity is not just consumer choice. Reporters now create living, breathing story records that will remain in the digital realm forever. The stories can be commented on and updated indefinitely. The Minneapolis *Star Tribune* created such an interactive masterpiece, called "13 Seconds in August," to explain the 2007 Interstate 35 West bridge collapse. It included an aerial view of the bridge with the cars on the bridge numbered. Click on the number and information about the person(s) in that car is revealed. Some stories include text, pictures, and video. At the bottom, an interactive invitation: "This is a living document, and we encourage you to send us your reactions and thoughts, and help us fill in the missing pieces." And for the vehicles that do not contain a story, viewers with information are invited to contact *Star Tribune* reporters through the emails provided.

Reporters must keep up with their stories—especially if they have a beat—to make sure questions are being answered and new leads are being followed—six days, six months or six years later. It can be a daunting task for already overworked, social media-immersed reporters. Digital storytelling opens many multi-platform options that make stories continuously relevant.

Interactivity also affects the skillset of the news workers. The audience expects a full sensory experience, which in turn effects what journalists need to know about their craft. "At the end of 2009 they eliminated my job," said Bridges, *Miami Herald* South American bureau chief and current reporter for *The Lens* (personal communication, February 20, 2013). "So, I resolved to learn these new skills, and that's what I dedicated my time at Harvard doing … particularly studying at the Kennedy School and before I began the Nieman [fellowship], I didn't know how to use Twitter, and I didn't know how Facebook worked. I certainly didn't understand how Google worked other than just type in a name in a search" (personal communication, February 20, 2013).

For the last 60 years, there has been a feud between print and broadcast journalists—now, everyone does it all. There is no one or the other. If you are assigned a

story, you take a still camera that also shoots video. Journalists are expected to handle social media as well. This is not a revelation in the industry, but the ones who jumped on board (even if they were kicking and screaming), the ones who adapted, are the ones still employed. The "I don't do video" attitude had to be broken. How else can news organizations do this without a sweeping change? Mathews said he doesn't believe incremental change would have worked.

"Now it's on us," said Bridges. "I didn't know how to do all this new stuff and I did realize that if I was going to remake myself, if I was going to be marketable, I need to learn the digital stuff. If you love being a journalist and you think it has an impact, and I certainly believe it does ... then you have to change" (personal communication, February 20, 2013).

Digital demands a different skillset and mindset. A different mindset that WWL's Hammer said we are not prepared for as consumers or creators. First, as news consumers, the information comes from so many places, it is hard for news consumers to know whom to trust, Hammer said. Second, the industry still continues to put more stock in the printed word. Hammer gives an example from his recent jump from newspaper to television. Hammer broke a story on the lack of offshore drilling safety audits for WWL online and on television. However, the story did not get picked up by the Associated Press. "If it had been in *The Times-Picayune*, it would've been picked up by the AP and maybe had more legs nationally" (personal communication, February 5, 2013). This harkens back to Hammer's time at the newspaper where "until it appeared in the paper, it wasn't really that important" (personal communication, February 5, 2013). Same reporter, same in-depth investigative work, only the venue had changed. Hammer gives a second example concerning sources. *The Times-Picayune* cachet gave him the ability to pick up the phone and call Washington sources for comments on his stories. Now, he is with *local* television, which the congressmen don't "know from a hole in the wall" (personal communication, February 5, 2013).

While Hammer and Bridges lament the changes at their former place of employment (Hammer was made an offer to stay, but turned it down to work at WWL-TV), their words concerning digital appear to echo their former bosses. Change and adaptation are necessary, even though it makes the work of good journalists harder and different. No one knows where these experimentations will lead the industry, but there is no question that there is no going backward. Digital is here to stay and the adjustment of journalists, news consumers, sources, and management is required. Ignore the changes at your peril.

Perhaps the need for a varied news diet is also nothing new. It goes back to the abundance—some would argue overabundance—of news and pseudo news being offered online. Shovelware gets a different connotation. It is not necessarily the same content across outlets owned by the same entity, but the shoveling of anything and everything across platforms is easy to do. Intentionally false stories have

been posted only to be picked up by prestigious news outlets. All it takes is one false tweet or Facebook post—it is easy to understand why many view the Internet with skepticism. Few have the time or inclination to sort through the vastness, yet it is a fundamental duty of a citizen, and we would argue, a fundamental role of the press to sort through and find information that is important to users. It is immediacy meets abundance meets interactivity that can turn out to be a domino of bad decisions and false information that in turn meets immortalization! Once it is out there—it is always there, in some form or fashion.

Journalism still needs its dutiful and ethical content creators and managers, trained in the art of good journalism. "Digital media is more immediate in nature of publication and the interaction (that is) possible, which ultimately makes it more democratic," said Rawls (personal communication, November 1, 2012). The burden and the responsibility on journalists and users are even greater in the digital space.

Mathews maintains the process of and adjustment to digitization will take time, for everyone.

> We have only just begun a journey. We're, maybe, chapter two in a 50-chapter book, and maybe other chapters will be added. But we realize that, culturally and strategically, we had to create a company that was nimble and had the ability to move faster. That … the print-centric culture from before did not enable us to move fast enough to meet the needs of the community and meet the needs of this market. And so, we're hoping that the efforts that are underway help us respond better (personal communication, April 25, 2013).

So—is digital better? Yes and no.

Users believe watchdog and public affairs journalism are important to community life. However, in larger numbers, they seek out soft, infotainment news over hard news. In turn, the media has responded with lighter fare and a range of offerings across outlets giving users choices with the goal of maintaining and attracting audience. For the user, the offerings and the experience are different. Choices, immediacy, video, animated graphics, crowdsourcing, data visualization, text, slideshows, maps, interactivity—all of these contribute to storytelling and information transmission when used appropriately to enhance the experience and retention of the user. Journalists appreciate the promise of digital, but recognize the additional skills, vetting, and investment it takes to get there. Is it worth the risk of a money-making, established business to turn things upside down with an unproven business model? Perhaps—if it is done well. For decades, *The Times-Picayune* has been the standard-bearer of journalism in New Orleans. It is hard to renovate an established pillar of society. News consumers say they worry about a decline in credible and trustworthy sources of news. However, with trial and time, perhaps digital will win over the community.

REFERENCES

Adams, W. C. (1978). Local public affairs content of TV news. *Journalism Quarterly, 55*, 690–695.

Bunton, K. (1998). Social responsibility in covering community: A narrative case analysis. *Journal of Mass Media Ethics, 13*(4), 232–246.

Deuze, M. & Yeshua, D. (2001). Online journalists face new ethical dilemma: Lessons from the Netherlands. *Journal of Mass Media Ethics, 16*(4), 273–292.

Eveland, W. P., Marton, K. & Seo, M. (2004). Moving beyond "just the facts": The influence of online news on the content and structure of public affairs knowledge. *Communication Research, 31*(1), 82–108.

Gaziano, C. (1984). Neighborhood newspapers, citizen groups and public affairs knowledge gaps. *Journalism Quarterly, 61*(3), 556–599.

Hamilton, J. T. (2006). *All the news that's fit to sell: How the market transforms information into news.* Princeton, NJ: Princeton University Press.

Hansen, E. K. & Hansen, G. L. (2011). Newspaper improves reader satisfaction by refocusing on local issues. *Newspaper Research Journal, 32*(1), 98–106.

Heider, D., McCombs, M. & Poindexter, P. M. (2005). What the public expects of local news: Views on public and traditional journalism. *Journalism & Mass Communication Quarterly, 82*(4), 952–967.

Hoffman, L. H. (2006). Is Internet content different after all? A content analysis of mobilizing information in online and print newspapers. *Journalism & Mass Communication Quarterly, 83*(1), 58–76.

Kim, Y & Miller, A. (2013). *The "SomeTimes Picayune:" Comparing the online and print offerings of the New Orleans' newspaper before and after the print reduction.* Paper presented at the annual conference of the Association of Education in Journalism and Mass Communication, Washington, D.C.

LSU Manship School of Mass Communication Public Policy Research Lab. (2012). The state of newspapers in New Orleans survey: Citizens' reactions to the loss of the daily *Times-Picayune.* Retrieved from http://sites01.lsu.edu/wp/pprl/files/2012/07/LSUTimesPicayuneSurvey Report_Final2.pdf

Maier, S. R. (2005). Accuracy matters: A cross-market assessment of newspaper error and credibility. *Journalism & Mass Communication Quarterly, 82*(3), 533–551.

Maier, S. R. (2010a). All the news fit to post? Comparing news content on the web to newspapers, television, and radio. *Journalism & Mass Communication Quarterly, 87*(3/4), 548–562.

Maier, S. R. (2010b). Newspapers offer more news than do major online sites. *Newspaper Research Journal, 31*(1), 6–19.

Maier, S. R. & Tucker, S. (2012). Online news readers get different news mix than print. *Newspaper Research Journal, 33*(4), 48–62.

Patterson, T. E. (2000). *Doing well and doing good: How soft news and critical journalism are shrinking the news audience and weakening democracy-and what news outlets can do about it.* Faculty Research Working Paper Series, RWP01–001. Cambridge, MA: John F. Kennedy School of Government, Harvard University.

Singer, J. B. (2001). The metro wide web: Changes in newspapers' gatekeeping role online. *Journalism & Mass Communication Quarterly, 78*(1), 65–80.

Singer, J. B., Tharp, M. P. & Haruta, A. (1999). Online staffers: Superstars or second-class citizens, *Newspaper Research Journal, 20*(30), 29–47.

Yu, R. (November 28, 2012). Cleveland *Plain Dealer* mulls layoffs, restructuring. *USAToday.com*. Retrieved from http://www.usatoday.com/story/money/2012/11/28/cleveland-plain-dealer-plans-cutback-and-restructuring/1726479/

White, J. (June 12, 2012). *Times-Picayune* lays off more than 200 employees. *NOLA.com*. Retrieved from http://www.*NOLA.com*/business/index.ssf/2012/06/times-picayune_lays_off_more_t.html

Zara, C. (September, 20, 2012). Newspaper industry shrinks 40 percent in a decade: Report. *International Business Times.com*. Retrieved from http://www.ibtimes.com/newspaper-industry-shrinks-40-percent-decade-report-793706

Digital, Social AND Mobile

The Multiplatform News Future of New Orleans

LANCE PORTER

New Orleans is rarely first to do anything. However, when the 175-year-old *Times-Picayune* reduced its print distribution to three days a week and moved to combine its online arm *NOLA.com* with its print operation under one roof, the paper made New Orleans the first major U.S. city without a daily print newspaper (Finch, 2012; Beaujon, 2012). While critics decried these cost-cutting and work-force reduction measures, and the citizens of New Orleans were understandably upset about losing their daily paper, *The Times-Picayune* was merely following the inevitable move newspapers and other *legacy* media are making toward digitization.

However, what was the real story? What does the literature predict about the effect of this change in distribution, and what do the residents of New Orleans really think the effect will be? In this chapter, I will outline some of the digital trends facing *The Times-Picayune* today, take a closer look at the real effects of these changes, and detail the results of a survey of New Orleans citizens conducted in the months leading up to *The Times-Picayune's* move toward a *digitally-focused* strategy.

DIGITAL TRENDS IN NEWSPAPERS AND THE MULTIPLATFORM CONSUMER

The Web began altering the media landscape in 1994, when widespread audiences suddenly gained the ability to access, share, and even create content when they

wanted, where they wanted, and how they wanted. Since content on the Web was *digital*, online news content shifted from being comprised of atoms to taking the form of 1s and 0s or *bits* (Negroponte, 1995). First upending the music industry in the late 1990s and then spreading into all forms of media content, such as television and film, the move from analog forms of media distribution to digital distribution completely revolutionized how audiences accessed content. In the process, digital distribution destroyed firmly established advertising and subscription revenue models. The digitization of content has hit newspapers particularly hard, as audiences have found news content freely available online. In other words, news content is what noted advertising critic Bob Garfield (2013) terms "substitutable":

> The advertising dollars that underwrote that enterprise for most of its history are spread too thinly among the infinite supply of content, driving prices of ads and publisher revenue down, down, down. The once obscenely profitable classified category has been craigslisted to almost zero. Meanwhile, the audience fragmentation that drives down ad prices also drives down circulation revenue. Then comes the cost cutting, which diminishes the content, which diminishes the audience, which diminishes the revenue, and so on into oblivion (n.p.).

The rise of social and mobile media a decade after the commercial Web's ascent has compounded these problems for the traditional media industry by placing a convergent and convenient connection in the audience's pocket, featuring a social media news stream that competes for both audience and advertising dollars. The rapid adoption of the smartphone among news audiences has created consumers who access content through multiple platforms and news sources, often simultaneously while they are consuming other media via another primary screen (Sassen, Olmstead & Mitchell, 2013). In 2012, approximately 31 percent of U.S. adults reported owning a tablet, triple the penetration in 2011 (Pew, 2012), and smartphones have now replaced feature phones as the dominant phone in the United States (Goldman, 2012). Furthermore, research predicted that in 2013, more digital content would be accessed from mobile smartphones than from personal computers (Gartner, 2012).

The end of print as a traditional medium now seems like a foregone conclusion. Following the announcement that *The New York Times* could purchase a Kindle for all of its subscribers at half the cost of a year of print distribution (Carlson, 2009), *The Times* predicted that it would cease printing a newspaper by 2020 (Blodget, 2010). *USA Today* has recently ramped up efforts to move away from print to a tablet model (Edmonds, Guskin, Rosenstiel & Mitchell, 2012). Jeff Jarvis, *Guardian* columnist and head of the interactive program at the City University of New York, summarizes the advantages of digital distribution over print:

It's not that print is bad. It's that digital is better. It has too many advantages (and there'll only be more): ubiquity, speed, permanence, searchability, the ability to update, the ability to remix, targeting, interaction, marketing via links, data feedback. Digital transcends the limitations of—and incorporates the best of—individual media (Jarvis, 2010, n.p.).

NEWSPAPERS EXACERBATING THE DIGITAL DIVIDE?

The implications for the move of content online are more than just financial. As content began to migrate online in the 1990s, policymakers and academics alike began to speculate about what this move meant for people of lesser means who could not afford the information and computer technologies (ICTs) required to access content. Has the so-called *digital divide* exacerbated existing divisions between the rich and the poor, male and female, the educated and the uneducated, or the developed world and the undeveloped world (Seong-Jae, 2010; Norris, 2001; Van Dijk, 2005; Warschauer, 2003)? Most policy work to date has focused solely on solving the problem of access (Epstein, Nisbet & Gillespie, 2011). However, additional work has pointed to a *second level* digital divide in Internet use, which concerns not just socioeconomic but psychological and cultural (Hargittai, 2002a, 2002b) as well as political (Seong-Jae, 2010) dimensions.

Social media and the rise of Facebook and Twitter have both created numerous opportunities for citizens to create content. However, researchers have pointed out that while mobile offers cheaper access, people with mobile access are less likely to create content, creating what Schradie (2011) has referred to as a "digital production gap." Mobile users and users connecting in public places may be less likely to produce content as those accessing from multiple platforms. Schradie said "access at a location over which economically disadvantaged people have no control, such as a library or school, limits their likelihood of producing online content" (p. 166). While the term itself is complex, as more content moves online, it is certainly apparent that not having access to the Internet, either physically or culturally, could pose a problem for citizens in poor or rural areas. Since a large number of *Times-Picayune* readers fit this category, we will explore questions relating to how moving more of *The Times-Picayune's* content onto digital platforms could affect its less affluent readers.

GLOBAL EFFECTS OF DIGITIZATION ON NEWSPAPER CONTENT

How have these changes affected newspapers' informational and watchdog role? With a reported 40 percent reduction in the newspaper workforce over the past decade (Sass, 2012), news content has understandably evolved. However, most

research shows that the newspaper industry has been slow to take advantage of the more interactive features of digital media, choosing instead to funnel print content to their online versions (Barnhurst, 2002; Finnemann & Thomasen, 2005; Hoffman, 2006; Mitchelstein & Boczkowski, 2009; Quandt, 2008). Furthermore, there have been some troubling implications for newspaper content. Researchers have found online news content to become more commercial (Barnhurst & Nerone, 2001), lighter and more sensationalistic (Fenton, 2010), and less international (Singer, 2001). The findings in chapter eight also support this. Some have speculated that online news, by its very nature, may remove the economic need for news' impartiality. According to Barnhurst and Nerone (2001, p. 294), online media dismantle the old models of local media having to remain impartial to serve large urban areas across partisan lines. In the late nineteenth century, advertisers took the place of political parties as the main source of profit for newspapers, driving newspapers to become "an impartial medium of information" (Porwancher, 2011, p. 186). Will the Internet's pressure on newspapers to rely less on advertising and more on subscriptions change this dynamic?

Other researchers have shown a mix of positive and negative results in the effects of the digitization of newspapers. In a cross-media systems study examining online newspapers in Denmark, the U.S., and France, Benson, Ørsten, Powers, Willig and Zambrano (2012) found online news outlets "simultaneously featuring more advertising and more localized, light news, while at the same time opening up (if only slightly) toward more deliberation, more opinion, and more nonjournalistic voices" (p. 32). Benson et al. (2012) pointed out that digital newspapers are now able to present information in ways that print simply cannot:

> Despite some decline in traditional news reporting, information is still the dominant genre online and certain forms less easily 'afforded' by print have in fact become more prevalent online, such as access to original documents, archive databases, and multimedia presentations of complex issues (p. 34).

In a study closely examining census data after the death of papers in Seattle and Denver, Shaker (in press) found that the demise of print newspapers across the nation has been linked to a reduction in civic engagement both at the local and national levels. However, in an earlier study, Shaker (2009) found that Internet access was correlated to more local political knowledge, not less as he had hypothesized. In addition, despite increasingly accessing news online, consumers have been shown to stick with traditional news brands as primary sources, with known news brands accounting for 20 of the 25 top news sites according to comScore's rankings (Edmonds, Guskin, Mitchell & Jurkowitz, 2013).

While Garfield's grim predictions about the substitutability of news may not be as dire as first thought, one possible complication for *The Times-Picayune* is that its website is known as *NOLA.com* without common branding with *The Times-Picayune*.

The Web presence for *The Times-Picayune* has been run as a separate operation with a separate editorial staff since its inception in 1997. As part of its movement toward a more digital product, the parent Advance Publications announced plans to combine these two operations, consolidating the staff under one roof in new office space. As part of this study, we will investigate the knowledge of New Orleans residents and whether they realize that the two entities are both owned by Advance. Given multiplatform users' inclinations toward established news brands, *The Times-Picayune* brand should figure largely in any digital content it produces.

THE COLLAPSE OF PRINT ADVERTISING AND THE RISE OF THE PAYWALL

As both users and advertisers turn to digital platforms, print fell for the 12th straight year, plummeting $1.8 billion or 8.5 percent in a slowly recovering economy (Edmonds, Guskin, Mitchell & Jurkowitz, 2013). Online ad spending outpaced print advertising spending for the first time in 2012 (eMarketer, 2012). Unfortunately, increased spending on digital advertising platforms does not begin to cover these losses. First, digital advertising brings in substantially lower rates than traditional advertising. Web advertising, priced at cost to reach one thousand readers or CPM, averages around $3.50 CPM, half the average CPM of newspaper print advertising (Fiegerman, 2012). The reason for this disparity in price can be traced back to the early days of display advertising.

Early online display or banner advertising falsely relied heavily on the click to measure success. That was with good reason. While early banner ads for Sears on the pioneering Web service Prodigy were not clickable, clickable ads debuted shortly thereafter on the Web versions of *Wired* magazine, *Hotwired.com*. When the first clickable online display advertisement debuted on *Hotwired.com* in 1994, the AT&T ad unit boasted a 44 percent click through rate (CTR) (McCambley, 2013). Understandably, online ad sales forces held up these high CTRs as proof that online advertising engaged Web audiences. However, when online consumers became more sophisticated and CTRs plunged below the hundredths of a percentage point in the late 90s, advertisers began to suspect the branding effectiveness of online display advertising. While numerous studies showed that display advertising was effective in moving brand metrics – such as awareness and purchase intention without consumers clicking (Briggs & Hollis, 1997) – advertisers, faced with the "dot bomb" of the late 90s, began to slow spending in display advertising. Despite Web usage continuing to skyrocket among audiences, online advertising spending dried up as click rates plunged. CPMs dipped below a dollar in these lean years for Web advertising.

However, advertisers could not continue to ignore the massive growth of online usage. With the rise of Google and Facebook, digital advertising has rebounded in the 2000s with double digit percentage growth in search, targeted, and local banner ads, rich media, and particularly in video and sponsorship with 46.5 percent and 38.9 percent increases between 2011 and 2012 (Sasseen et al., 2013). However, 64 percent of advertising expenditures have largely gone to the top five advertising networks of Google, Facebook, Yahoo, Microsoft, and AOL (eMarketer, 2012). Since network display advertisements are delivered through central servers and not hard coded to actual Web pages themselves, these networks allow advertisers to purchase extremely targeted advertisements across networks of numerous websites, which has created additional downward pressure on online newspaper advertising rates. Currently, Google's Doubleclick ad network allows advertisers to reach 90 percent of all Internet users. Therefore, to generate revenue from display advertising, news operations must have a national or even global footprint or news sites must join the larger ad networks, forfeiting a large share of their revenues. Even so, local and targeted advertising remains a large source of income for newspapers, since the large majority is local players. However, since local ads are defined as ads purchased by a client or company located in the same market as the news outlet, Google and the large ad networks are starting the move in on this territory as well, as their networks also allow local targeting.

Deepening the digital dilemma facing newspapers, the move of audiences and content to mobile platforms has further lowered CPMs. While Web CPMs are half of those paid for print newspapers, mobile CPMs are actually only a fraction of Web CPMs, averaging less than 75 cents (Fiegerman, 2012). Certainly smaller screens and less proven ad formats are contributing to these low rates. However, iPad CPMs are averaging a more promising $4.42 CPM, offering perhaps a glimpse of an opportunity for tablet profitability for newspapers. Even so, the mobile ad networks are entirely controlled by some of the same platforms currently dominating the Web display advertising space. Google and its Android platform, along with Apple and Amazon, control the entire platform on which newspapers' mobile and tablet offerings are built. Accordingly, these platforms take a large percentage of any advertising revenue generated from news content in these areas. Consequently, newspapers are beginning to experiment with newer technologies such as HTML5, which allow them to create a mobile and tablet presence without building on the iOS or Android platforms. Effectively, they are using HTML5 to avoid having to pay shares of their ad revenue to Apple and Google.

Furthermore, local newspapers have had to figure out new revenue streams from digital circulation and advertising. Nearly 33 percent of the country's daily newspapers had adopted digital paywalls by the end of 2012 (Sasseen, Olmstead & Mitchell, 2013). Paywalls involve charging readers for content accessed digitally, or placing news content behind digital walls only accessible for a fee. Typically,

casual news consumers are not charged for initial visits to news sites, but after they reach a certain threshold of content, they are asked to pay. *The New York Times* leads the charge on this trend, appearing profitable and nearly tripling its digital subscription base in the past two years (Lazaroff, 2013), actually making more money for the first time this year in circulation than in advertising. This is a staggering statistic considering that newspapers have traditionally generated the large majority of their income through advertising. Other online news outlets seem to be following *The Times'* lead, with the *Daily Beast* and *Time* experimenting with paywalls this year. Gannett (Bercovici, 2012), Lee (Brown, 2012), McClatchy (Beaujon, 2012), E.W. Scripps (Monk, 2012), and even longtime holdout *The Seattle Times*, all announced plans to institute paywalls in 2012. One important element of paywalls is that most newspapers also offer digital access for free or at greatly reduced prices to print subscribers. The *Los Angeles Times* offers the Sunday print edition plus digital access for a lower price than digital only subscriptions (Edmonds et al., 2013).

Newspapers are also branching far afield from their traditional sources of revenue, from purchasing specialized websites such as *The Dallas Morning News'* entertainment site, *Pegasus*, (now GuideLIVE) to administering professional conferences or even providing professional social media marketing services to local businesses (Edmonds et al., 2013). Some are experimenting with sponsored stories, which involve using the editorial resources of newspapers to create actual content designed to accomplish the brand objectives of advertisers and running that content alongside traditional editorial. Other outlets have featured affiliate links, whereby news outlets place links to advertising content listed under "Similar Stories" or "Stories You Might Like" (e.g., "Top Celebrity Plastic Surgery Disasters"). Advertisers then pay by the click on traffic generated by these links.

So far, Advance Publications is keeping digital content free, investing in building digital audiences through search engine optimization and by raising print advertising rates on the three days they distribute a print edition. This digital strategy seems to be working, as it is rolling out similar strategies at its other 33 papers (Edmonds et al., 2013). However, the findings of this study will indicate how the citizens of New Orleans felt about this strategy shortly before its employment.

RESEARCH QUESTIONS

As stated in previous chapters, New Orleans is a distinct news market, with passionate and devoted readers of the city's only newspaper. Will these national and global trends hold up? With the shift away from print a few weeks out, we had a unique opportunity to examine a newspaper on the precipice of addressing these monumental changes. Therefore, I propose to pursue the following research

questions to explore the implications of these changes from the point of view of New Orleans citizens.

RQ1: Will the change to digital distribution exacerbate the digital divide in New Orleans?

RQ2: How do New Orleans residents feel about how the shift to digital distribution will affect their ability to obtain the news they need?

RQ3: How do New Orleans residents feel about paying for digital content through *NOLA.com*?

METHODS

As noted in earlier chapters, the LSU Manship School of Mass Communication Public Policy Research Lab (PPRL) conducted a random-digit-dial telephone survey of 1,043 respondents, including 530 respondents from landline telephone numbers and 513 from available cell phone blocks (PPRL, 2012). We conducted telephone interviews from July 31 until August 26, 2012. We weighted the results to reflect the current population demographics of race, age, gender, education, and parish, according to the most recent available census data. We included the following parishes as the greater New Orleans area: Jefferson, Orleans, Plaquemines, St. Bernard, St. Charles, St. John the Baptist, and St. Tammany. Margin of error was +/- 3 percent. In chapter eight, the data from the same survey were used to describe media users and their perceptions of journalistic tenets. In this chapter, data are used beyond the descriptive to answer questions of digital penetration and to compare online media use. Therefore, a more quantitative presentation of the data is required.

To measure multiplatform access, I constructed a multiplatform index with items from a "check-all-that-apply" question: "And which of the following devices do you personally use to connect to the Internet?" These items included desktop computer, laptop computer, video game system (Xbox, PS3, Wii, DS, etc.), tablet (iPad, etc.), e-reader (Kindle, NOOK, etc.), and mobile phone. In addition, I constructed the mobile index with the items laptop computer, tablet, e-reader and mobile phone. I converted each choice to a dummy item before constructing an additive index for each scale.

RESULTS AND DISCUSSION: A NEW DIGITAL DIVIDE?

Obviously, a survey will not completely answer the first research question of whether these changes will exacerbate the digital divide in New Orleans and hurt its most vulnerable citizens. However, a look at the penetration numbers

combined with surveyed opinion identifies some critical issues. Predictably, the shift to a primarily digital mode of news distribution is going to hurt underserved areas more. With 83 percent indicating home Internet access, New Orleans falls in a statistical dead heat with the national average of 85 percent (Pew, 2013). Although these numbers are better than expected, certain areas are still underrepresented in terms of home Internet access. Observation of the adjusted standardized residuals in cross tabulation indicates that both urban and majority African American Orleans parish (78.8 percent) and the more rural St. John the Baptist parishes (65 percent) have significantly less than the expected level of Internet access, as compared to the other parishes, and also fall below national averages for rural and urban areas that both average 80 percent penetration (Pew, 2013). In contrast, St. Tammany parish, the wealthy and majority Caucasian suburb on the north shore of Lake Pontchartrain, reports a significantly higher than expected home Internet access (91.5 percent) at the .05 level.

In addition, white residents tend to significantly outpace black residents in their embrace of multiplatform news. An analysis of variance with Tukey post hoc tests indicated that white residents score significantly higher (M = 1.33, SD = 1.15) than black residents (M = 1.68, SD = 1.46, $F(4,979)$ = 3.82, $p < .01$) on the multiplatform scale. These results indicate that African Americans and residents of more urban and rural areas surrounding New Orleans believe that they will undoubtedly have a harder time keeping up with the news and issues important to them. In addition, citizens in these areas will experience what Shradie referred to as the digital production gap, making them less likely to contribute political and cultural content to *The Times-Picayune's* social media offerings. In short, these groups are more likely to be left out of the conversation.

Is mobile access the solution for these underserved populations? True, St. John the Baptist residents seem to be adopting mobile access at higher levels than those residents living in other parishes in the metro area. However, mobile seems to be a current weakness with *The Times-Picayune's* content, with more mobile platform respondents reporting they are significantly less likely to subscribe to the paper. Accordingly, *The Times-Picayune* needs to ramp up its mobile distribution methods to immediately meet these citizens' news needs. As mobile access reaches critical mass, more citizens will certainly begin to take advantage of this more affordable means of accessing Internet content.

There also seems to be an opportunity in targeting younger consumers with digital offerings. While nonsubscribers scored significantly higher on the mobile index (M = 1.33, SD = 1.15) than subscribers (M = 1.19, SD = 1.13, $F(1,1007)$ = 4.16, $p < .05$), age, measured by year born, and the multiplatform index were positively correlated, $r(976)$ = .379, $p < .001$. Age and the mobile index were also positively correlated, $r(976)$ = .405, $p < .001$. Therefore, younger readers are more apt to access digital content through mobile devices and through multiple

platforms. *The Times-Picayune* would do well to target this multiplatform group with incentives to engage in and create content.

However, the digital news product is certainly not something New Orleans citizens are routinely consuming. The answer to the second research question, "How do New Orleans residents feel about how the shift to digital distribution will affect their ability to obtain the news they need?" was decidedly mixed. The results indicate some cause for concern over possibly losing current subscribers. In response to the question "Where do you plan to get local news from in the future?" residents did not indicate they would use the three-day-a-week *Times-Picayune* as their primary news source, with only 2.5 percent (25) choosing that option. The rest were split with 22.1 percent (223) indicating they would turn to weekly print newspapers such as *Gambit* and *Louisiana Weekly* and 21.6 percent (218) indicating local television. Furthermore, 15.7 percent (158) indicated local Internet sites such as *NOLA.com* and thelensnola.org, while 15.1 percent (152) chose radio and 14.8 percent (149) chose word of mouth.

The picture is not much rosier when examining the Internet news patterns prior to the switch. While respondents reported Internet access is at national levels, New Orleans residents are currently lukewarm about accessing news from digital platforms. Most of the city does not access online news on a regular basis. Even readers of online news are not currently daily readers, and current digital readers of *NOLA.com* do not consume that content regularly. In response to the question, "How many days in the past week did you read news about your local community on the Internet?" 42 percent of residents reported reading local news online. The resident average for the metro area was 2.2 days in the past week (SD=2.71), ranging from zero days to every day. Of those residents who reported going online to read local news, residents averaged 4.28 (*SD* = 2.34) days each week reading news online. Specifically, 42.5 percent of residents reported going "online to *NOLA.com* specifically" with the overall resident average of 1.6 days per week (*SD*=2.35). *NOLA.com* readers reported going online to the site 3.63 days per week (*SD* = 2.32). In comparison, 6.6 percent of residents went online to read competitor *Gambit* .15 days (SD=.72) each week, and 2.7 percent of residents visited thelensnola.org .08 days (SD=.60) each week.

Fortunately, for the paper, the readers who regularly accessed *NOLA.com* content before these changes are not as concerned as those who weren't familiar with the online product. Residents who indicated that they connected to the Internet at home disagreed significantly more (*M* = 2.68, *SD* = 1.98) with the statement, "The changes underway with *The Times-Picayune* will make it more difficult for ME to stay informed about current events" than those residents who do not connect at home (*M* = 3.02, SD = 2.03, $F(1,993)= 4.22$, $p < .05$). The solutions to this problem could lie in producing compelling content and interactive content for the audience. Perhaps in the past, users did not realize that they had a reason to go online as opposed to reading the content in print.

As *The Times-Picayune* ramps up its digital and mobile services, it would do well to not follow the regrettable "shovelware" history of other newspapers who simply placed print content online. It is imperative that it take advantage of the more interactive features of digital media, and develop new ways to feature citizen-reported content and commentary via social media and location-based news. To get into readers' newsfeeds, it must create content that readers want to share. It should showcase access to original documents, archived information, and digital media's capabilities in the multimedia presentation of complex and "big" data.

BRANDING ISSUES CREATE PAYWALL RESISTANCE

Whether New Orleans residents would actually pay for this type of interactive content remains to be seen. Only 11 percent of residents answered yes to the question "Would you pay a monthly subscription fee in order to receive local news coverage online or on a mobile device?" However, the small group of residents who answered "yes" to this question scored significantly higher ($M = 2.18$, $SD = 1.36$) on the multiplatform index than those who answered "no" ($M = 1.78$, $SD = 1.78$, $F(2,1007) = 4.32$, $p < .05$). Furthermore, residents who answered "yes" to the same question scored significantly higher on the mobile index ($M = 1.67$, $SD = 1.14$) than those who answered "no" ($M = 1.21$, $SD = 1.13$, $F(2,1007) = 8.22$, $p < .001$). Therefore, there is perhaps an opportunity as the multiplatform and mobile user base grows in New Orleans.

In addition to facing the same content issues that every newspaper in the world is currently facing during the inevitable move toward multiple platforms, *The Times-Picayune* has a digital branding problem. Many of the newspaper's current digital issues could be traced to the fact that most users do not understand the relationship between *The Times-Picayune* and their current digital arm, *NOLA.com*. In fact, most residents are not aware that *NOLA.com* and *The Times-Picayune* involve content produced by the same company. In answer to the question "To the best of your knowledge are *The Times-Picayune* and *NOLA.com* connected publications that share stories, and are owned by the same company, or are they separate companies with no connection at all?" Only 47.3 percent of residents said "connected," while 17.1 percent indicated "separate" and 35.7 percent said they "don't know."

This confusion about the brand could explain the majority of residents' apathy toward the digital news product and *NOLA.com* as an important news source. Certainly *NOLA.com* does outpace current online competitors *The Lens* and *Gambit* by a wide margin. However, *The Times-Picayune* will not only need to shift its distribution online but also its powerful local brand. To suit the needs of the

multiplatform consumer, the brand will need to be uniform across those platforms. By emphasizing its successful legacy in the city and using its traditional news brand, *The Times-Picayune* would do well to follow national trends among multiplatform users, who tend to stick with established news brands when they look for news online.

Aside from the *NOLA.com* branding challenges, my results do point toward opportunity for *The Times-Picayune* and *NOLA.com*. Younger residents are following the patterns of the rest of the country and accessing the Internet more from multiple platforms. Understandably, those residents are significantly less concerned about *The Times-Picayune's* distribution change as affecting their own ability to stay informed about current events. Perhaps most important for future news revenue models and the national trend toward paywalls, multiplatform users are more open than more digital averse users to paying for digital content. Therefore, to ensure its viability in the future, *The Times-Picayune* is going to need to produce a more digital, social and mobile product to meet the needs of these more connected consumers.

The same advice could be followed for newspapers nationwide. The newspaper industry needs to pay close attention to the lessons learned in this ongoing news experiment, and take note of which news offerings work. As of this writing, the early financial trends are looking optimistic. *Times-Picayune* Editor Jim Amoss has reported that traffic is up on his digital offerings and that his print sales are up as well on the three days they are printing a paper (Wells, 2013.) Advance claims it is making money (Edmonds et al., 2013), and the *NOLA.com* brand has recently been made over with an emphasis on *The Times-Picayune's* long-standing logo. Pew is predicting that more and more papers will move toward the three-days-a-week printing schedule (Rosenstiel, Jurkowitz & Ji, 2012). How will these trends affect the nation's poorest citizens? For better or worse, New Orleans should prove an excellent canary in the coal mine for the newspaper industry's quest to lure the multiplatform consumer.

REFERENCES

Barnhurst, K. G. (2002). News geography & monopoly: The form of reports on U.S. newspaper internet sites. *Journalism Studies, 3(4)*, 477–489.

Barnhurst, K. G. & Nerone, J. (2001). *The form of news*. New York, NY: The Guilford Press.

Beaujon, A. (2012, July 27). McClatchy to expand paywalls across chain in fourth quarter. *Poynter.org*. Retrieved September 10, 2013 from http://www.poynter.org/latest-news/mediawire/183028/mcclatchy-to-expand-paywalls-across-chain-in-fourth-quarter/

Beaujon, A. (2012, August 31). How the *Times-Picayune* and *NOLA.com* covered Hurricane Isaac, *Poynter.org*. Retrieved September 11, 2012 from http://www.poynter.org/latest-news/mediawire/187185/how-the-times-picayune-and-nola-com-covered-hurricane-isaac/

Benson, R., Blach-Ørsten, M., Powers, M., Willig, I. & Zambrano, S. (2012). Media systems online and off: Comparing the form of news in the United States, Denmark, and France. *Journal of Communication, 62(1)*, 21–38.

Beniger, J.R. (1986). *The control revolution: Technological and economic origins of the information society.* Cambridge, MA: Harvard University Press.

Bercovici, J. (2012, February 2). Gannett building paywalls around all its papers except USA Today. *Forbes.com*. Retrieved from http://www.forbes.com/sites/jeffbercovici/2012/02/22/gannett-building-paywalls-around-all-its-papers-except-usa-today/

Blodget, H. (2010, September 8). We will stop printing *The New York Times* sometime in the future. *www.businessinsider.com*. Retrieved from http://articles.businessinsider.com/2010–09–08/entertainment/29986156_1_printing-newsroom-ad-revenue

Briggs, R. & Hollis, N. (1997). Advertising on the Web: Is there response before click-through? *Journal of Advertising Research, 37(2)*, p. 33–45.

Brown, L. (2012, March 21.) Lee newspapers will soon charge for online access. *St. Louis Post-Dispatch*. Retrieved from http://www.stltoday.com/business/local/lee-newspapers-will-soon-charge-for-online-access/article_204da3b8–736c-11e1–8ee9–0019bb30f31a.html

Carlson, N. (2009, January 30). Printing the NYT cost twice as much as sending every subscriber a free Kindle. *www.businessinsider.com*. Retrieved from http://www.businessinsider.com/2009/1/printing-the-nyt-costs-twice-as-much-as-sending-every-subscriber-a-free-kindle

eMarketer. (2012). *US Ad Spending Forecast*. Retrieved from eMarketer database.

Edmonds, R., Guskin, E., Mitchell, A. & Jurkowitz, M. (2013). Newspapers: Stabilizing, but still threatened. The Pew Center's Project for Excellence in Journalism. The State of the News Media 2013. Retrieved from http://stateofthemedia.org/2013/newspapers-stabilizing-but-still-threatened/#fnref-12990–11

Edmonds, R., Guskin, E., Rosenstiel, T. & Mitchell, A. (2012). Newspapers: By the numbers. *The Pew Center's Project for Excellence in Journalism*. The State of the News Media 2012. Retrieved from http://stateofthemedia.org/2012/newspapers-building-digital-revenues-proves-painfully-slow/newspapers-by-the-numbers/

Epstein, D., Nisbet, E. C. & Gillespie, T. (2011). Who's responsible for the digital divide? Public perceptions and policy implications. *Information Society*, 27(2), 92–104.

Fenton, N. (Ed.). (2010). *New media, old news.* London, England: Sage.

Fiegerman, S. (2012.) Why are mobile ads so cheap? Retrieved on July 10, 2012 from http://mashable.com/2012/10/23/mobile-ad-prices/

Finch, S. (2012, September 10). Death of a daily: When the end began for *Times-Picayune* staffers. *www.myneworleans.com*. Retrieved September 2012, from http://www.myneworleans.com/New-Orleans-Magazine/September-2012/Death-of-a-Daily/

Finnemann, N. O. & Thomasen, B. H. (2005). Denmark: Multiplying news. In R. Van der Wurff & E. Lauf (Eds.), *Print and online newspapers in Europe: A comparative analysis in 16 countries* (pp. 91–103). Amsterdam, The Netherlands: Het Spinhuis.

Garfield, B. (2013). How will journalism keep the lights on? [Radio series episode]. In *On the media*. WNYC. Retrieved from http://www.onthemedia.org/2013/may/10/how-will-journalism-keep-lights/transcript/

Gartner. (2010, January 13). Gartner newsroom. *www.gartner.com*. Retrieved September 4, 2012 from http://www.gartner.com/it/products/newsroom/index.jsp

Goldman, D. (2012). Half of U.S. cell phones are now smartphones. *CNNMoney*. Retrieved September 2, 2013 from http://money.cnn.com/2012/05/16/technology/smartphones/index.htm

Hargittai, E. (2002a). Beyond logs and surveys: In-depth measures of people's Web use skills. *Journal of the American Society for Information Science and Tech-nology, 53(14)*, 1239–1244.

Hargittai, E. (2002b). Second-level digital divide: Differences in people's online skills. *First Monday, 7(4)*. Retrieved from http://firstmonday.org/ issues/issue7_4/hargittai/index.html.

Hoffman, L. H. (2006). Is internet content different after all? A content analysis of mobilizing information in online and print newspapers. *Journalism & Mass Communication Quarterly, 83(1)*, 58–76.

Jarvis, J. (2010, April). The print media are doomed. *Business Week*. Retrieved from http://www.businessweek.com/debateroom/archives/2008/12/the_print_media.ht

Lazarroff, L. (2013, August 9). Memo to 'The Post's' Bezos: Newspaper paywalls work. *Thestreet.com*. Retrieved from http://www.thestreet.com/story/12004481/1/memo-to-the-posts-bezos-newspaper-paywalls-work.html

McCambley, J. (2013). Stop selling ads and do something useful. Retrieved from http://blogs.hbr.org/cs/2013/02/stop_selling_ads_and_do_someth.html

Mitchelstein, E. & Boczkowski, P. (2009). Between tradition and change: A review of recent research on online news production. *Journalism, 10(5)*, 562–586.

Monk, D. (2012, November 15). Scripps newspapers adopting paywalls. Retrieved from http://www.bizjournals.com/cincinnati/blog/2012/11/scripps-newspapers-adopting-paywalls.html

Negroponte, N. (1995). *Being digital*. New York: Vintage.

Norris, P. (2001). *Digital divide: Civic engagement, information poverty, and the internet worldwide*. New York: Cambridge University Press.

Pew Research Center. (2012, Oct. 1). *The future of mobile news*. Pew Research Center's Internet and American Life Project Spring Tracking Survey. Retrieved from http://www.pewinternet.org/Static-Pages/Trend-Data-(Adults)/Whos-Online.aspx

Porwancher, A. (2011). Objectivity's prophet: Adolph S. Ochs and New York Times, 1869–35. *Journalism history, 36(4)*, 186–195.

Quandt, T. (2008). (No) news on the World Wide Web? *Journalism Studies, 9(5)*, 717–738.

Rosenstiel, T., Jurkowitz, M & Ji, H. (2012). The search for a new business model. *Journalism.org*. Retrieved from http://www.journalism.org/analysis_report/search_new_business_model?src=prc-headline

Sass, E. (2012). Newspaper jobs shrink 40% in 10 years. *MediaDailyNews*. Retrieved http://www.mediapost.com/publications/article/183378/newspaper-jobs-shrink-40-in-10-years.html?print#axzz2U8puxkTF

Sasseen, J., Olmstead, K. & Mitchell, A. (2013). *Digital: As mobile grows rapidly, the pressures on news intensify*. The Pew Center's Project for Excellence in Journalism. The State of the News Media 2013. Retrieved from http://stateofthemedia.org/2013/digital-as-mobile-grows-rapidly-the-pressures-on-news-intensify/#fnref-12962-40

Schradie, J. (2011). The digital production gap: The digital divide and Web 2.0 collide. *Poetics, 39 (2)*,145–168.

Seong-Jae, M. (2010). From the digital divide to the democratic divide: Internet skills, political interest, and the second-level digital divide in political internet use. *Journal of Information Technology & Politics, 7(1)*, 22–35.

Shaker, L. (2009). Citizens' local political knowledge and the role of media access. *Journalism & Mass Communication Quarterly, 86(4)*, 809–826.

Shaker, L. (in press). Dead newspapers and citizens' civic engagement. *Political Communication*.

Singer, J. B. (2001). The metro Wide Web: Changes in newspapers' gate-keeping role on line. *Journalism and Mass Communication Quarterly, 78(1)*, 65–80.

Van Dijk, J. (2005). *The deepening divide: Inequality in the information society.* London: Sage.

Warschauer, M. (2003). *Technology and social inclusion: Rethinking the digital divide.* Cambridge, MA: MIT Press.

Photojournalism IN
THE Digital Age

NICOLE SMITH DAHMEN

Compelling photographs are central to good storytelling. Photos capture emotion and bring a story to life in a way that words alone cannot. With this in mind, this chapter explores three intertwined narratives: the changing role of the photograph in the digitally-focused model and the consequent added responsibilities of – and pressures on – the photojournalist; the story of the dedicated *Times-Picayune* photojournalists who captured the emotional toll of Hurricane Katrina through photography; and, the awkward metamorphosis of the venerable *Times-Picayune* into a digitally-centered media outlet, during which some of those same photojournalists became casualties.

It is the job of the photojournalist to capture the "decisive moment," a term coined by legendary photographer Henri Cartier-Bresson. Hal Buell (2002), a celebrated photojournalist himself, writes, "Photography is a process that starts in a photographer's brain and ends up on film—or, these days, on a digital chip. What happens in between … cannot be described. It is a combination of instinct, insight, anticipation, technical proficiency, visual awareness, and the ability to express visually a mood or an understanding of a subject" (p. 9).

To this combination of technical skill and emotional connectedness—which has always been the stock in trade of the photojournalist—must now be added knowledge of the new digital technologies. Today's photojournalists—sometimes referred to as "broadband journalists" (Bock, 2008, p. 170)—are now faced with "considerable" new responsibilities (Santana & Russial, 2013, p. 81). In addition to capturing still photographs, photojournalists now handle most of the video

shooting/editing, online photo galleries and audio slideshows, and even inter-active multimedia presentations. And while some photojournalists view video as enriching what they do, recent research suggests that overall job satisfaction among photojournalists is not high (Santana & Russial, 2013).

Moreover, media companies are increasingly eliminating photojournalism positions. In May 2013, the *Chicago Sun-Times* made the shocking announce-ment that it would immediately lay off the entire photography staff – 28 full-time employees. The new plan, according to the newspaper's announcement, is to use reporters with iPhones and freelance photographers to shoot both photos and video. The newspaper defended its decision based on "rapidly-changing" business motives and the fact that audiences are requesting more video content.

Among those staffers let go was *Sun-Times* veteran photographer and Pulit-zer Prize winner John White. In an interview with the Poynter Institute, White poignantly stated the harsh reality of the layoffs: "It was as if they pushed a button and deleted a whole culture of photojournalism" (Irby, 2013, n.p.).

Referring to the cuts at the *Sun-Times* as the "latest example of a disconcert-ing trend in American media," Kenneth Irby (2013), a senior faculty member in visual journalism at Poynter, writes: "professional photojournalism is being down-sized and devalued, with news organizations increasingly turning to wire services, citizen-submitted content and independent/freelance contributions" (n.p.).

This is the case at the New Orleans *Times-Picayune*. In October 2012 when *The Times-Picayune* moved to a digitally-focused model, more than 200 employees—including 80 news staffers—were let go. Among those were key photojournalism staffers: Photo Editor Doug Parker and five photojournalists, including veteran *Times-Picayune* photographer John McCusker, Matthew Hinton, Scott Threlkeld, Ellis Lucia, and Eliot Kamenitz (Allman, 2012).

As previously noted, quality photography is central to good storytelling. Part of what led *The Times-Picayune* to take home the 2006 Pulitzer Prize in the cat-egory of public service was compelling photography in telling the story of Hur-ricane Katrina. The Pulitzer was awarded to *The Times-Picayune* for "its heroic, multi-faceted coverage of Hurricane Katrina and its aftermath, making exception-al use of the newspaper's resources to serve an inundated city even after evacuation of the newspaper plant" (The Pulitzer Prizes, 2006, n.p.).

David Halberstam writes about the "… immense, powerful connection" of photographs to human emotion (Buell, 2002, p. 7). This is certainly true in the visual reporting of Hurricane Katrina: people stranded on rooftops, waiting to be airlifted from their flooded homes; dead bodies floating in stagnant water; aban-doned and frustrated mobs of people crammed in the Superdome; a beautiful and historic city entrenched in flood waters.

John McCusker, one of *The Times-Picayune* photojournalists who was let go, stayed in New Orleans in the aftermath of Katrina, capturing the gripping

photographs that would tell the story to millions across the globe. In a community radio interview a year after Katrina, McCusker conveyed the weighty reality of that experience:

> They all had the same look on their faces, perplexed disbelief. Just these thousands of people, invalids and old people pushing shopping carts up onto the Interstate. Seven and eight year old girls, the same ages as my daughters, literally begging me for food, begging me for water and I had nothing for them … It was the first time I covered anything where I knew exactly what most of those people were feeling, cause I was feeling it myself. It wasn't like when I go cover a fire and somebody else's house burns down or somebody else's daughter dies in a car crash. This was my city. This was my town. This was my life. My house had seven feet of water in it. You're almost crying as you're taking the pictures (Franzel, 2006, n.p.).

Two months before this interview, McCusker had a public breakdown in which he pleaded with New Orleans police officers to kill him; ultimately, he was taken to jail and placed under medical supervision (Saulny, 2006). This story is recounted here not to belabor McCusker's suffering, but rather, to highlight the intense emotional toll of covering Katrina. Countless other photojournalists, like McCusker, have put their own physical and emotional safety and security second to their responsibility of capturing the story through photography.

The ultimate exemplar of this is South African photojournalist Kevin Carter, who won the Pulitzer Prize for a disturbing and unforgettable photograph of a young victim of the 1993 famine in Sudan. Shortly after being awarded the Pulitzer, Carter took his own life at the age of 33. While a multitude of factors were involved in his downfall, his suicide note recounted being "haunted by the vivid memories of killings & corpses & anger & pain … of starving or wounded children, of trigger happy madmen, often police, of killer executioners" (Macleod, 1994, p. 73).

According to Halberstam, "… in most cases, the great photo is not the product of exceptional good fortune and a bit of extra luck on a given day … Rather, far more often it is the product of constant hard work, of rare preparation, and of uncommon human sacrifice—of a gifted person of exceptional talent who is willing to give up the protections and safety of a 9-to-5 life and work long, bewildering shifts on endless days often in difficult, very dangerous venues" (Buell, 2002, p. 7).

Through in-depth interviews, this chapter examines the changing nature of visual reporting in the digital age. Interviews were conducted with photo staffers from leading newspapers across the country. A list of the top 25 largest circulation newspapers, as collected by the Audit Bureau of Circulations, was reviewed. The websites of these 25 newspapers was then searched to find contact information for the photo manager/editor at each of these news outlets. Photo managers/editors from seven news organizations agreed to participate: *Detroit Free Press, Chicago Tribune, The Dallas Morning News, San Francisco Chronicle, Tampa Bay Times, The Denver Post*, and *San Jose Mercury News*.

All interviews were conducted by phone and via e-mail in early 2013. For some of the interviews the initial person contacted agreed to participate, while in other cases the initial contact referred the researcher to another photo staffer. In the case of *The Dallas Morning News*, the contacted photo editor participated in the interview and voluntarily recruited two other photo staffers to participate. This was the only group interview conducted.

Additionally, two former *Times-Picayune* photojournalism staffers, Doug Parker and John McCusker, agreed to be interviewed. But, due to contractual obligations, they were restricted in what they were allowed to say. McCusker now works as a photojournalist for the Baton Rouge *Advocate*.

THE RETURN OF THE "PICTURE STORY"

Historically, one of the biggest obstacles for telling any good story is column inches—a problem that ceases to exist in a digital world. Across the board, photo editors agree that in regard to photojournalism, the switch to digital means unlimited space for visual reporting. And because of this unlimited space, Tim Rasmussen, Assistant Managing Editor for Photography and Multimedia at the *Denver Post*, strongly believes that we are currently in the "Golden Age" of photography (personal communication, February 14, 2013). He explains, "We publish a significantly higher number of photographs today than we ever have, which allows our readers to have a better understanding of their world through photography" (personal communication, February 14, 2013).

Rather than having to select one or maybe two photos for a print news story, photo editors now have the luxury of including an unlimited number of photos in any given digital news story to enhance the quality of the news coverage. As Michael Malone, Director of Photography at the *San Jose Mercury News*, says, "Another happy advantage to the digital model is that the picture story has returned, in the form of slide shows or photo galleries" (personal communication, February 5, 2013).

Former *Times-Picayune* Photo Editor Doug Parker agrees that—done correctly—a digital environment can enhance storytelling through photography (personal communication, March 14, 2013). Citing the high-quality photo slideshows of *The Boston Globe* and *The Washington Post*, for example, he argues: "If you wanted to build galleries and build photo essays online, you have an unlimited amount of space … there's an outlet for photographers to do great work and have their work shown" (personal communication, March 14, 2013).

And with the model of digital slideshows, the perceived direct benefit is to the audience. According to Mark Hume, Photo Editor at the *Chicago Tribune*, "Our readers get more visual information in the digital realm" (personal communication,

February 1, 2013). And, that information is easier to share in a digital format. Adds Michael Hamtil, Photo Editor at *The Dallas Morning News*, "I don't think people were mailing hard copies of *The Dallas Morning News* all over the world in the way they are emailing or sharing on Facebook or Twitter" (personal communication, January 28, 2013). Malone agrees that "the move to digital has increased the capabilities of the story-tellers because so many more people can access the information rather than being limited to only the number of print papers produced and circulated" (personal communication, February 5, 2013).

EXPERIENCING PHOTOGRAPHY IN A DIGITAL SPACE

Visual reporting is more timely and often of better quality in a digital format. Hamtil says, "it puts our photos and videos out into the world faster, where more people can see them" (personal communication, January 28, 2013). And there is no denying that the quality of photos on a digital platform far exceeds the low resolution, often grainy photos reproduced in print. Digital technologies allow the viewer to experience photography in a manner that is not possible in print. "Our photos look so much better on the iPad than in the paper, and you can touch them and swipe them and enlarge them," adds Hamtil (personal communication, January 28, 2013).

Yet a visit to *NOLA.com* will quickly demonstrate that this isn't the case for the digital news presented to New Orleanians. Called a "creaky mess" by *New York Times* media columnist David Carr, *NOLA.com* is riddled with poor-quality photos, archive photos, and awkwardly placed photos (2013, n.p.). And while there are still some high-quality photos to be found on the site, they are often associated with sports or entertainment stories.

When done effectively, the potential for unlimited space, speed, and quality are substantial gains, yet we must also consider what is lost with regard to visual storytelling in the switch from print to digital news. Consider the moment in which one literally "stumbles" upon a newspaper that has been left behind in a doctor's office, a bus stop, or on a street car. According to Nicole Frugé, Deputy Director of Photography at the *San Francisco Chronicle*, the process of sharing news through print can be a more "democratic process" (personal communication, February 6, 2013). She explains that audiences do not necessarily "seek out" photographs for inspiration (personal communication, February 6, 2013). Rather, they just end up in front of us due to the "nature of print" (personal communication, February 6, 2013). In an online environment, we generally search for topics of interest. Print news—especially given the fundamental power of a photograph—can "expose people to things they don't know they should be interested in," said Fruge (personal communication, February 6, 2013).

Another key consideration in the switch from print news to digital news is the loss of the meticulously-crafted front page layout that functions as a guide in telling the most important news of the day. Fruge explains it best: in a print layout, the audience is guided through "a sequence of events" in which photographs are precisely selected and placed; some are used as lead photos, others act as secondary information (personal communication, February 6, 2013). Kathy Kieliszewski, Director of Photo and Video at the *Detroit Free Press*, said, "One picture has one effect on a viewer and when you combine two images, it has a different impact, and I think you lose that in the digital world" (personal communication, January 30, 2013). Irwin Thompson, Assistant Director of Photography at *The Dallas Morning News* and a Pulitzer Prize winning photojournalist, adds that in print, the lead photo can be highly visible and widely circulated (personal communication, January 28, 2013). The bottom line, according to Nicole Frugé, is that with a print layout, there is a definitive way to give photographs "differential treatment" (personal communication, February 6, 2013).

Conversely, in a digital environment, says Thompson, "the pictures won't be as big and as visual, but you can put multiple pictures together and you can show more" (personal communication, January 28, 2013). But, Frugé argues that the concern with slideshows is the tendency is to put everything into a gallery and the effect is that all photographs get "equal treatment" (personal communication, February 6, 2013). This practice can be exacerbated under tight deadlines. With the demise of the print front page, we lose impact of the "one picture that was thoughtfully chosen to reflect the news of the day," says Frugé (personal communication, February 6, 2013).

The "challenge" in the switch from print to digital, states Hamtil, "is for us to keep up the quality of photojournalism" (personal communication, January 28, 2013). *Tampa Bay Times* Photo Editor Boyzell Hosey says that due to cutbacks in newsrooms, "even though you have photographers out in the field taking great photos, that decision on how those photos are being used on the Web is by and large often made by folks who aren't invested as much in the visual content" (personal communication, February 14, 2013). He adds that digital media provide "opportunity for dramatic galleries and storytelling," but urges that multiple photos should be used in an "intelligent way" to enhance storytelling and not simply repeat content (personal communication, February 1, 2013).

Moreover, Hosey and Hamtil argue that digital news outlets should be cautious about creating online photo galleries for purely economic incentives. Hosey said photographs shouldn't be "indiscriminately put up in photo galleries just because people will click through" (personal communication, February 1, 2013). Hamtil warns that we must continue to have discussions about "quality versus hits that we want for popularity sake or hits for advertising," adding that that it is an "ethical and economic dilemma" (personal communication, January 28, 2013).

Photo editors were generally in agreement that the quality control *must* come from attention to photo editing. Malone of the *San Jose Mercury News* refers to photo editors as a "valuable element" in the shift to digital news (personal communication, February 5, 2013). He explains: "A poorly edited slide show with too many images or too many repetitive images can be more harmful because the reader tires and never completes viewing the project. It's the digital version of a picture page or picture story in print that has too many pictures squeezed onto the page. Good picture editors are the key" (personal communication, February 5, 2013). Kieliszewski agrees. She says, "As the editor, my job is to make a photo gallery really tell a story and not just be a collection of photos slapped online" (personal communication, January 30, 2013).

Hume of the *Chicago Tribune* argues that "good photo editing is still worth more than ever" (personal communication, February 1, 2013). Hume says that simply posting every single photo taken is the equivalent of "a first draft of a story you wouldn't show anyone" (personal communication, February 1, 2013). Frugé states that posting every photograph a photographer turns "is a terrible disservice to the readers and the viewers" (personal communication, February 6, 2013). She argues, "We're not doing our jobs when that happens. Because we're asking people to basically find the good pictures, somewhere in there" (personal communication, January 30, 2013).

But the reality is that photo editing takes resources. And many news organizations simply don't have the time or the staff to devote to thorough photo editing. Hamtil of *The Dallas Morning News* admits that—due to limited resources—about 95 percent of posted slideshows are in no particular order with little photo editing (personal communication, January 28, 2013). And while this may be a nationwide concern, it is certainly true at *The Times-Picayune* since the layoff of much of the photo staff.

Referring to the photojournalism tradition at *The Times-Picayune* as "dead," former Photo Editor Doug Parker argues, "… when you put the power of photos in the hands of people who don't understand it, all sorts of things happen" (personal communication, March 14, 2013). For example, using file photos that are misleading or poorly edited photo slideshows or multimedia presentations. Referring to the remaining photo staff at *The Times-Picayune*, Parker adds, "… they don't have time to do any sort of projects that make photography shine in the paper and be a powerful tool to communicate to the readers" (personal communication, March 14, 2013). With a keen understanding of the immense power of the image, Parker says, "Photography makes a difference and photography can change people's lives, and it needs to be treated with as much respect as the printed word" (personal communication, March 14, 2013).

While the inclusion of a photo slide show with a story can certainly enhance audience understanding of a news story, an additional concern arises: the potential

of an excess of photos to dull the impact of the story. McCusker and Frugé both state that with regard to photography, less can be more. McCusker acknowledges that while it can be good storytelling to have multiple photographic viewpoints, an excess of photos "chips away" from that "one crystallizing image" (personal communication, March 5, 2013).

Hume, of the *Chicago Tribune*, agrees that a poorly-edited slideshow of one picture after another can "dull the impact of whatever you're presenting" (personal communication, February 1, 2013). In addition to audiences not having the patience to click through dozens of photos, Kieliszewski argues that an excess of photos can "water down" the content, adding "not every photo is going to stick in our memory" (personal communication, January 30, 2013). And because of this, Hume states that he doesn't create online galleries unless there are enough quality photos to warrant it, arguing that "readers want quality" (personal communication, February 1, 2013).

Hume concludes, "Good photo editors will realize there are times when one picture does tell the story, and you just present that one photo" (personal communication, February 1, 2013). But, "as long as you're showing photos that are impactful and relevant to the story and informational and work well together in a group, then it wouldn't dull the impact of having that single, iconic image" (personal communication, February 1, 2013).

"FROZEN MOMENTS" IN A DYNAMIC ENVIRONMENT

Scholarly research has established that photographs can invoke a powerful and lasting emotional response. As Malcolm Mallette wrote in 1976, "The frozen moment … remains. It can haunt. It can hurt and hurt again. It can also leave an indelible message about the betterment of society, the end of war, the elimination of hunger, the alleviation of human misery" (p. 120). It is this "frozen moment" that allows photographs to invade our soul, thus becoming lasting moments and photographic "icons:"

> A naked Vietnamese girl screaming out in pain following a napalm attack. U.S. soldiers raising the American flag at Iwo Jima. A slain president's young son saluting his father's coffin.

Moments like these become part of our collective consciousness largely due to their prominent placement on the front pages of newspapers from around the world. Carolyn Kitch (2009) suggests that print news has an afterlife that we collect on event anniversaries or special events for commemoration, remembering, and historic record. But in the Internet age, one only need run a quick search to find countless digital images—as well as appropriations—of these iconic photos. So what happens when that "frozen moment" becomes freed from time and

place, jumping from digital device to digital device? What happens when that "frozen moment" moves from a static, front-page photo to a dynamic, multimedia environment?

Photography's power is in its ability to "freeze" a moment in time. Frugé explains: "When you think of the Hindenburg disaster, when you think of that picture, you think of the front page that that picture was on … and it plays together as this complete, finished thought, which is really amazing and wonderful" (personal communication, February 6, 2013). She adds, "In terms of high impact, single image, nothing is better than opening up a newspaper and seeing a big six column picture. That's a really powerful experience" (personal communication, February 6, 2013).

Hume argues that in regard to iconic photos, without a print product—essentially something to keep—there is the potential for something to be "lost" in a "fleeting" digital environment (personal communication, February 1, 2013). Parker states that we will still have great images, but "unless there's a specific effort to hang on to that photo and see it over a day or two, it's going to be there and then it's gone" (personal communication, March 14, 2013). He adds, "… nothing replaces paper as far as burning an image in your brain, it's one of the most powerful communication tools ever devised" (personal communication, March 14, 2013).

Since the "pioneering work" of Mathew Brady in the 1840s, photographs have been shown to change the way we remember and understand historical events (Borchard, Mullen & Bates, 2013). Although journalism isn't technically a business of history, Hume argues that news organizations do play a critical role as recorders of history, especially when considering community, an aspect central to *The Times-Picayune* story: "there are going to be certain moments that are pivotal to that community … and if you have that photograph people are going to hang on to it to look at it" (personal communication, February 1, 2013).

While Vernon Bryant, a staff photographer at *The Dallas Morning News*, believes that it is still possible to have an iconic photo in the digital age, he agrees that many people have at least one newspaper from a historical event that they have saved, acknowledging that this isn't possible in the same manner in a digital environment (personal communication, January 28, 2013).

Yet other photo editors strongly disagree. Tim Rasmussen states that it is not the front page that is the "defining factor" in creating an iconic photograph—it is the photograph itself (personal communication, February 14, 2013). He argues: "Photographs stay with people. The picture is what's important. How you get it to your readers—a gallery, a book, a magazine, or the front page of a newspaper—is just a delivery device … Ink is not the only way to tell stories, and it never has been. The photograph lives on because of the nature of the photograph" (personal communication, February 14, 2013).

Hosey agrees. He states that it is "absolutely" possible to have iconic images in the digital age (personal communication, February 14, 2013). He adds, "No matter

how much multimedia we have, that moment in time, that moment in history that's frozen forever—that is not fleeting; it's not going to go away … That iconic image, once it's seared into somebody's mind, it's never going to go away. And that's the beauty of what we do. We become a part of capturing history" (personal communication, February 1, 2013).

Some photo editors say that new technologies allow us to experience the iconic photo—essentially enhanced—in innovative ways. Thompson adds that the iconic photo will still be remembered, and unlimited digital space allows for additional photographs to add perspective to the story (personal communication, January 28, 2013). And while a print newspaper makes for a nice keepsake, Hamtil adds that in a digital environment, the photo will live on and be more "easily searchable" than a print photo "someone saves in their attic or in a drawer" (personal communication, January 28, 2013).

And combined with new technologies, the impact of an iconic photo can be even more powerful, says Malone: "The value is enhanced even greater if that single image or series of images are part of an audio slide show or video presentation. In a fashion, a newspaper is limiting. Paired with a properly developed digital partnership, the reach and power is immense. I don't want to see print newspapers die away. They have their place and audience. But paired up with digital and promoted via social media, the power of the reporting can be global rather than being limited by the physical circulation numbers of the printed product" (personal communication, February 5, 2013).

While a digital presentation of photography can enhance storytelling, it is critical that the photograph be capable of being "celebrated" on its own and that it is not simply part of the "design" or an "art element," warns Kieliszewski (personal communication, January 30, 2013). Referring to the "value of photography," she urges that photojournalists must be an essential part of the newsroom in the digital age. "We are not going to escape this digital age, but we can help shape and define what it's going to look like and still maintain the integrity of photojournalism" (personal communication, January 30, 2013).

RE-DEFINING THE ROLE OF THE PHOTOJOURNALIST

One significant shift in the digital world is speed. Thompson, a Pulitzer Prize winning photojournalist and now a photo editor at *The Dallas Morning News*, says, "It's happening now, and we need the picture now" (personal communication, January 28, 2013). Hosey at the *Tampa Bay Times* says there's a "premium" on "now vs. quality" (personal communication, February 14, 2013).

Frugé says the freedom from having to process film gives photojournalists more time to spend taking better pictures (personal communication, February 6, 2013).

Rasmussen agrees that digital technologies allow journalists to "spend more time and make better photography" (personal communication, February 14, 2013). But, conversely, adds Frugé, because of the speed of digital news, photojournalists are asked "to turn things around a lot more quickly" (personal communication, February 6, 2013). She compares it to a "juggling" act in which photojournalists are constantly balancing taking photos, sending in photos, and taking more photos (personal communication, February 6, 2013). Malone says that the pressure of competing with live television and radio news and the websites of other newspapers requires photojournalists "to be able to produce images on the run, literally, and transmit them back for near-instantaneous online updates even as a news situation is still developing" (personal communication, February 5, 2013).

McCusker suggests that this is a critical, "larger scale" issue of "delivering immediate news." He explains that a photojournalist who is required to file from the field—while the story is "still evolving"—is at risk of missing the *complete* story, which is a disservice to readers (personal communication, March 5, 2013).

In addition to speed, photojournalists are "pulled in more directions, because of the need to do more than just shoot photos for the paper. They're shooting for multiple platforms for multiple deadlines," says Hamtil (personal communication, January 28, 2013). For example, staff photographers are frequently sent to a story and asked to get an iPhone photo for speed, enough high-quality photos for a slideshow, and video clips for multimedia presentations.

The effect, worries Hamtil, is on the photographer's ability and focus to capture the defining moment of the story (personal communication, January 28, 2013). In the field, Bryant adds, there is a real "fear" of missing an ideal "still" moment while shooting a video (personal communication, January 28, 2013)—missing the "decisive moment," as Cartier-Bresson calls it.

From the editorial perspective, Hume said that the "biggest challenge" is the "constant deadlines," adding that all news staffers "have to be more and more nimble, and quick on our feet" (personal communication, February 1, 2013). Frugé also argues that photo editors "need to be smarter with how they explain the assignment to the photographer and what the purpose of the news story is" (personal communication, February 6, 2013). She adds that editors and photojournalists must strike a balance between stories that require "getting information out quickly" and stories that "one can be more thoughtful with" (personal communication, January 30, 2013).

Malone says responsibility now lies with the photo manager to "not only ensure the photographer on the scene is supplying the needed material but is also properly supported to meet both the print and digital goals" (personal communication, February 5, 2013). Sometimes that means sending two photographers to a scene: "one to handle the still photos and a second to concentrate on video" (personal communication, February 5, 2013).

According to Hosey, there is a "tremendous opportunity for the talented visual journalist to do some great work on the Web, but … we need to return to leadership that understands that relationship, that can help photojournalists in a newsroom meet that balance between quality—something that's going to connect to the audience—and the needs of the news organization"(personal communication, February 14, 2013).

At most media outlets today, photojournalists are responsible for taking both still and moving images. McCusker says this is problematic because still photos and video are not shot in the "same way" (personal communication, March 5, 2013). He explains that when shooting video, you let the motion "go through the frame;" conversely, with still photography, you "follow the motion" (personal communication, March 5, 2013). The effect of trying to simultaneously do both is that "you can end up doing both badly instead of doing one of them well," McCusker argues (personal communication, March 5, 2013).

Frugé believes that shooting and editing good video can be much more time-consuming than producing a photograph, but if it's done right, video can be the "highest form of storytelling" (personal communication, February 6, 2013). Hume states that video can show a "process," which can be vital for breaking news (personal communication, February 1, 2013). But it is the still photograph (and not the video) says Frugé and Hume, that ultimately gives us the emotion and impact and burns itself into our collective memory. And because of this, in a recent *New York Times* article, Nick Bilton (2013) argues that the "death" of photography has been "greatly exaggerated" (n.p.). Consider the rise in popularity of the "selfie." The next question becomes what about the death of the *quality* photograph?

In a sardonic blog post in response to the layoffs at the *Sun-Times*, *New York Times* Editorial Board member Lawrence Downes (2013) asks, "Do newspapers need photographers?" He quips:

> Maybe the business of newspapering is so hopeless that throwing all of this ability to the curb makes sense. Professional photography is expensive, after all, and often the most widely viewed news images are amateur- or machine-made: cellphone shots and stills from security videos, as in the Boston bombing. Who cares about news judgment, composition, story-telling, impact, beauty or whether an image is even in focus? Photos are just something bright and colorful to wrap the text and ads around. They are just digital content, and these days, as news Web sites gasp for air, content needs to be cheap (2013, n.p.).

Rasumussen is adamant that digital does not inherently do away with photojournalism. He emphasizes (and this is a key point) the "mistake" that news organizations like *The Times-Picayune* are making is the dismissal of many talented journalists who produced compelling content (personal communication, February 14, 2013). In McCusker's case, he began as a freelance photographer with *The Times-Picayune* when he was 20-years-old. He spent the next 30 years of his career covering the rich stories of New Orleans and her people.

He recalls, "I don't know if there ever was a newspaper that was more connected or was more important to its readership in a time of crisis than was the *Picayune* after Katrina ... Because people genuinely respected and appreciated what we had done ... As powerful as something like Katrina was, it made me feel useful, like I was doing something that needed doing and mattered to people, which has made it so much harder when that was gone. People who had given everything to this newspaper were suddenly disposable. That made it jarring for us, and I know it made it jarring for the readership" (personal communication, March 5, 2013).

THE FUTURE OF PHOTOJOURNALISM IN THE DIGITAL AGE

Most of the photo editors interviewed for this chapter generally state that photojournalism's future is bright: "There's a great future ahead. Photojournalism is always relevant, but we can be more timely in the digital world," says Hume. "We can get photographs back more quickly, and we can get it posted to our website right away. Our digital readers are getting valuable visual information" (personal communication, February 1, 2013).

Hosey says, "I think you're going to see more and more newspapers doing an all-digital format in the future ... it's a beautiful time in the industry ... what an opportunity we have now to really lead the way for the newsroom—and journalism in general—as story tellers" (personal communication, February 14, 2013).

Timeliness, unlimited space, and quality are significant potential gains. Larger audiences can have access to limitless photos that are timely and of high-quality in a digital format. Because of these gains, Rasmussen says, "I think we get caught up in the changing environment that we are in and do not realize the opportunities are there" (personal communication, February 14, 2013).

The switch to digital doesn't change photojournalism in any way, emphasizes Malone: "The bottom line objective of the visual journalist is still to tell the story as best he or she can. We're slowly losing the romance of the ink-stained publication and the work that goes into producing it. But that same energy can be channeled positively to insuring the digital products shine, are edited and designed well and meet the needs of our readers/viewers. Photojournalism is still important. Digital has allowed us to gain an audience" (personal communication, February 5, 2013).

Interviews for this chapter were conducted prior to the dismissal of the entire photo staff at the *Chicago Sun-Times*. A follow-up interview was requested with Hume at the *Chicago Tribune*, but he declined based on the sensitivity of the issue in the Chicago area (personal communication, July 13, 2013).

In early 2013, Hume said, "Time and time again it's proven that trained, ethical photojournalists generate material that is unique, trusted, and helps viewers

connect emotionally with whatever story you're doing. We've proven our relevance through these recent challenges" (personal communication, February 1, 2013).

The photo editors interviewed all say a necessary condition for the potential gains of photojournalism in a digital space is an experienced and supported photo staff. Talented photojournalists who have the time and space will continue to take compelling photographs. Autonomous photo managers will continue to provide the direction and editing necessary to allow for the emergence of iconic images and enhanced storytelling through photography in a digital space.

REFERENCES

Allman, K. (2012). Dark days at the *Times-Picayune*. *Gambit*. Retrieved from http://www.bestofneworleans.com/gambit/dark-days-at-the-Times-Picayune/Content?oid=2024583

Bilton, N. (2013). The death of photography has been greatly exaggerated. *The New York Times*. Retrieved from http://bits.blogs.nytimes.com/2013/07/05/the-death-of-photography-has-been-greatly-exaggerated/?smid=tw-nytimes

Bock, M. A. (2008). Together in the scrum: Practice news photography for television, print, and broadband. *Visual Communication Quarterly*, (15:3), 169–179.

Borchard, G. A., Mullen, L. J. & Bates, S. (2013). From realism to reality: The advent of war photography. *Journalism & Communication Monographs*, (15:2), 1–42.

Buell, H. (2002). *Moments: Pulitzer-Prize winning photographs, a visual chronicle of our time*. New York, NY: Black Dog & Leventhal Publishers.

Carr, D. (2013). Newspaper monopoly that lost its grip. *The New York Times*. Retrieved from http://www.nytimes.com/2013/05/13/business/media/in-new-orleans-Times-Picayunes-monopoly-crumbles.html?pagewanted=all&_r=2&

Downes, L. (2013). Do newspapers need photographers? *The New York Times*. Retrieved from http://takingnote.blogs.nytimes.com/2013/05/31/do-newspapers-need-photographers

Franzel, J. (2006, November 22), "Katrina photojournalist John McCusker from Adeline Goss of Next Generation Radio." *Generation PRX*. Retrieved from http://generation.prx.org/katrina-photo-journalist-john-mccusker-from-adeline-goss-of-next-generation-radio/

Irby, K. (2013). John White on *Sun-Times* layoffs. *Poynter Institute*. Retrieved from http://www.poynter.org/latest-news/top-stories/215016/john-white-on-sun-times-layoffs-it-was-as-if-they-pushed-a-button-and-deleted-a-whole-culture/

Kitch, C. (2009). The afterlife of print. *Journalism*, (10:3), 340–342.

Macleod, S. (1994, September 12). The life and death of Kevin Carter. *Time*, 73.

Mallete, M. (1976, March). Should these news pictures have been printed? *Popular Photography*, 73–75, 118–120.

Santana, A. D. & Russial, J. (2013). Photojournalists' role expands at most daily U.S. newspapers. *Newspaper Research Journal*, (34:1), 74–88.

Saulny, S. (2006). After long stress, newsman in New Orleans unravels. *The New York Times*. Retrieved from http://www.nytimes.com/2006/08/10/us/10orleans.html?_r=0

The Pulitzer Prizes. (2006). The 2006 Pulitzer Prize Winners. Public Service. *The Pulitzer Prizes*. Retrieved from http://www.pulitzer.org/citation/2006-Public-Service

Government AND THE Digital Fourth Estate

AMY REYNOLDS & LINDSAY M. MCCLUSKEY

Noted throughout the book, one of journalism's central roles in a democracy is to serve as a watchdog and hold governmental and political leaders accountable to the public (Kovach & Rosenstiel, 2010; Downie & Schudson, 2009; Hindman, 2008; Schudson, 2008; Shirky, 2008). But, many would argue that the function of journalism also includes serving as an important governmental institution in its own right. How? "Because of their historical development, because of shared processes and predictable products across news organizations, and because of the way in which the work of newspersons is so intertwined with the work of official Washington that the news itself performs governmental tasks" (Cook, 1998, p. 3).

This chapter looks beyond the watchdog function of the press to explore how the digital disruption of newspapers affects journalism's ability to continue to serve as a "central political force in government" (Cook, p. 3), particularly at the local and state level. Using Timothy Cook's (1998) framework that defines media as a political institution, we examine whether that function is diminished as newspapers increasingly produce different kinds of digital content for Web audiences (as noted in chapter eight). In-depth interviews with current and former public officials in Syracuse, New York and in the state of Louisiana suggest that public officials share concerns about the digital migration of news. They suggest that shrinking newsrooms and less online content about civic and public affairs issues may be harming the relationship between the government and the public by diminishing the watchdog role of the press; by embracing news values and routines that favor speed and maximizing story "clicks;" by giving advantage to politicians

who no longer need the press to directly reach the public en masse; and, by increasing media bias and diminishing journalistic credibility.

GOVERNING WITH THE NEWS

More than 50 years ago, Douglass Cater suggested "the reporter is the recorder of government but he is also a participant. He operates in a system in which power is divided" (p. 7). Journalists "illumine policy and notably assist in giving it sharpness and clarity; just as easily, (journalists) can prematurely expose policy, and ... cause its destruction" (p. 7). Cater noted that the work of journalists can exert influence on government. Building from Cater's premise, Cook (1998) argues "the news media (is) a coherent intermediate institution without which the three branches established by the Constitution could not act and could not work" (Cook, p. 3).

Much of Cook's argument traces back through history, beginning in the late eighteenth century, when freedom of the press referred less to journalistic independence from government intervention than to the capacity of individuals to have free access to a printing press in order to disseminate their views. He notes that government provided much news content via official notices, announcements, proclamations, and briefs. At the same time, printers commonly served as postmasters, where they were well placed to gather news, especially as it arrived from overseas (Schudson, 1978). According to Cook (1998), "Newspapers in the colonial and revolutionary eras were supported by political patronage, factional disputes, and the participation of politicians in the assembly of the newspaper" (p. 25).

In 1801, when Thomas Jefferson ousted the Federalists, he changed federal policy and prevented printers from serving as postmasters. Congress called on the Secretary of State to name up to three newspapers in each state to publish the federal laws. And, printer exchanges emerged that allowed newspapers to report news from other papers and share newspapers through the postal system at no charge (Kielbowicz, 1990). "The printers' exchanges that had worked to build a wide system of newspapers were now used to fashion a national party" (Cook, p. 29).

In 1829, when Andrew Jackson was elected president, he elevated the position of the press, appointing editors to important political positions, allowing them to again serve as postmasters, as well as clerks and librarians to the Congress (Cook, 1998). The early nineteenth century was the height of the party papers, before the rise of the penny press in the 1830s. The "party papers were dependent on political leaders, not only for their initial capital and their point of view, but for maintenance through the paid publication of legal notices when the party they backed held power" (Schudson, 1978, p. 15).

"The shift from a personally organized politics of the 1780s to the partisan organization of the early nineteenth century occasioned a shift in what newspapers did and said," observes Cook (1998). "But the centrality of the press for the party also suggests that the political system, too, was dependent upon the newspaper system, to the point that is, for reasons largely beyond politics, the press were to change, so too would the political possibilities of newspapers, and so in turn would politics" (p. 31).

As journalism developed into a profession through the later part of the nineteenth century (see chapter one), the relationship with government changed. The news media, "instead of depending on the day-to-day sufferance of political patronage, access and potential prosecution, entered a more stable era of political subsidies, indeed entitlements from government" (Cook, p. 37).

In 1841, Congress opened up a press gallery. Later in the nineteenth century the Washington press corps developed and public relations emerged within the government. The public relations infrastructure within the government subsidized the operations of the news media; public relations within government followed the growth of the newspaper industry. As news grew, the press became more hierarchical and specialized, just as governmental public relations did the same (Cook, 1998; Reynolds & Hicks, 2012).

As Cook (1998) notes, government public relations officials began to better understand the benefits of more collegial relationships with the press. "Only late in the century did officials start to realize that, if reporters were going to be interested in particular developments anyhow, the sources of the news could favorably influence the final product less by stonewalling or intimidating (the press) than by cooperating and providing them with help" (Cook, p. 47).

In 1897, President William McKinley invited reporters into the White House; by 1901 President Theodore Roosevelt had reserved a separate room for the White House press corps. During President Woodrow Wilson's term, he deferred to the press to decide who would attend White House press conferences. All the while, governmental public relations grew as the federal government shouldered increasing responsibilities in coordinating and directing economic and social life, while it lacked the resources that would enable it to directly carry out those responsibilities (Cook, 1998).

Within the twentieth century, the news media continued to benefit from government subsidies and policies. Examples include the regulatory structure that emerged for radio and television; exemptions from laws that included mandatory minimum wage, overtime, social security, and child labor laws; and, tax exemptions for certain activities. Cook shows that "not only has there been a public policy toward the news media as a whole for the entire history of the republic, but it was justified by references to political and governmental functions specifically accorded to the media by the law" (p. 44). All of the press-friendly policies "were designed

with a presumption on the part of policymakers that the news media performed governmental and political functions and roles, and needed to be assisted in doing so properly" (p. 60).

Cook (1998) further argues that the role of the news media as a political institution is seen today in the coverage of politics (deciding what is newsworthy; deciding which sources to interview with a bias toward official/governmental sources; and, a storytelling narrative approach that focuses on conflict). Cook writes that, making news is, in and of itself, action – where it focuses the attention of other policy makers and thereby sets the agenda; and where it helps to persuade others into action. Cater (1959) and Cook's (1998) assertions that the news media are the fourth branch of government is the context in which we explore how public officials view newspapers' move to digitally-focused content, and how they identify its impact. If the power of the press is diminished because it is less centrally involved in reporting in-depth on government and policy issues, what does this mean for the future of the American political system?

SYRACUSE, NEW YORK & LOUISIANA

We chose to elicit the opinions of public officials in Syracuse, New York and the broader state of Louisiana because these are two of the first locations at which Advance Publications rolled out its print and delivery reduction strategies, and because the cities and states involved in this specific digital transition are quite different. It is helpful to see if patterns emerge in different political environments. The reduction in print publication at the New Orleans *Times-Picayune* occurred in October 2012. Modeled after its NOLA Media Group in New Orleans, Advance Publications announced the changes to its business and production model in Syracuse in August of 2012 and formally launched Syracuse Media Group and Advance Central Services in February 2013. Syracuse Media Group was charged with a "focus on news advertising and marketing," while Advance Central Services Syracuse was designed to "provide various support services to the Media Group such as production, circulation, information systems, accounting and human resources" (*The Post Standard*, October 2, 2012). While it continued daily publication of the newspaper—the Syracuse *Post-Standard*—on February 3, 2013, Syracuse Media Group reduced home delivery of the newspaper to three days a week. *Syracuse.com* reported that the newspaper intended to "double down on its digital offerings, making it easier to access the news from the desktop, mobile devices and tablets" (*The Post-Standard*, August 28, 2012). To this end: "Home delivery subscribers will get papers Tuesday, Thursday and Sunday at a price lower than they pay now. They will gain access to a daily 'e-edition' online—a digital replica of the newspaper printed each day" (*The Post-Standard*, August 28, 2012).

Our interviews in Syracuse occurred at the local level. We broadened our Louisiana interviews to include former governmental officials in Louisiana as opposed to just New Orleans because *The Times-Picayune* is so central to coverage of state politics and issues of concern to all Louisianans.

Louisiana is a medium-sized state with 4.5 million residents, 32 percent of whom are African American (U.S. Census, 2012). The state is divided into 64 parishes (counties) and has six Congressional districts. Currently, representation in the House of Representatives is by five Republicans and one Democrat. One U.S. Senator is a Republican, as is the current Governor, Bobby Jindal (re-elected in 2011). Baton Rouge is the capital, and New Orleans is the largest city, with a 60 percent African American population.

Louisiana's political and legal structure retained elements from the state's French and Spanish roots, most notably the state's application of civil law instead of common law. Civil law, in essence, means that the controlling law in the state comes from core principles that are codified into a system that serves as the primary source of law. In all other states, common law, or law that comes from the courts, is the basis for statutes. Louisiana is also notable for using an open primary system for its state and local elections (California and Washington also use an open primary system at the state and local level). This means a voter does not have to be affiliated with a political party in order to vote for partisan candidates, and all candidates appear on the same ballot. The two candidates with the highest number of votes proceed to a runoff, unless one candidate earns a majority (50 percent) of votes (in which case he or she wins outright). Louisiana is also one of 18 states that run separate elections for Governor and Lieutenant Governor, which can result in mixed party outcomes.

The state of New York is significantly larger. It is the third most populous state in the U.S. with more than 19.5 million people, of which 18 percent is Latino/Hispanic, 17 percent is African American, 8 percent is Asian and 57 percent is White (U.S. Census, 2012). Albany is the state capital and New York City is the largest city in the state with a population of more than 8 million. The state is divided into 62 counties and has 27 Congressional districts. Currently, representation in the House of Representatives is by 21 Democrats and six Republicans. Both U.S. Senators are Democrats, as is the current Governor, Andrew Cuomo (elected in 2010).

Syracuse is located in Central New York in Onondaga County. All of Central New York—including Onondaga, Madison, Oswego and Cayuga counties—is home to more than 740,000 people, 466,852 of whom live in Onondaga County (U.S Census, 2012). The City of Syracuse has a population of slightly more than 144,000, of which 56 percent are White and 29 percent are African American (Weiner, 2013; U.S. Census, 2012).

When Advance Publications began the transition to its digitally focused strategy in Syracuse, *The Post-Standard* announced it would lay-off about 115 of

415 total employees (about 25 percent), although it was never clear how many of the positions would be inside the newsroom (*The Post-Standard*, October 2, 2012 and *The Post-Standard*, January 20, 2013). It was reported that about 60 new positions would be available after the formation of Syracuse Media Group and Advance Central Services Syracuse (*The Post-Standard*, October 2, 2012). During the transition, the company worked to inform readers about how to use the new Web version of the newspaper by promoting free workshops and presentations at local libraries. Syracuse Media Group President Tim Kennedy published a letter online at *Syracuse.com* to explain the changes related to the formation of Syracuse Media Group, specifically highlighting some of the new features geared toward digital access and saying the company had a "mission to empower and inform Central New York" (Kennedy, February 3, 2013). Also on *Syracuse.com* that same day, readers could find a "Subscriber's guide" that detailed features of each of the days of home delivery, information about "seven day digital delivery" through the e*Post-Standard*, information about apps and social media, information about e-newsletters, and more (*The Post-Standard*, February 3, 2013).

THE DETERIORATING GOVERNMENT-PRESS RELATIONSHIP

Our interviewees include two former Louisiana governors; the current Syracuse Mayor and former co-chair of the New York State Democratic Committee; the Assemblyman who represents the 129th Assembly District in New York; two New York State Senators who represent the 50th and the 53rd Districts; the Onondaga County Executive; and, the Syracuse Common Council President. We also added comments from interviews with journalists who focused their answers on the relationship between the press and government. They include a veteran Syracuse television reporter, and a *Wall Street Journal* editor. All of our interviewees underscored the importance of the press to the health of government and its relationship with the public, and most worried about what they perceive as a general decline in the quality and quantity of accurate, in-depth government and policy content in the news.

Charles "Buddy" Roemer served as Louisiana Governor from 1988 to 1992. Between 1981 and 1988 he represented Louisiana's Fourth District in the U.S. House of Representatives. He says the news media serve public officials in four ways:

> A newspaper has historically been one indicator of what the public is thinking. Second, the editorial positions of the news media has historically been a place where politicians would come and get a view, a reasoned view or a view of more than passion about a particular problem. So, that's been very beneficial. Number three, the news media, and I'm thinking primarily newspapers, have historically followed a story deeper than the headlines with some analysis, with the reporter on the case for a period of time ... So, there's some

longevity to their scrutiny … And finally, the news media have been an amplifier for the politician's or the office holder's point of view. We not only listen and learn, but we use it as a microphone to say, "Well, here's what I'm doing." … It's these sorts of windows that the news media can give an expert government performer, that he or she has in no other … way (Roemer, personal communication, July 22, 2013).

Roemer's sense of this relationship between the press and the government matches Cook's (1998). One of Roemer's concerns with the modern state of the news media is the enhanced power he says it gives to elected officials—power that goes unnoticed by the general population. "I think we're in a world now where the politicians have a decided advantage over the people. Because there's no one digging," he says. Roemer says the shrinking of newsrooms, particularly in the area of public affairs reporting, and the replacement of speed as opposed to in-depth reporting as a primary news value, has made some public officials "emboldened to go undercover, go under the table, and do things that they know the public will be only luckily knowledgeable about," he says. "I really think the purchase of Washington by special interest money is a direct threat to the health and security of our nation. And this change in newsgathering is allowing it to continue unabated" (Roemer, personal communication, July 22, 2013).

Roemer says the Web's obsession with breaking news has altered the quality of news. "You're attention span is limited to 24 hours in a day. And most of us sleep 6 or 7 or 8 hours, so it's limited to 15 hours a day," he says. "There's only a finite period, and fast only works so far. What you need when there is a problem, an outbreak of influenza, a war pending, a corruption, corroding, what you need at these times of crisis is in-depth, penetrating news coverage. I don't think we're getting it" (Roemer, personal communication, July 22, 2013).

An experienced public official like Roemer, Syracuse Mayor Stephanie Miner shares her concerns about newsroom cuts and what that does to both the quality and quantity of coverage of local government. "There used to be actual beat reporters who covered topics. We would often have two or three newspaper reporters, somebody who would be dedicated to a policy area, and then somebody who just covered City Hall," she says of *The Post-Standard*. "And that has scaled back to—now we have somebody who covers City Hall, but they're not available necessarily all the time, and they don't have any time to do any in-depth reporting, and they are really running around, posting, looking first and foremost to be able to post content on the Web, and secondarily, to be able to look at that content, where it used to be just the opposite." She adds, "Content used to drive them," as opposed to speed or the number of "clicks" on a story (Miner, personal communication, April 1, 2013).

Miner is in her second term as mayor of Syracuse. Prior to becoming mayor, she served on the Syracuse Common Council for eight years. She became co-chair of the New York State Democratic Committee in 2012, but left in 2014. "As a

politician, with the media, I'm sort of at odds with them," she says. "But, by and large, I think that the Syracuse newspaper has served as a watchdog and a way that we all can unite. The transition to digital has been very difficult in that matter because the salacious content is really driving it, and sometimes to be a watchdog means that you've got to delve into things that are boring and talk about them. My hope is that this will be a learning process and that at the end we will end up with a venue or a media that continues to serve that role, but right now it doesn't seem to be really working" (Miner, personal communication, April 1, 2013).

Onondaga County Executive Joanie Mahoney echoes Miner's concerns. In her second term as county executive and as someone involved in politics since 1977, she says coverage of politics and local government stories has declined over the years as the local media corps in both print and television has changed. Now there are fewer reporters, many of whom have limited backgrounds and little context to cover legislative issues. The result? More shallow stories, she says, and, "now if you're trying to do a good job of getting a story out to the public, there's a lot more work on our end when you're dealing with a reporter that you're meeting for the first time. And that's happening a lot more than it ever used to happen," she says. "There seems to be a lot of turnover. You don't get reporters at the meetings. There's an opportunity for people who want to take advantage of it. You can really mislead reporters now. We're trying to get accurate stories out and we're always trying to do the right thing around here, but I'm seeing reporters that just write down whatever somebody tells them, and they don't do any investigation behind it, and that can be a bad thing" (Mahoney, personal communication, April 11, 2013).

Bill Carey has reported on Central New York for more than 40 years. An award-winning radio and television journalist, Carey is currently a general assignment senior reporter for the 24-hour Time Warner Cable local news television channel. He says that although Syracuse Media Group says it has more reporters on staff now, a significant number of the reporters are new and inexperienced. "It doesn't mean they're not good reporters, but it takes them time to learn the lay of the land, takes them time to make the mistakes and to figure out how to best go about getting a story – and while the newspaper retains some people who are really good at doing that, there's not as many as there used to be," he says. "And that's where you begin to see things falling behind as far as keeping an eye on local government, keeping an eye on what's going on" (Carey, personal communication, April 3, 2013).

Both New York State Senator Dave Valesky and State Senator John DeFrancisco see some positive aspects of the changes to the media landscape in Syracuse. Valesky commends the Syracuse Media Group for its forward thinking and proactive approach, and says digital delivery is clearly the way of the future. DeFrancisco says that the newspaper is becoming less of an established institution, and that political and governmental leaders using other tools to communicate

with constituents can be beneficial. DeFrancisco says that a decade ago politicians fought for the endorsement of a newspaper because it could mean "up to 10 percent in votes that could go your way." He says back then, "People took anything in the newspaper as gospel ... If the paper said you're right, you're right. If the paper said you're wrong, you're wrong, and oftentimes that led to—I believe—some very bad decisions in public life because there are politicians who want to get reelected, and the safest way to be reelected is to be loved. The safest way to be loved ... was to make sure that ... you were in tune with [the newspaper's] point of view" (DeFrancisco, personal communication, April 19, 2013). DeFrancisco says there are "more options now to get a message out than simply the print media," such as direct e-mail and video messages, which allow political and governmental leaders more flexibility to express their positions and rationale for their decisions (DeFrancisco, personal communication, April 19, 2013).

SOCIAL MEDIA

In today's political environment politicians can effectively by-pass the media because they have their own websites to distribute information about their stances on issues and policies. They don't have to engage the media in person to reach an audience; instead they can direct journalists and the public to their websites for more information. They can also use social media, such as Facebook and Twitter, to directly engage with the public and even raise money during campaigns.

"We had been ramping up our own internal digital presence and social media, in terms of pushing our information out and relying less on the newspaper here in town, long before they [*The Post Standard*] cut back," Valesky says. "It's not just me, lots of elected officials have been moving in that direction. And we continue to try to expand our own ability to push out content, based on some of the things that we're doing from a governmental perspective" (Valesky, personal communication, April 1, 2013).

Mahoney agrees. "We can take a picture and send a tweet out and send a link to a press release that is in our own words and a lot more accurately reflects what we're trying to say," she says. "So we're able—if that's the way the newspaper is going to report—we're able to report it ourselves just as easily" (Mahoney, personal communication, April 11, 2013).

The use of digital and social media by public officials and politicians has grown over the past several years, independent of the digital choices of news organizations. Alex Martin, Page One editor at *The Wall Street Journal*, says the move to use social media by public officials is a way for them to shape news coverage as well as communicate directly with the public. "I would imagine they spend all their time figuring out how to use social media to disseminate the conversation

they want to have with the public," he says (Martin, personal communication, November 14, 2012). This is one of the reasons journalists now use Twitter and other social media as a source of information to aggregate for the public. They monitor social media for information and content as much as they use it to break stories quickly and drive people to their websites.

Miner, who has used Twitter to conduct a "town hall" Q & A, sees the value of social media to communicate with younger constituents, but wonders, "How are we going to be able to communicate with the 75-year-olds about water main breaks or change in trash days? They're not going to get on Twitter, they're not going to get on Facebook." She adds, "What I worry about is that while those are great tools, they really are very unique to certain audiences" (Miner, personal communication, April 1, 2013). According to the Pew Internet and American Life Project, Internet users between the ages of 18–29 are most likely to use a social networking site of any kind (83 percent), while users under 50 are "particularly likely" to use a social networking site. Women use social media more than men, and people living in urban areas are significantly more likely to use social media than rural Internet users (Duggan & Brenner, 2013).

As a journalist, Carey is concerned that the use of social media by the public has lessened the civility of some of the conversations about government and specific issues. "I just see it as another example of people feeding their own viewpoints and people getting to spew views that sometimes we wouldn't have allowed them to say in public places because they were obnoxious or threatening," he says. "I guess that serves a purpose of letting them vent, but does it add to anybody's understanding? No" (Carey, personal communication, April 3, 2013).

When Roemer ran for president in 2012, he found social media a useful tool for raising money and for challenging the national Republican Party, which did not want him on the party ballot. Roemer says social media gave him the opportunity to be heard. He connected with people online and raised more than one million dollars, with the average gift less than $25. "I had tens of thousands of people give, never met me, never had a fundraiser," he says (Roemer, personal communication, July 22, 2013).

BIAS AND CREDIBILITY

Another concern that public officials express about the new digital focus of newspapers is that it can promote bias and lead to a lessening of professional journalism standards. As noted earlier, public officials articulated similar concerns when they talked about the weakening of the relationship between government and the press. Some argue that the speed with which news is now distributed leads to more fact errors and less detailed stories, both of which lessen a news organization's

credibility. Bias can appear because of the diminished credibility. Some argue that journalists know less about the issues they cover, which can allow politicians to have more ability to frame stories. Or, on the flip side, the lack of knowledge results in no coverage of an idea or a perspective.

Roemer says that in the new digital domain, "there are no standards." He argues that the new digital journalists may understand the technology but they often do not have deep knowledge of government or the important policy issues the public needs to understand in order to form an opinion. "Most of the reporters who cover me now ... have no intellectual framework from which to proceed. They're no better trained than I am in journalism. So, conversation with them is easy and non-productive," he says. "The hard questions don't come, all the passionate questions come, but not the hard questions" (Roemer, personal communication, July 22, 2013).

When Roemer ran for president in 2012 he expected journalists to ask him questions focused on the economy and how to fix the nation's banking regulations. Roemer holds a bachelor's degree in economics as well as an M.B.A. in finance from Harvard, and while in Congress he served on the Banking Committee. He also has founded two banks in Louisiana. "How many times was I not asked that question that should have been asked? How would you change banking regulation? In the old days, that would have been the beginning conversation. 'You're on the banking committee Congressman Roemer, banks are collapsing now at a rate unlike any time since the Great Depression, is there a solution a hand? What is yours?'" (Roemer, personal communication, July 22, 2013).

"The questions I was asked ... they were all passionate, personal short-term questions," he continues. "So, it seems to me that the new world is faster, there is more access to an amplifier on the part of the politician, and on the part of the loud speaker to the politician, so there is more access. But, it's less disciplined, less schooled, more shallow ... I like to think in terms of solutions. We'll need to develop some standards for the engagement. Not to shut people out, but to inform the general public who is asking these questions and what qualifies them," (personal communication, July 22, 2013).

Assemblyman Bill Magnarelli shares Roemer's concerns about the consequences of speed. "Will the quality of the reporting and investigations be at the same level? ... Everything has to be so fast. Again, do you have enough time to really look into a matter, to investigate it, to report it properly, or are we just throwing things out there? That's a concern to me," he says (Magnarelli, personal communication, April 3, 2013).

According to Mahoney, "The information going out quickly, I think, sometimes leads to a compromise in quality, and I'm also seeing a lot more opinion going out that's not under the banner of opinion." She adds, "It's led to some changes inside my office ... If information's just going to go out quickly without

the story being framed, then we have to take on more of the role of framing stories" (Mahoney, personal communication, April 11, 2013).

Concerns about bias are not just based on partisan affiliation, but also on making sure that under-represented populations are not lost in the digital world. Syracuse Common Council President Van Robinson says newspaper "reporters covered many events in the communities that were not so affluent. The (digital) media doesn't do that. If you have someone living within a certain neighborhood there may be blight, or it might be an abandoned house, or there may be an issue within that neighborhood," and often none of that information is clearly communicated (Robinson, personal communication, April 2, 2013).

Kathleen Blanco served as Louisiana Governor from 2004 until 2008. Prior to becoming governor, she served as Lieutenant Governor, as a state representative (45th district), and on the Public Service Commission (second district). She is best known nationally for governing the state of Louisiana during Hurricane Katrina (2005). And while she has concerns about bias and the quality of journalism in the digital realm, her experiences during Katrina illustrated that problems of bias and misinformation existed before the digital shift.

Blanco says that in the aftermath of Katrina, Karl Rove (President George W. Bush's senior advisor) told *The Washington Post*, *Time* magazine and a few other publications that the reason the federal response to the storm was slow was because Governor Blanco had not declared a state of emergency until after the storm hit Louisiana. She says after that story hit, her press office was inundated with calls from media. "And they're saying why didn't she declare an emergency? Why did she wait? And my people were going, 'What are you talking about? Did you bother to check her website? She declared it the Friday before the storm, before anyone in Louisiana knew a hurricane was aiming at Louisiana,'" Blanco says (personal communication, August 20, 2013).

She said *The Washington Post* ran a correction buried on an inside page (the original story appeared on page one), and a few weeks later she heard the same falsehood repeated by Newt Gingrich during a television interview when he was asked who was to blame for the slow Katrina response. "This is a month later … And when newspapers make that kind of mistake, it lingers because people can pull it up" (Blanco, personal communication, August 20, 2013).

When asked if the same situation would be better or worse in today's age of social media and digitally-focused news, Blanco noted that while the mistake could easily be corrected, it could also be "more widely distributed and believed. You see both ways. So, the lie can go further and deeper while the truth is there. It'll just be kind of hitting and missing. And you don't know who continues to push the lie out" (Blanco, personal communication, August 20, 2013).

CONCLUSION

As Cook suggested, changes in the press can lead to changes in politics. Many of the people we interviewed say the new digitally focused news environment offers more opportunity for public officials to behave badly, to drive people to political extremes, and to dumb down political discourse. Politicians and elected officials gain more control over their messages: "the people will only get one side and it's the side you want them to have. That's the beauty for the elected official," Blanco says. "That's the downside for the general public" (personal communication, August 20, 2013).

Blanco says that politicians should always get pushback from the media, but in the digital world the pushback now rarely comes from an objective press. "Now the pushback is not valid, it's your political opponents are manufacturing things, and they can say lies and they don't have to prove anything. So, you can get attacked unfairly also. It's a mixed bag" (personal communication, August 20, 2013).

Perhaps it is for this reason that public officials were among the first and the loudest protestors when *The Times-Picayune* announced its print reduction. In an open letter to Steven Newhouse, chairman of Advance Publications, U.S. Senator David Vitter wrote, "no digital platform, no matter how good, can completely replace a printed daily in substance, use, and significance to the community. This is particularly true in large, important segments of the population" (Vitter, 2012). He added that his own social media presence had more impact than the *NOLA. com* website: "As a single member of our Congressional delegation, I actually have far more Facebook followers than your whole enterprise" (Vitter, 2012).

The Times-Picayune's "journalists' dedication and professionalism have made our civic, business and education institutions stronger, more transparent and honest," wrote U.S. Senator Mary Landrieu, in a statement she issued immediately after the print reduction in New Orleans was announced. "In the midst of Hurricane Katrina's horrific aftermath, its courageous journalists and photojournalists provided reliable news when our region and nation needed it most. To think of not having a daily print edition saddens me. However, New Orleans will always need a robust news gathering operation to provide us with accurate and balanced news. In whatever new form *The Times-Picayune* takes, that need will not change" (Beaujon, 2012). Governor Blanco agrees. "You have to have the checks and balances. Anybody can tell their story the way they want it told and none of us like pushback, none of us do," (Blanco, personal communication, August 20, 2013).

For more than a century professional journalism has served as the fourth estate, as a recognized political institution in its own right (Cook, 1998). Should journalism continue to serve democracy and public life in its institutional capacity, it will need to publish credible and objective reporting about politics, government,

policy, and issues of public importance. It must continue its watchdog function. It must engage citizens in the political processes that elect leaders and determine the direction of our country. It may not matter if this occurs in digital or printed form. It simply matters that it is done, and done well.

REFERENCES

Beaujon, A. (2012, May 24). Sen. Landrieu on *Times-Picayune:* To think of not having a daily print edition saddens me. *Poynter.org.* Retrieved from http://www.poynter.org/latest-news/mediaw-ire/175055/sen-landrieu-on-times-picayune-to-think-of-not-having-a-daily-print-edition-saddens-me/

Cater, D. (1959) *The fourth branch of government.* Boston: Houghton Mifflin.

Cook, T.E. (2005). *Governing with the news: The news media as a political institution* (2nd ed). Chicago: University of Chicago Press.

Downie, L. & Schudson, M. (2009, October 19). The reconstruction of American journalism. *Columbia Journalism Review.* Retrieved from http://www.cjr.org/reconstruction/the_reconstruction_of_american.php?page=all

Duggan, M. & Brenner, J. (2013, February 14). The demographics of social media users 2012. Pew Internet and American Life Project. Retrieved from http://pewinternet.org/Reports/2013/Social-media-users.aspx

Hindman, M. (2008). *The myth of digital democracy.* Princeton, N.J.: Princeton University Press.

Kennedy, T. (2013, February 3). Introducing Syracuse Media Group: A new era for *Syracuse.com* and *The Post-Standard. syracuse.com.* Retrieved from http://www.syracuse.com/news/index.ssf/2013/02/introducing_syracuse_media_gro.html

Kielbowicz, R.B. (1990). Postal subsidies for the press and the business of mass culture, 1880–1920. *Business History Review, 64,* 451–488.

Kovach, B & Rosenstiel, T. (2010) *Blur: How to know what's true in the age of information overload.* New York: Bloomsbury.

Krupa, M. (2012) Mayor Mitch Landrieu vows to help *Times-Picayune* 'grow and not diminish.' *NOLA.com.* Retrieved from http://www.nola.com/politics/index.ssf/2012/05/mayor_mitch_landrieu_vows_to_h.html

The Post-Standard. (2012, August 28). *The Post-Standard* to reduce print edition delivery in bold bet on stronger digital presence. *syracuse.com.* Retrieved from http://www.syracuse.com/news/index.ssf/2012/08/the_post-standard_to_reduce_pr.html

The Post-Standard (2012, October 2) *The Post-Standard* and *Syracuse.com* take next step in forming new companies. *syracuse.com.* Retrieved from http://blog.syracuse.com/news/print.html?entry=/2012/10/syracuse_media_group_1.html

The Post-Standard (2013, January 20). Syracuse Media Group's move signals shift to digital-first focus for news and ads. *syracuse.com.* Retrieved from http://www.syracuse.com/news/index.ssf/2013/01/digital-first_syracuse_media_g.html

The Post-Standard (2013, February 3). Subscribers guide to the new *Post-Standard* and *syracuse.com. syracuse.com.* Retrieved from http://www.syracuse.com/news/index.ssf/2013/02/subscribers_guide_to_the_new_p.html

Romenesko, J. (2012, July 9). Our city wants a daily, printed paper. *Romenesko.com*. Retrieved from http://jimromenesko.com/2012/07/09/our-city-wants-a-daily-printed-paper/

Reynolds, A. & Hicks, G. (2012). *Prophets of the fourth estate: Broadsides by press critics of the Progressive Era*. Los Angeles: Litwin Books.

Schudson, M. (2008). *Why democracies need an unlovable press*. Malden, Mass.: Polity Press.

Schudson, M. (1978). *Discovering the news: A social history of American newspapers*. New York: Basic Books.

Shirky, C. (2008). *Here comes everybody: The power of organizing without organizations*. New York: Penguin Books.

U.S. Census (2012). Quick facts. Retrieved from http://quickfacts.census.gov/qfd/states/22000.html

Vitter, D. (2012, July 26). David Vitter to Steve Newhouse: I urge you to sell. *Romenesko.com*. Retrieved from http://jimromenesko.com/2012/07/26/david-vitter-to-steve-newhouse-i-urge-you-to-sell/

Weiner, M. (2013, May 23). New U.S. census report: Syracuse area shows more signs of stability. *syracuse.com*. Retrieved from http://www.syracuse.com/news/index.ssf/2013/05/new_us_census_report_syracuse.html

Conclusion

ANDREA MILLER & AMY REYNOLDS

In a 2012 *Nieman Reports* cover story, the authors, including Harvard Business School Professor Clayton Christensen, laid out the argument of how journalism can "Be the Disruptor." In three parts, they take readers through why newbies *The Huffington Post* and *BuzzFeed* are "eating away at the customer base of incumbents" and how the journalism business can recover by being innovative (Christensen, Skok & Allworth, 2012, p. 6). This is a simplistic summary of what is a brilliant challenge to the industry, mainly to the large media companies, to make changes now or lose mainstream status. There has never been any doubt that the industry needed to adapt. The form of the adaptation is what has eluded the professionals. The global newspaper industry has reached that crescent turn in the river—you can't see what is in front of you until you make the turn.

When we began our research on the changes at *The Times-Picayune*, we thought our findings would be straightforward. Instead, the deeper we would dig, the more complexity we would find. This was true no matter the context—social, political, economic. While we did discover clear patterns and approaches that suggest what the future of journalism might look like (highlighted below), the news revolution is still too new to definitively decide how the story will end. As Shirky (2008) notes, "We are living in the middle of the largest increase in expressive capability in the history of the human race. More people can communicate more things to more people than has ever been possible in the past, and the size and speed of this increase, from under one million participants to over one billion in a generation, makes the change unprecedented, even considered against the background of previous revolutions in communication tools" (p. 105–106).

The book's title asks, "news evolution or revolution?" We conclude that what we've seen and will continue to see is more like a revolution—the overthrow of the existing system in favor of something new. But, evolution is a part of this, too. As journalists and news organizations use the new digital tools readily at their disposal, the characteristics of news are changing.

Technology is one of the key reasons behind this change. Technological changes broke down the barriers to entry into the information business. Citizen journalists and bloggers don't need millions of dollars for a printing press or television broadcasting equipment. They don't need FCC approval. Access is literally at their fingertips. Technological changes and the choices news organizations have made in how they use (or ignore) technology underlie all of the themes presented in this book. Access to technology can determine who gains information. New platforms can alter the kind of content we choose to access, when we access it, and how we access it. Twitter considers itself a technology company in a media space. Media are information companies in a technology space. Media are in the information transmission business, and they have lost ground on the transmission-side. This is one of the reasons behind the industry's stumbling. The avenues of transmission changed and for years were ignored. News outlets focused on the information part of their mission, but did not consider how new technology was changing the form of information, as well as offering a new and effective way to transmit it to their audiences. "When new technology appears, previously impossible things start occurring. If enough of those impossible things are important and happen in a bundle, quickly, the change becomes a revolution," Shirky writes (p.107). "The hallmark of a revolution is that the goals of the revolutionaries cannot be contained by the institutional structure of the existing society." Ample evidence presented in this book supports the idea that the current institutional structure of the news industry cannot be sustained in its current form, and that those who run news organizations are behaving differently than they have in decades past. "Revolution doesn't happen when society adopts new technologies," Shirky notes. "It happens when society adopts new behaviors" (Shirky, 2008, p. 160).

OVERALL FINDINGS

While we primarily explored the story of *The Times-Picayune*, we also examined various business models for newspapers; differences in how communities handle news during a crisis; how Advance Publication's decision impacted other newspapers it owns; and, how different communities believe a decline in print journalism impacts politics and local government. *New York Times* columnist David Carr, who broke the story of the print reduction at *The Times-Picayune*, perhaps best explains

why the focused study of the New Orleans news environment is relevant to the broader questions facing the news industry as it moves forward. "Journalists have a sentimental attachment to *The Times-Picayune* in the same way that people have a sentimental attachment to New Orleans. It's weird, it's got its idiosyncrasies, but it's got charms that sort of give you faith in human nature and there's just—and, the other thing is for people who are interested not just in journalism as it is evolving but in print as its own artifact, (New Orleans) was one of the few American cities where you could go and see people engaged in the act of steadily reading a newspaper" (Carr, personal communication, July 20, 2013).

What has our exploration of *The Times-Picayune's* aggressive migration to digital taught us? The patterns we saw across chapters include:

- **Robust local news is central to healthy communities, particularly in times of crisis.**

History tells us that newspapers have played a central role in the strengthening of American democracy and building a public-minded society. The value of local information from well-trained journalists who intimately know their communities shows up particularly in coverage of local and state government, and in times of crisis. Citizens rely on local news to provide them with life-saving information during a crisis. Local news organizations and journalists who have a commitment to their communities provide more thorough, accurate and useful information than national news organizations. Local journalists, because they live and engage in public life with their fellow citizens, are committed to the success of their local communities.

- **The watchdog function is crucial.**

When our various interviewees across chapters and topics were asked about the central functions of journalism that cannot and should not change in the digital environment, nearly everyone talked about the watchdog function. Even the New Orleans area residents we surveyed identified the importance of the press serving as public protector: 77 percent believe it is the newspaper's duty to protect the public from government corruption, and 76.1 percent believe the role also applies to corporate corruption (PPRL, 2012). Some New Orleans-area residents even believe that the loss of the daily *Times-Picayune* will cause increases in both government and business corruption (roughly 20 percent)(PPRL, 2012).

As Broussard and LaPoe explained in chapter two, protecting the city and its readers was part of *The Times-Picayune's* first mission statement. If the watchdog function of the press diminishes or goes away, most people believe this puts the welfare of the public in danger. We agree.

- **Digital content is different and still evolving.**

Social media, data-driven news, citizen journalism, native advertising, extensive photo slideshows, and multimedia journalism are all new components of digital news. New features and ideas occur on a regular basis. What is different about digital content? It is published more quickly, it leans toward sports, entertainment and crime news and eschews depth coverage of public issues, it can blur lines between sponsored advertising and objective journalism, and it can be tailored to appeal to smaller, niché audiences. As new forms of technology emerge, content will likely continue to evolve, some of it looking nothing like traditional news in a newspaper.

- **Content will still drive consumption and changing economic models.**

It seems obvious to say that content is the product that news media sell and subsidize through advertising. Yet, given the rapid changes in how news organizations are crafting strategies to turn high profit margins, it seems important to state this, and to remember that all decisions should be driven by content. This notion appeared throughout the book's chapters, whether in the context of political, economic or social/community challenges.

Richard Gingras, Google's senior director of news and social products, said his company is building a "social spine" that connects everything people do (personal communication, January 28, 2013). However, information remains the neural impulses that run up and down that social spine. No matter the platform, content remains king. News, information and knowledge are, and always will be, central to what news organizations produce. What separates content in *The Times-Picayune* or any other newspaper online from the variety of other non-journalism news sources is the professional standards applied by a newspaper's journalists, the newspaper's credibility, the resources a newspaper devotes to producing quality journalism, and its ability to leverage its brand to gain access to powerful leaders and significant places the public can't readily go.

- **Different economic models will prevail, and a one-size-fits-all approach doesn't exist.**

YouTube representatives told a Manship School of Mass Communication group that students need to be confident enough to innovate and confident enough to fail (personal communication, January 29, 2013). The same could be said of all media companies. Everyone is looking for the "holy grail" of economic models or business strategies to rescue newspapers. The various approaches we've identified in the book show that many different ideas can work in different ways for different news organizations. The key is to know your news product, know your audience (or community), recognize how disruptive technology works, and diversify in some cases. News organizations also should not be afraid to try new ideas. Is the digital

approach *The Times-Picayune* has chosen the right one? It's too early to know, but it is possible that a strategy that works for one organization might not work for another. Additionally, the most successful model may yet to be discovered and implemented.

- **Local news is now part of a more diverse news ecosystem.**

Diversity is good, as is "more" when it comes to knowledge, news and information. The challenge is for citizens to learn how to navigate the new ecosystem and find the news and information they need. It is also incumbent upon dominant news organizations and newspapers to adapt as well.

Rosental Alves, Knight Chair in international journalism and professor at the University of Texas School of Journalism, says he uses the metaphor of a desert and a jungle. Because of limited water, the desert does not have much life, only a few cactuses. But, in the jungle, water and life is abundant. Alves suggests that our traditional media landscape was the desert, and the new landscape is the jungle. "We move from that desert where having a channel was a privilege, was a big asset ... because there were just a few channels available. And the barriers to establish a channel were so high," Alves says. "But we've come to a point where there's no barrier at all ... We move from the mass media to the mass of media environment where mass media is still there too, but it is in another context, and ... with a basic need of a symbiotic relation with the rest of the media. That cactus cannot do that. ... The cactus has to become something completely different" (Alves, personal communication, July 29, 2013).

"In the digital space, it's a whole new ballgame," says *Times-Picayune* publisher Ricky Mathews. It was a cultural change, he says, that lead to "enormous numbers of competitors" (personal communication, April 25, 2013).

NEXT UP: TELEVISION?

So, where do we go from here? The lessons that the newspaper industry are learning from the news revolution have put them far ahead of television news in crafting workable strategies for sustaining themselves in the digital world. Although no one would suggest that television is in danger of dying, it is facing the same digital disruption as newspapers. The disruption just hasn't hit television as hard yet. But, like reading news in print versus on the Web, viewers are increasingly watching television on mobile devices and desktop computers.

More than five million homes "cut the cord" in 2013 and began to receive their television programs from Internet streaming or through DVD or video game consoles, according to a Nielsen study (Baker & Grover, 2013). In 2012, for the first time in 20 years, Nielsen reported a drop in the number of television sets with

a signal in U.S. households. In New York City, upstart tech company Aereo has emerged to capture some of these viewers, raising questions about copyright and the ability of broadcasters to retain the nearly $3 billion in retransmission fees that they collect from cable and satellite providers each year. Basically, Aereo uses hundreds of individual, dime-sized antennas to retransmit over-the-air TV signals to consumers via the Internet for a fee. Broadcasters in New York have sued the company, and the case is currently on appeal. A similar service in California prompted a lawsuit in which broadcasters won, but until resolution in the Aereo case the company is expanding its service to cities across the country (Baker & Grover, 2013).

Is it an unnecessary worry to suggest that the 18–24-year-old age group is moving away from television? Based on Nielsen data and television consumption patterns between 2011 and the second quarter of 2013, people in the 18–24-year-old age group are watching less television, but the decline is not precipitous. Perhaps more worthy of note is that people in all age groups consumed less television. Only those in TV households were measured (Marketing Charts.com, 2013).

Forbes notes that three distinct "players" are competing to control the future of the television industry: "large distribution companies that have amassed enormous power, creators of original content who are increasingly driving most of the value, and developers of emerging technologies that are attempting to transform the viewing experience" (Gerber, 2013).

If this sounds familiar, it should. What Deborah Potter (2013) reports about changes in viewing habits in local television news should also sound familiar to those who have followed the decline of newspapers. Despite the fact that revenue was up in 2012, largely due to election-related political advertising, Potter (2013) writes that local television news lost "audience in every key time slot, including those that gained viewers the year before. In most nontraditional time slots, viewership stagnated. And the total audience for all local news programs combined was smaller than the year before. The strategy of gaining viewers by adding more and more time for news appears to have stopped paying off" (Potter, 2013).

Potter (2013) says that local television news stations report that their social media, online, and mobile news audiences are growing, but little public data supports that. Data that are public suggest digital revenue is growing slowly.

Sound familiar?

A Pew survey shows that 31 percent of people say they have abandoned a "particular news outlet because it no longer provides the news and information they had grown accustomed to" and "those most likely to have walked away are better educated, wealthier and older than those who did not—in other words, they are people who tend to be most prone to consume and pay for news" (Enda & Mitchell, 2013).

A recent study of local television newscasts on eight stations in four different markets found less substance and a shortened length of stories. "When 2012 is compared with 2005, the amount of time devoted to edited story packages has decreased and average story lengths have shortened, signs that there is less in-depth journalism being produced," Potter (2013) reports. "Traffic, weather and sports—the kind of information now available on demand in a variety of digital platforms—is making up an ever-larger component (40 percent) of the local news menu. Meanwhile, coverage of politics and government is down by more than 50" percent (Potter, 2013).

Sound familiar?

As recognized in chapter three, social media often breaks stories, usurping what was the power of television. Audiences then continue to other media for more information on a story. This anxiety-reducing strategy is followed every time a big story breaks. Television ratings surge as users seek out information—usually in the form of video. But, as shown in the crisis chapter, overloaded websites still crash, and the video on many sites is of poor quality or loads slowly. Until this is remedied and all news outlets realize the importance of having robust websites with an efficient player, television will continue to dominate in visual, breaking news situations. But that time is ending, and strategies have to be in place to convince users that television remains the go-to outlet as crises develop.

While we believe the disruption to television is only a few years behind news-papers, that still doesn't tell us what all of these changes mean. Where does the story of the news revolution of the twenty-first century end? As former journal-ists-turned-professors we don't want to use the tired expression "time will tell." But, it is still too early in the digital transition to make sweeping generalizations about the future.

YouTube representatives told the Manship group that they have made the strategic choice to "dominate the next generation"—Generation C—and they are already well on their way (personal communication, January 29, 2013). Company representatives say that negotiating partnerships with legacy media (television and newspapers) is not an option. Six billion people around the world still don't have access to the Internet, and they say that has great implications for their business model. They asked us to imagine: What might we unlock by connecting all these people? Using the term "participocalypse," the company representatives foreshad-owed the information industry's future, one that could cause further market dis-ruption (personal communication, January 29, 2013).

We believe that the continued study of organizations like *The Times-Picayune* and communities like New Orleans will give us important insights, but probably won't provide complete answers. When the next chapter of the history of *The Times-Picayune* is written, it will likely include analysis of the "frequency change" spearhead-ed by Advance's Mathews and *Times-Picayune* Editor Jim Amoss. What we present

in this book is only a snapshot of the dynamic news industry at a certain point in time—a time of great upheaval and uncertainty, but also opportunity. Whatever the future holds, our hope is that citizens, consumers, audiences, and communities will demand quality journalism from their news providers and use the new technology tools to produce even more robust news environments, and that the people and the corporations behind the news will listen.

REFERENCES

Baker, L.B. & Grover, R. (2013, April 7). *Tech upstarts threaten TV broadcast model. Reuters,* Retrieved from http://www.reuters.com/article/2013/04/07/us-broadcaster-threats-idUSBRE9360E220130407.

Christensen, C.M., Skok, D. & Allworth, J. (2012). Breaking news: Mastering the art of disruptive innovation in journalism. *Nieman Reports,* 66(3), 6–8.

Enda, J. & Mitchell, A. (2013). Americans show signs of leaving a news outlet, citing less information. *Stateofthemedia.org.* Retrieved from http://stateofthemedia.org/2013/special-reports-landing-page/citing-reduced-quality-many-americans-abandon-news-outlets/

Gerber, R. (2013, September 18). Investing in the future of television. *Forbes.com.* Retrieved from http://www.forbes.com/sites/greatspeculations/2013/09/18/investing-in-the-future-of-television/

Marketing Charts (2013, September 10). Are young people watching less TV? *Marketingcharts.com.* Retrieved from http://www.marketingcharts.com/wp/television/are-young-people-watching-less-tv-24817/

Potter, D. (2013, March 18). The state of local TV news. *Advancingthestory.com.* Retrieved from http://www.advancingthestory.com/2013/03/18/the-state-of-local-tv-news/

Shirky, C. (2008). *Here comes everybody: The power of organizing without organizations.* New York: Penguin Books.

About the Authors

Andrea Miller (Editor) is the Huie-Dellmon Professor and Associate Dean for Undergraduate Studies in the Manship School of Mass Communication at Louisiana State University. Prior to joining the faculty in 2003, Miller received her Ph.D. from the University of Missouri-Columbia School of Journalism and was an award-winning television news producer for a decade. Miller has published articles on television news and crisis coverage in *Journalism & Mass Communication Quarterly*, *Media Psychology*, *Visual Communication Quarterly*, and the *Journal of Contingencies and Crisis Management*. Miller is the co-author of the upcoming book *Oil & Water* about the media lessons from Hurricane Katrina and the BP oil disaster.

Amy Reynolds (Editor) is the Thomas O. & Darlene Ryder II Distinguished Professor and Associate Dean for Graduate Studies and Research in the Manship School of Mass Communication at Louisiana State University. She also co-directs the school's Press Law & Democracy Project. Her research focuses on dissent, First Amendment and press history, and breaking news. She has written or edited seven books, as well as more than a dozen articles and book chapters. Prior to becoming a professor, she worked as a reporter, editor, producer and news director at newspapers and television stations.

Jinx Coleman Broussard is an associate professor and Remal Das & Lachmi Devi Bhatia Memorial Professor in the Manship School of Mass Communication at Louisiana State University. After working briefly as a journalist, she began a

distinguished career as a public relations practitioner and professor. Broussard is a media historian and the author of two books and dozens of articles on the Black Press. The first book, *Giving a Voice to the Voiceless: Four Pioneering Black Women Journalists*, was published in 2004. The second book, *African-American Foreign Correspondents: A History*, came out in June 2013 to rave reviews.

Jerry Ceppos has been dean of the Manship School of Mass Communication at Louisiana State University since 2011. Earlier, he was dean of the Reynolds School of Journalism at the University of Nevada, Reno. He has spent most of his career in the newspaper industry. Ceppos was vice president for news of Knight Ridder, at the time the second-largest newspaper publisher in the United States, and executive editor and managing editor of the *San Jose Mercury News*. He is a former president of the Associated Press Managing Editors and the California Society of Newspaper Editors. He was one of three recipients of the first Ethics in Journalism Award from the Society of Professional Journalists.

Nicole Smith Dahmen is an associate professor in the Manship School of Mass Communication at Louisiana State University. Her research on ethical and technological issues in visual communication is published in *Visual Communication Quarterly*, *Newspaper Research Journal*, and *Journalism Studies*. Her work on visual ethics centers on photojournalism and the associated moral responsibilities of visual communicators. In regard to technology, her works examines the visual presentation of mass-mediated information and associated technologies—both from a content and effects perspective. Dahmen also has extensive professional design experience, ranging from the development of content to design and production for multiple platforms.

Ben Rex LaPoe II is an assistant professor of interactive storytelling in the School of Journalism and Broadcasting at Western Kentucky University. He received his Ph.D. in mass communication and public affairs, with a concentration on race in political communication, from Louisiana State University's Manship School in 2013. LaPoe received a B.A. in English in 2003 and a M.S. in journalism in 2008, both from West Virginia University.

Lindsay M. McCluskey is a Ph.D. student in the Manship School of Communication at Louisiana State University. She served as press secretary for Syracuse Mayor Stephanie A. Miner from 2010–2012, and as press secretary for the Miner for Mayor campaign in 2009. She earned her master's degree in public relations from Syracuse University in 2008, receiving the Graduate School Master's Prize and the Public Relations Certificate of Achievement. She

earned her bachelor's degree in Communication/Journalism from St. John Fisher College in 2007, graduating summa cum laude.

Lance Porter currently directs the Digital Media Initiative in the Manship School of Mass Communication at Louisiana State University where he studies the effects of digital media on culture and creativity. With more than 20 years of marketing experience, Porter has focused on digital media since 1995, when he built his first commercial website. Before LSU, Porter spent four years as executive director of digital marketing for Disney. There he oversaw the creative and media strategies for more than 80 films and won a Clio Award for excellence in advertising. He holds a joint appointment with the Center for Computation and Technology (CCT).

Chris Roberts is an assistant professor at The University of Alabama, where he earned his bachelor's and master's degrees. He earned his doctoral degree at the University of South Carolina. Roberts was a reporter and editor at Southeastern newspapers nearly continuously between ages 14 and 40, including a nine-year stint at *The Birmingham News* as a reporter, weekend editor, technology columnist, and database editor. After taking a pension buyout from Newhouse in late 2012, he has no financial interest in the newspaper other than his print subscription.

Paromita Saha is a master's student in the Manship School of Mass Communication at Louisiana State University. Originally from London, England, Saha started her career at the British Broadcasting Corporation (BBC) as a broadcast journalist. She has also freelanced as a news producer for major British broadcasters such as ITN News and GMTV, and has worked on numerous high-profile BBC documentaries. In recent years, Saha was a communications consultant on major projects for the British government and the nonprofit sector. In her spare time, Saha is a music journalist and regularly writes for the award winning British blues magazine, *Blues Matters*.

Index

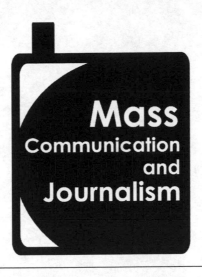

Lee B. Becker, *General Editor*

The Mass Communication and Journalism series focuses on broad issues in mass communication, giving particular attention to those in which journalism is prominent. Volumes in the series examine the product of the full range of media organizations as well as individuals engaged in various types of communication activities.

Each commissioned book deals in depth with a selected topic, raises new issues about that topic, and provides a fuller understanding of it through the new evidence provided. The series contains both single-authored and edited works. For more information and submissions, please contact:

Lee B. Becker, Series Editor | *lbbecker@uga.edu*
Mary Savigar, Acquisitions Editor | *mary.savigar@plang.com*

To order other books in this series, please contact our Customer Service Department at:

 (800) 770-LANG (within the U.S.)
 (212) 647-7706 (outside the U.S.)
 (212) 647-7707 FAX

Or browse online by series at www.peterlang.com